The Art of the Old West

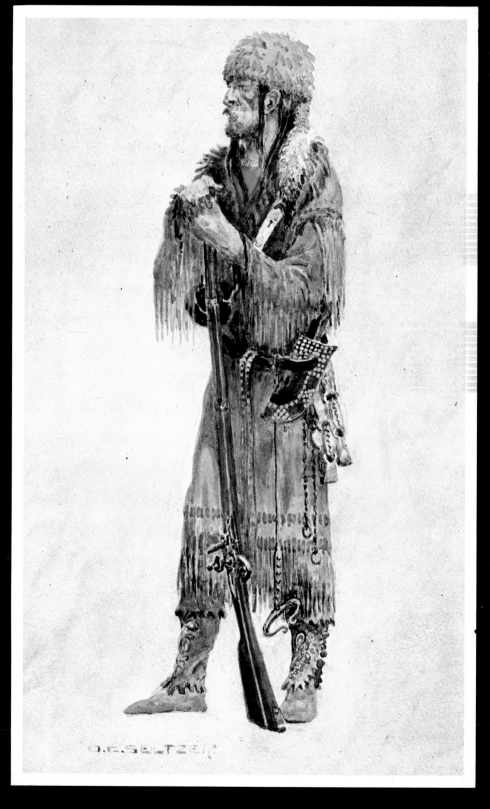

O.C.SELTZER

PROMONTORY
PRESS

The Art of t

FROM THE COLLECTION OF THE GILCREASE INSTITUT

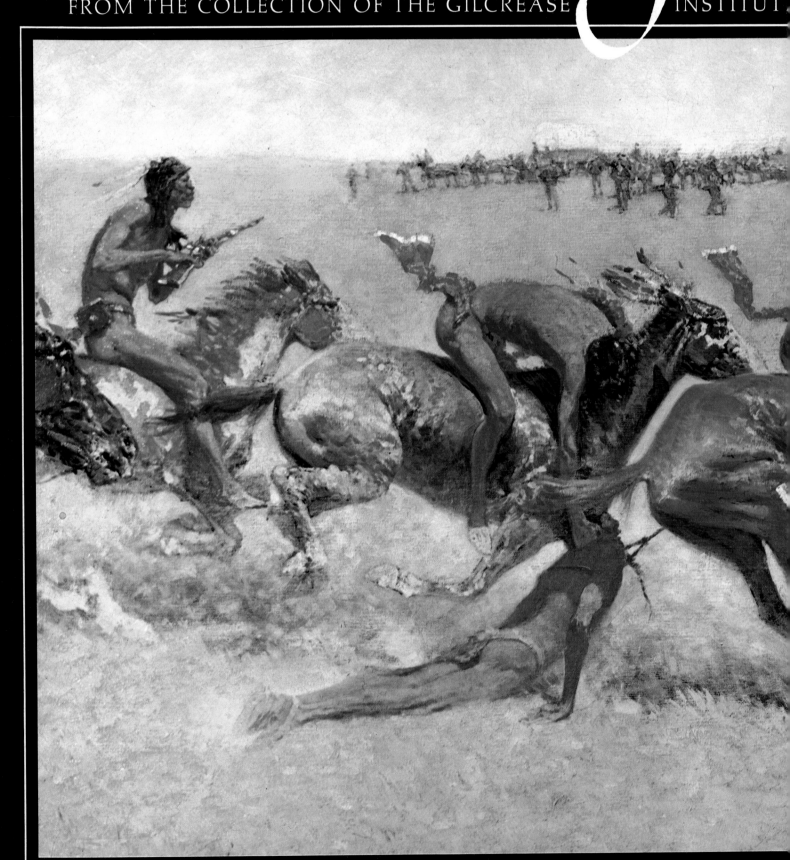

ne Old West

SELECTIONS AND TEXT BY PAUL A. ROSSI AND DAVID C. HUNT

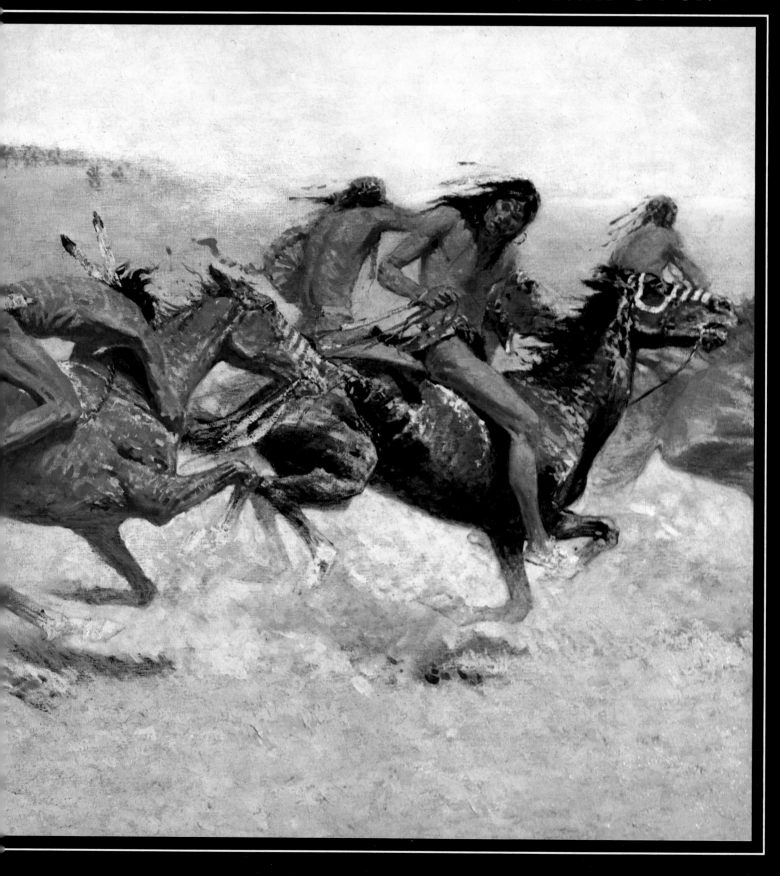

This edition published in the United States of America in 1991 by:
Promontory Press
A division of LDAP, Inc.
386 Park Avenue South
Suite 1913
New York, New York, 10016
By arrangement with Alfred A. Knopf, Inc.
First published in the United States by Alfred A. Knopf, Inc. in 1971.

Library of Congress Catalog Card Number: 81-81151
ISBN: 0-88394-045-0
Printed and bound in Italy

This book is respectfully dedicated
to the memory of the late
Thomas Gilcrease
founder of the Thomas Gilcrease
Institute of American History & Art
in Tulsa, Oklahoma.

ACKNOWLEDGMENTS

*I*n the process of compiling the present volume, a number of persons associated with the Gilcrease Institute of Tulsa, Oklahoma, necessarily played parts of greater or lesser importance in its development. Initial interest in the project was shown by Mr. Dean Krakel, former Gilcrease director, Mr. Alfred E. Aaronson, past Chairman of the Gilcrease Board of Directors, Mr. Alfred A. Knopf himself, and Mr. Angus Cameron, Vice President and Senior Editor of Alfred A. Knopf, Inc., all of whom were actively involved in its inception. Encouragement also was offered at this early stage by Mr. George H. Bowen and Mr. David R. Milsten, who, as newly elected President of the Board in 1967, appointed a special committee composed of Board members Aaronson, Bowen, and Otha H. Grimes to help guide the effort toward completion.

Through Mr. Aaronson's personal friendship with Alfred Knopf in particular, a line of communication was maintained between the New York publisher and the Institute in Tulsa that proved to be of vital importance to the final success of the venture. At this same time Mr. Nick Broyles, as Chairman of the Parks and Recreation Board of the City of Tulsa, carried the burden as liaison between the City and the Gilcrease Institute.

Acknowledgment also is due other City officials for their interest in and approval of the project, especially to James M. Hewgley, former Mayor of the City of Tulsa, Mr. Charles E. Norman, former attorney for the City, and Mr. Lowell Long, City Personnel Director. Among those on the Gilcrease staff itself who willingly contributed their time and efforts in behalf of the authors, a very special word of appreciation is extended to Donnie D. Good and to Mrs. H. H. Keene for services rendered in the editing, typing, and proofing of portions of the manuscript itself.

For the production of all the illustrative material featured in this book, both in color and in black and white, credit goes to the Institute's staff photographer, Mr. Oliver Willcox, who spent many hours laboring among the works of art in the Gilcrease collection. Thanks also should be expressed to Mr. Robert Scudellari, Art Director for Knopf and Random House and the designer of this book, and to Mr. Sidney Jacobs, Vice-President in charge of Production, for their respective contributions to the design and production of this publication.

Thanks also should go to Gilcrease Executive Committee members William S. Bailey, Jr., Morton R. Harrison, Mrs. Roger Devlin, James C. Leake, Joseph F. Glass, Paul H. Johnson, and Vernon Kidd for their support throughout the length of this project.

Above all, we owe a debt of gratitude to the late Thomas Gilcrease, founder of the Institute that bears his name, whose lifetime of accomplishment made all of this possible.

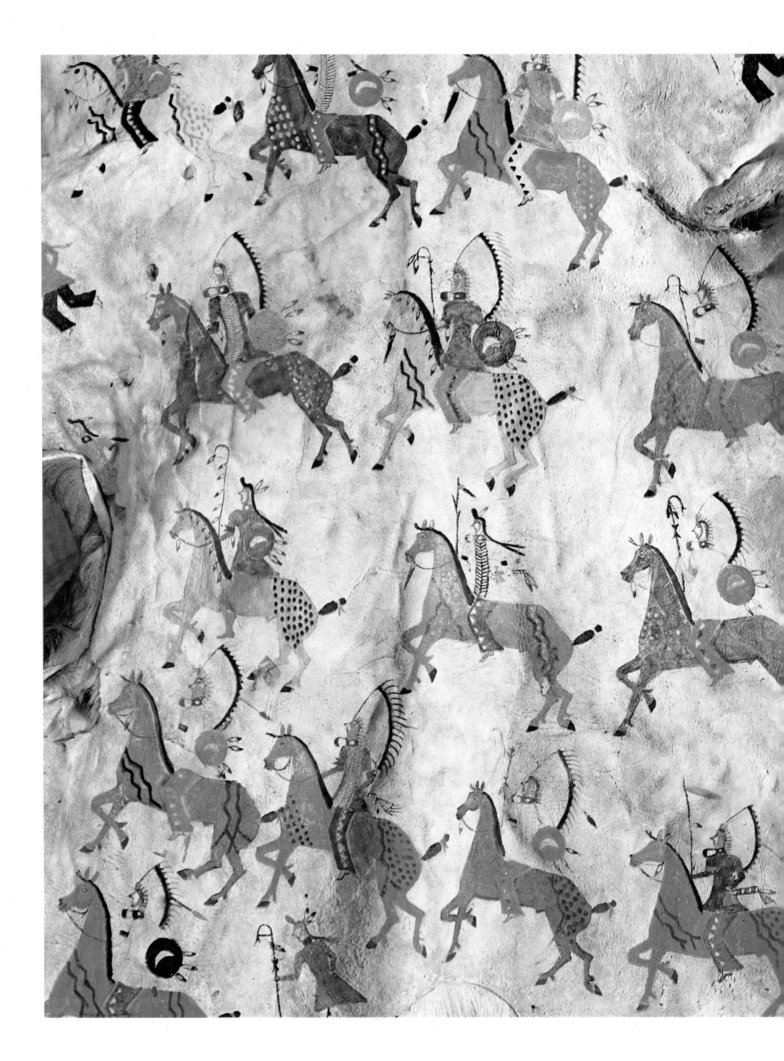

CONTENTS

Detail of an elk hide

Art of the Old West: pp. 3, ***4-5, **10*, 37*53, *57, *59*, *61, *64,
*82, *103, 105, *110*, *116-117*, 124, 126, *129, *134-135*, 144**, 150-151*,
156-157, *160*, *166*, ***173, *175, *191*, ***196-198*203, *215, *220-
221**, *204, ***228-231****, ***240, ****242-243, ****247**, 255, ***258-259**, 268,
*268*273***, ***270*274-275, *277, *280-281*, *282-283*, *286-287, *288-289*,
290-291*, **293-294, *296-297*, **303-307, **308-310**, *19-31**

AUTHORS' PREFACE

During a long and active career as a private collector, Tulsa oilman Thomas Gilcrease accumulated a vast inventory of materials documenting the history of North America. Beginning about 1910 and continuing throughout the 1950's, he traveled widely in search of works of art, books, and artifacts relating to this country's earlier development, gradually enlarging the scope of his quest to include, in time, nearly the whole range of American achievement and experience. If a picture or a report told a story about America, he made every effort to acquire it, especially if the story happened to make reference to one of the native Indian tribes or to the settlement of the trans-Mississippi west. Buying single items and sometimes entire catalogues of works from other collectors, dealers, or the heirs of earlier adventurers on the American frontier, he built a collection of his own that exists today as one of the finest of its kind in the world.

His Indian ancestry was a point of pride with Thomas Gilcrease. Born in Robeline, Louisiana, in 1890, he grew up in nearby Indian Territory, where in 1899 each member of the Gilcrease family received an allotment of 160 acres of land in the Creek Nation. Young Tom's tract lay near the center of what became the Territory's first major oil-producing field, a few miles southwest of the present Tulsa, Oklahoma. On his initial earnings from this source he educated himself. Soon he was engaged in trading oil leases in Oklahoma and Texas, drilling wells, and amassing the fortune that in later years enabled him to pursue his interest in things American.

In 1925 he made the first of many trips to Europe to broaden his knowledge of history and the arts. World War II curtailed his trans-Atlantic travels, but by no means ended his collecting activities, which lasted a lifetime. Thirty years after making his first acquisition, he chartered a private foundation for the purpose of maintaining an art gallery and library devoted to the preservation of American culture. Today the Thomas Gilcrease Institute of American History and Art, owned and operated by the City of Tulsa, continues that original aim, offering to visitors from all parts of the nation and the world the opportunity to explore its assembled treasures.

Included in its collections at the present time are more than 5,000 works of art, approximately 200,000 prehistoric and historic artifacts, and over 60,000 books, manuscripts, and related documents dealing with successive periods in the growth of the United States. Some of the nation's most celebrated painters and sculptors are represented in its galleries, in particular those hardier individuals who ventured beyond the bounds of established settlement. The anthropological and archeological divisions of the Institute preserve many examples of the handiwork of those who occupied the Americas before the coming of Columbus, and the Gilcrease Library remains an almost untapped reserve of primary and secondary reference materials pertaining to the conquest of the American West.

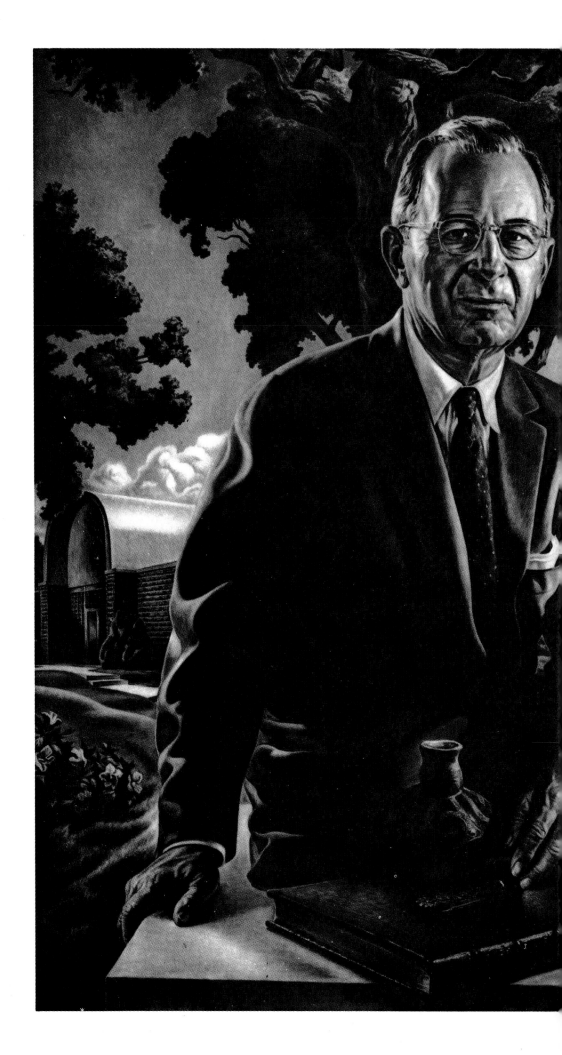

WILLIAM THOMAS GILCREASE (1890–1962)
Charles Banks Wilson

Some months before his death in May 1962, Thomas Gilcrease made what was, for him, a rare public expression of his private sentiments regarding the Institute's future role in the field of historical research. Summarizing how and why he had acquired his collection and what he felt to be its greatest potential, he voiced the hope that writers and educators would continue to make use of its varied resources. He suggested that publications on a nationwide scale be undertaken, either privately by the Institute or in conjunction with outside publishers. It was his feeling at this time that publishing could represent one of the most important efforts of the Institute, and that through this medium of communication it might come to be more widely known.

To those responsible for the administration of the Institute, this desire on the part of its founder proved to be a significant factor in the formation of subsequent projects. It was not until 1964, however, that the real groundwork for a publications program was laid. The Institute was paid a visit by Mr. Alfred Knopf and later by Mr. Angus Cameron, Knopf's senior editor, who, after an examination of the collections, decided on a practical course of action.

The publisher's proposals for a series of publications was given careful consideration, and choice of authorship for a first book based upon the resources of the Gilcrease Institute was made. It was suggested that the first publication should deal with the western or frontier aspect of American life, since this forms the basis of the Gilcrease collections. Envisioned as a descriptive social commentary, the manuscript took shape with the idea in mind that it would offer to the reader a broad spectrum of activities characterizing the development of the Old West, utilizing wherever possible the first-hand reports of those who observed or participated in the United States' westward expansion across the continent.

The story of the American Indian is an important feature of the present narrative, as is that of the Indian fighter, mountain man, homesteader, cowboy, and entrepreneur. Admirably represented is the western artist himself, whose contribution as picture-maker and historian is outstanding among those who recorded the American experience in volume and detail. The illustrative material has been selected primarily for its value as a historical record, but with consideration of its aesthetic quality also. The resulting text thus presents a social history of the Old West in terms that reveal something of the daily life and activities and the character, imagination, and ideals of the men and women who settled the American frontier.

The spirit of the past is preserved in such records. Recounting the struggles and adventures of earlier generations of Americans, they embody a great many facts, both essential and incidental, important to our understanding of and appreciation for the events that shaped those people's lives. As time moves ever more rapidly away from the frontier period in our history, the pictures and commentaries descriptive of that time and place become increasingly valuable to us. Tom Gilcrease accomplished far more than he realized, or perhaps even intended. The reports he gathered remain among the records of history; they are a tribute to the man who preserved them and a significant part of our national heritage.

The Wilderness

New World Reports and the First Frontier

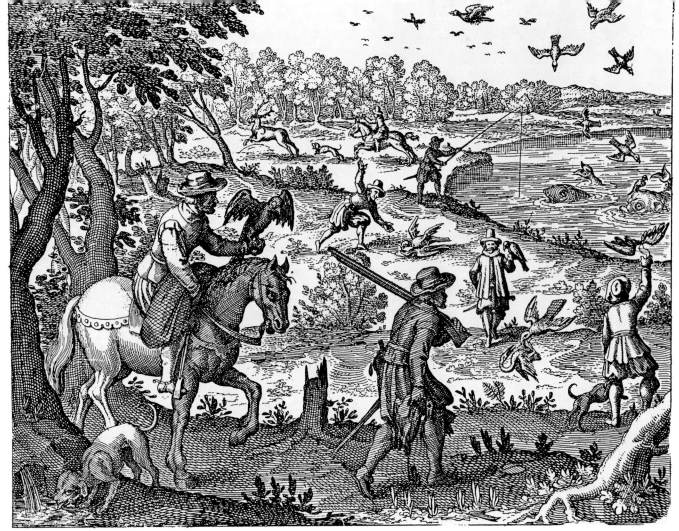

The Wilderness

Respect for realism is a familiar feature of contemporary American life: the professed desire to see things as they are or to "tell it like it is." Likewise, twentieth-century readers tend to exhibit the most interest in those commentaries that, with reference to the historical record, seem to them to tell it "like it was." This attitude is very much in evidence among historians themselves, who, in reflecting upon the past, often find the results of present-day research more reliable than earlier narratives, even though the authors may have observed or participated in the events described. The romantic interpretation or personalized account is viewed with suspicion by those who would have us believe that truth is to be approached by only the most matter-of-fact terms.

History, however, represents the sum of many human observations: a record compiled from many differing sources. The ideas and experiences of former times are a substantial part of that record, and it may be that what we like to think of as our modern "sense of reality" necessarily includes at least a limited awareness of the world as envisioned by our ancestors. To be sure, our knowledge of these things has come down to us in many varying forms. History itself has taken many forms and served many purposes. At best, the record is incomplete, for what has been recorded or preserved is only a part of what might be thought of as the continuity of human experience.

LEWIS, CLARK, AND SACAJAWEA (*previous page*)
Henry Lion after a C. M. Russell sketch

18

The artist as newsman or commentator is not a familiar figure to most of us today, for we live in a world attuned to statistical reports and filmed documentaries. Nevertheless, the artist has in the past and on more than one occasion acted as a chronicler of events when none other was at hand. This was particularly the case before the camera came into wide use, when visual descriptions could be produced only by the painter or engraver. In less obvious ways as well, through his portrayals of people and places, the portraitist, sculptor, or landscape painter has served over the centuries as the recorder or historian of his times.

Very early the artist as observer played a part in the history of settlement in America. Among the first published reports about the New World were those that featured the work of the draftsman or mapmaker, whose pictures of a strange new land captured the attention of Europe at a time when pamphlets promoting colonization were commonly circulated. A continuing interest in the American wilderness is found in subsequent written or printed accounts throughout the nineteenth century. In the majority of these, the work of the artist as illustrator figures prominently.

It is sometimes difficult to relate material of this kind to the aims of modern historical research. The average student usually refers to such reports, if at all, only for particulars descriptive of a past day. Yet he may, in the process of examining the illustrative details, gain valuable insight into the attitudes and manner of expression characteristic of the time or locale under investigation. Like his contemporaries in other fields, the artist was by no means a disinterested observer of the events he witnessed. What he recorded depended not only upon when and where he lived or traveled, but also upon his view of his subject and his innate powers of observation. Thus, his pictures often are documents having much more to convey than the mere particulars of the subject depicted.

From the first moment of its discovery, the North American continent was the subject of many and varied descriptions for the benefit of interested readers in the Old World. Earliest reports are filled with glowing references to its great forests, wide rivers, and flourishing plant and animal life. Rumors of natural bounty brought French and English ships early to these shores, while a relatively mild and variable climate prompted the more adventurous or commercially aggressive European nations to attempt "plantings" in the new country.

Colonists in New England found the woods to be alive with "the largest wild beasts." Reports of deer in greatest plenty and streams jumping with "fish of all kindes" were typical. The whole region from Maine to present-day Georgia is said to have abounded in quail, grouse, and turkeys traveling in great flocks of five hundred or more. Wild ducks, geese, and pigeons are said to have been so numerous that many reports mention them as virtually darkening the sky in passing, much as the thundering herds of bison later were described as darkening the distant prairies beyond the Mississippi.

One of the first artists to depict this primitive scene was an Englishman by the name of John White. At one time governor of the ill-fated Roanoke Colony, White produced a remarkable documentary on aboriginal life in the sixteenth-century Virginia wilds. Copies of

Sixteenth-century line engraving attributed to Theodore DeBry

his drawings appeared in 1590 in the first of a multi-volumed series of books on New World discovery issued by the Flemish engraver Theodore DeBry. They were supplemented the following year by the illustrations of Jacques le Moyne de Morgues, a French surveyor in what is now Florida, whose pictures likewise were reproduced many times during the next several decades.

In these illustrations, considered to be among the very earliest to describe native life in North America, John White pictured the Indians of present-day Virginia and North Carolina as inhabiting towns and raising corn and tobacco. Le Moyne, on the other hand, presented his Florida chiefs as fierce and warlike physical specimens adorned with shells and feathered headdresses, their bodies decorated with tattoos like the South Sea islanders represented in the eighteenth-century plates illustrating Captain James Cook's Pacific voyages.

Charles Bécard de Granville, seventeenth-century French-Canadian cartographer, has left a report of plant and animal life of the Great Lakes, Ontario, and upper New York regions, which is preserved in an album in the Gilcrease Library. An unusually interesting volume containing some 180 drawings, this manuscript is of particular importance to the early history of the French colonies in North America. Hardly an accomplished artist, de Granville nevertheless succeeded in giving a lively picture of nature, observing many details that seem to have escaped the attention of most of his contemporaries. His linear renditions of elk, owls, bears, fish, squirrels, and flowers may appear to modern eyes as fabulous; but despite the fancy or prejudice that may distort such early-day accounts as these, they manage to indicate the widespread interest Europeans had in the natural history of America during the adventurous days of discovery and settlement.

From the two maps at the beginning of the album—showing the Great Lakes area and portions of what are now New Jersey, New York, and some of the New England states, as well as much of Canada and nearly the entire course of the Mississippi River—it is inferred that de Granville traveled widely. His sketches of the Indians of these regions also depict dress and equipment not found in any other contemporaneous reports. Representing tribes as far to the west as the Sioux and the Illini and as far south as those in Virginia, de Granville's sketches do for the aboriginal inhabitants of the interior of North America what those published by Theodore DeBry did for the Atlantic seaboard tribes. All his portraits and sketches are of the greatest interest, for de Granville provides us with exact transcriptions of the names of those he represents and often the terms used for designating the Indians' various weapons.

Many of de Granville's Indians are portrayed in war attire or ceremonial dress, their tattooing and body paint clearly indicated. Some are pictured at ceremonial dances or cannibalistic feasts, supposedly witnessed by de Granville. One picture shows a young Iroquois who, according to the inscription on the sketch, had himself tortured by his companions at an initiation ceremony. A captive

VILLAGE OF SECOTA
Line engraving by Theodore DeBry
after a watercolor by John White

20

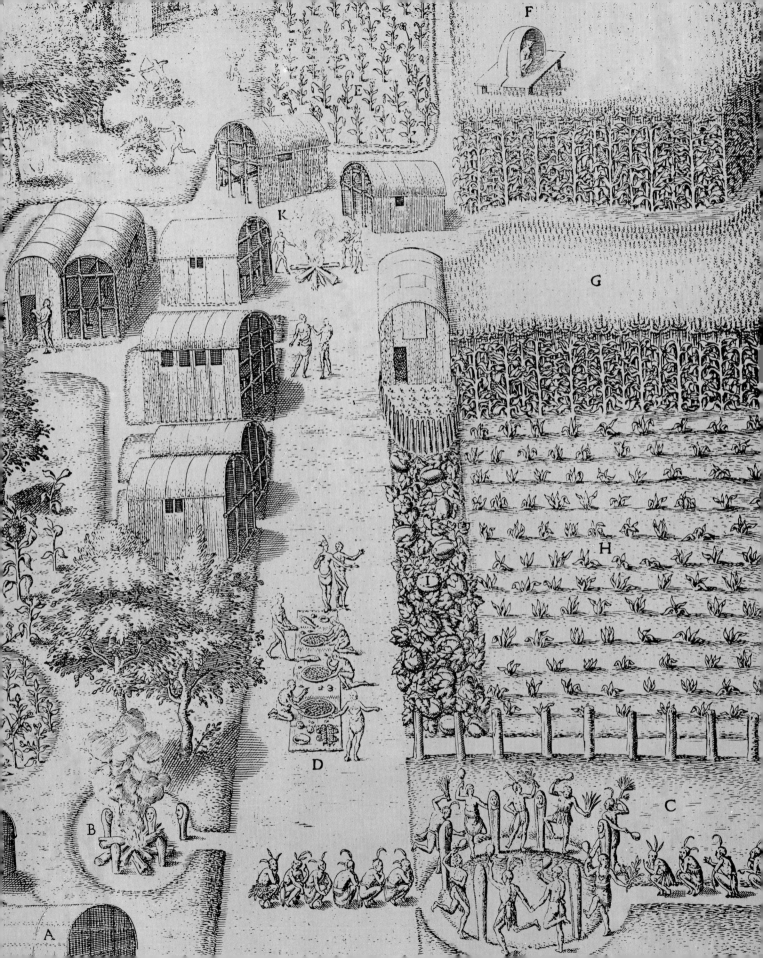

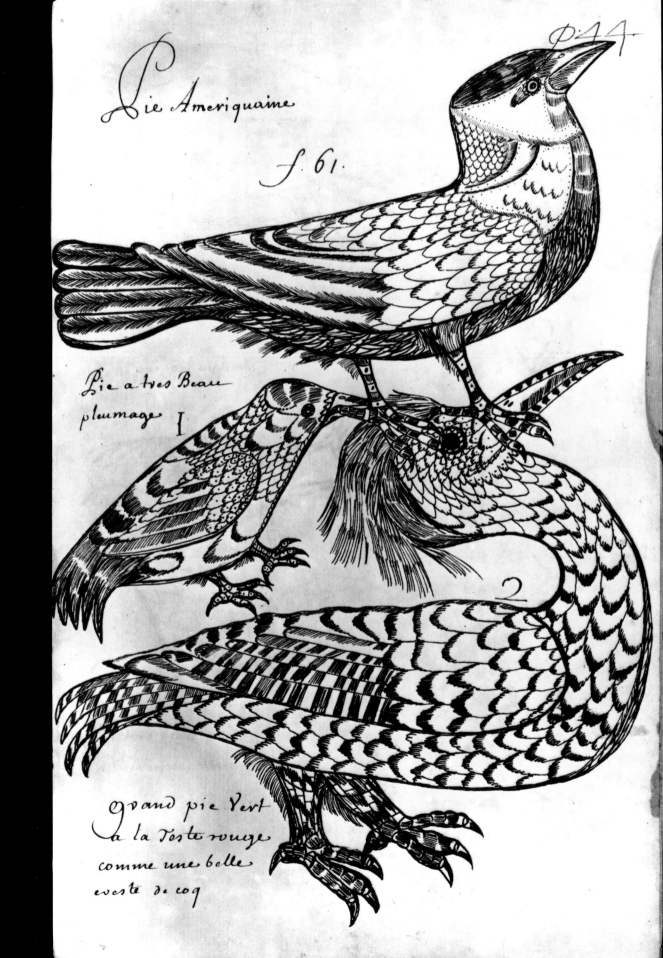

Pie Ameriquaine

f. 61.

Pie a tres Beau
plumage 1

2

grand pie Vert
a la Teste rouge
comme une belle
creste de coq

Indian woman is also described, whom de Granville saw burned at the stake and subsequently eaten.

Animals inhabiting North America are rendered with exact indications of the quality and coloring of their furs or skins. Also shown are a unicorn, a tiger, and a large turtle from the island of St. Helena. A sea horse and a sort of "sea monster" with a human head—"killed on the river Richelieu in New France"—are also depicted, and may in fact have been actual "creatures" sewn together from different carcasses or parts of carcasses that were then exhibited around Canada to amaze the inhabitants.

Indeed, the interest in exotic portrayals of life in the New World at this time suggests that the notion of America as being a part of the Indies had not been dispelled entirely. In any case, America continued for more than a century and a half after its discovery to be regarded as a fabulous place inhabited by strange and wonderful animals and people. Examples illustrative of this popular fantasy are evident even in the more exacting descriptions dating from this period.

Europe throughout the seventeenth and eighteenth centuries was beginning to envision the world as a whole and to understand itself, as a result, in relation to its knowledge of non-European regions. The discoveries of the age, whether geographic or scientific, were beginning to influence all areas of activity among people who were the first in history to realize the size of the world and the extent of its oceans and continents. The intellectual curiosity that prevailed throughout the eighteenth century was increasingly directed toward studies of man and the universe as scientific horizons widened and philosophic views broadened, and scholars and poets pondered the world of nature and the moral implications of natural law. Many investigations of the geography, topography, and plant and animal life of North America, the islands of the Pacific, and Australia were undertaken during this period, and several important scientific and philosophic societies were formed to bring men variously engaged in the new fields of study into closer and more frequent communication.

This is the chapter usually referred to in history texts as the "Age of Enlightenment," the era when man's perception of the order and arrangement of the physical world first gave him the idea that he was capable of directing the forces of his environment to his own advantage. This is also the point in history when man's growing confidence in himself encouraged religious and political theorists to attempt another thoroughgoing reconstruction of society: the century that witnessed both the American and the French revolutions, as an awakened respect for the dignity of man and regard for his natural or "God-given" rights fostered many movements for the establishment of more democratic institutions.

The predominance of France in European affairs, apparent since the days of Louis XIV, was the result of not only political and military power, but also the country's great reputation in science and the arts. Thus, French painting and architecture set the styles throughout Europe, and French literature, philosophy, and the spoken language continued to radiate from the capital where once the "Sun King"

Page from an album of drawings attributed to French-Canadian cartographer Charles Bécard de Granville. Entitled "Les Raretes des Indies" by the artist, the sketchbook was published in 1930 by Baron Marc de Villiers in facsimile under the title CODEX CANADIENSIS. De Villiers credited the work to de Granville at this time.

had directed his armies, policies, and ideas to all corners of the continent.

Art itself came to be viewed ideally as an "imitation of nature," reflecting once again that concept held by the ancient Greeks. However, if by "imitating" nature it might be supposed that the painters and sculptors of that day meant to suggest that they *copied* nature, one might refer to a remark made by the eighteenth-century English wit Dr. Samuel Johnson, who said:

"It is justly considered as the greatest excellency in art, to imitate nature; but it is necessary to distinguish those parts of nature which are *most proper* for imitation."

In other words, the eighteenth-century artist felt he should select from nature those significant forms or familiar aspects that, in themselves, might represent life in its larger sense. A work of art should present a broader, universal "truth" within the framework of a particular scene or subject. In the seventeenth and eighteenth centuries, this ideal was formalized into the doctrine known as *la belle nature.*

It is generally agreed that Benjamin Franklin was the most distinguished scientist in Colonial America, although the average American of his day exhibited scant interest in most of his experiments. In back-country settlements there was little time to spare for discussions pertaining to science or philosophy, to say nothing of the arts.

*Drawings from an album
attributed to Charles Bécard de Granville*

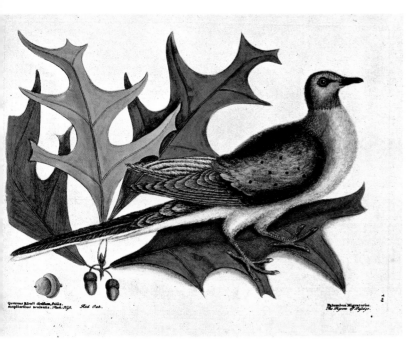

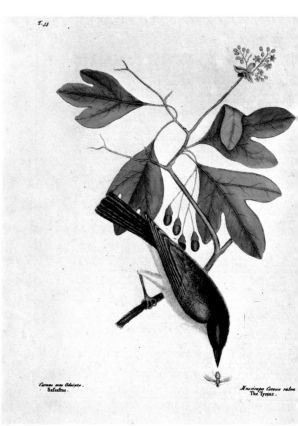

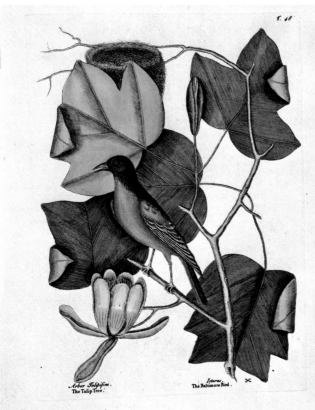

¹Plates from Mark Catesby's
NATURAL HISTORY OF CAROLINA,
FLORIDA, AND THE BAHAMA ISLANDS

et men were interested in the natural features of
America, and several gained distinction and even i
tional recognition as a result of their American s
studies. John Winthrop, professor at Harvard from
1779, is credited with having made the first systematic astron
observations in the English colonies. Thomas Jefferson—philo
political theorist, scientist, and architect—is accorded the dist
of having conducted the first recorded archeological excavatio
Indian mound, in Virginia. Cotton Mather, one of the more
known of the Puritan clergymen, contributed many papers to th
Society in England on the subjects of natural history and biolo
William Byrd II wrote several papers that he later incorporat
his own *Natural History of Virginia*.

The Back Fin.

Suilhis.

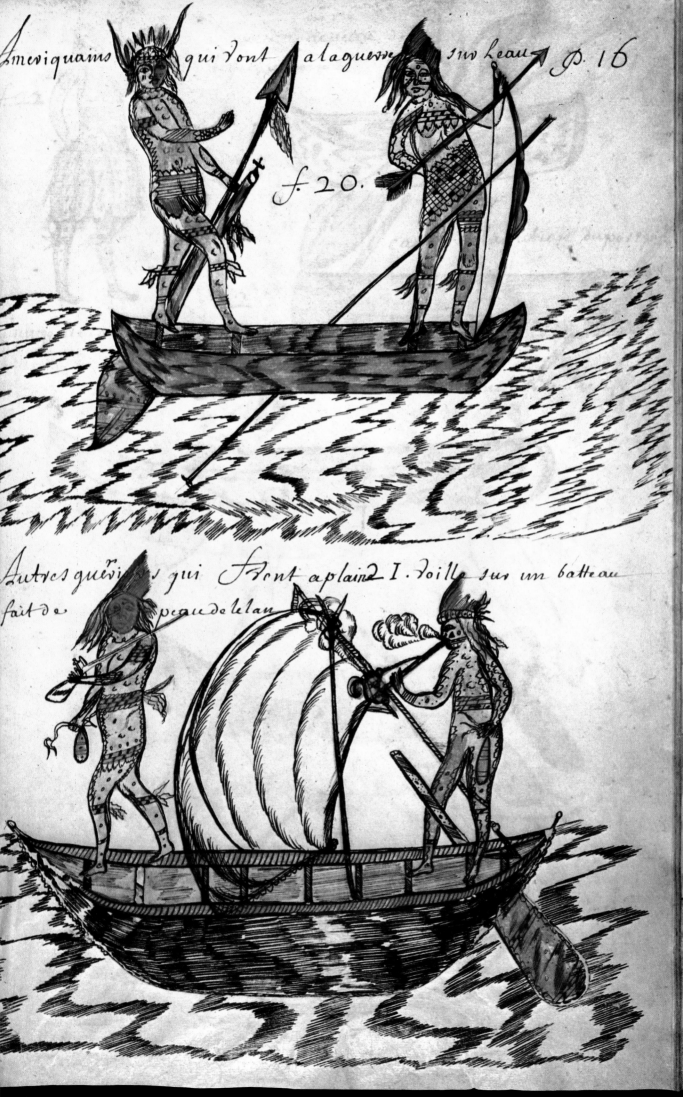

Ameriquains qui sont a laguerre sur l'eau. P. 16

f. 20.

Autres guerriers qui sont aplain I. soille sur un batteau fait de peau de l'elan

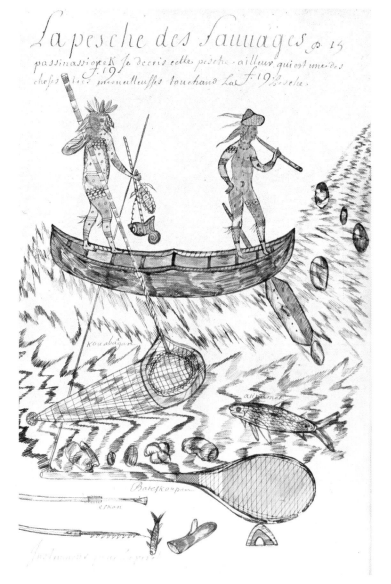

A page from the de Granville album illustrating the American Indian's method of catching fish

Scientific curiosity about the New World prompted many investigations of the plant & animal life of North America throughout the eighteenth & nineteenth centuries.

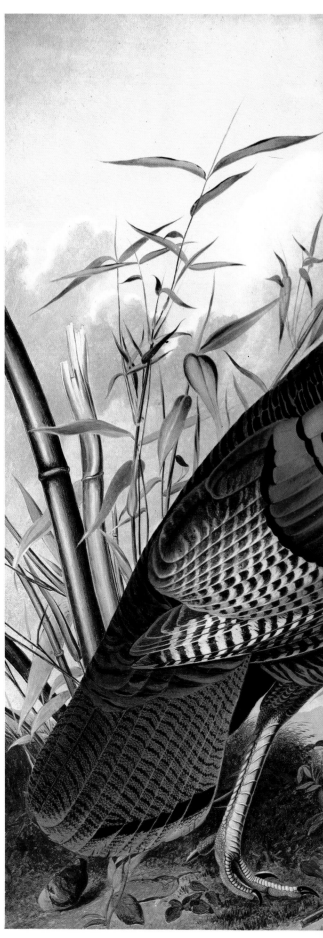

WILD TURKEY
John James Audubon

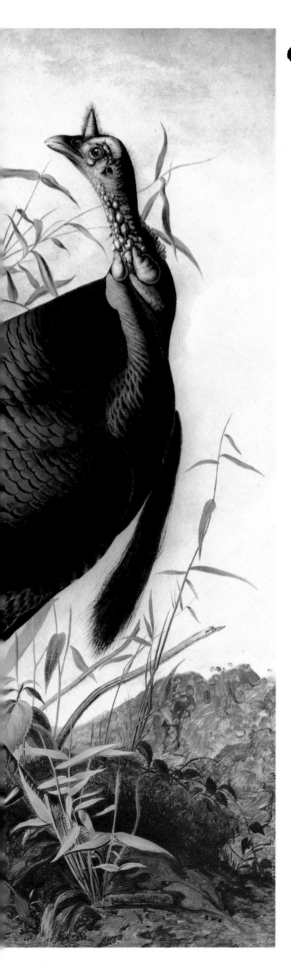

The first man to study both the plant and animal life of the southern Atlantic seaboard was the English author, artist, and scientist Mark Catesby. His *Natural History of Carolina, Florida, and the Bahama Islands,* published in two volumes, in 1731 and in 1743, has 220 hand-colored etchings of birds, reptiles, insects, mammals, and plants native to North America, and is perhaps the finest publication pertaining to the natural history of the colonies to have survived to the present time. John Bartram's accounts of his travels with his son, William, also have come down to us in published form. Journeying up and down the colonies from Ontario to Florida collecting specimens for the Royal Gardens in London, John Bartram established the first botanical garden in America at Philadelphia in 1728. William Bartram's list of 215 native American birds was one of the first important works in American ornithology, recognized as a standard reference for many years until the monumental publications of John James Audubon appeared in the following century.

The work of George Dennis Ehret, the artist who assisted Catesby in his publishing venture, is also of special interest. A portfolio containing five original studies for the *Magnolia Altissima,* reproduced in part in Catesby's work in Volume II as Plates 60, 61, and 80, are preserved in the Gilcrease Library along with an original edition of the Catesby publications. Ehret's renderings are among the earliest examples of an art that was soon to develop into a careful discipline of its own.

In his now famous thesis concerning the evolution of American society in the eighteenth and nineteenth centuries, historian Frederick J. Turner stated that the greatest single factor influencing the develop-

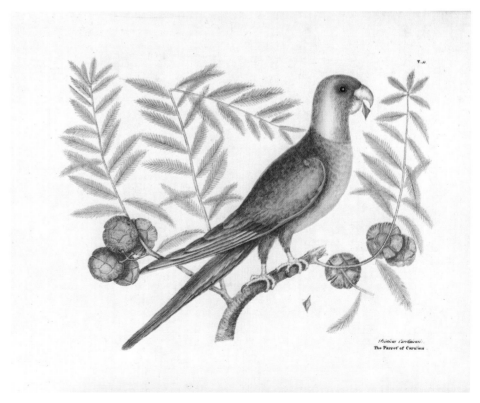

THE PARROT OF CAROLINA
Hand-colored plate from Mark Catesby's NATURAL HISTORY

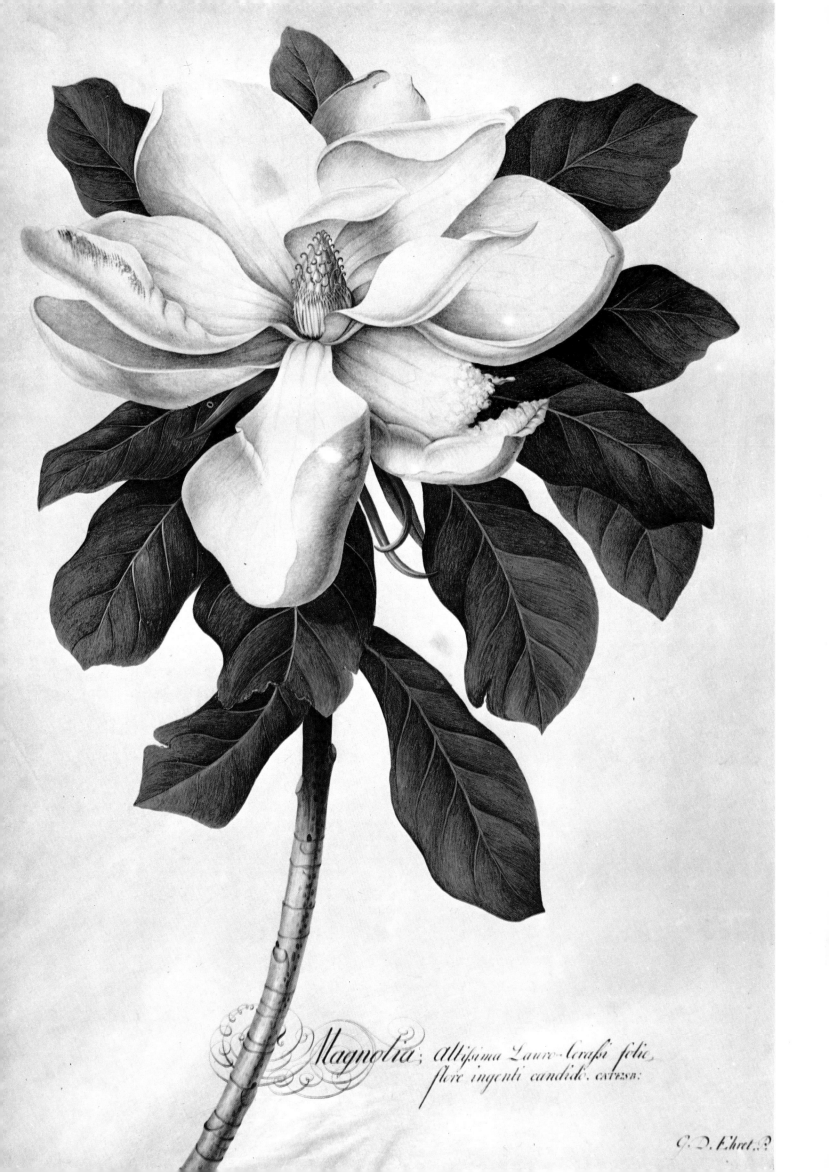

Magnolia; Altissima Lauro-Cerasi folie, flore ingenti candido. CATESB:

G. D. Ehret P.

ment of civilization in the United States was a natural one: the American wilderness. As Turner saw it, wild nature itself was the phenomenal force that transformed the American colonist from a civilized citizen of Europe into a rough-and-ready frontiersman, an environment that, as time went on, increasingly alienated him from the influences of the Old World. With its westward advance across the continent, according to this viewpoint, American culture continued its steady growth of independence along distinctively American lines; or, in short, the rugged conditions of frontier existence so changed the habits and thinking of the American pioneer that he came at last to be a very different kind of individual from his European relatives, creating a different, if not altogether original, kind of society for himself.

More recently, however, historians have tended to discount the all-powerful influence of America's primordial environment by suggesting that the frontier was only what the name implies: the "front" of an ever-penetrating Anglo-European civilization before which even the ancient wilderness retreated, swiftly subdued by ax, rifle, fence, and plow. Affirming that the colonists and later pioneers maintained knowledgeable connections with the Old World from which they came, scholars today have formed the opinion that these people remained, essentially, Europeans, and that despite the habits and usages they may have acquired from the Indians or the wilderness, they retained at least the rudiments of their age-old European heritage.

Indeed, it is apparent today that not only our language, religious attitudes, and political ideals, but also many other features of modern American society are an inheritance from Europe. Thus, when trying to account for the development of this nation, it is important that we maintain an intelligent reference to those philosophies or prevailing forms of political, social, scientific, and artistic expression characteristic of the "enlightened" world during the preceding two hundred years. In the rough and underdeveloped land that was the United States in its earlier days, such activity was admittedly an extension or at least a reflection of that of England or France; and nearly all material and creative development in America continued for generations to revolve around the careers of those who came to this country from abroad, who visited as Americans the foreign capitals of Europe, or who were, in turn, influenced by those who visited Europe or studied in Europe's academies.

Even the majority of those explorers, scientists, artists, and literary men who ventured beyond the frontier in the early nineteenth century were conversant with European philosophy and familiar with the methods of inquiry characteristic of Europe's schools. A great many of them were Europeans, for that matter, and none of them frontiersmen except perhaps in a very limited or temporary sense. Traveling beyond the borders of established settlement, these men observed life in the wilderness from an intellectual and essentially European point of view: and those ideas and ideals that had transformed Europe in the 1700's continued to echo across the American continent in the 1800's, carried forward by a love of the inspiring, the morally significant, the beautiful, which, as the infatuation increased, resulted in the overwhelming Romanticism of the mid-nineteenth century.

Like his artist-naturalist predecessors, John James Audubon went directly to the wilderness sources to study and paint the birds and mammals of a frontier that was for the most part scientifically, as well as geographically, unexplored.

Daniel Boone began the first westward movement across the Alleghenies as early as 1773, acquiring title to his Kentucky land from the Indians five years later. Founding the settlement of Boonesboro, he guided many settlers to this region and later into western Virginia, moving even farther west, where, in the opening years of the nineteenth century, a grant of land was confirmed to him by Congress in Missouri Territory. George Rogers Clark, surveying in Boone's country, was also active among the frontiersmen, organizing and leading them against the Shawnee and other Indians throughout the period of the Revolutionary War. Gaining the approval of Patrick Henry, then governor of Virginia, to explore the Illinois country across the Ohio, Clark captured the key points of Kaskaskia and Vincennes from the British in 1778, thereby saving this area for the Continental government. In that same year, he founded the future city of Louisville and remained to fight both the British and the Indians throughout the early 1780's.

North of the Ohio was a vast region that had been recognized as "Indian Territory" since the Treaty of Fort Stanwix in 1768. During the war for American independence, the Indians of this region had sided with the British, and the Americans had established Fort McIntosh in 1778 as headquarters for their western operations. Here, in 1785, the new U.S. government negotiated with the Indians for large sections of their land in partial reparation for the Indians' part in the war with the British. As a result, a new Northwest Territory was created in 1787, establishing a wedge for future settlement in the hitherto untouched Indian country.

Free men poured from the eastern seaboard following the war. Settlers crossed over the mountains into the Ohio and Mississippi valleys, through the Cumberland Gap, and along the Wilderness Road into Tennessee and Kentucky. Farmers from Connecticut crossed the Housatonic and the Hudson on their way to the western lands, and through Pennsylvania rolled the heavy-laden Conestoga wagons as Americans everywhere pushed westward into a wild and ever-widening land.

With Ohio land available, a company was organized in Boston to secure a grant of some 1,500,000 acres from Congress. In 1788 the first settlement in the new Northwest Territory was made at Marietta, Ohio. In this same year the Ohio Company of Associates established a land office to serve as headquarters for the enterprise. Shortly following the founding of the Marietta settlement, another million acres was purchased from the Miami Indians on the north side of the Ohio, where the city of Cincinnati shortly came into being.

Far to the northwest along the edge of this territory lay the strategic waterway known as Sault Ste. Marie—or St. Mary's River—connecting Lakes Huron and Superior. On the north shore of Superior stood the trading post of Grand Portage, a depot for furs taken from and supplies destined for the great fur trapping country beyond. Subsequent to the Peace of Paris in 1783, the British had retained control of these northwestern posts, but following the signing of another treaty eleven years later, sovereignty passed to the United States. Accordingly, the British established Fort William a few miles into Canada and Grand Portage fell into disuse.

STANLEY HAWK
John James Audubon

GEORGE ROGERS CLARK ON HIS WAY TO KASKASKIA
Howard Pyle

Map of LOUISIANA *published by*
Henry Popple (London, 1773)

was focused on the land Mississippi watershed
by traveler and artist alike who followed close
on the heels of the Lewis and Clark expedition.

Fourteen years after the founding of the Union on the terms of the Constitution, the United States of America more than doubled in size by its purchase of the vast French property west of the Mississippi known as Louisiana. President Jefferson had wanted originally to buy only New Orleans in order to safeguard American commerce on the Mississippi; but Napoleon, desperate for money at that time, sold him the entire territory. The area that later became the state of Louisiana was organized as the Territory of Orleans, while the part lying north came to be known as Missouri Territory. Here, with the frontier city of St. Louis as its center, a widespread and profitable fur trade developed with the Pawnee, Osage, and other bands of marginal plains tribes who roamed that wide area.

Immediately following the acquisition of Louisiana, President Jefferson sent an expedition out to explore this vast country. Under the leadership of Meriwether Lewis, one-time secretary to the President, and William Clark, brother of George Rogers Clark, a party assembled in St. Louis in the fall of 1803 and the following spring loaded flatboats with the necessary supplies and ascended the Missouri River to seek its distant source.

The epic journey of Lewis and Clark across the continent has been the subject of considerable historic comment. The Montana artist Olaf Seltzer, in a series of paintings depicting events in the history of his adopted state, devoted several of them to the story of this first expedition into the interior of the American wilderness. His portrayal of *Lewis and Clark at Black Eagle Falls of the Missouri, June 13, 1805* shows Lewis attired in a coonskin cap and buckskin shirt, attended by Clark's Negro body servant, York, who appears in the uniform of the Continental army. The guide, Sacajawea, can be discerned in the background.

During the course of his journey up the Missouri that summer, Lewis made several trips alone to reconnoiter the surrounding country. One such side trip is mentioned in his journals, when, with spyglass in hand, he walked to the top of a rise on the north side of the river a little west of Black Eagle Falls and caught his first glimpse of the Rockies gleaming above the surface haze some 150 miles away. From this vantage point, he also noted a smaller river flowing into the Missouri which he named the Medicine.

While Lewis and Clark were struggling over the Rockies in the summer of 1805, another expedition started from St. Louis under the command of Lieutenant Zebulon Pike. Instructed to seek the sources of the Mississippi, to report on possible sites for future military posts, and to discover whatever he could concerning the activities of the

LEWIS AND CLARK AT BLACK EAGLE FALLS
O. C. Seltzer

group traveled north past the mouth of the Minnesota River and selected the site for the future Fort Snelling.

The following year, Pike went westward through Pawnee country, wandering along the eastern edge of the Rocky Mountains, where in the distance he saw the snow-covered peak that ever since has borne his name. Searching for the headwaters of the Red River of the South on yet another leg of his journey, Pike accidentally crossed the upper Rio Grande into forbidden Spanish territory, where he and his company were captured and taken to Mexico's northern capital at Santa Fe. Later released after being questioned with regard to his presence in the area, he returned to the United States with many vivid descriptions of that region, exciting the more commercially minded concerning the possibilities of trade with the rich Spanish-American empire to the south.

Lewis, Clark, and Pike were not the only men engaged at this time in exploring the wilderness of Louisiana. Many accounts of travel in this region by private individuals indicate the presence of a less official interest in the unexplored lands beyond the frontiers of the United States. Perrin de Lac's journals of his travels through the "two Louisianas" published in 1807 typify such early-day reports; while *Travels in Arkansa Territory* published in 1821 by a Philadelphia botanist, Thomas Nuttall, is probably one of the more descriptive publications from this period.

Honorary member of both the American Philosophical Society and the Academy of Natural Sciences, Thomas Nuttall was an energetic man whose studies in botany, geology, history, and ethnology suggest the varied interests that were to send many scholarly men into the wilds during the coming decades. In the preface to his *Travels in Arkansa Territory*, he explains some of the reasons for his extensive investigations of that wild region, remarking that: "For nearly ten years I have traveled throughout America, principally with a view of becoming acquainted with some favorite branches of its natural history . . . To converse, as it were, with Nature, to admire the wisdom and beauty of creation, has been, and I hope will ever be, to me a favorite pursuit."

Nuttall also refers in this same introduction to a future volume he is preparing that will contain a description of the Indians of the western territories and a comparison of their languages, commenting:

The literary character of the aboriginal languages of America have, of late years, begun to claim the attention of learned men both in Europe and America. The reports and correspondence of the Historical committee appointed by the American Philosophical Society stand meritoriously preeminent in this research; and it must be highly gratifying to the public to know that these same members continue still to labour in the field with unabated vigour. These various efforts united, I may venture to predict, will be crowned with successful discoveries which could not have been anticipated, and which will ultimately contribute towards the development of that portion of human history which, above all others, appeared to be so impenetrably buried in oblivion.

MULTNOMAH FALLS
Albert Bierstadt

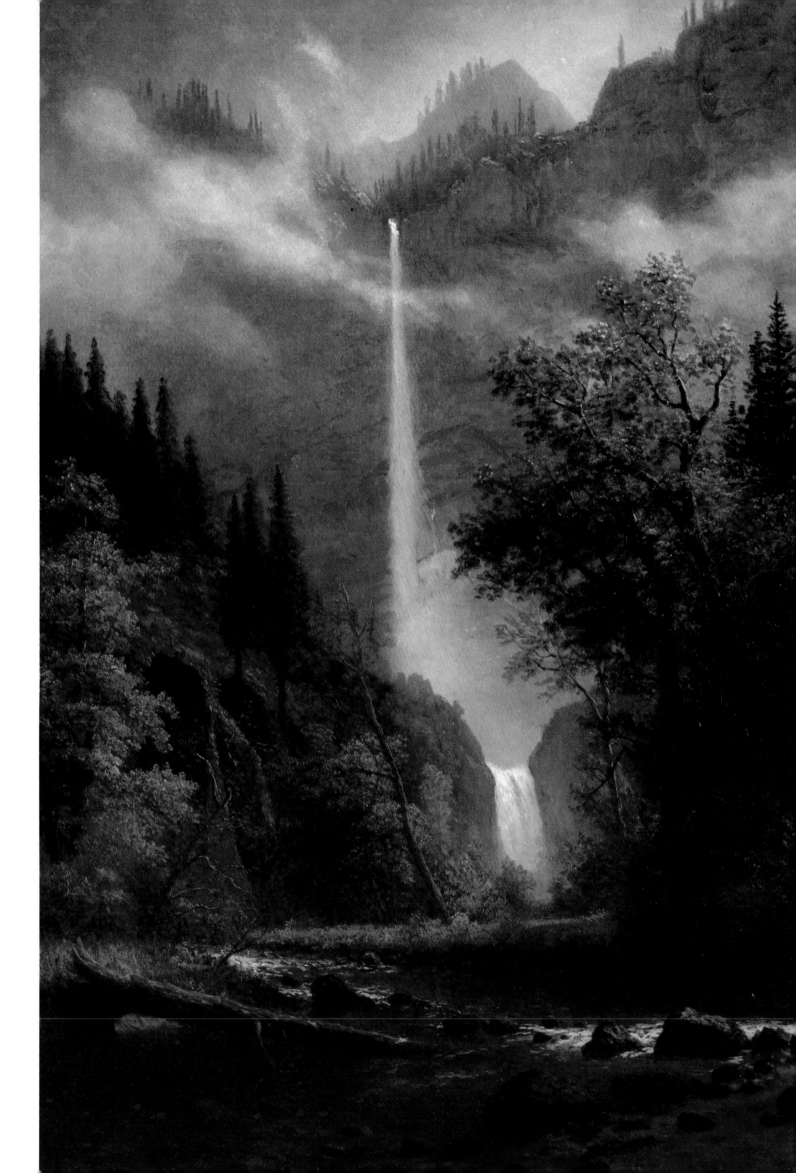

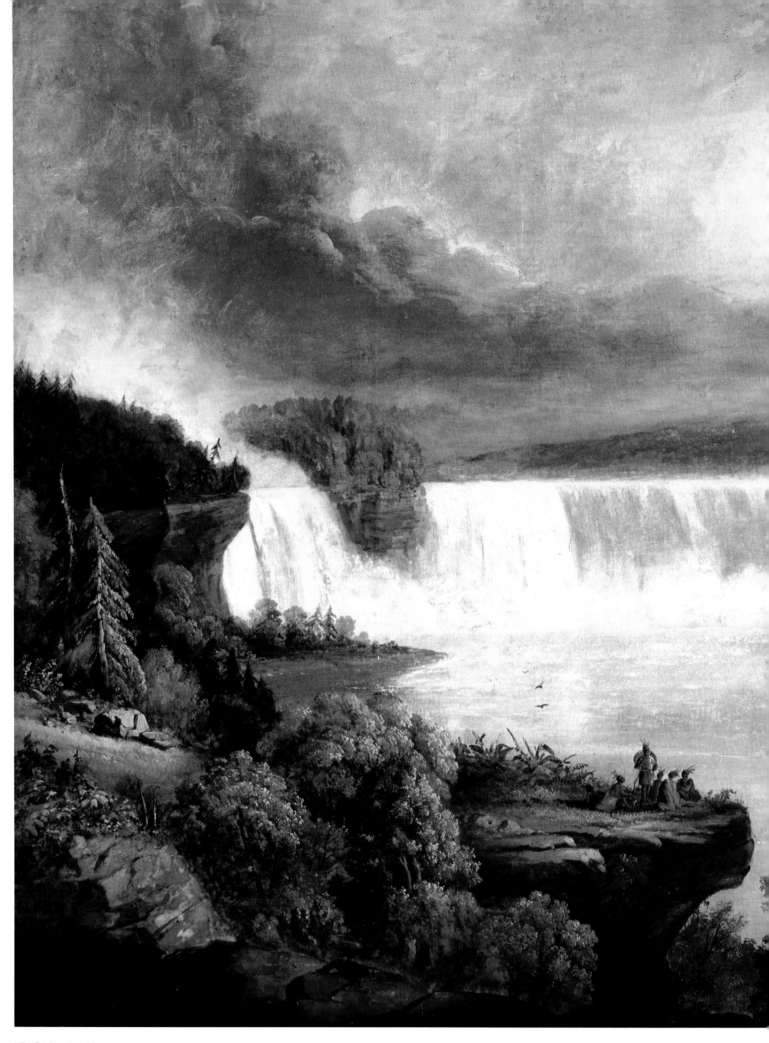

NIAGARA FALLS
Frederic Church

The distractions attending the War of 1812–14 only temporarily turned the nation's attentions from its settling frontier, and Americans were quick to resume their westward march. An abundance of natural resources provided almost all the materials needed for expansion and development. A land of trees offered timber for houses, wood for fuel, and other related needs, while a wilderness filled with game and fish provided food, furs, and a variety of articles for trade. Relying almost entirely upon such resources to supply him with shelter and sustenance, the American pioneer pushed the limits of the frontier ever westward and early came to be familiar with nature and all her manifestations.

American poets and writers returning from abroad during this era, inspired by what they had seen developing in the national schools of Europe, set out to establish an authentic, native American tradition in their works. Washington Irving's Hudson Valley folktales and James Fenimore Cooper's idealized epics of the early-day frontier found an appreciative audience in America. Native philosophers such as Henry David Thoreau and Ralph Waldo Emerson added their encouragements to the nation's awakening regard for its heritage; and a whole "school" of painting developed around an interest in the American landscape—a discipline now conveniently called the Hudson River School, after the area in which it first became apparent. This landscape tradition, greatly expanded in scope as time went on, was maintained throughout the nineteenth century; and while such early and lesser-known American artists as Alvan Fisher and Frederic Church painted simple country scenes that featured wooded hills and waterfalls, later artists, looking farther west for inspiration, attempted to capture the grandeur of the Rockies and the mountain landscapes of the Far West at a time when more and more settlers were crossing the Mississippi and the Great Divide.

LEWIS AND CLARK AT THE GREAT FALLS OF THE MISSOURI
O. C. Seltzer

39

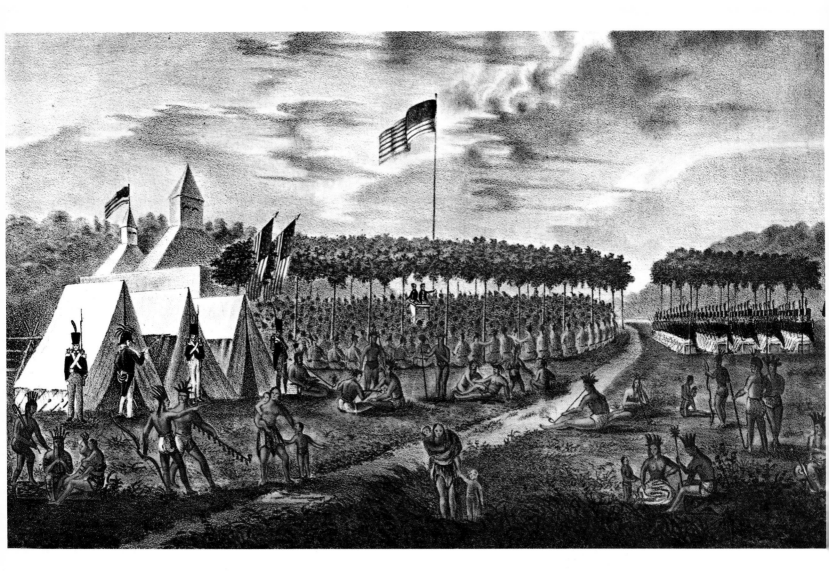

The U.S. government
sponsored many explorations
of its western lands,
authorizing commissioners
to meet with representatives
of the Indian tribes

Scientists, naturalists, and novelists continued to accompany expeditions to the western regions throughout this period, traveling in the company of scouts, trappers, or representatives of commercial trading firms, glad of the opportunity to investigate the interior of the continent and to document life on the far frontier. In Washington Irving's *Astoria* or his equally famous *Tour of the Prairies*, a picture of activities in the American wilderness is eloquently described. Likewise, in such reports as John K. Townsend's *Narrative of a Journey Across the Rocky Mountains*, the modern student of history, biology, or ethnology can find a ready source of reference pertaining to conditions beyond the frontier in the early 1800's.

The U.S. government, however, sponsored the majority of the expeditions to explore the unknown regions beyond its western border. Knowledge of the land and the various Indian tribes inhabiting this region was needed; information as to the friendliness or unfriendliness of certain tribes was sought, and reports of their habits requested for study. Meetings between representatives of the U.S. government and the western tribes frequently was authorized, and many career officers were sent out to report on tribal affairs. Professional men in the fields of science or the arts invariably accompanied these excursions to observe life among the savage nations and to witness meetings between the warrior chiefs and those sent out to "treat" with them.

Sent to explore the distant parts of Missouri Territory and to establish, if possible, friendly relations with the Indians he encountered along the way, Major Stephen Long met with chiefs of several tribes

in 1819 at a campsite on the western side of the Missouri River near a place called Council Bluffs. Attending this meeting was one Samuel Seymour, English-born scenic designer who had been sent along to serve as draftsman for the expedition. Seymour made numerous landscape studies of the country and rendered portraits of the Missouri-Otoe, Pawnee, and others with whom Long met. Engraved copies of several of his drawings illustrated the first publication of Long's reports as compiled by Edwin James, botanist and geologist for this expedition, in 1823.

Long explored a vast area during his travels in the western wilderness. Following the Platte and the South Platte rivers as far as the foothills of the Rockies, he turned south until he came to the banks of the Arkansas. Descending the Arkansas, he came to the mouth of yet another stream, which he mistook for the Red River but which in fact was the Canadian, a southern tributary of the Arkansas in what is today the state of Oklahoma. Returning to the Mississippi, Long set out again in 1823 in a northerly direction from Fort Snelling, situated at the meeting of the Mississippi and Minnesota rivers, and traveling to the junction of the Red River of the North, traced its northward flowing course until he reached the Forty-ninth Parallel, which, by previous agreement between Great Britain and the United States, had been established as the International Border.

The entire upper Mississippi region at this time, including the Minnesota and Wisconsin territories and areas surrounding Lake Superior in Canada, represented a stronghold of several Indian tribes.

MEETING OF U.S. COMMISSIONERS AND INDIANS AT PRAIRIE DU CHIEN
Hand-colored lithograph after J. O. Lewis

WAR DANCE OF THE SAUK AND FOX
Lithograph after Peter Rindisbacher

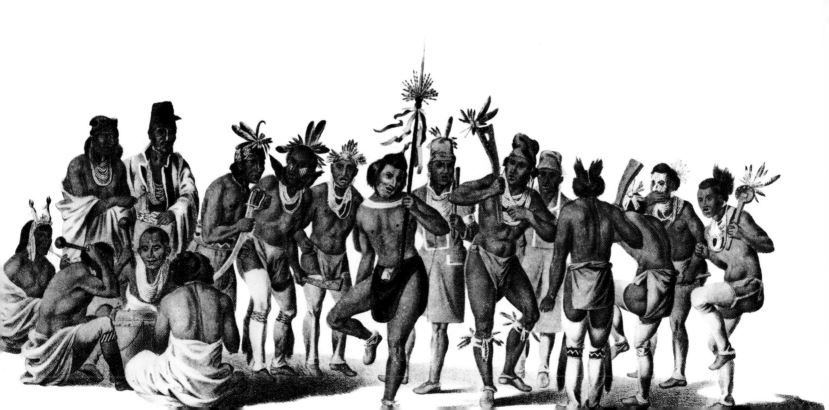

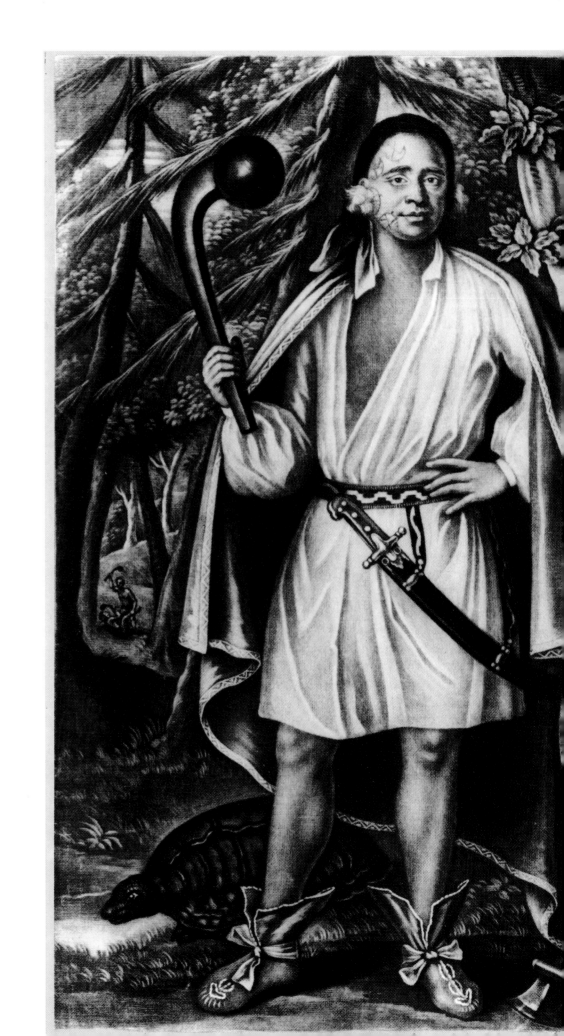

Drawings of wild fowl attributed to Charles de Granville

Here the Chippewa, the Pottawatomie, Winnebago, and Eastern Sioux had dwelt for centuries, traveling about on the many lakes and rivers of this wilderness, hunting deer and moose, spearing fish by torchlight, and gathering wild rice from the sluggish marshes that fed the mighty flowing "Father of Waters" to the south. Since before recorded time friendly tribes in this area had gathered and held councils at the point where the Wisconsin empties into the Mississippi. Named Prairie du Chien by French trappers at a later period, this area had been explored and Fort Crawford had been erected by the United States in 1816 near the ancient meeting place.

Here, in 1825, just two years after Long's visit to the region, a council was held and a treaty agreed upon between members of the northern and western tribes and U.S. commissioners. Outside the walls of Fort Crawford the Sioux from the western part of Wisconsin met to talk peace with their long-time enemy, the Chippewa from the north. The Sauk, Fox, Pottawatomie, and Winnebago tribes were also represented. Clothed in all his official trappings came Keokuk, as well, a chief of the Sauk nation, who was one day to replace the warrior Black Hawk as leader of his people.

The year following the treaty at Prairie du Chien, Governor Cass of Michigan Territory met with the Chippewa in their own country at a place called Fond du Lac at the western end of Lake Superior, where the American Fur Company had set up a post. The U.S. commissioners also came, by canoe, and another friendly "talk" was held.

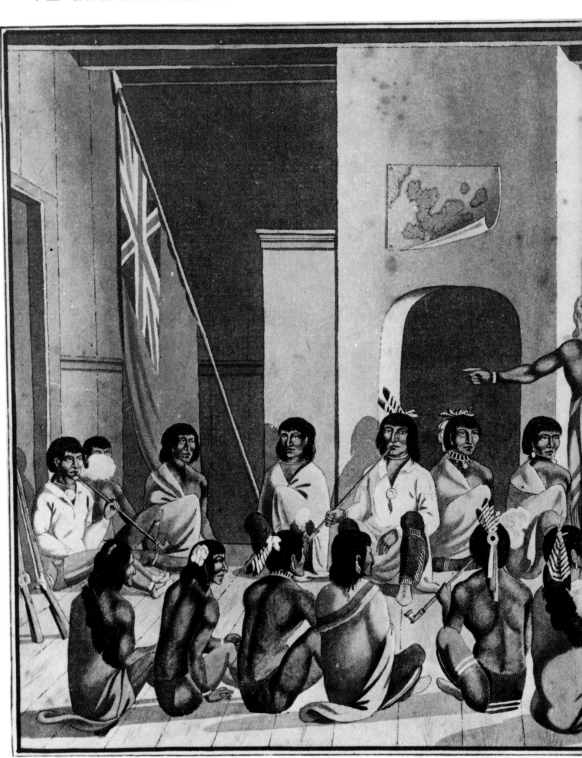

Drawings and commentary
Charles de Granville

CONFERENCE
Peter Rindisbacher

On hand to witness councils between officials of the government and the Indian tribes were a number of westward-traveling artists, who, despite the hardships they encountered, managed to produce a revealing documentary of those events.

At this time the Chippewa agreed to meet again with the Winnebago and Menominee at Green Bay the following summer. Accordingly, in 1827 the Indians and commissioners met at the designated spot near a place bearing the name Butte des Morts, or "Hill of the Dead"— actually a prehistoric Indian mound from which subsequent excavations have brought forth a number of relics, both prehistoric and historic.

Peaceable councils prevailed only a little while in this area, however, for even as the treaty at Butte des Morts was being negotiated, a Winnebago chief called Red Bird, realizing as had others before him that the presence of the white man in his country constituted a threat to Indian supremacy in the land, organized his people and prepared for war. This last-minute uprising, too late to do any good insofar as the Indians were concerned, was swiftly quelled. Red Bird was carried off to the prison at Prairie du Chien, and a new fort soon stood in Winnebago country, which, within a decade, the Winnebago had ceased to frequent.

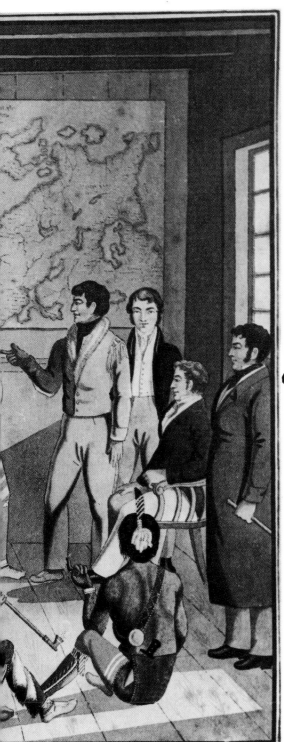

The hardships experienced by those who were engaged to report on activities in this unsettled region are hard perhaps to appreciate today. But James Otto Lewis, who was sent out to observe government-Indian councils in those years between 1825 and 1828, makes very clear the conditions under which he labored in the preface to his *Aboriginal Portfolio*, published in 1835. Attempting to justify the quality of his collection of Indian portraits to his patrons and readers, he explains:

The great and constantly recurring disadvantages to which the artist is necessarily subject, while travelling through a wilderness, far removed from the abodes of civilization, and in 'pencilling by the way' with the rude materials he may be able to pick up in the course of his progress, will, he hopes, secure for him the approbation, not only of the critic, but of the connoisseur.

And when it is recollected that the time for holding Indian treaties is generally very limited, that the deepfelt anxieties of the artist to possess a large collection must be no small impediment in the way of his bestowing any considerable share of his time or attention on any one production, together with the rapidity with which he is obliged to labour—he confidently believes, as they are issued in their original state, that whatever imperfections may be discoverable, will be kindly ascribed to the proper and inevitable cause.

Thomas McKenney and James Hall state similar views in the 1837 edition of their *History of the Indian Tribes of North America.* Crediting an illustration of a Sauk and Fox war dance to Peter Rindisbacher—whom they describe as "a young Swiss artist who resided for some years on the frontier and attained a happy facility in sketching both the Indians and the wild animals of that region"—they qualify the importance of such documentation by saying:

"This drawing is considered to be one of his best efforts and is valued not so much as a specimen of art . . . as on account of the correct impression it conveys of the scene intended to be represented."

McKenney and Hall also present what was doubtless the prevailing sentiment at that time with respect to the government's treatment of the Indians at the treaty table. Referring in the first chapter of Volume I, Biographical Section, to a drawing by a Tuscarora artist named Cusick that had been exhibited some years before, they recall the scene depicted at the moment of the settling of terms of peace between a native chief and an American army officer.

Describing the Indian in the sketch as reaching out to take a scroll from the hand of the officer who stands opposite with his musket pointed at the other's breast, they remark that "it was an affecting appeal from the Indian to the white man; for although the Indians have never been compelled by direct force to part with their lands, yet we have triumphed over them by superior power and intelligence, and there is a moral truth in that which represents the savage as yielding from fear what his judgment and attachments would have withheld."

The editors go on to say, however, that they do not mean to suggest that all our colonial and national transactions with the Indians have been unjust.

"On the contrary," they insist, "the treaties of Penn and Washington, and some of the Puritans to name no others, are honorable to those who presided at their structure and execution . . .

"Nor do we believe at all that migrating tribes, small in number and of very unsettled habits of life, have any right to appropriate to themselves as hunting grounds, and battle fields, those large domains which God designed to be reclaimed from the wilderness, and which under the culture of civilised man, are adapted to support millions of human beings and to be made subservient to the noblest purposes of human thought and industry.

"Nor can we in justice charge, exclusively, upon the white population, the corrupting influence of their intercourse with the Indian tribes. There is to be presupposed no little vice and bad propensity among the savages, evinced in the facility with which they become the willing captives and ultimate victims of that 'knowledge of evil' which our people have imparted to them . . .

"However," they add, "the burthen of guilt must be conceded to lie upon the party having the advantages of power, civilisation, and Christianity, whose position places them in a paternal relationship with these scattered children of the forest." And they conclude in a somewhat more sympathetic vein:

Scene along the upper Mississippi and a view of Fort Snelling
Peter Rindisbacher

All the controlling interests of the tribes tend to instill in them sentiments of fear, of dependence, of peace and even friendship towards their more powerful neighbors; and it has chiefly been when we have chafed them to madness by incessant and unnecessary encroachment, and by unjust treaties, or when they have been seduced from their fidelity by the enemies of our country, that they have been so unwise as to provoke our resentment by open hostility.

These wars have uniformly terminated in new demands on our part, in ever growing accessions from their continually diminishing soil, until the small reservations which they have been permitted to retain in the bosom of our territory are scarcely large enough to support the living, or hide the dead, of these miserable remnants of once powerful tribes . . .

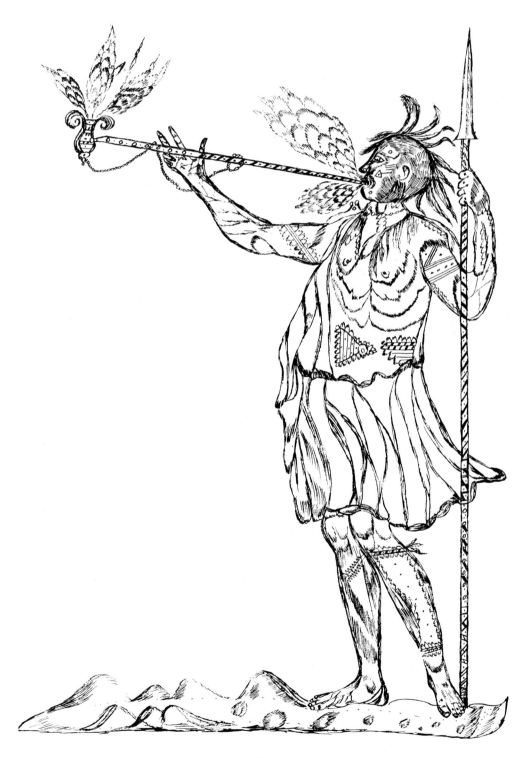

CAPITAINE DE LA NATION ILLINOIS / *Pen and ink drawing attributed to Charles de Granville*

A Narrative of Indian Life in the Trans Mississippi West

Indians of the Plains

Indians of the Plains

Throughout its history the American frontier as a place, idea, or descriptive term represented different things to different men because so many varied reasons brought them to the brink of the wilderness in the early days of settlement. To some it was a new land in which to settle and plant, or perhaps a place of refuge from the poverty, political oppression, or religious intolerance that worked such hardship and common tragedy upon men of earlier centuries. To others it was a wide, new world to explore, an unknown wilderness of forests and rivers to discover and name for those who would follow to claim it for their own. Some came as soldiers to occupy the frontier outposts of the West, to secure the peace and provide protection for the many traders' caravans that crossed the plains. Others came as missionaries to educate the ever-retreating Indian tribes, spreading a gospel of brotherly love among those who suffered most from the suspicions, hatreds, and conflicts of interest that characterized encounters between the Indians and the whites.

The territory west of the Mississippi was a wild and dangerous place through which to travel at the beginning of the nineteenth century. Most of it was thought to be a region unfit for the habitation of civilized men; thus the interior of the continent remained for many years a lonely place, until adventurers of one sort or another pushed inland to stake out vast claims to wilderness wealth and, inadvertently, to mark the way for future settlement.

The central plains of North America were at this time wide open, unmapped, unfenced. Vast herds of buffalo moved across the prairies. Uncounted numbers of deer and antelope roamed the foothills. Bears, beavers, and turkeys populated the river bottoms. Huge flocks of wild geese and duck followed the passing seasons north and south across the spring and autumn skies, while in isolated spots along the winding watercourses of the Missouri, the Arkansas, and the Platte, trading posts carried on a lonely commerce, exchanging furs and animal hides for trinkets, hardgoods, cloth, and beads.

One of the first civilians to visit this area was the novelist Washington Irving. In *Tour of the Prairies*, his account of his travels in 1832 across what is now the state of Oklahoma, he described this region as "a vast tract of uninhabited country, where there is neither to be seen the log house of a white man nor the wigwam of an Indian . . . a great grassy plains interspersed with forests and groves and clumps of trees and watered by the Arkansas, the Grand Canadian, the Red River and all tributary streams."

He further observes:

Over these fertile wastes still roam the elk, the buffalo, and the wild horse in all their native freedom. These, in fact, are the hunting grounds of the various tribes of the Far West. Thither repair the Osage, the Creek, the Delaware, and other tribes, that have linked themselves with civilization and live within the vicinity of white settlements. Here also resort the Pawnees, the Comanches and other fierce and as yet independent tribes, the nomads of the prairies, or the inhabitants of the skirts of the Rocky Mountains. . . .

The region I have mentioned forms a debatable ground for these warring and vindictive tribes. None of them presumes to erect a permanent habitation within its borders. Their hunters and "braves" repair thither in numerous bodies during the season of game, throw up their transient encampments, formed of bowers, branches, and skins; commit hasty slaughter among the innumerable herds that graze the prairies; and having loaded themselves with venison and buffalo meat, retreat rapidly from the dangerous neighborhood. These expeditions partake, always, of a warlike character, and the hunters are always armed for action . . . Should they, in their excursions, meet the hunters of an adverse tribe, savage conflict takes place . . . Mouldering skulls and skeletons, bleaching in some dark ravine or near the traces of a hunting camp, occasionally mark the scene of a foregone act of blood, and let the wanderer know the dangerous nature of the region he is traversing.

The Cheyenne and the Arapaho, having migrated westward into this region at some earlier time, followed a way of life based on an ancient tradition of hunting, war, and savage ceremony. The Wichita, or "grass hut people," inhabited this region, as did the many branches of the great family of the Sioux who dwelt along the Mississippi Valley and the grasslands westward—the Missouri, the Osage, the Ponca, the

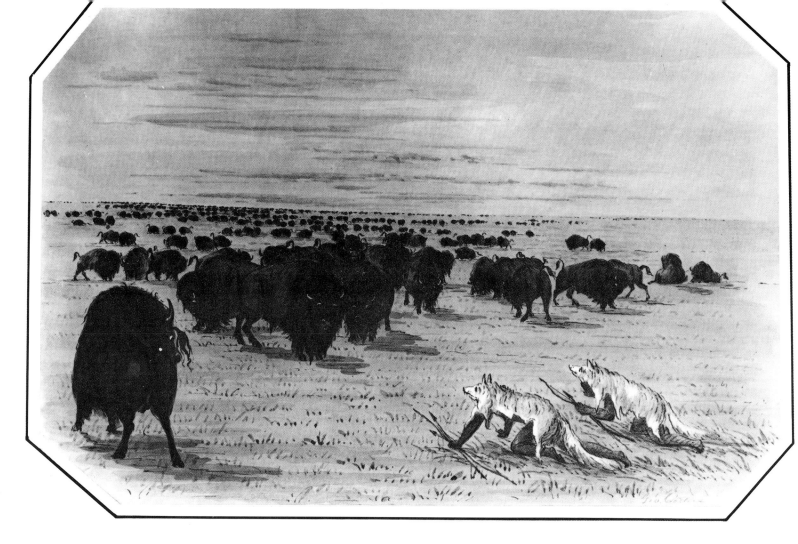

BUFFALO HUNT UNDER WHITE WOLF SKINS
George Catlin

From prehistoric times the hunters of the plains stalked the bison on foot, disguising themselves as animals when approaching a wary herd.

Kansa or Kaw, and the Quapaw, whose name denotes a "downriver people." A few of these tribes and branches of tribes had frequented the wide region between the Mississippi and the Rocky Mountains since before the dawn of recorded time.

The Sioux, it is surmised, came from the southeast, the Algonquin from the northeast, and the Caddoan tribes from the lower Mississippi Valley region. This latter group seems to have been working its way onto the plains at just about the time the great westward expansion of the United States in the nineteenth century brought to an end all further native development. There were some, such as the Comanche, who may have come from the mountains to the west and others who migrated from western Canada, as did the Athabaskan or Apache peoples, who were inhabiting the plains when Coronado ventured into the area; they were probably the "Querechos" or the "Teya" mentioned in his reports. The Kiowa, too, may have been on the plains at this time and perhaps also the Osage, of Siouan ancestry, the Caddoan-Pawnee, and the Caddoan-Wichita, essentially agricultural people who sometimes made limited excursions onto the prairies to hunt and forage.

In prehistoric times, the forerunners of such people had hunted among the herds of giant bison that thundered over the plains. Having no horses, they necessarily had hunted these great beasts on foot, adopting tactics similar to those described by George Catlin in his *North American Indian Portfolio of Hunting Scenes and Sporting Amusements* published in 1844. Approaching a wary herd disguised as an animal was a common ruse among some tribes even in the nineteenth century. Other methods of overtaking game included simply chasing

them on foot, surprising them from cover, or setting fire to the prairies and stampeding the animals over a convenient precipice, where they could be retrieved later from below by members of the hunting party or followers from the nearby Indian camp.

From about 4500 to 2500 B.C. the central plains seem to have been subjected to the increasing heat of the so-called "alti-thermal" period, which marked the disappearance of the Pleistocene bison as well as the earliest people of the plains. The margin of the prairie and woodlands areas to the east were not so severely affected, and prehistoric hunter bands survived there throughout a difficult period. Eventually, groups of hunters again drifted back onto the plains, but at this later time several important features had been added to their material culture, not the least of which were a knowledge of agriculture and of pottery making. These later people came out of the eastern forests for the most part bringing with them the habits acquired from the woodland cultures established there.

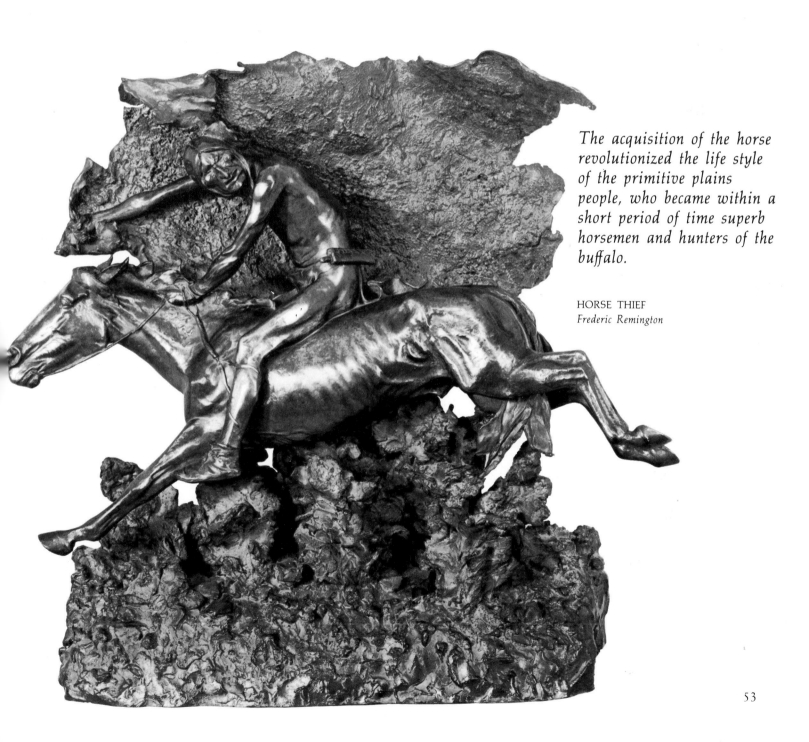

The acquisition of the horse revolutionized the life style of the primitive plains people, who became within a short period of time superb horsemen and hunters of the buffalo.

HORSE THIEF
Frederic Remington

53

Great Camanchee Village 800 Buffalo Skin covered Lodges.

page 64 164.

page 65 167.

Camanchee War Party on Wild Horses.

page 70 173

Pawnee Village (Rocky Mountains) 600 Wigwams, thatched with Prairie Grass

The introduction of the horse to the western plains by the Spaniards precipitated in the 1700's a revolution in the habits of the plains Indians' life style comparable to the change that the discovery of agriculture or the smelting of metals had effected among European and Near Eastern peoples thousands of years earlier. Providing heretofore undreamed-of mobility, the horse made it possible for the Indian to extend the boundaries of his hunting range, and within these hundred years many tribes abandoned for the most part their former agricultural pursuits to become, instead, superb horsemen and hunters of the buffalo. The Dakota Sioux in time came to depend almost entirely upon the buffalo for their subsistence. Buffalo-hide containers soon replaced the more fragile pottery of former times, and the products of the hunt came to represent the basis for their whole culture, as old habits and ways were adapted to the greatly expanded nomadic life typical of those who followed the vast migrating herds.

The buffalo were exceedingly unpredictable in their wanderings, going westward in the spring and sometimes toward the south in fall and winter. In one year, a certain area might literally be overrun with buffalo and the next year visited by scarcely a single animal. The necessity to follow the wayward beast brought many bands or tribes into conflict and the territory occupied by the herds in summer or fall often became very dangerous ground for those who ventured there to hunt. Each tribe tended to regard the buffalo found in its vicinity as its special property: evidence of the favor of Providence. Each resented the intrusion of others into its selected hunting preserves and skirmishes between rival parties were both frequent and bloody.

Because of the necessarily unsettled life led by those who followed the herds from one season to the next, all plains Indian property was portable. Campsites were seldom occupied for long, and when game grew scarce in a particular area, runners were sent out to locate new herds and hunting grounds. When these advance scouts returned with reports of good hunting in some area, the men of the village prepared themselves, mounted, and started out in the direction of the reported herd. The women and children were left behind to break camp and follow along at a much slower pace.

Lodges, or "tipis," were taken down and rolled up, belongings tied to the poles, travois fashion, and pulled by horses or dogs. Babies were slung at the side of the saddles of the women and additional pack horses brought up the rear. The older children usually walked along behind the camp dogs, hunting and playing in the manner of children of every age and culture. The poles serving as the runners or "legs" of the travois became lodge poles once more when the tipis were set up at the new campsite near the hunting grounds. These poles usually were made from pine or spruce trees carefully selected for that purpose, peeled of bark, and "seasoned" for a time. A set of well-dressed poles was regarded as a valuable asset to an Indian woman on the western plains. She was, as well, the exclusive owner of such equipment and of the lodge, which she made with her own hands, set up, took down, and carried with her wherever she went.

The tipi of the western tribes was covered entirely with dressed buffalo hides and its entrance invariably faced eastward. Across this

Because of the unsettled life characteristic of the buffalo hunters, plains Indian property was for the most part portable. Lodges or tipis were easily transported from campsite to campsite.

opening a string of dewclaws from the deer, buffalo, or, later, cattle was often suspended to serve as a door "rattle" to announce the arrival of a newcomer to those within. The arrangement of the opening at the top of the lodge through which the smoke of cooking fires found its way was of particular importance. Flanked by sail-like projections or "ears" that acted as draft regulators or vents, this particular feature of the plains Indian dwelling sometimes required careful engineering on the part of the designer to make sure a sudden change of wind direction would not send the escaping smoke back down inside.

The majority of those tribes who came onto the plains throughout the sixteenth and seventeenth centuries followed the artistic traditions of the eastern woodlands peoples, as evidenced by several similar forms of sculpture, shell engraving, and imaginatively carved and painted masks. Also familiar with the use of copper, they sometimes worked it into decorative objects such as hair pins and ear spools and were known to have covered wooden utensils with it. As with most primitive peoples, they were concerned chiefly with the production of utilitarian or ceremonial objects, and their artistic activity might be said to have been confined to two general categories: one stemming from a characteristic desire to create something attractive as well as useful, the other evolving out of a need to objectify or formalize ideas of a historical or religious nature in terms of music, dance, and oral or dramatic expression.

Animals and birds had a prominent part in plains Indian beliefs. The owl was considered by many to possess great powers with regard to war because this bird captured his prey and subsisted on flesh. The owl's claws and feathers were often used to ornament war shields, and some tribes believed that certain species, principally the great horned owl, represented the spirit world. Individual owls often were believed to embody the ghost of a person and some Indian groups believed that by listening to the cry of this nocturnal creature one might discover the identity of the spirit of the deceased.

The dances of the plains tribes embodied the very life of these people. There were buffalo dances, grass dances, scalp dances, and a host of others of even a more symbolic nature. The buffalo dance was, of course, the most important among the buffalo hunting people. Dancers were chosen out of respect for individual distinction in war or the hunt and tokens of personal merit or reputation customarily were displayed on the person or costume of the respective participant. The horns of a dancer's headdress might be painted a color indicative of his bravery, or he might carry his war shield or a spear used in actual battle. In later years, warriors sometimes carried muskets or rifles and pretended to shoot at each other. Episodes of the hunt were re-enacted or pantomimed in a very stylized manner, and as many as four "singers" usually accompanied the performers to the steady, rhythmic beat of drums.

Two or more tipis were in most cases joined together to form a large dance lodge, outside of which the various headdresses and other articles of costume were displayed suspended from a large central pole. Before the dance, a feast was held inside the lodge, following which the dancers retired to don their apparel. The buffalo dance

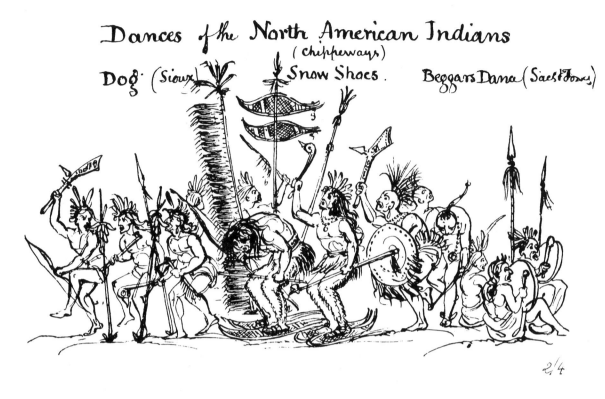

Dances of the North American Indians
(chippeways)
Dog (Sioux) Snow Shoes. Beggars Dance (Sacs & Foxes)

The dances of the plains tribes embodied the very spirit of these people. Episodes of the hunt were re-enacted in a very stylized manner.

INDIAN CAMP AT DAWN
Jules Tavernier

DANCES OF THE NORTH AMERICAN INDIANS
George Catlin

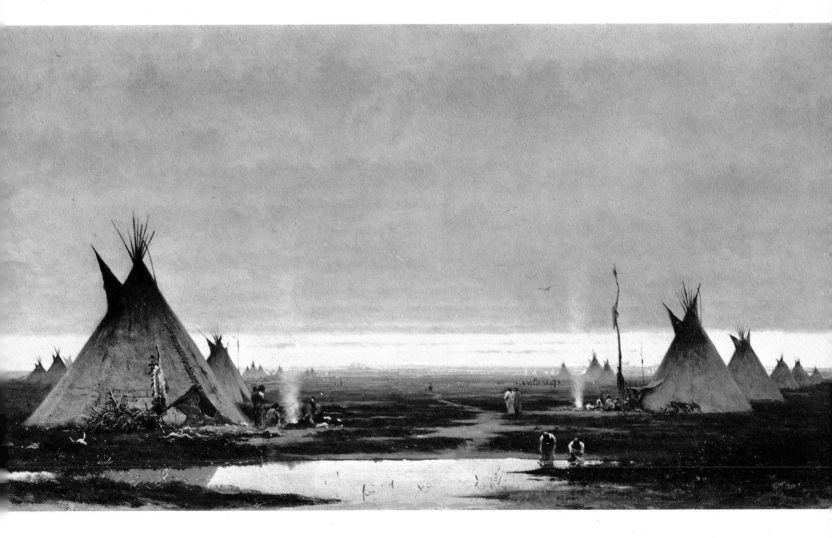

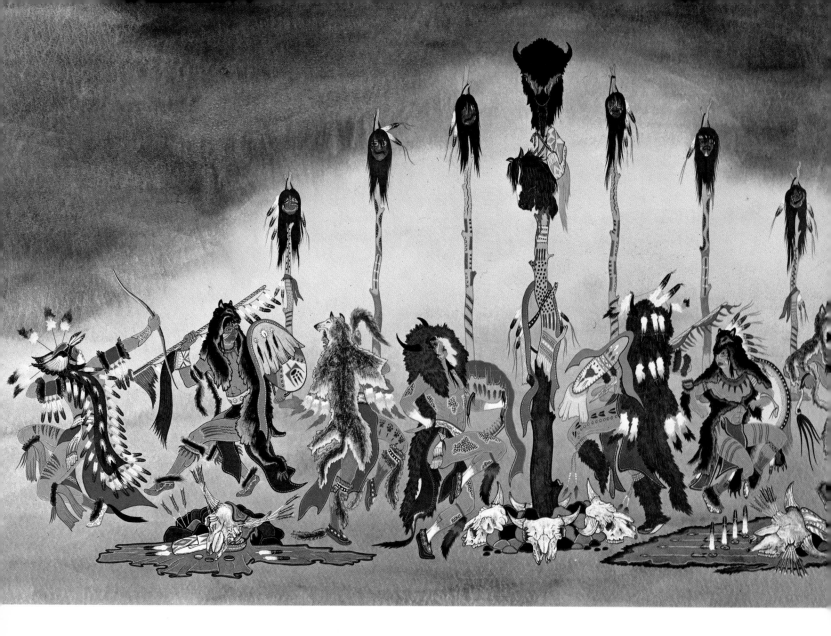

ANIMAL DANCE
Woodrow Crumbo

Donning animal skins, individual Indian dancers identified themselves with the groups or clans to which each belonged.

among the Sioux and Blackfoot tribes was similar in many respects to the grass dance of the Cree. In both cases, such a ceremony was based on activities or elemental concepts concerning the people's means of survival.

Enlarging on the traditions of art and storytelling handed down among the Indian peoples for generations, the contemporary Indian artist Woodrow Crumbo has presented the beliefs and practices of the past from the Indian's point of view in his large watercolor portrayal of an animal dance between two clans representing the buffalo and the wolf. Here can be seen the insignia of the respective clans and various painted masks suspended from poles that surround the dancing area. The dancers themselves wear pieces of costume symbolic of the animal each personifies. Such dances are still performed today, carried out for the sake of tradition in a fast-changing modern world; but it is in the works of the Indian artists themselves that the spirit of those earlier days is more readily understood.

Most of the artists and journalists who recorded life among the shrinking nations of the West were aware that they were capturing impressions of a swiftly passing scene. George Catlin in particular was distressed by the persistent evidence that the Indians were threatened with extinction. Today, his portraits of these vanished tribes are almost all that remains to remind us of their "native looks and history" or to recall a way of life as it was lived among a fierce, free

58

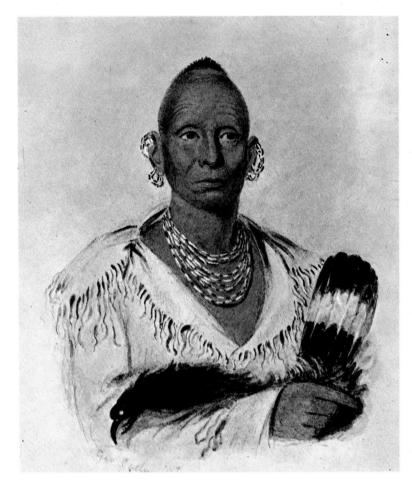

BLACK HAWK, SAC CHIEF
George Catlin

WAH-RO-NEE-SAH, OTO CHIEF
George Catlin

SHA-KO-KA, MANDAN GIRL
George Catlin

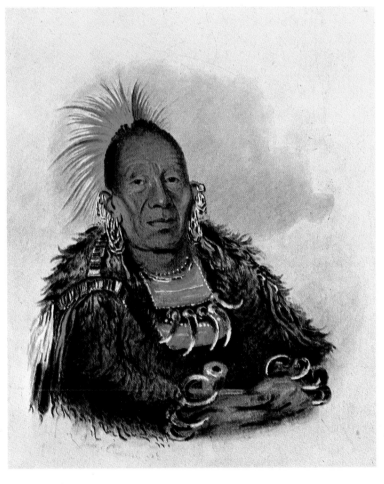

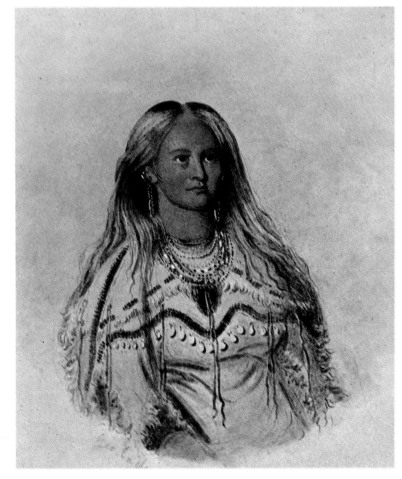

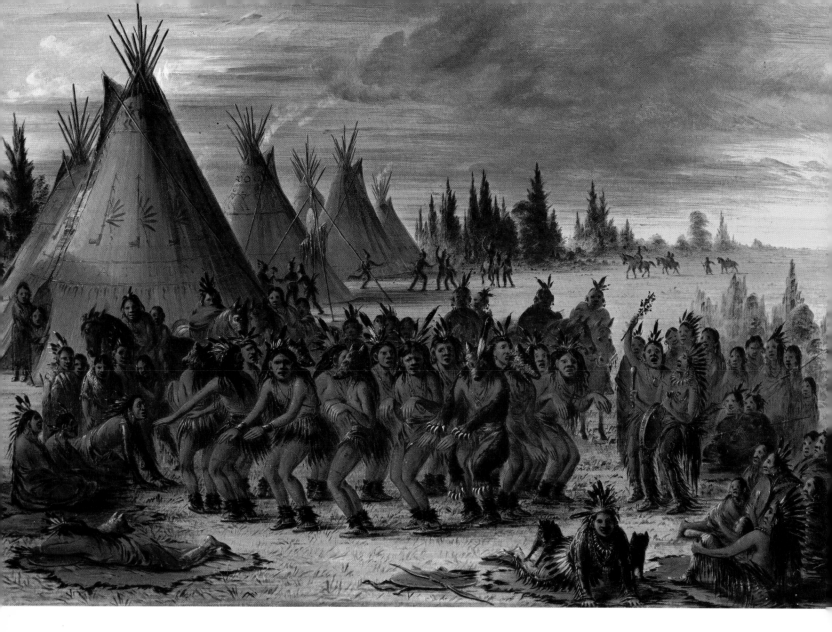

SIOUX BEAR DANCE
George Catlin

"Man, in the simplicity and loftiness of his nature, ...is surely the most beautiful model for the painter."

people in the days before European civilization intruded into their unsuspecting world.

Catlin's oil painting of a Sioux bear dance presents the view of a foreign observer witnessing a ceremony that in his day was still a vital part of plains Indian life. Catlin's picture is descriptive but does not suggest familiarity with the essential meaning of the dance or the character of the Indians themselves. More than a hundred years separate these two reports of a similar activity. Catlin saw the Indians when they were still in possession of their aboriginal culture and customs. Although this culture was much diminished when Woodrow Crumbo painted his people, he nevertheless captures their fundamental expression in his picture, recalling to life what Catlin and other western observers of the early nineteenth century may never have understood.

Catlin's contribution to the record of Indian history and culture in the last century represents nearly a lifetime of endeavor with that end in view. A tireless traveler, he spent eight years in the western wilds documenting the life and customs of the native tribes of America and another fifteen or more traveling in the East and abroad with his collection of scenes and portraits, lecturing and publishing his "memorial" to his country's aboriginal inhabitants. Of all the reporters on the American frontier during the early half of the century, perhaps no one regarded the Indian with more respect or genuine sympathy.

60

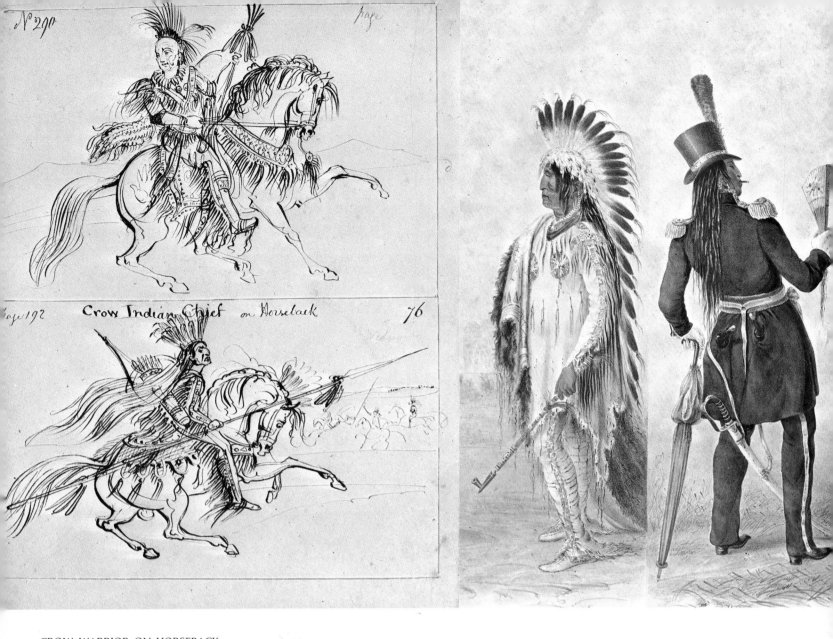

CROW WARRIOR ON HORSEBACK
George Catlin

ASSINIBOINE CHIEF GOING TO AND
RETURNING FROM WASHINGTON
after George Catlin

Certainly, no one tackled his self-appointed job with more energy or sense of purpose.

Having abandoned law practice to apply his hand to painting, Catlin had been following his new vocation with moderately increasing success for a few years—"during which time," he says of himself, "my mind was continually reaching for some new branch or enterprise of the art, on which to devote a lifetime of enthusiasm"—when a delegation of ten or fifteen Indians on their way to Washington stopped by Charles Willson Peale's natural history museum in Philadelphia, where Catlin saw them. Struck by the dignified demeanor of these chieftains from the wilds of the Far West, the artist further relates that he was given to reflect upon dubious effects that "black and blue cloth and civilization" seemed to be having upon the hapless savage.

"Man, in the simplicity and loftiness of his nature," he continues in the preface to his *North American Indian Portfolio,* "unrestrained and unfettered by the 'guises of art,' is surely the most beautiful model for the painter, and the country from which he hails is surely 'the best school of arts in the world,' and such I am sure, from the models I have seen, is the wilderness of America."

Catlin already had established himself as a portrait painter both in New York and Philadelphia when he conceived his plan to tour the Far West and attempt to produce a pictorial history of the Indian

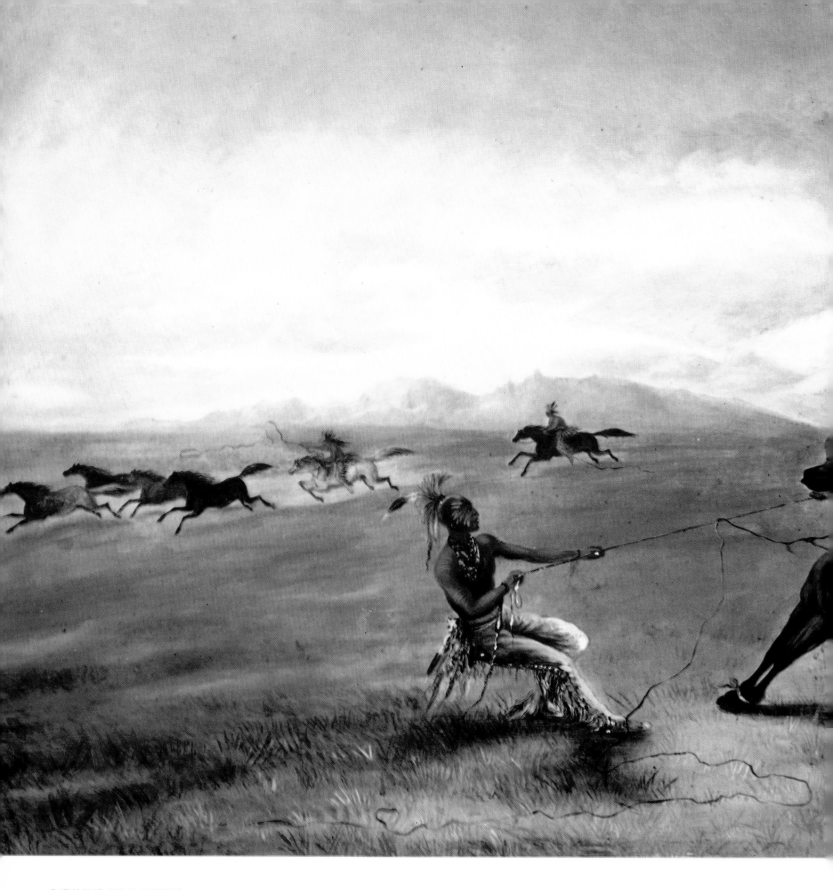

CATCHING WILD HORSES
George Catlin

Traveling over the "vast and pathless wilds of the Far West," Catlin spent eight years among the Western tribes, documenting "their native looks and history."

tribes of North America. Such an idea would require considerable funds to carry out, however, and he set about obtaining a number of commissions from important citizens including New York's governor, DeWitt Clinton. Thus fortified with money as well as purpose, the young artist set out in 1830 for St. Louis, where he introduced himself to the former explorer William Clark, then serving as Superintendent of Indian Affairs for the Western Tribes. Traveling the rounds of the Indian encampments out of St. Louis, Catlin accompanied Clark on a trip up the Mississippi to Prairie du Chien, where he began making portraits of the Iowa, Eastern Sioux, Sac, and Fox yet residing in that vicinity.

In the fall of that year he went in the direction of Fort Leavenworth, where he stayed for a time painting portraits among those nations lately pushed westward from their ancestral homelands in the northeastern and Great Lakes regions. In the late autumn he went with Superintendent Clark to the Kansas River encampments and again the following spring to the villages north along the Missouri and Platte rivers beyond Council Bluffs, where he observed activities among the Pawnee, Omaha, Missouri, and other indigenous tribes of the north-central prairies. Then, in 1832, he ventured into "the vast and pathless wilds familiarly denominated 'the Great Far West,'" as he tells it, ". . . over the almost boundless prairies and through the Rocky Mountains with a light heart, inspired with an enthusiastic hope and reliance that I could meet and overcome all the hazards and privations of a life devoted to the production of a literal and graphic delineation of the living manners, customs, and character of an interesting race of people who are rapidly passing away from the face of the Earth."

Aboard the American Fur Company steamer *Yellowstone* on its maiden voyage, Catlin traveled up the Missouri River toward Fort Union at the mouth of the Yellowstone River, a two-thousand-mile trip from St. Louis. During the voyage he began making sketches of Indian village life and scenes of hunting and other amusements common among the warlike Western Sioux, Cheyenne, Assiniboin, and Blackfoot tribes. A sketchbook he carried with him on this excursion is now in the Gilcrease Institute archives. In it the artist has described many scenes and likenesses of the peoples he encountered on this trip, quick pen-and-ink drawings that also may be seen reproduced in several of his larger paintings or as line engravings featured in his *Letters and Notes on the Manners, Customs, and Condition of the North American Indians* published by the author while in London in 1841.

WIGWAMS OF THE CROW TRIBE *(detail)*
George Catlin

Catlin's commentaries further illuminate the scenes he described with his pen or brush. Admiring the lodges of the Crow encamped in the vicinity of Fort Union for the purpose of trading furs, he remarks that they, "of all the tribes in this region, or on the continent, make them of the same material; yet they oftentimes dress the skins of which it is composed almost as white as linen, and beautifully garnish them with porcupine quills, and paint and ornament them in such a variety of ways, as renders them exceedingly picturesque and agreeable to the eye."

"They are sufficiently large for forty men to dine under," he observes further. "The poles which support it are about thirty in number, of pine and all cut in the Rocky Mountains, having been some hundred years, perhaps, in use. This tent, when erected, is about twenty-five feet high, and has a very pleasing effect; with the Great or Good Spirit painted on one side, and the Evil Spirit on the other."

Of the warriors of this tribe he writes:

There is an appearance purely classic in the plight and equipment of these warriors and "knights of the lance," and they wield these weapons with desperate effect upon the open plains; where they kill their game while at full speed, and contend in like manner in battles with their enemy. There is one prevailing custom in these respects, amongst all the tribes who inhabit the great plains or the prai-

INDIAN TROUPE
George Catlin

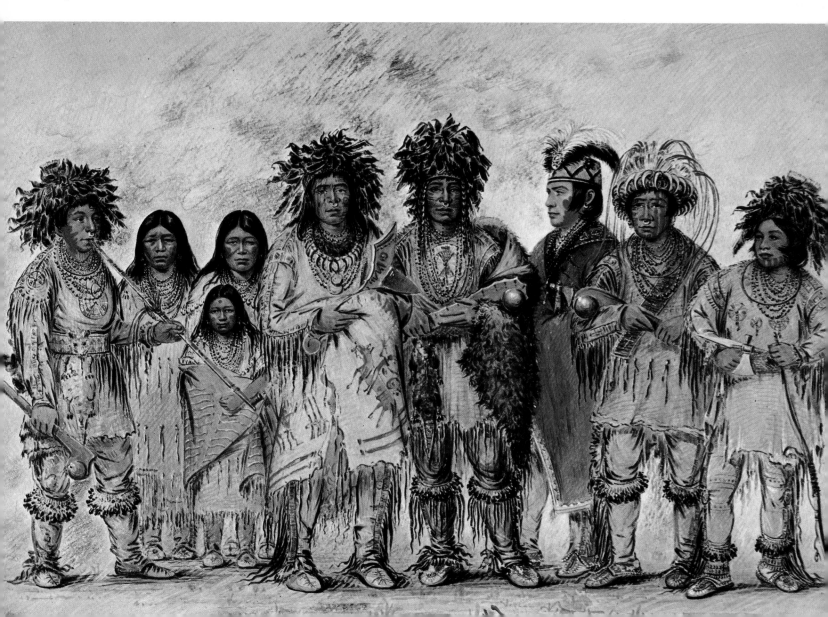

ries of these western regions. These plains afford them an abundance of wild and fleet horses, which are easily procured; and on their backs, at full speed, they can come alongside of any animal, which they can easily destroy.

Other artists also found the Indians a subject of much interest, among whom few had more intimate knowledge of the Far West of the 1840's and 50's than John Mix Stanley. Born in 1814 in New York, Stanley commenced his career as a painter in 1835 in Detroit and first began to portray Indian subjects in the vicinity of Fort Snelling about 1842. Stanley ventured farther afield in pursuit of more Indian studies, influenced perhaps by Catlin's recent successes in this field. He arrived at Fort Gibson in present-day eastern Oklahoma in the fall of 1842, some eight years after Catlin's visit to this post. Later trips took him along the Santa Fe Trail with a party of traders led by Josiah Gregg. At Santa Fe, he joined the expedition of Colonel Stephen W. Kearny as artist with this company en route to California.

In Oregon in 1847, Stanley braved the dangers of the Indian trouble following the massacre at the Whitman mission and made his way to Fort Walla Walla. By 1852 he possessed a considerable collection of Indian paintings, which he took back with him to Washington to be shown at the library of the Smithsonian Institution, hoping as had Catlin before him to interest Congress in purchasing his work for the

GAME OF CHANCE
John Mix Stanley

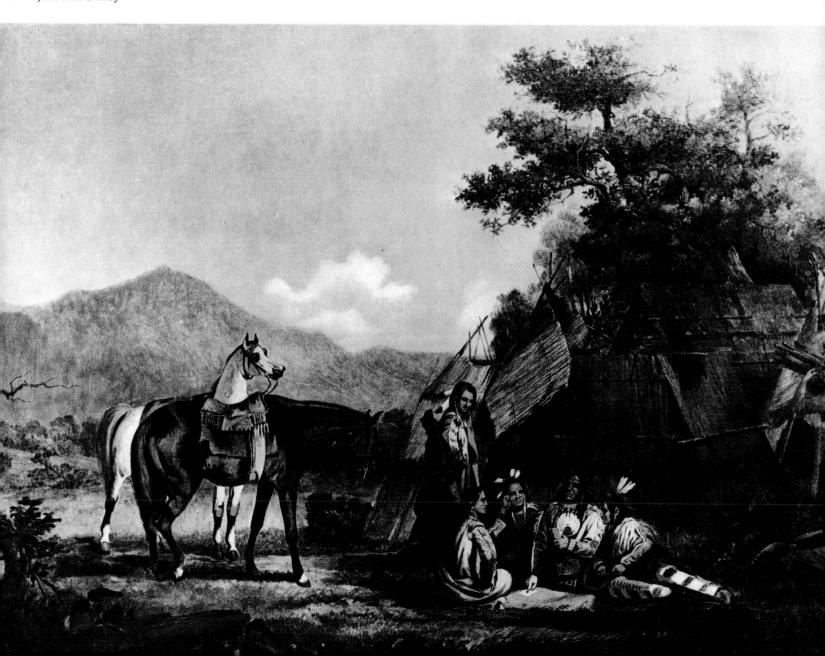

proposed national gallery. A fire at the Smithsonian in 1865 destroyed all but five of his Western paintings, and Stanley did not return to the frontier. He spent the remainder of his life between Washington and Buffalo, New York, and died in Detroit in 1872.

Among the few of his frontier scenes to have been preserved to the present are his *Tepia Gatherers,* owned by the Gilcrease Institute, and his *Game of Chance,* depicting a group of Indians occupied with one of their favorite pastimes: gambling. The Indians are probably Sioux whom he saw in the vicinity of Fort Snelling. The brush-type structure seen here was used occasionally by hunters or families during the summer months along the fringes of the great plains in the north.

While satisfying from an artistic standpoint and in accord with the romantic taste of his times, many of Stanley's paintings fail to afford the student of ethnology sufficient detail for the purposes of documentation. He depicts an Indian pony, for example, but does not appear to have been interested in describing it with respect to type, breed, or strain. This same criticism has been directed toward many of the artists of the Western scene in the early half of the nineteenth century; but perhaps the horse in those days was taken for granted and was not the subject of particular interest that it is for modern Western buffs.

Stanley does describe adequately the type of saddle used by his subjects, known as a "pad" saddle, common throughout Europe in the sixteenth century and undoubtedly brought to America by the Spaniards. The plains horseman found this piece of gear sufficient to his needs and it was a common item throughout the 1700's and early 1800's.

Like Stanley, Henry F. Farny was interested in the more common or "everyday" aspects of Indian life; many other observers, of course, approached the subject from a strictly ethnological standpoint or the point of view of a dramatist interested only in action. A student of the academies of Düsseldorf, Vienna, and Rome, Farny made a trip down the Missouri River in 1878 studying and sketching Indian life. At the Sioux agency at Standing Rock he obtained additional drawings during the time when the "Ghost Dance" movement was sweeping the plains. Returning to his studio in Cincinnati, he set about putting onto canvas his views of the plains Indian. Not as prolific as other and better-known artists who portrayed the West, Farny nevertheless can be included among the best of the documentary artists of this period.

In his painting of an Indian boy in the process of breaking a pony to ride, Farny depicts one of the most common methods used by the plains Indians in taming a mount. Backed by the encouragement and advice of elders along the riverbank, an Indian boy has led an unbroken horse out into the stream to a depth sufficient to enable him to clamber on its back. While the horse thrashes about, the boy holds its head close by the halter. A number of trips into the water might be required to sufficiently tire the horse and accustom it to the rider on its back. Sometimes only one or two such dips in the river calmed the animal so that it might be safe to ride on dry land.

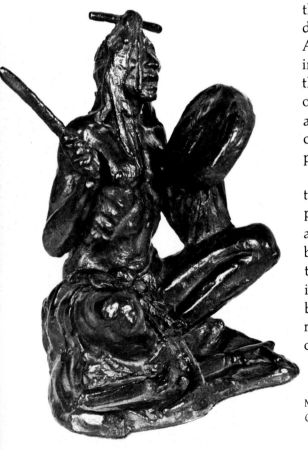

MEDICINE MAN
C. M. Russell

Other methods of breaking horses were also employed, many of a rougher nature than the one depicted here. Riding into swampy or muddy areas was sometimes tried, and, as extreme measures, roping and choking the horse were done if the horse proved exceptionally wild and unruly. Some Indians, especially those residing west of the Rockies, broke their mounts in much the same manner as the modern rodeo bareback or "bronc" rider. Most Indians mounted their horses from the right hand side instead of the left as is common among riders today. The Indian usually relied on a good grip of the horse's mane to help him climb on. Once the plains tribes began to use white men's saddles, they invariably mounted from the left, white man's style.

Comparatively few painters who depicted the life of the plains Indian bothered to show the more domestic side of it. Farny has given us a rare view of a commonplace event in the culture of the plains in which the horse was of paramount importance. His canvas entitled *The Sorcerer* is another in this same vein, presenting the lonely figure of a prophet or "medicine man" chanting a hymn to the morning. Nearby are seen various fetishes or amulets. One might view this picture for some minutes studying its various points of interest and fail to detect the presence of the coyote in the background peering cautiously from his hiding place in the sagebrush.

BREAKING A PONY
Henry F. Farny

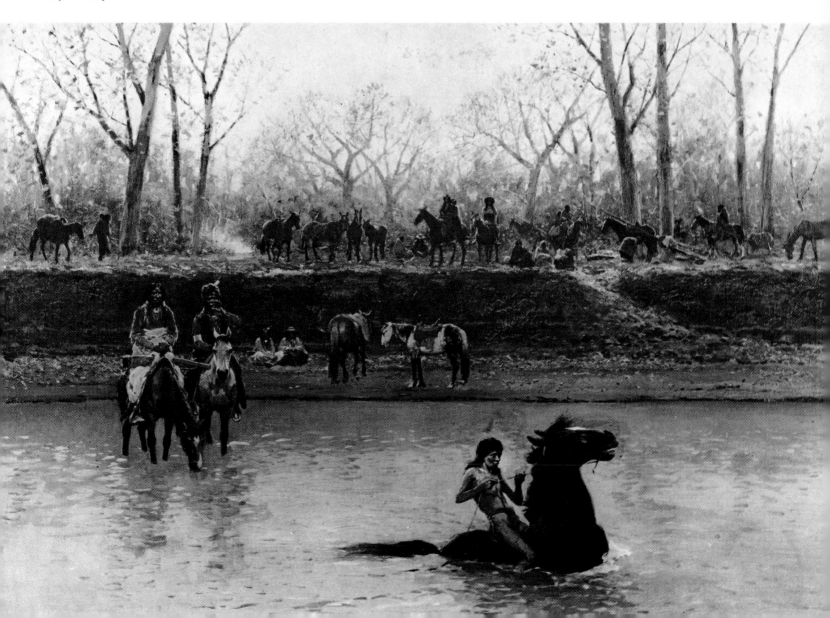

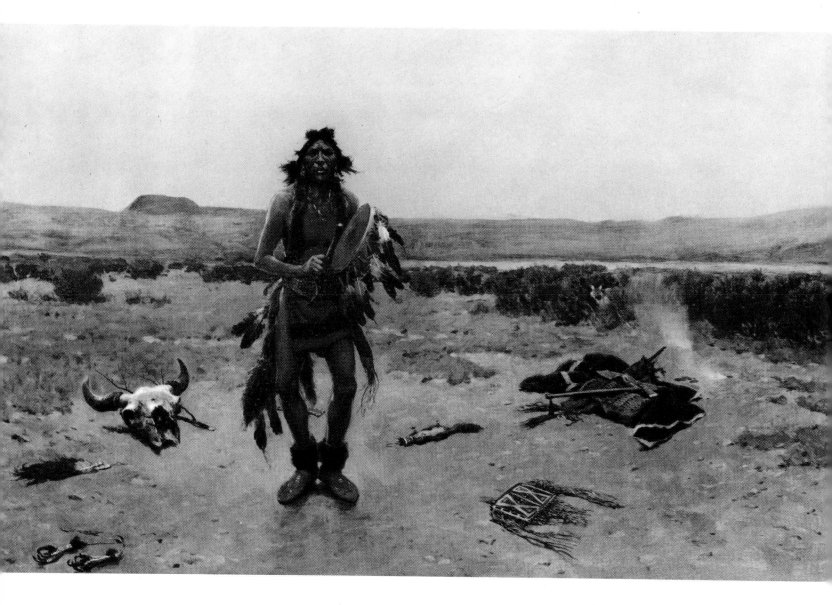

THE SORCERER
Henry F. Farny

Comparatively few artists depicted the more commonplace aspects of Indian life, preferring scenes of action and drama associated with hunting or war.

The Sorcerer presents a somewhat melancholy scene and is, in fact, a painting dating from the latter-day period in the history of the plains Indians when the buffalo were no more and the majority of the plains warriors were restricted to reservations, struggling to adapt to a more sedentary existence. Likewise, Russell's portrait of the Indian he calls "Buffalo Coat" describes a man who has abandoned the hunt for the less exciting life of a trapper in a day when the plains tribes were becoming increasingly dependent on the manufactured goods of the white traders. Probably a Blackfoot in the vicinity of Fort Benton, Montana, Buffalo Coat is pictured wearing a variety of garments, including a shirt and breechclout made of flannel. The Hudson's Bay coat has replaced the buffalo robe of an earlier period, and the Indian carries a strike-a-light suspended from his belt. The sawed-off musket, run through the belt, was commonly carried in this way whether a man was on foot or horseback. Buffalo Coat may yet preserve something of the native dignity of his people, but he is not the dashing figure described by Catlin and other observers of an earlier day.

In our mechanized society, it is difficult to imagine the elemental life of the plains Indian or the style of horsemanship acquired by those who hunted and fought on horseback over the trackless prairies. Jumping onto a horse going at full speed or dropping to one side of

68

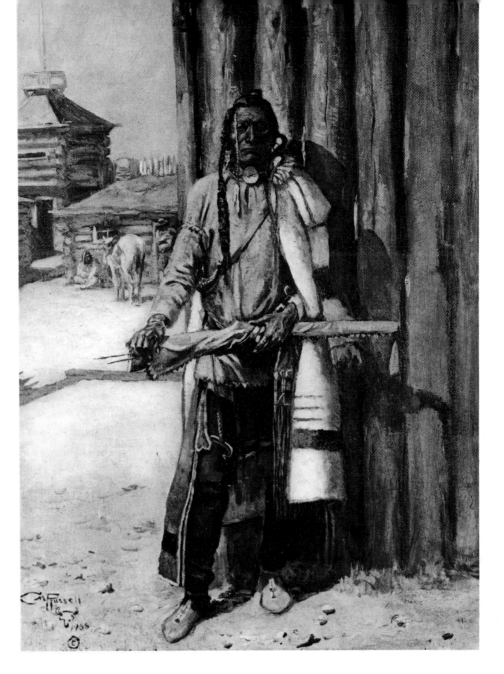

BUFFALO COAT
C. M. Russell

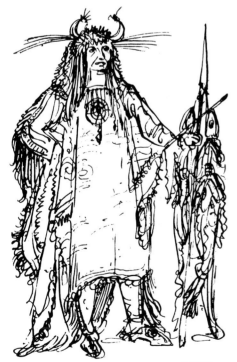

PA-TOH-PEE-KIGI
George Catlin

his mount to avoid an enemy were only a few of the tricks acquired by a young Indian boy in his training as a horseman; less dramatic, but crucial, elements in his education were the making of shoes of grass or buffalo hide to protect his mount's hoofs in rocky country, the cutting of winter grass for fodder, the use of healing plants, and the brewing of medicines and poultices to cure distemper, cough, or various wounds and sores. Many games played by plains Indian boys were actually training in disguise, involving horsemanship, marksmanship, and the development of various skills necessary in war or the hunt. In the process a young warrior became a good judge of horses. Sometimes this judgment was part of the tribal lore; for instance, if the budding young warrior were a Blackfoot, he would look on a horse with black hoofs with disdain as a "woman's horse"; however, most plains horsemen considered an animal with light-colored hoofs inferior to one with dark or black hoofs.

Boys were taught from earliest childhood that only in war could they realize great honor and respect. Death in battle was much to be preferred over the miseries and forgetfulness of old age. Revenge, whether personal or tribal, also was regarded as an honorable sentiment prompting warfare. But the chief motive for war, perhaps, was a love of fighting, for there was little else of more importance to the

plains warrior than distinguishing himself in battle and thereby receiving the applause of his fellow tribesmen. There were many and varied customs and ceremonies connected with war. In preparation for battle, warriors might not eat or drink during the daylight hours of the first day of a campaign. Dreams could encourage or cancel previous plans or tactics. Visions seen in the clouds or signs detected within other natural formations were everywhere respected.

Among most of the plains Indians, killing the enemy was important. Scalping was not so important as is generally thought, although it was a common practice. Touching the enemy with the bare hand, a stick, or any other handy instrument—known as "counting coup"—was a custom of the highest merit: an action giving proof of a warrior's courage.

Remington's well-known painting entitled *Indian Warfare* depicts a band of Cheyenne warriors attacking a column of U.S. infantry grouped in the distance. In this case, the war party is shown as it normally engaged in battle, the warriors and mounts stripped of saddles, robes, and any other equipment that might prove cumbersome and carrying only the barest essentials: weapons and shields. The bodies of both men and horses are painted for battle. A ring around a horse's eye was believed to insure his unfailing eyesight. Lightning stripes painted on the forelegs of a warrior's mount aided his sure-footedness. Most body paint used by the warrior himself was highly individualized and of strictly personal significance. The central incident in this picture concerns the recovery of a dead or wounded comrade during the heat of the battle.

INDIAN WARFARE
Frederic Remington

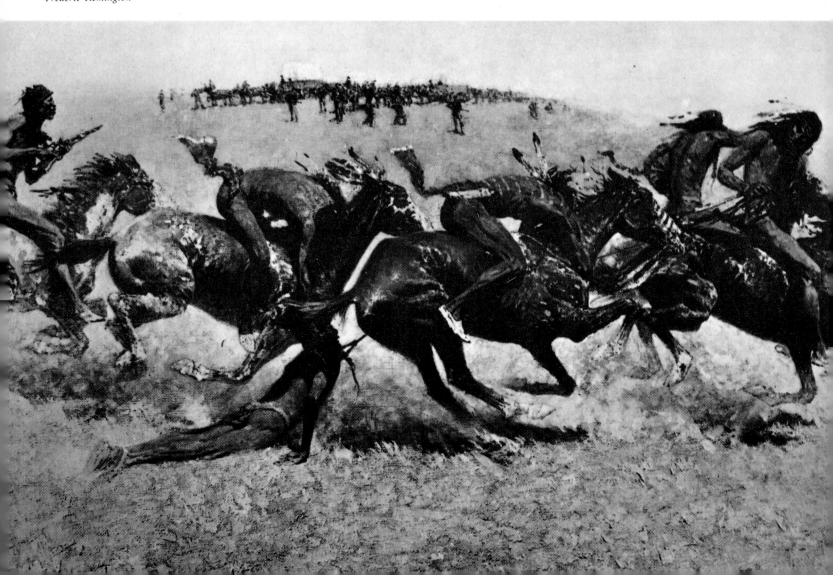

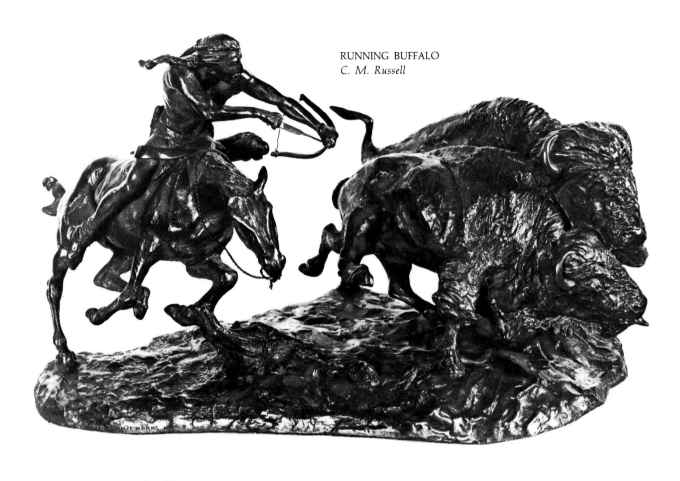

RUNNING BUFFALO
C. M. Russell

HER HEART IS ON THE GROUND
C. M. Russell

When not otherwise impossible, dead or wounded men were never left behind on the battlefield, and part of an Indian boy's training involved the practicing of the recovery of his friends on foot or lying prostrate on the ground. Usually a wounded man would be picked up by two riders on either side, who would lift him by his arms and carry him out of the range of the enemy. Remington shows his warriors employing a leather rope drawn under the arms of the fallen man.

Normally a war party was small among the plains tribes, although larger formations were directed against U.S. army units following the Civil War. Even in these larger battles, individual bravery and such practices as "counting coup" were regarded as important. Generally speaking, the decision to engage in battle was a personal choice on the part of the individual warrior. If the signs seemed unfavorable to him, he might refuse to join a war party and no questions would be asked.

Warfare involved more than warriors, and in the days of Indian conflict on the western plains, all members of the tribe or nation were immediately affected. In Charles Russell's sympathetic portrayal entitled *Her Heart Is on the Ground* is presented a Blackfoot woman mourning her dead husband, whose covered form may be detected in the background where it has been placed in its final attitude of rest. As was customary among the plains people, the woman has cut her arms to express her great sorrow. Cutting the hair was also common. In accordance with plains Indian custom, the dead man is placed above ground and not buried. In this instance, an outcropping of rock serves as a scaffold upon which the dressed and painted body has been wrapped and placed. When Indian dead were interred along a river bottom, a tree scaffold was built. On the prairies, tipi poles provided the necessary support, placing the body out of reach of coyotes, wolves, or other predators. No effort to identify the remains was made, and fear of the dead often kept mourners away from those places set aside for the bodies. A less common practice with respect to those slain in battle was that of leaving the bodies as is the case described by Russell. Usually such a practice accorded with the request of those about to engage in warfare.

The dying often made requests of the living that certain personal belongings be "buried" with them, for among the plains tribes the belief that the spirit of the dead must undergo a long journey to reach the "hereafter" was universal. Sometimes the warrior's horse was killed and placed beneath the scaffold supporting his body. Often his mount's tail and mane would be cut whether the animal was sacrificed or not. Other items left at the burial site were hunting and war gear and food, which would be needed for the long journey into the spirit world.

As missionaries came into contact with the plains tribes, most of the customs surrounding the mourning of the dead passed out of use. Scaffold burial also disappeared, although many tribes resisted interment in the ground, feeling it interfered with the passage of the spirit of the dead from its terrestrial abode.

The Missouri River, Waterway West

Selections from Frontier Travelogues

The Missouri River, Waterway West

The Missouri is, perhaps, different in appearance and character from all other rivers in the world; there is a terror in its manner which is sensibly felt, the moment we enter its muddy waters from the Mississippi. From the mouth of the Yellow Stone River, which is the place from whence I am now writing, to its junction with the Mississippi, a distance of 2,000 miles, the Missouri, with its boiling, turgid waters, sweeps off, in one unceasing current; and in the whole distance there is scarcely an eddy or resting-place for a canoe. Owing to the continual falling in of its rich alluvial banks, its water is always turbid and opaque; having, at all seasons of the year, the colour of a cup of chocolate or coffee, with sugar and cream stirred into it.

. . . I arrived at this place yesterday in the steamer "Yellow Stone," after a voyage of nearly three months from St. Louis . . . The American Fur Company have erected here, for their protection against the savages, a very substantial Fort; with bastions armed with ordnance; and our approach to it under the continued roar of cannon for half an hour, and the shrill yells of the half-affrighted savages who lined the shores, presented a scene of the most thrilling and picturesque appearance . . .

So wrote George Catlin in 1832 from Fort Union on the Upper Missouri, where he had traveled with the party of Pierre Chouteau, Jr., scion of the famous fur trading family, aboard the newly built steamer *Yellowstone.* Representing at this time the largest establishment of its kind along the Missouri and perhaps in all the West, Fort Union served as the principal headquarters for the American Fur Company's

MISSOURI ROUSTABOUT AT THE TILLER OF A MACKINAW BOAT (*previous page*)
William Cary

VIEW OF THE GRAND DETOUR
George Catlin

The Missouri River became in the early decades of the nineteenth century the easiest route to some of the wildest and most beautiful country on the continent. An early visitor was artist George Catlin, who traveled to its upper reaches in 1832.

business in that wild and lonely region—the veritable frontier "palace" of the Scottish trader Kenneth McKenzie, who was then at the height of his career and entertaining his guests at a table which, according to Catlin, "groans under the luxuries of the country."

Catlin's reason for undertaking so long a journey to the northern reaches of the Missouri was, of course, to obtain portraits among the Indians of that distant region. His subjects were "a host of wild and incongruous spirits—chiefs and sachems—warriors, braves and women and children of different tribes . . .

"Amongst and in the midst of them am I, with my paint pots and canvasses, snugly ensconced in one of the bastions of the Fort," he writes. "My easel stands before me, and the cool breach of a twelve-pounder makes me a comfortable seat."

A sketchbook he carried with him on this remarkable voyage today preserves innumerable views of the unsettled region of the Upper Missouri. Reproduced in part as illustrations for his published commentaries or incorporated into the finished studies that constitute the greater part of his surviving works, these drawings furnish a modern-day reader with descriptions of a country that in Catlin's day was as yet virtually untouched by the "improvements of civilized man." The journey itself, of nearly two thousand miles, punctuated with many incidents, provided the artist with much material for study, to which he referred in voluminous notes and letters. As he remarks in his *Letters and Notes on the Manners, Customs, and Condition of the North American Indians,* published some years afterward in London:

A voyage so full of incident, and furnishing so many novel scenes of the picturesque and romantic . . . would afford subject for many epistles; and I cannot deny myself the pleasure of occasionally giving little sketches of scenes that I have witnessed . . . and of the singular feelings that are excited in the breast of a stranger travelling through this interesting country.

About twenty miles above the mouth of the Platte north of present-day Omaha, Nebraska, was located Cabanne's Post when Catlin traveled aboard the *Yellowstone* on its maiden voyage upriver in 1832. A few miles north of the post along the west bank stood Fort Atkinson, a military post abandoned in 1827. Beyond this point, where the Missouri swings northward into the Dakotas, began a picturesque section of the river known variously as the "Big Bend" or the "Grand Detour," where the Missouri described a gigantic "S" through the surrounding rock cliffs.

"Our canoe was here hauled ashore," recalls the artist, "and a day whiled away again amongst these day-built ruins"—referring to the weathered domes along the riverbank. "We clambered to their summits and enjoyed the distant view of the Missouri for many miles below, wending its way through the countless groups of clay and grass-covered hills."

Alluding to a study he made of a prominent range of bluffs in this region, he remarks:

The sketch of the bluffs denominated "the Grand Dome" is a faithful delineation of the lines and character of that wonderful scene; and the reader has here a just and striking illustration of the ruin-like appearance, as I have formerly described, that are so often met with on the banks of this mighty river . . .

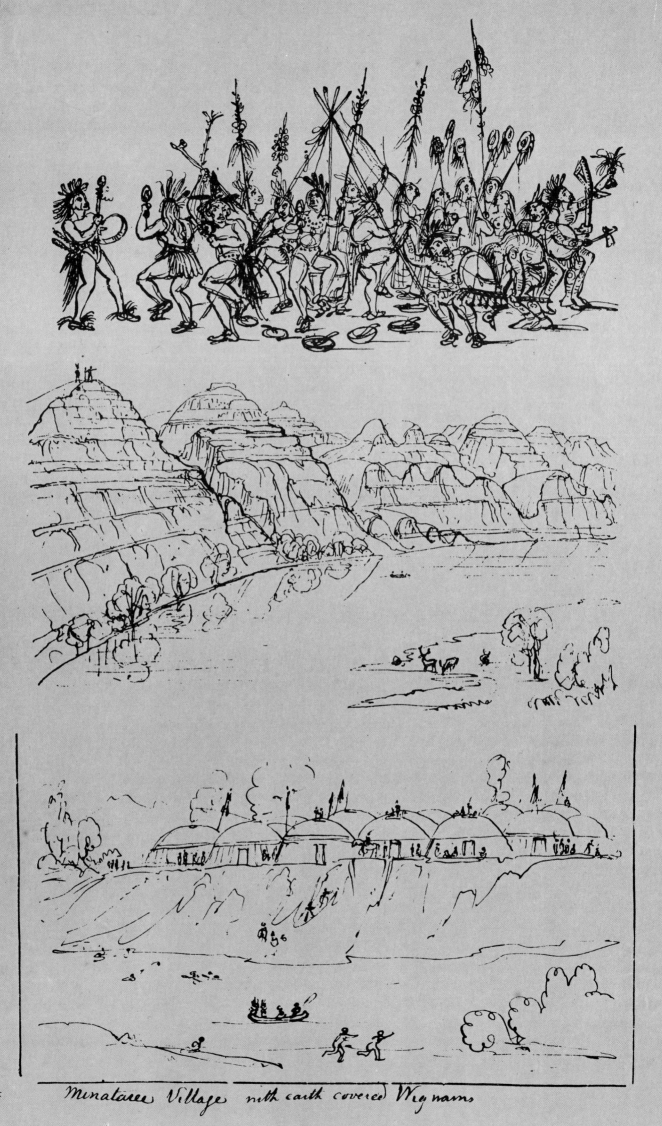

Minataree Village with earth covered Wigwams

This is, perhaps, one of the most grand and beautiful scenes of the kind to be met with in this country, owing to the perfect appearance of its several huge domes, turrets, and towers, which were everywhere as precise and as perfect in their forms as they are represented in the illustration. These stupendous works are produced by the continual washing down of the sides of these clay-formed hills; and although, in many instances, their sides, by exposure, have become so hardened, that their change is very slow.

Near the entrance of the White River, the *Yellowstone* struck and lodged upon one of the sandbars in the river. While the crew worked to free it, Catlin and Pierre Chouteau trekked overland to Fort Pierre. Named for Catlin's host and companion, this post was the center of fur trading activity with the Sioux in that vicinity and "drawing from all quarters," as Catlin remarks, "an immense and incredible number of buffalo robes."

Chugging past Fort Manuel Lisa, the *Yellowstone* entered the territory of the present state of North Dakota and near the mouth of the Grand River came into view of a number of earth-lodge villages ranged along the banks of the river. Here the Arikara, or "Riccarees," had their principal settlement. These people had a fearful reputation at the time because of their hostility to earlier explorers and traders passing through this region.

"This village is built upon an open prairie," comments Catlin in his *Notes*, "and the gracefully undulating hills that rise in the distance behind it are everywhere covered with a verdant green turf, without a tree or a bush anywhere to be seen."

He adds, however, that "they certainly are harbouring the most resentful feelings at this time towards the Traders, and others passing on the river; and no doubt, that there is a great danger of the lives of any white men, who unluckily fall into their hands. They have recently sworn death and destruction to every white man, who comes in their way; and there is no doubt, that they are ready to execute their threats."

The Mandan villages above Fort Clark—earlier the locale of "Fort Mandan," where Lewis and Clark had spent the winter of 1804-5 —provided Catlin with one of his most entertaining stops. His sketchbook is filled with scenes of this place and studies of various Indians. Although soon to be nearly exterminated by the smallpox epidemic that ravaged the plains within the next six years, these Indians were then still full of vitality and preparing for their annual religious ceremonies. Catlin watched them at their games and sketched the warriors doing their frenzied Bull Dance. He also witnessed the dread *O-kee-pa*, or torture ceremony, to which the young men subjected themselves.

Nothing escaped Catlin's inquiring eye. Pronouncing the village to be "the strangest mixture and medly of trash that can possibly be imagined"—he elaborates further:

On the roofs of the lodges, besides the groups of the living, are buffaloes' skulls, skin canoes, pots and pottery; sleds and sledges—and suspended on poles, erected some twenty feet above the doors of their wigwams, are displayed in a pleasant day, the scalps of warriors, preserved as trophies. In other parts are raised on poles the warriors' pure and whitened shields and quivers, with medicine bags

Catlin journeyed nearly 2,000 miles from St. Louis to Fort Union aboard the steamer Yellowstone. A sketchbook he carried with him on this voyage is preserved in the Gilcrease Library. It is filled with hundreds of drawings, many of which were later reproduced in engraved form in the artist's Letters and Notes on the Manners, Customs, and Condition of the North American Indians, 2 vols. (London, 1841).

"Big Muddy" was the primary route to the unknown,
—uncharted western wilderness—

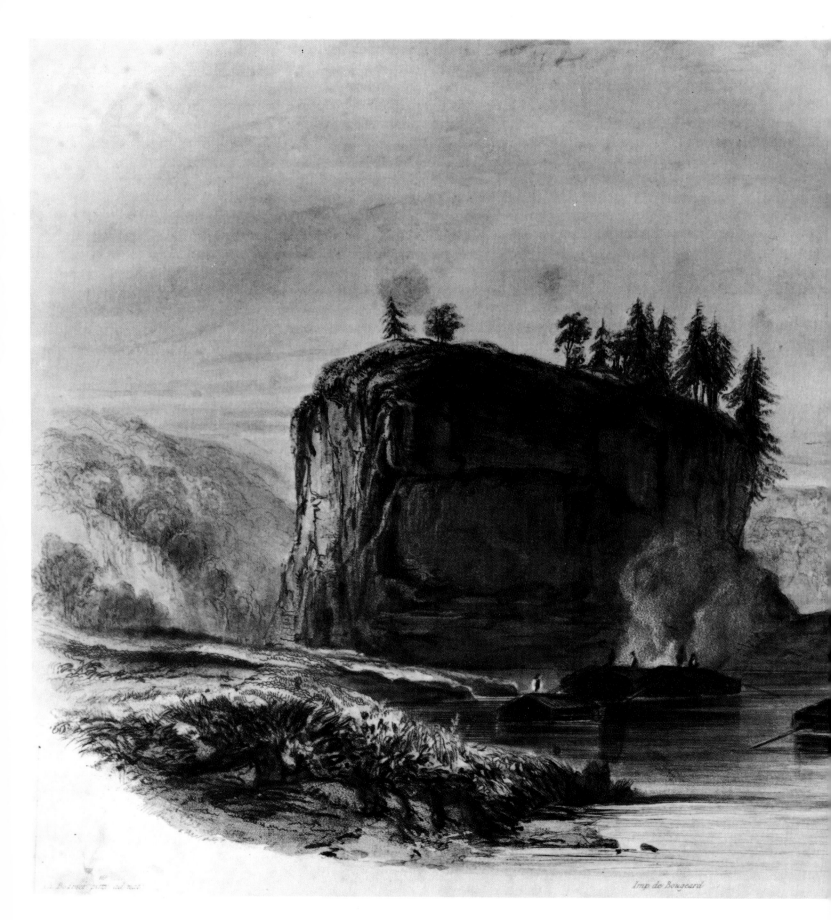

attached; and here and there a sacrifice of red cloth, or other costly stuff, offered up .to the Great Spirit. In the distance can be seen the green and boundless, treeless, bushless prairie; and on it, and contiguous to the piquet which encloses the village, a hundred scaffolds, on which their "dead live," as they term it.

And he describes yet another of the earthen villages along the river, that of the Minataree farther upstream:

Soon after witnessing the curious scenes described in former letters, I changed my position to the place from whence I am now writing—to the village of the Minatarees, which is also located on the west bank of the Missouri river, and only eight miles above the Mandans. On my way down the river in my canoe, I passed this village without attending to their earnest and clamourous invitations for me to come ashore, and it will thus be seen that I am retrograding a little, to see all that is to be seen in this singular country . . .

The Minatarees (people of the willows) are a small tribe of about 1500 souls, residing in three villages of earth-covered lodges, on the banks of Knife river; a small stream, so called, meandering through a beautiful and extensive prairies, and uniting its waters with the Missouri.

The Missouri River was at this time the principal route to the interior of the continent, having achieved its initial fame as the means by which earliest explorers had penetrated the unknown regions west of the Mississippi at the beginning of the century. Lewis and Clark, the first to investigate the vast wilderness of Louisiana Territory, had been the first as well to employ this river as their highway, traveling the length of its winding course to its headwaters in the Rockies above the present city of Helena, Montana. Shortly thereafter, Zebulon Pike had traveled from St. Louis up the Missouri to its junction with the Platte, and Major Stephen H. Long had journeyed about as far upriver in 1819 aboard a steamer called the *Western Engineer*, the first steam-propelled craft to be used on Missouri waters.

On the heels of these men came other adventurers—trappers and then traders, who sought to exploit the riches in furs to be had in this wide region. The hostility of some of the local tribes discouraged river trade, however, and many of the earlier traders switched their operations to the central Rockies. By the 1820's, two companies had established themselves along the Missouri: the Columbia River Fur Company, composed largely of men from the old British North West Company, and the western branch of John Jacob Astor's American Fur Company. In 1828, the same year in which Fort Union was established, Astor's company absorbed its powerful rival, and by 1832, when Catlin visited the area, the American Fur Company monopolized the trading scene.

Many kinds of craft operated on the Missouri and all the western waterways by the beginning of the second quarter of the nineteenth century. Canoes, perhaps the most common, were usually hewn from the trunks of trees and were capable of carrying three people. In the early nineteenth century such craft often navigated the Missouri or the Platte all the way from the Mississippi to the Rockies and back again. Keelboats also were used to transport trade goods or travelers on government business to the western territories.

VIEW ON THE MISSISSIPPI: TOWER ROCK
after Carl Bodmer

Sketch of Jim Buter on the
West Boundary Survey
Sketch on the other Side

JIM BUTER, MOUNTAIN MAN . . .
William Cary

*The traders to the upper
Missouri used flatboats,
keelboats, and later steam
packets to get into the fur
country; trappers like Jim
Buter sometimes had to
resort to Indian crafts, like
the willow-ribbed skin
bull-boats, to get out.*

The keelboats on the western rivers were similar to those that had been used on the Ohio and the Mississippi for many years. On the Missouri, however, this shallow-draft vessel was equipped with a number of extra means to expedite its progress upriver. Usually it had a mast and sail, oars to be used when the wind proved wanting or wayward, and a set of long poles that often were employed literally to "walk" the craft through the shallows and over the sandbars for which the western rivers in general and the Missouri in particular were famous. The upstream progress of such a boat could be tedious in the extreme and often required the exertions of all hands, passengers included, who might be compelled to clamber ashore to drag their means of conveyance along at the end of a length of stout cable while others paddled, poled, or pushed.

The first steamboat on the Missouri had been built expressly for the convenience of Major Long during his journey from Pittsburgh to the Rocky Mountains in 1819. A really remarkable craft for its time, this boat had been designed for the purpose of impressing the western Indians. The bow was fashioned to resemble the neck and head of a sea serpent from whose mouth issued clouds of smoke. The machinery for propelling the boat was hidden from view by a superstructure, as was the paddle wheel at the stern, which agitated

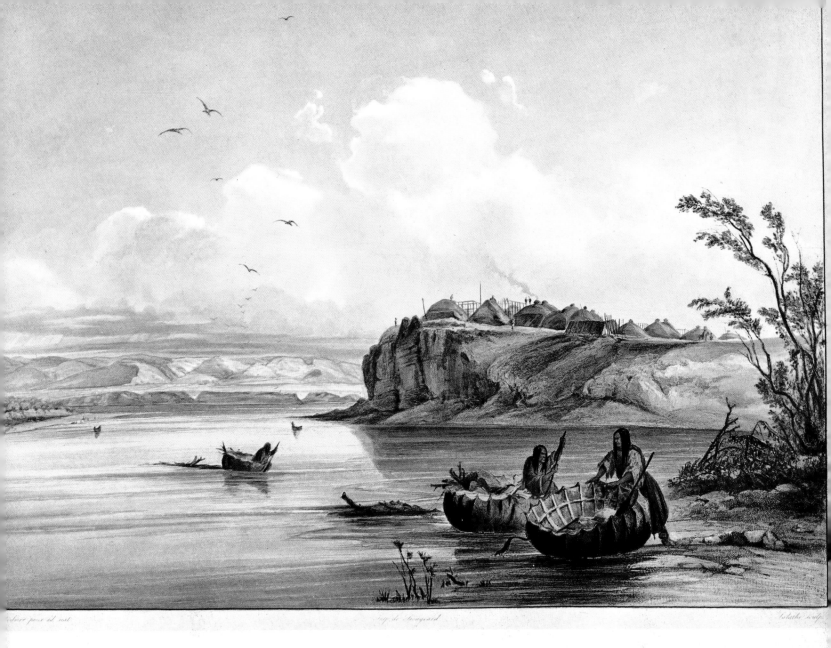

BULL-BOATS
after Carl Bodmer

the water in the manner of some supposed aquatic monster. This awe-inspiring vessel got no farther upriver than the present Council Bluffs, however, and it was not until 1829 that a regular steamer made its appearance on the Missouri plying between St. Louis and Fort Leavenworth. Three years later, the *Yellowstone* attempted the first voyage to the upper waters of the river and again made the trip in 1833, accompanied by another of the American Fur Company's boats called the *Assiniboine.* In the next decade, steamer travel on the Missouri became more or less regular, with an average of one or two trips annually being made to the distant forts upriver by one or another of the fur company packets.

The bull-boat, so called, adopted from the Indians and consisting of a shallow "basket" or oval framework covered with dressed buffalo hides, continued to be one of the most common conveyances used by the Anglo-American or French trappers on the Upper Missouri. Similar to the coracle used by the ancient Britons, this primitive craft could manage a stream whose depth did not exceed ten or twelve inches —a distinct advantage in the Missouri's unpredictable waters. In deeper water, the bull-boat was difficult or impossible to navigate, however, and often proved to be a contrary craft where steering was concerned. It was used primarily for the downstream transportation.

81

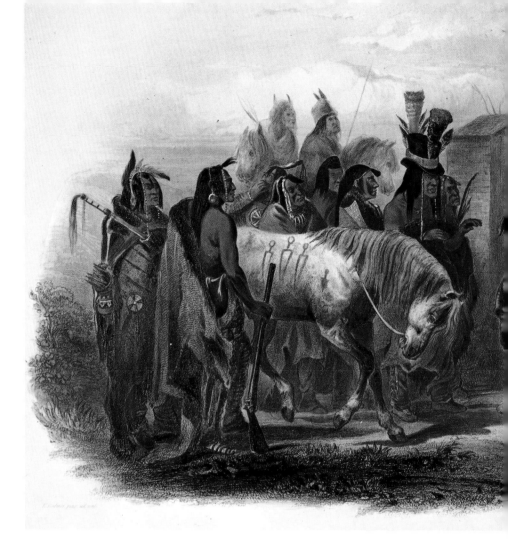

● TRAVELERS MEETING WITH MINATAREES
after Carl Bodmer

ENCAMPMENT OF TRAVELERS ON THE
MISSOURI
after Carl Bodmer

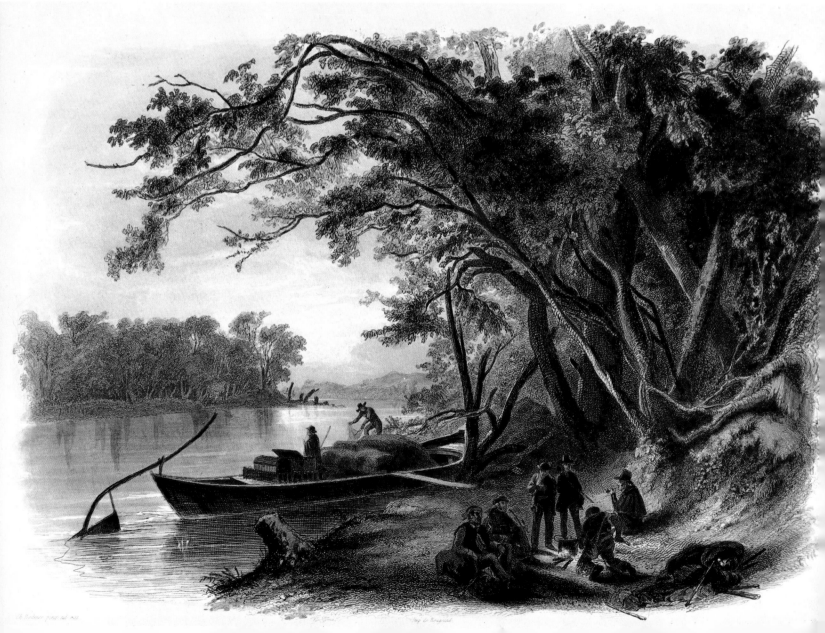

Among the many narratives of river travel is the published journal of Prince Maximilian of Wied, who visited Fort Union on the Upper Missouri in 1833–4. Accompanying the prince was the Swiss artist Carl Bodmer, who recorded many scenes along the route into the interior of North America.

Navigation on the Missouri was even more difficult than on the Ohio or the Mississippi, for besides being filled with snags, shallows, and sandbars, the big western river was extraordinarily erratic regarding its course through any given area. In common with many of the streams winding through the vast plains country, the Missouri constantly was shifting its position from one season to the next. Following heavy rains and flooding in an area, it would often be found flowing through a tract of country several miles from the channel it had occupied the previous year. It was an almost hopeless task, therefore, to maintain up-to-date knowledge of the position or condition of the river from season to season, and the various craft that plied its waters did so with care, prepared for any surprise.

Departures from St. Louis or St. Charles farther upstream invariably were attended by carousing and revelry, particularly among the keelboat and steamer crews, for a trip to the interior in the early days of navigation on the Missouri might mean years of absence for some of those attempting it. Embarkation was accompanied as often as not with a barrage of musketry or cannon fire, which was kept up by the mountaineers and others until the craft was out of range of hearing, after which the business of getting the deck in order, the various passengers settled, and the bales of goods stowed below usually occupied the crew until nightfall.

The passengers in many instances represented a more heterogeneous mixture than the cargo itself. There were the regular crew members, numbering from about thirty to forty persons, perhaps a party of Indians returning home from St. Louis or Washington, recruits for the various trading companies, and sometimes a company of soldiers destined for Leavenworth or another of the military posts beyond. Sometimes distinguished passengers of wealth or scientific status were aboard, bound westward for the purposes of pleasure or research. Government exploring parties usually traveled by steamer to the initial point of their expedition. In all, there were sometimes as many as two hundred people aboard a vessel bound for the upper waters of the Missouri in the heyday of travel on that river.

Many narratives of travel on the river exist today. Perhaps the most comprehensive of those dealing with early steamboat navigation is to be found in the memoirs of Joseph La Barge, pioneer boatman, navigator, and trader. Other accounts survive that indicate in considerable detail the natural history of the surrounding wilderness. Of these, none presents a more comprehensive view than that compiled by a German prince, Maximilian of Wied, who, in the course of his travels across North America in the 1830's, organized an expedition to explore the little-known regions beyond the western frontier of the United States.

Like Catlin, Maximilian followed the historic trail of Lewis and Clark upriver aboard the *Yellowstone* on its second voyage, arriving at Fort Union the year following Catlin's visit. Maximilian went some miles farther, however, on the fur company's second steamer, the *Assiniboine,* which was caught by low water and subsequently compelled to remain amid the snow and ice of that country until the following spring. Having kept a careful record of his day-to-day expe-

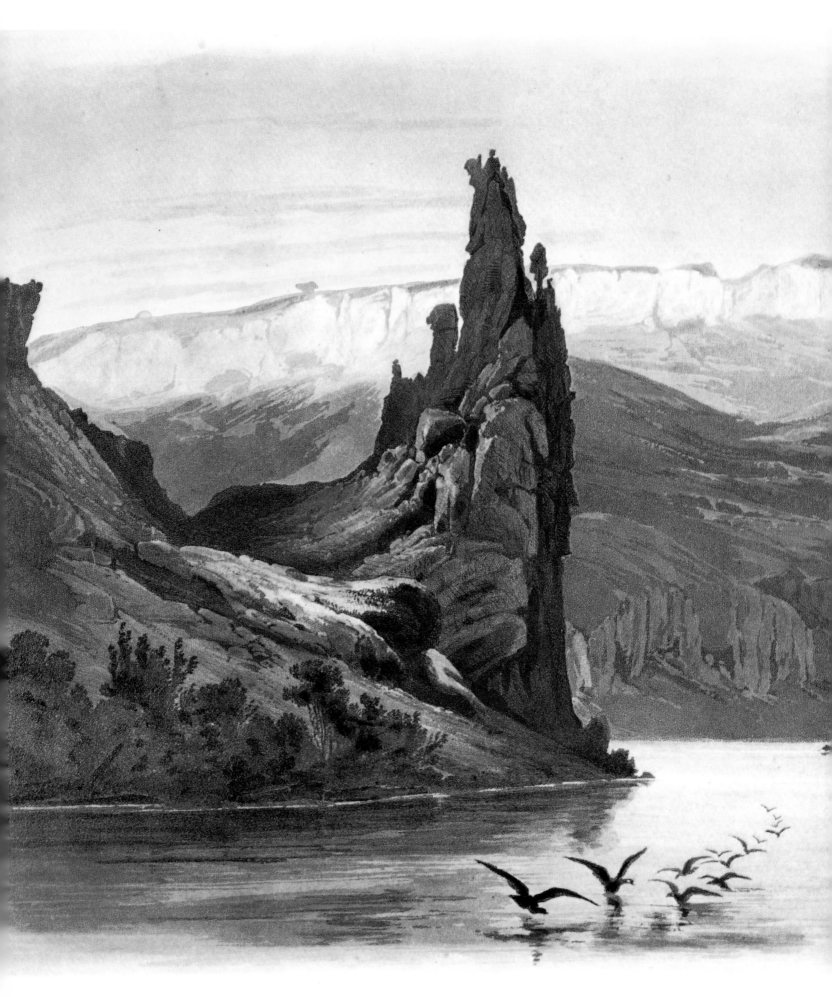

CITADEL ROCK ON THE UPPER MISSOURI
after Carl Bodmer

riences since his arrival in Boston nearly a year earlier, the German aristocrat also collected zoological and botanical specimens along the route of his further travels, preserving all that he observed of "that remarkable country" in his detailed notes.

With his party was a young Swiss artist, Carl Bodmer, whom Maximilian had chosen to accompany him as draftsman to record in pictorial terms the scenes and events of the expedition. A separate folio of colored engravings based on Bodmer's work supplemented the first publication of Maximilian's notes some six years later. *Travels in the Interior of North America*, first published in German in 1839, was followed by subsequent editions in French and in English in 1841 and 1843. The bound atlas of polychrome plates that accompanied the text is now regarded as one of the finest picture histories of the Missouri frontier ever published.

Maximilian, a naturalist and widely traveled celebrity in his day, held a somewhat less romantic view of the American frontier than many of his contemporaries. As a result, his journal not only consists of an interesting narrative of travel west of the Mississippi at a time when few Europeans had ventured so far, but also presents a considerable record of his scientific observations concerning the geography, climate, and aboriginal population of the continent. In the preface to the 1843 edition of his work, translated into English by H. Evans Lloyd, Maximilian explains:

There are two distinct points of view in which North America may be considered. Some travellers are interested by the rude, primitive character of the natural face of that remarkable country, and its aboriginal population, the traces of which are now scarcely discernable in most parts of the United States; while the majority are more inclined to contemplate the immigrant population and the gigantic strides of civilization introduced by it. The account of my tour through a part of these countries . . . is chiefly intended for readers of the first class. I have avoided the repetition of numerous statements which may be found in various statistical publications but, on the contrary, have aimed at a simple description of nature. As the United States were merely the basis of my more extensive undertaking, the object of which was the investigation of the upper part of the course of the Missouri, they do not form a prominent feature, and it is impossible to expect, from a few month's residence, an opinion of the social condition and character of that motley population. . . Some few scientific expeditions, among which the two under Major Long produced the most satisfactory results for natural history, although on a limited scale, were sent on foot by the government; and it is only under its protection that a thorough investigation of those extensive wildernesses, especially in the Rocky Mountains, can be undertaken. Even Major Long's expeditions, however, are but poorly furnished with respect to natural history, for a faithful and vivid picture of those countries and their original inhabitants can never be placed before the eye without the aid of a fine portfolio of plates by the hand of a skillful artist. In my description of the voyage up the Missouri, I have endeavored to avail myself of the assistance of an able draughtsman, the want of which I so sensibly felt in my former travels in South America. On the present occasion I was accompanied by Mr. Bodmer, who has represented the Indian nations with great truth, and correct delineation of their characteristic features . . .

Maximilian also notes the hazards of river travel and comments on the dangers to be anticipated from the surrounding wilderness. Of the river itself he remarks that its course is exceedingly wayward and strewn with hidden obstacles.

The Yellow Stone had several times struck against submerged trunks of trees, but it was purposely built very strong, for such dangerous voyages . . .

The drift wood on the sand banks, consisting of the trunks of large timber trees, forms a scene characteristic of the North American rivers; at least I saw nothing like it in Brazil where most of the rivers rise in the primeval mountains or flow through more solid ground. On the banks which we passed, the drifted trunks of trees were in many places already covered with sand; a border of willows and poplars was before the forest, and it is among these willow bushes that the Indians usually lie in ambush, when they intend to attack those who tow their vessels up the river by long ropes.

Passing other travelers on the broad waters of the Missouri, he also comments on the activities of the traders in this region; and Bodmer sketched several scenes along the way, such as that of the plate entitled *Encampment of Travelers on the Missouri*, which shows a group of traders on their way downriver who have pulled their craft up along the shore and disembarked to prepare the evening meal.

During the course of such a trip, while the officers and crew were kept busy with the navigation of the boat, the passengers spent their time as best they could. Conversation was one of the mainstays of

NORTHERN BOUNDARY SURVEY UNDER MAJOR TWINING
William Cary

Other artists ventured to explore the Missouri frontier, following the route of Catlin and Bodmer. William de la Montagne Cary produced an extensive documentary of his voyages upriver in 1861 and 1874. On-the-spot sketches served him later as references for details incorporated into his finished studio productions.

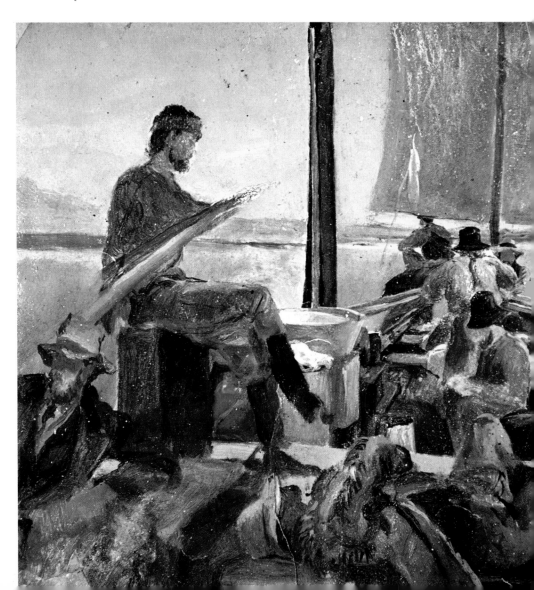

river travel, and because of the variety of people who usually traveled in this fashion, it seldom proved monotonous. Games of a more practicable sort were indulged in, and a not uncommon pastime consisted of standing on the foredeck or boiler housing to shoot at geese or ducks on the river. When there was no danger from Indians or wild animals in a particular vicinity, some passengers, in order to relieve the tedium of the trip, disembarked at the beginning of a winding or torturous stretch of water, cut across the open country at a more or less leisurely pace, and rejoined the boat farther upstream when it came along sometime later. River transportation was nothing if not slow.

The problem of securing fuel to keep the boat going was almost equal to that of feeding so many people on board. Enormous quantities of wood were used by the boat's furnaces, and its procurement was not always an easy matter. Wood yards were established at certain points along the way, in some localities operated by the friendlier Indian tribes in the area. More often, the cutting and loading of a supply of material for fuel was attended by threats and harassment from the natives.

The food furnished passengers aboard the keelboats and other craft operating on the river before the appearance of the steamer was simplicity itself and consisted almost entirely of salt pork, beans, corn, and coffee. With the appearance of scientists and government men on these waters, however, the larders of the steamers began to reflect

DECK HOUSE ON THE FONTANELLE
William Cary

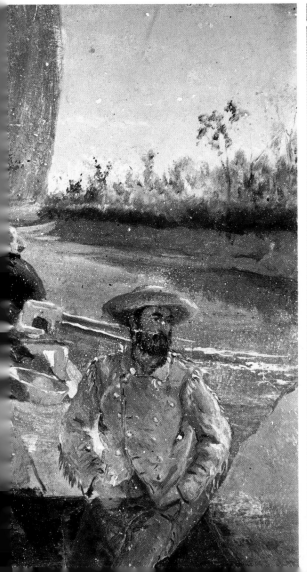

ROUSTABOUTS ON THE STEAMER <u>FAR WEST</u>
William Cary

BLACK SQUIRREL
William Cary

CHASING OFF GRIZZLIES
after Carl Bodmer

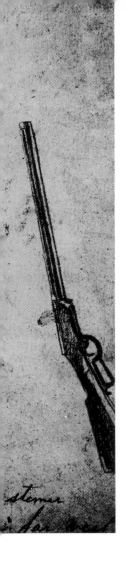

Meat hunters who ranged ahead of the boat provided a relief for passengers and roustabouts from the diet of salt pork and beans by caching fresh meat, which was picked up later as the boat made its way upriver. The pick-up, however, was not always a simple matter.

more diversified tastes. The demand for fresh meat kept certain members of the steamer crew busy. Hired expressly for this purpose, the hunter's only duty was to kill game for the table. Such a man or group of men customarily went ahead of the boat on foot, disembarking around midnight while the steamer was tied up along the shore. From then until ten or eleven o'clock the next day, they scoured the country ahead for deer, antelope, bison, or whatever it afforded, stashing the game along the riverbank, in a tree, or any other conspicuous place to be picked up by the lookout aboard the steamer as it made its way upriver.

The pickup of fresh meat was not always an easy matter, as Bodmer shows in his illustration of a landing party approaching some cached meat. In this case, the game was discovered by a couple of grizzly bears prior to the arrival of the boat crew, and there is little left for the men to take back to the waiting keelboat downstream.

Neither Catlin nor Maximilian ventured much beyond Fort Union where yet another post existed, at the mouth of the Marias River. Named Fort Piegan, this depot had been built by the American Fur Company only the year before the *Yellowstone* made its momentous first voyage. The Blackfoot Indians went on a rampage during the summer of 1832 and burned Piegan to the ground even while Catlin was visiting at Fort Union. A new fort soon replaced Piegan at Brule Bottoms, about six miles above the Marias junction. Named Fort McKenzie by its founder, David Mitchell, this post stood as the northernmost stronghold of the American Fur Company on the Missouri until Fort Benton was established in 1846 as the uppermost headquarters for steamboat navigation on the river—and gateway to the goldfields of western Montana.

The Missouri continued to be employed as the principal route for westward travel throughout the first half of the nineteenth century, facilitating the United States' penetration of the continent until the completion of the transcontinental railroad in 1869. Even when progress was not made in water craft upon the river itself, as was the case with the wagon caravans that followed the overland trail to Oregon, for hundreds of miles travelers kept as close as possible to its banks or its principal tributaries.

The record distance for a steamer navigating the upper waters of the Missouri had been made by the *Assiniboine* in 1833-4, and it was not until 1853 that a vessel named *El Paso* outdistanced the *Assiniboine* when it reached the mouth of the Milk River, which joins the Missouri nearly 150 miles above Fort Union. Finally, in 1860, the *Chippewa* and the *Key West* arrived at the distant Fort Benton in the present state of Montana and in so doing reached a point farther from the sea by continuous water travel than any other boat in America at that time. Even as these new records were being made, however, travel on the western rivers was gradually being supplemented by the overland routes to Oregon and Santa Fe. When the transcontinental railroad joined the country east and west, river traffic began to fall off sharply, replaced at last by the faster rail travel through the Rockies and across the mountain passes south to California.

Throughout the 1840's and 50's, civilian travelers and government agents continued to visit the Upper Missouri country. Artists such as

John James Audubon and Rudolph Friedrich Kurz made excursions upriver on one or another of the American Fur Company's boats, intent on their respective, private purposes. Audubon's *Western Journal*, since reprinted in part or in whole in a number of more recent publications, offers the reader a personal and at times almost poetic account of his experiences in the wilderness west of the Mississippi. Kurz's documentary of his sojourn in America between the years 1846 and 1852 is not as well known. His journals reside today in a museum in his native Berne, Switzerland, along with numerous sketches and paintings. Fourteen watercolors and four pen-and-ink or wash drawings are preserved by the Gilcrease Institute, possibly the only extant examples of this artist's work in the United States.

These pictures involve scenes observed during his trip up the Missouri River in 1851, when he visited Forts Clark, Berthold, and Union, having engaged himself at that time as a clerk with the American Fur Company to secure the cost of his passage. His studies of the natives of this region include numerous depictions of everyday life. Of even more interest, perhaps, to the student of frontier history are sketches he made while at Fort Union during the winter of 1851-2. One of these, dated October 19, 1851, shows an interior scene of a council session between a group of Cree Indians and the post's agents. Edwin T. Denig, chief agent, and an interpreter called Battiste are

Accounts books on the desk behind the American Fur Company factor record the deals made between traders and Indians in Fort Union in 1851. Artist Kurz has left a vivid record here of a meeting between two cultures.

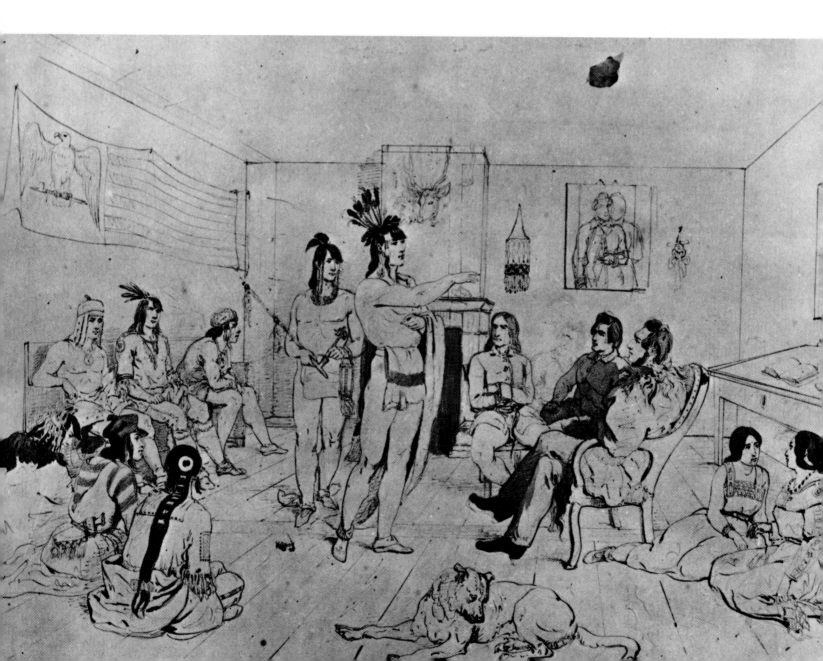

BLACK SQUIRREL
William Cary

CREE CHIEF LE TOUT PIQUE AND
FUR COMPANY AGENTS AT FORT UNION
Rudolph Friedrich Kurz

shown to the right seated in chairs opposite Cree chieftain *Le Tout Pique,* as the French called him. It is thought that Kurz has represented himself in this drawing, seated between Denig and Battiste. Two Indian women seated on the floor behind Denig may be his two wives. The fort's eagle banner is roughly suggested above the group of seated figures along the wall at the left.

Kurz's pen-and-ink sketch of the inner courtyard or plaza of Fort Union is very descriptive of life at a trading post at this time. Conceived as something of a bird's-eye view, this drawing provides a rare glimpse of the arrangement of the buildings and the general appearance of the fort. It is dated April 7, 1852, some few days prior to the artist's departure to St. Louis to return home to Europe.

One of the last artists to make his way to the forts along the Upper Missouri before waning commercial prospects in that region resulted in their eventual abandonment was also one of the youngest: twenty-year-old William de la Montagne Cary, who, with two youthful companions, set out from New York City in the spring of 1860 to explore the western wilds. With no commission in hand or particular destination in mind, these three young men ventured up the Missouri to Forts Union and Benton and, continuing across the mountains, reached Oregon. Journeying to San Francisco, they returned to New York by boat via Panama, crossed the Isthmus, embarked on the Caribbean, and eventually arrived home at the outbreak of the Civil War. A remarkable journey in those days and a trip that scarcely could be equaled today, it furnished Cary and his two friends with a glimpse of the Missouri frontier as it was in the days before settlement finally penetrated that region.

It might well be imagined what such an adventure must have meant to three youthful travelers from the East with no notion of what experiences might await them. Cary, like many an artist before him, ventured westward simply to see what he could see; or, as one of his companions, W. H. Schieffelin, recalls in his own later accounts: "The reading of the history of the Lewis and Clark expedition and of James Fenimore Cooper's tales awakened in us a spirit of interest and desire for travel and adventure." Schieffelin and William Cary compiled narratives of their excursion together. Some of these in both manuscript and printed form are today preserved in the manuscript files of the Gilcrease Library.

Schieffelin's narrative is especially entertaining, considered in retrospect, although his account of western riverboat travel even in the 1860's does not suggest that this was the most luxurious way in which to travel. The frequent stops for firewood, which had to be cut and brought on board as it was needed, and the delays incurred by the steamboat's encounters with the shallows, snags, and sandbars of the Missouri make the trip seem arduous today. Cary, however, comments lightly on such inconveniences, remarking that the frequent stops along the way gave them ample opportunity to try their luck at hunting.

INTERIOR VIEW OF FORT UNION
Rudolph Friedrich Kurz

Kurz's view of the plaza at Fort Union provides a glimpse of the interior layout of this important Missouri post. William Cary's drawings of the rivermen who brought up the provisions from St. Louis show the breed of men who helped open that wild frontier.

here was always plenty of game hung on the lower deck of the boat," he says, "such as elk, buffalo, bear, duck, geese, and swans. The distance from St. Louis to Fort Benton is 3,000 miles," reports Schieffelin in an article printed in *Recreation* magazine shortly before the turn of the century. "It took us about six weeks to make the trip traveling by day only. At night we made fast to the shore or in case of danger from hostile Indians anchored in the middle of the river. The vessels were loaded principally with goods for the trading posts in the far Northwest, there being but few passengers for that remote country in those days."

One of the most anticipated of diversions among riverboat passengers was the arrival at the trading posts along the way. To the occupants of these remote stations, shut away for months at a time from the outside world, the arrival of the annual boat or steamer was of even greater interest than to those arriving on it. Often the man in charge of a post, with several of his employees, would drop downriver two or three days ahead of time to meet the boat. When nearing the post, salutes would be exchanged, colors displayed, and the passengers would throng the deck to greet the crowds that lined the banks in something of the manner in which George Catlin described his arrival at Fort Union in 1832.

Cary preserved several scenes from his memory of those days in a number of oil paintings included in the Gilcrease Institute's inventory of his work. One he entitled *The Fire Canoe* places the viewer

RIVER MAN
William Cary

ROUSTABOUTS
SLEEPING
ON DECK . . .
William Cary

among a group of Indians along the riverbank outside the confines of a river outpost gathered there to witness the arrival of the annual steamer. A companion piece to this picture depicts the trading after the boat has docked. Of interest is the figure of one of the fur company agents, himself of Indian blood, decked out in a dark-blue suit of uncertain origin and sporting what appears to be a silk hat, sitting atop a consignment of goods with which he seems in no particular hurry to part.

Of the numerous studies Cary made during the course of this trip up the Missouri in 1861, many are preserved today in the collection of the Gilcrease Institute. Some of these obviously served as references for later studio pieces that in some cases are also included in the Gilcrease collection.

Cary's studies of riverboat men, trappers, and traders in particular are deserving of attention, describing as they do a breed of men almost totally extinct in this mechanized age. His oil sketch of roust-

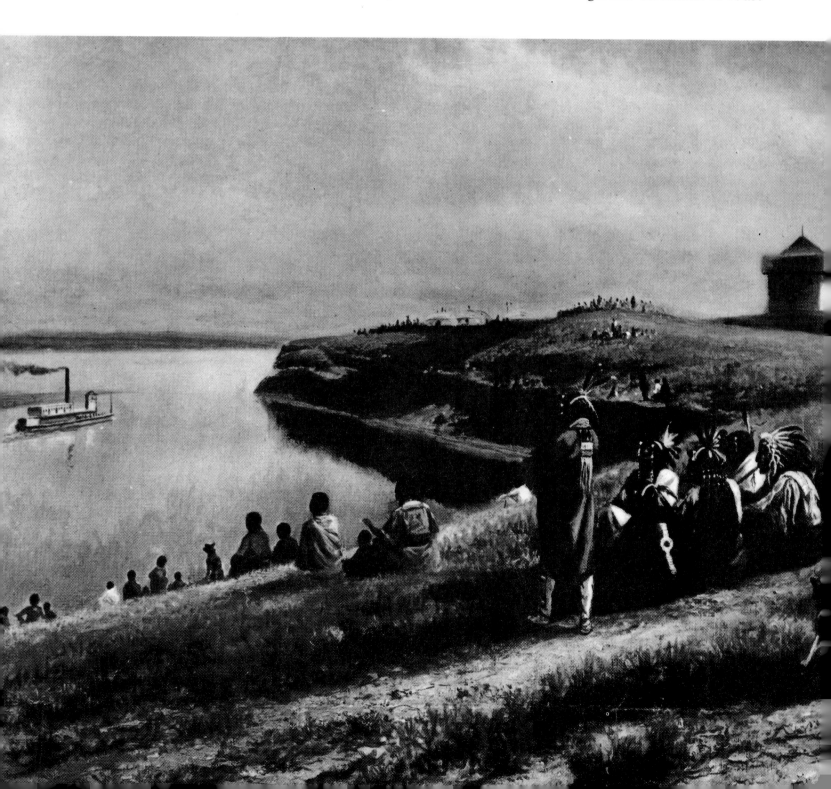

abouts on the steamer deck is suggestive of a life with few comforts for those who plied the waters of the Missouri in the mid-nineteenth century; and his full-figure portrait of an unidentified river man done in pencil is one of his most sensitive and unusual studies.

Not all these sketches and paintings relate to Cary's first western adventure, for he made at least two more trips beyond the frontier: one in 1867, when he traveled to Fort Riley, Kansas, and a second trip up the Missouri River in 1874, when he was invited by a friend to accompany the U.S. government's survey of the Northern Boundary between the United States and Canada.

"I had received a letter from Major Twining to meet them at St. Paul, Minnesota, and accompany the expedition of the Northern Boundary Survey," he relates in a journal filed in the Gilcrease Library, "but as I had the invitation too late to make the necessary arrangements with the party before they left Bismarck . . . I followed on the next steamboat up the Missouri . . .

THE FIRE CANOE
William Cary

TRADING ON THE UPPER MISSOURI
William Cary

FOLLOWING THE WHITE MAN'S PATH
William Cary

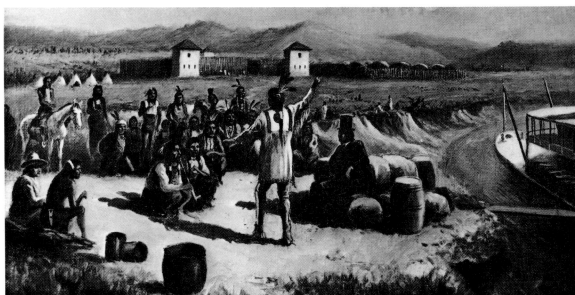

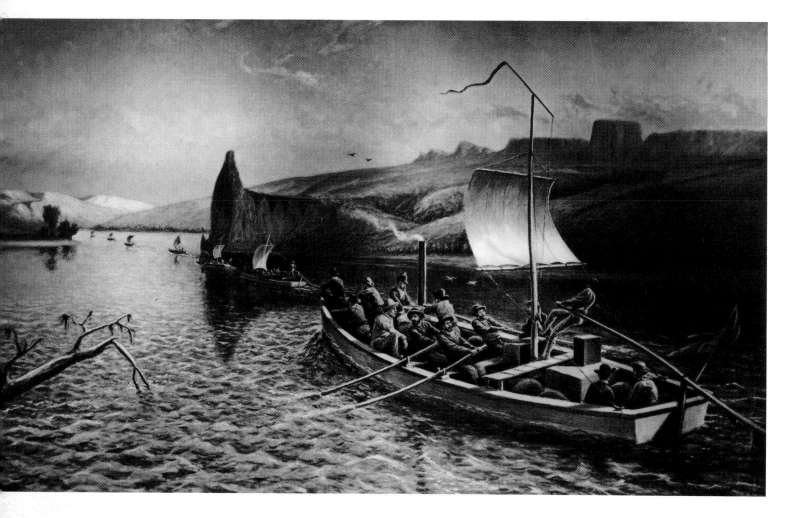

RETURN OF THE NORTHERN
BOUNDARY SURVEY PARTY
William Cary

The Gilcrease Institute is fortunate to have so many of the field sketches Cary executed after joining up with the government survey on its return from the northern reaches of the Missouri. A few of the oil studies on paper now are in rather fragile condition, but one is worthy of special note, being a sketch of men in the main boat, on the back of which Cary has jotted in pencil:

"The Northern Boundary Survey, 1874. Dr. Coues of the Smithsonian Institute in the lower left of sketch."

A very large canvas depicting the return of the Northern Boundary Survey team is a much later work based on earlier sketches, to which the artist frequently referred when producing his finished studio pieces back in New York. The subject matter of these pictures, many of them apparently done between the years 1861 and 1875, ranges from Indian life on the western plains to later pioneering progress and settlement in the days following the end of the Civil War. Excepting his pencil studies and sketches, the bulk of Cary's work may leave something to be desired from the art critic's standpoint, but it contributes much to a broader understanding of the earlier and more primitive American West.

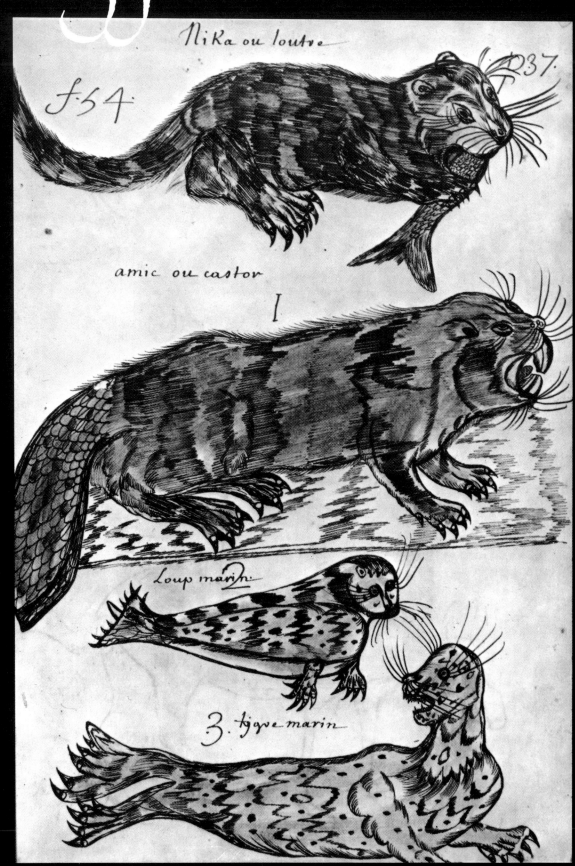

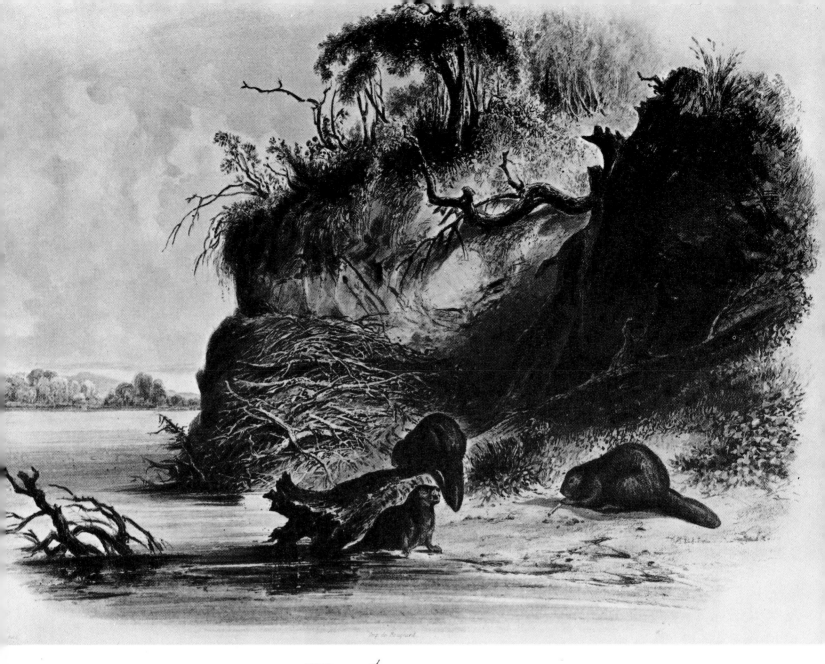

Trappers & Traders

The varied motives that brought our forefathers to this hemisphere have been forgotten by most of us today. In a broad sense, however, it was their response to the quickening spirit of their times that brought about not only the discovery of new worlds but the building of new nations. Prompting adventurers to cross oceans and continents, this same spirit of inquiry in succeeding generations encouraged men in other fields of endeavor to experiment, undertake, discover, and claim an ever-widening realm of new knowledge and experience. It was particularly evident during that period in the eighteenth century when the foundations of a new republic were being laid out in the wilderness of America.

Perhaps commerce is not always given the attention it deserves in the annals of the settlement of America, although it was the desire to find a convenient trading route to the Orient that brought the first European discoverers to these shores. Rumors of fabled "cities of gold" tempted the Spaniards into the central plains of North America as early as the sixteenth century, while an interest in furs encouraged the French, British, Dutch, and later the Russians to penetrate the continent. Commercial enterprise of one sort or another resulted in the founding of most of the original English colonies in the eighteenth

century, in an age when the New World was looked upon as a vast piece of real estate; and it was trade, again, particularly in furs, that preceded the eventual settlement of almost the whole expanse of the western wilderness.

The introduction of the beaver hat into the European men's fashion market was perhaps the most important single factor influencing the development of the fur trade in America. Earliest accounts of French and English exploration into the forests and rivers of the Atlantic coastal plain make special mention of this animal, and throughout the eighteenth and nineteenth centuries, individuals and companies pushed into the most isolated areas of the interior in pursuit of the industrious rodent.

The sketch of a beaver by a French-Canadian cartographer, Charles Bécard de Granville, in an album of drawings dated at the turn of the seventeenth century, is one of the earliest on record. A little fanciful, perhaps, revealing more of an interest in draftsmanship than natural history, it is in many ways superior to other descriptions of North American wildlife reported by observers at that time. Suggesting an animal that in those days averaged from three to four feet in length and weighed anywhere from forty to one hundred pounds, de Granville's version records the peculiar characteristics of a creature whose likeness was later to be incorporated into the Canadian national coat-of-arms: a symbol of wealth and point of controversy for nearly two hundred years among competing European powers in America.

In the early days of colonization and later westward continental expansion, the beaver's pelt became generally accepted as the basic unit of value along the American frontier. The beaver pelt became the basis for evaluating the worth of other animal skins as well, and great fortunes were made in the American wilderness as a result of this trade in furs. Until approximately 1840, most beaver pelts went into the manufacture of hats or coats, and accessories accounted for the remainder. As can be imagined, the drain on the beaver population was tremendous. Between 1753 and 1777, it is estimated that the Hudson's Bay Company alone sold close to three million beaver skins on the London market. In many areas the animal became virtually extinct, and has only recently come back in some remote areas.

The French called the beaver hunter a *coureur de bois.* To the English, he was simply a "woods runner," and to the Americans, a fur hunter, trapper, free man, or in later years, mountain man. Whatever he was called, he wrote a chapter in America's history noted for its adventure, hardship, and, in some cases, cruelty. If not "free" in the sense that some writers would have us believe, the beaver hunter was a free-spirited individual whose exploits in fact and fiction are matched only by that of the cowboy during the 1870's and 80's. A renegade from civilized society, recognizing no law or authority other than that to which he voluntarily subscribed, the lone trapper lived unto himself, depending solely on his skill in hunting and his knowledge of woodcraft to sustain him in the unsettled wilds.

Almost a legendary figure today, the fur trader of the northern forests has become the subject of many a historian's research as well as a popular character in novels of life in the early-day American

BEAVER HUT ON THE MISSOURI
Carl Bodmer

The rich brown pelt of that great rodent, the beaver, became the symbol of wealth and point of conflict among competing European powers for nearly two centuries; pursuit of the animal opened both the Canadian and United States wildernesses.

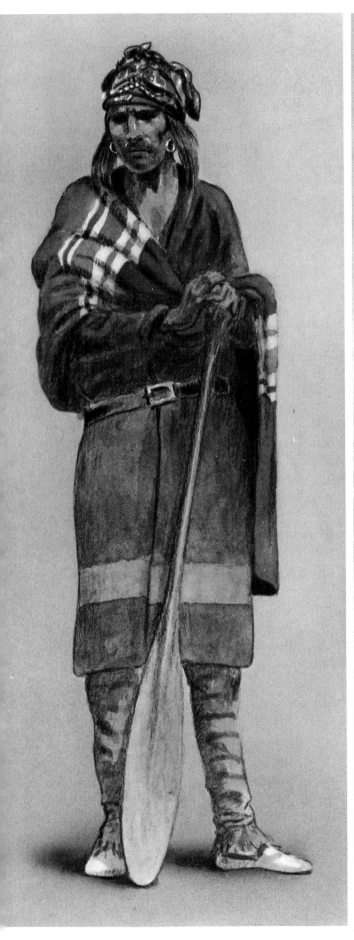

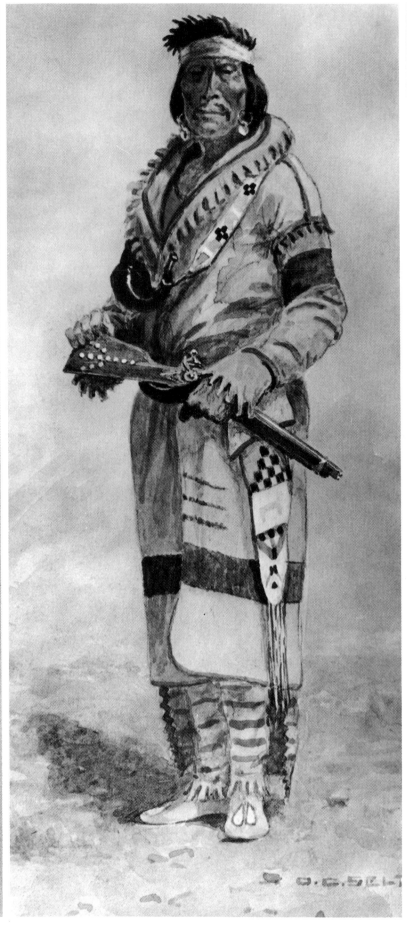

L'VOYAGEUR
O. C. Seltzer

HALF BREED
O. C. Seltzer

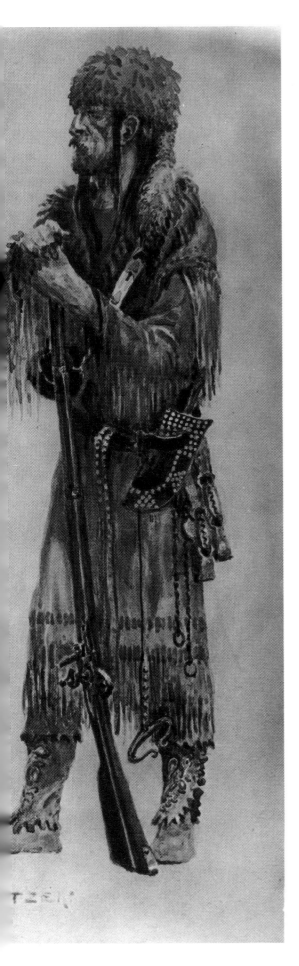

HUDSON'S BAY TRAPPER
O. C. Seltzer

wilderness. In more recent times, the artist has attempted to re-create the character of the trapper in his solitary habit—painters such as the Montana artist Olaf Seltzer, whose love of history and attention to the details of his subject are evident in his watercolor portrait *L'Voyageur,* which depicts a French-Canadian trapper as he probably appeared in the early 1800's. The hip-length leggings and moccasins worn by this trapper were probably acquired from the Indians of the Great Lakes region and are, perhaps, the handiwork of an Indian wife. The eastern Indian floral designs made of beads and porcupine quills suggest a type universally employed by the trappers before increasing contact with western tribes provided the trapper with geometric decorative ideas of the plains variety. The French trade blanket depicted in this illustration, however, never gained the popularity among either Indians or trappers as did the later Hudson's Bay trade item.

Seltzer carried on exhaustive research into the background of his subjects on American frontier life. A series of frontier characters that he did for the late Western art collector Dr. Philip Cole includes many portraits such as *L'Voyageur.* His figure of a French-Canadian trapper of the 1840's called simply *Half-breed* wears a Hudson's Bay coat common on the northern fringe of settlement throughout the early half of the nineteenth century. He carries a flintlock trade musket that has been sawed off for ease of handling on horseback. The stock is studded with brass tacks typical of many plains Indian firearms of the last century, and his earrings are a combination of European brass rings and Indian shells.

Canada was the home of organized fur trade, while in the United States and its western territories it was the so-called "free" trapper or trader who generally prospered. Men such as John Colter, Kit Carson, and Jedediah Smith constituted a class of commercial adventurers by themselves. The free-roving plains and mountain men were a motley lot. Generally their style of dress was a fur cap, fringed deerskin shirt and leggings, and moccasins of the same material.

Fur trappers were among the first to explore the vast country west of the Mississippi. Jacques Cartier was the first to open up the North American interior when he sailed up the St. Lawrence River in 1535. In 1608 Samuel de Champlain led the founding of Quebec and established a profitable trade arrangement with the Huron Indians. The French government put Champlain officially in charge of the American fur trade on the condition that he push explorations westward.

Twenty-five years later, Pierre Radisson and Médart Groseilliers, traveling in canoes, were the first to explore the country west of the Great Lakes. The French word *voyageur,* meaning "traveler," was first applied to these two men, and henceforth used to describe all French-Canadian trappers. Returning from the country of the Sioux, Menominee, and Cree Indians loaded with prime beaver pelts, Radisson and Groseilliers were full of plans for extending the fur trade for France farther westward. The French governor of Quebec was not interested in their reports and chose to fine them severely for not having the required government permit.

The English, however, took advantage of the knowledge supplied by the two Frenchmen and established the Hudson's Bay Company. With the beginning of the Hudson's Bay Company in 1670, com-

petition between the French and British for control of North America was greatly intensified. At the onset the English were not interested in exploration as long as their Indian allies continued to bring their furs into Hudson Bay's posts. In the meantime, France extended her investigations of the country westward to establish more distant posts, hoping thereby to intercept the flow of furs into British posts. The new competition jolted the British into action.

In 1754 an emissary was sent west to persuade the Indians to deal only with the English traders. However, before any great movements by either nation developed, France lost all of Canada to the British through its defeat in the Seven Years' War across the Atlantic and in the French and Indian War here. As a result the English inherited the lucrative St. Lawrence fur trade. Instead of lessening the French–English rivalry in America, however, this loss of the French seemed to increase it.

The popular notion of the trapper, or mountain man, in the minds of most people today is in reality that of a later-period Hudson's Bay trapper in the Rockies as depicted by Olaf Seltzer in his *Hudson's Bay Trapper.* The skin hat, the long buckskin or elkskin coat with beaded or red flannel trim of plains Indian design, the brass-studded knife sheath, and the wrap-around leggings with separate moccasins pictured here were usually manufactured by an Indian wife or several wives scattered throughout the tribes. The long flintlock rifle he carries is of an earlier period than the weapon more often associated with the mountain man, which had a shorter barrel and was of a larger caliber for use against the larger game of the western plains and mountain country. The strike-a-light that Seltzer shows hanging from the trapper's belt is of a variety typical of the period, although the double-spring traps shown suspended from his belt suggest a later period than that indicated by the trapper's costume. They are also rather small in size—suitable, perhaps, for use in trapping smaller animals such as muskrats but hardly adequate for a forty- to sixty-pound beaver.

Here, again, Seltzer shows the single powder horn, which was more commonly attached to a bag carrying additional equipment for the trapper's use in the field. In keeping with the character of most mountain men, these bags and pouches were made strictly for utilitarian purposes and varied not only in design but in the accouterments they carried and the manner in which they were attached.

It is not known whether Frederic Remington had in mind a Hudson's Bay man or an American trapper in his superb bronze entitled *The Mountain Man,* but the piece fits either description. The figure more nearly resembles an American "free" trapper, however, following the Hudson's Bay style of dress heavily decorated with Indian-made ornaments. The half-stock plains flintlock is shown along with traps of a size more suited to handling beaver. The horse's gear consists of a typical plains Indian saddle (men's) with a crupper for use in mountain country, since Indian saddles had a reputation for slipping forward over the horse's withers at times. Over the rawhide-covered wooden frame is thrown a piece of buffalo hide, tanned, with the hair cut, an article which made a reasonably comfortable seat. The trapper carries a plains Indian knife sheath and combination

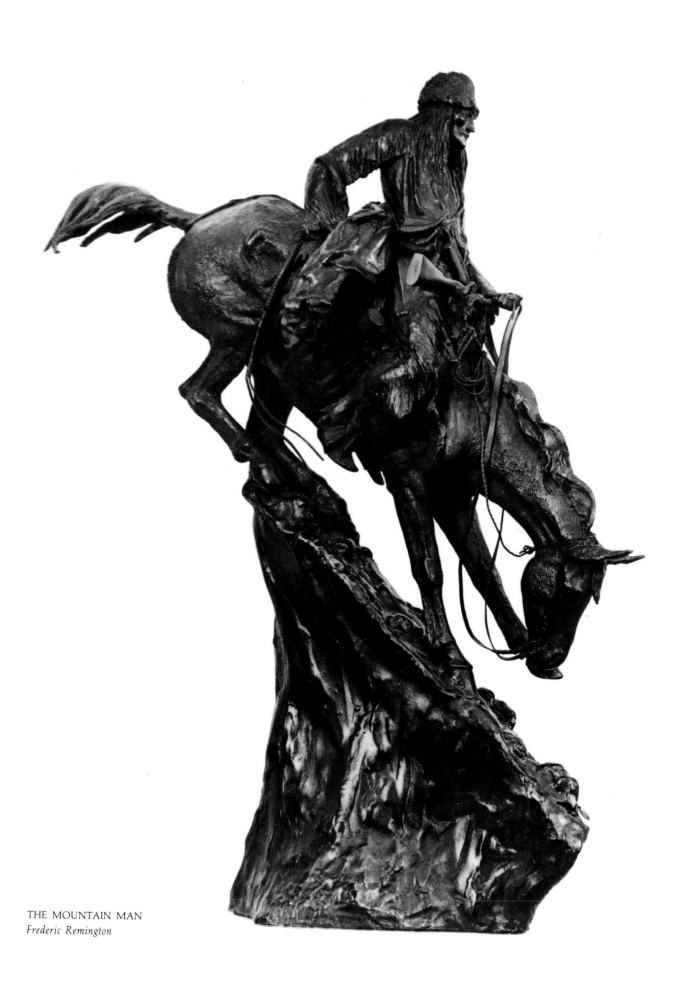

THE MOUNTAIN MAN
Frederic Remington

In the early half of the nineteenth century, trappers explored all the western rivers in search of beaver and other fur-bearing animals. After skinning, beaver pelts were stretched on willow frames to dry; wooden board stretchers were preferred for the skins of the smaller fur bearers.

powder horn and bag. The horse is of a common breed of Indian mountain pony well known to the artist, possibly thirteen to fourteen hands high and weighing nine hundred pounds or a little more. His ears are set forward in anticipation of the trail ahead.

By 1840 the beaver was so scarce that few could be found except in the most remote areas of the Rockies or the Pacific Northwest. The change in men's hat styles in the 1830's from beaver felt to silk undoubtedly saved the beaver from virtual extinction.

In the opening years of the nineteenth century, while they were still plentiful, beavers were hunted not only for pelts but also for "musk." Products from the animal's scent glands were believed to contain medicinal properties and sold for high prices. In later years, this musk, called castoreum, was used by trappers to attract individual animals to their "sets," or traps. A double-spring beaver trap generally weighed about five to seven pounds.

The most successful sets were made at points where the beaver were accustomed to come out of the water onto the riverbank. Wading upstream to keep his own scent behind him, a trapper located these spots and drove a stake into the streambed. He then attached his trap to this stake and set it, normally on a rock several inches below the surface of the water. If the trap were improperly set and the captured beaver managed to reach the riverbank, he invariably twisted or chewed his foot off to effect an escape. Otherwise, he simply drowned. The drowned beaver was skinned immediately after being taken from the water, and the pelt, musk glands, and tail were taken by the trapper. The tail was considered a delicacy by mountain men, who broiled it after charring away the scaly skin.

An adult beaver weighed approximately forty pounds, although seventy-pound animals were occasionally reported. His fur was particularly rich and dark in the northern latitudes, consisting of a dense undercoat protected by long guard hairs on the upper parts. The coat was characteristically of a purplish or bluish cast; sometimes rare albinos and even spotted animals were captured. After skinning, the beaver's pelt was stretched on a circular frame of willow to dry and subsequently stored in a cool place until it could be taken to market.

Board stretchers also were employed as a method of drying some types of animal skins, preferred because they maintained the natural shape of the skins, which thus were easier to pack for shipment than those stretched on bows or hoops. Stretchers for mink or marten pelts shown in the accompanying illustration were approximately two feet long. Larger boards were required for drying the skins of the otter, the wolf, or the muskrat.

A great deal has been written about the history of the fur trade in North America, much of it compiled from the accounts of those men who engaged in it themselves or built great fortunes as a result of their ventures—men such as John Jacob Astor, founder of the American Fur Company and the first American to open up the Pacific Northwest when he extended his operations to the Columbia River in 1811. Ten years after the founding of Astoria, a trading route between Missouri and Mexico was established and the overland trails to Oregon and Santa Fe became in time much-traveled highways joining St. Louis with the Rockies and the Spanish Southwest.

LOST TRAPPER
A. J. Miller

Engravings of board stretchers and beaver trap
from THE TRAPPER'S GUIDE, *S. Newhouse (New York, 1874)*

TRAPPERS ON THE BIG SANDY *A. J. Miller*

In little more than a decade trappers had
penetrated to the smallest tributaries of the great
western rivers in pursuit of the beaver; they
were free spirits at heart, whose wanderings
"mapped" Lewis & Clark's great wilderness.

Engraving of a trapper's lean-to from THE TRAPPER'S GUIDE, *S. Newhouse (New York, 1874)*

At the beginning of the nineteenth century, Santa Fe was the capital of a very large province inhabited by a few Spaniards and a considerable number of Indians, many of whom were actively hostile. A thousand miles west of the Mississippi, the little capital was in an isolated spot, the closest town of any consequence being that of El Paso del Norte, 320 miles to the south. Most of the New Mexicans were farmers, sheepherders, or soldiers. There were few artisans among them, and they all suffered from a shortage of manufactured goods. Even the best homes had little in the way of furniture, which continued to be too expensive to import even after trade with the States had been established. Woolen homespun fabrics represented the most plentiful of the locally manufactured items, but this material was not particularly good. Thus, manufactured textiles from the East came to be much in demand when trade with the Anglo-Americans was in full swing.

Typical of the rest of the Anglo-American West, fur trappers and traders were the first to establish commercial contacts with this region before a regular trade route was opened following Mexico's declaration of independence from Spain. There was some trouble at a later time with Mexicans who suspected the Santa Fe traders of being Texas spies, but most of the problems arising between 1821 and the beginning of the war with Mexico in 1846 concerned tariff rates. Prior to 1821 Pierre Chouteau and Jules De Mun had trapped over most of the Colorado region, including the Spanish portion of that territory, and by 1830 several parties had made their way from New Mexico to the lower waters of the Colorado River and even as far as California on trapping expeditions.

Manuel Lisa was among the most prominent of the early northwestern traders. Of Spanish extraction, Lisa was a member of the Lewis and Clark expedition of 1804–5. On their return trip in 1806, he separated from the company and went back to the Upper Missouri River region to continue his occupation as a trapper. He established

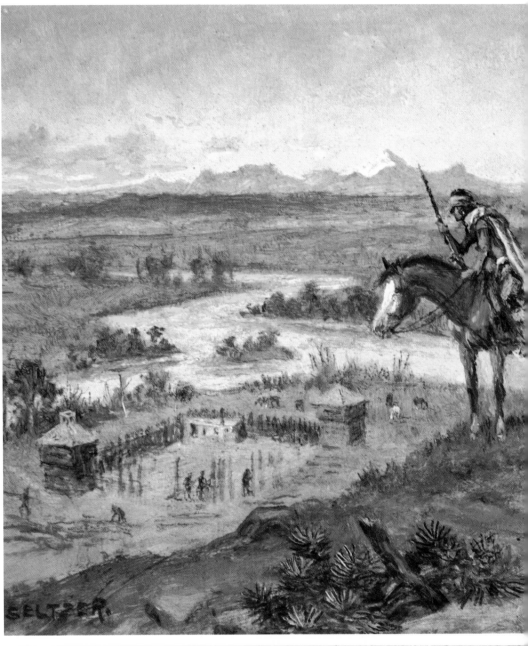

MANUEL LISA WATCHING THE
CONSTRUCTION OF FORT LISA
O. C. Seltzer

THOMAS FITZPATRICK
O. C. Seltzer

*Interested in the history of
the American West,
contemporary artist Olaf
Seltzer produced many
paintings illustrative of the
frontier fur trade. His
picture of Manuel Lisa
shows one of the most
prominent of the early
traders overlooking the site
of his first post on the
Yellowstone. Other studies
represent the explorer,
trapper, and some of the
inhabitants of the early-day
trading depots.*

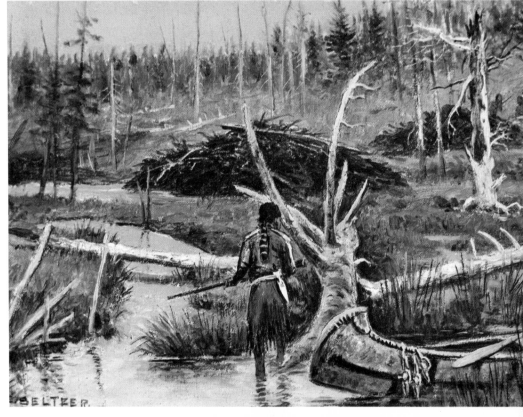

his first trading post in 1807 near the modern site of Mandan, North Dakota, posting a branch of this enterprise on the Yellowstone near the mouth of the Big Horn River. Lisa returned to St. Louis and made several trips back and forth to the northern prairies trading furs with the Indians. Appointed by Governor Clark of Missouri to act as sub-agent for all the tribes above the mouth of the Kansas River, he continued for the next ten years as the only trader working regularly in this area. During the War of 1812–14, Lisa was instrumental in curbing British influence east of the Rockies. In 1817 he resigned his commission as Indian agent and returned to St. Louis, where he spent the remainder of his life.

Lisa remains one of the most controversial figures involved in the American fur trade, some contemporaries and later historians describing him as a villain, others as a noble character. Hated by his rivals in the Upper Missouri trade, he was hardly better liked by his own men or those whom he persuaded to back his many ventures. Olaf Seltzer has pictured Manuel Lisa in one of his miniature oils as he might have appeared overlooking the construction of his first fort along the Yellowstone. Named Fort Raymond in honor of his son, the post in later years became better known as Manuel's Fort or simply Fort Lisa. Another post, also called Fort Lisa, was built on the Missouri in 1844. Seltzer's miniatures do not lend themselves to the depiction of more specific details, but the artist presents a fine, graphic sense of place and time in this portrayal.

With the sanction of the U.S. government, John Jacob Astor founded the American Fur Company and established his post on the distant Columbia River in 1811, supported by a chain of lesser posts inland to supply the fur market in China and Russia. Astor was forced to sell the post in 1813 to the British North West Fur Company which then merged with the Hudson's Bay Company in 1821. This merger extended the operations of the Hudson's Bay Company to the Pacific. Throughout this period, the majority of the American trappers confined their hunting to the lower country, not wishing to challenge the more powerful British interests in the north.

In the 1820's, many American traders and trappers operated in the north-central plains and Rocky Mountain regions. William Sublette, Robert Campbell, and Thomas Fitzpatrick explored practically every stream in this wide area hunting for beaver, whose pelts continued to bring the very best prices in the East and in Europe. Fitzpatrick in particular became familiar with the entire country as well as with the many Indian tribes in the area—the Flathead, Crow, Ute, and others who came to trade furs and hides for gunpowder, lead, knives, fancy-colored cloth, and, of course, whisky.

By 1822, four major fur companies operated in Missouri Territory. The Missouri Fur Company, headquartered at Fort Benton at the mouth of the Big Horn River, controlled the Crow Indian trade, whence came superior beaver hides owing to the higher altitude and colder climate. The Columbia Fur Company, formed of remnants from Astor's earlier enterprise, and the North West Fur Company supervised much of the trade on the Upper Missouri and the Red River country to the north and east. The French Fur Company was made up principally of St. Louis traders under the direction of the

FRONTIER TRADER
O. C. Seltzer

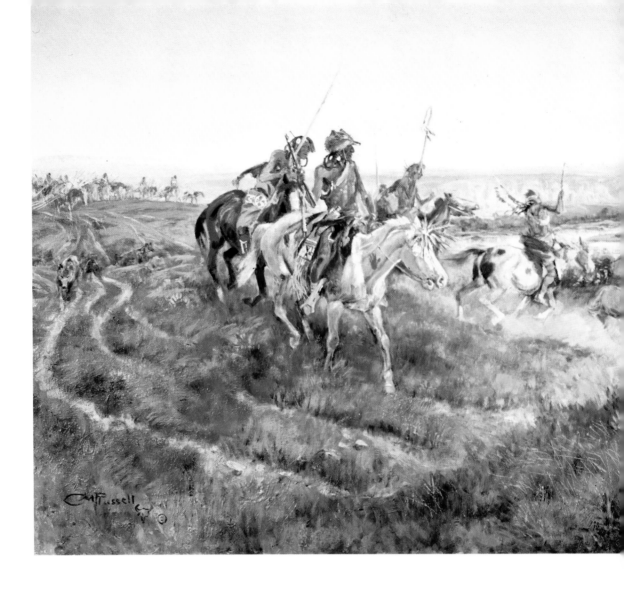

SALUTE TO THE ROBE TRADE
C. M. Russell

JIM BRIDGER
C. M. Russell

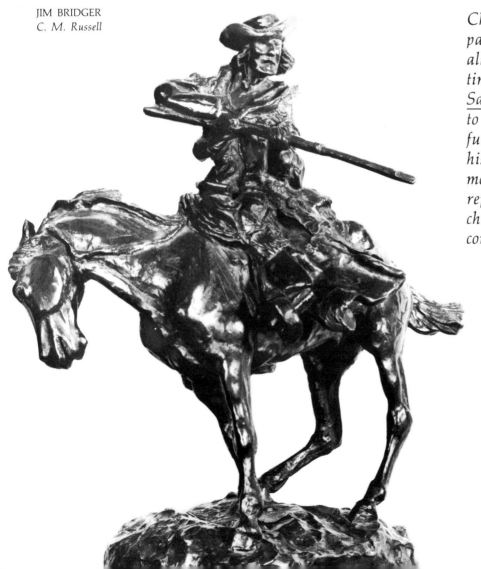

Charles Marion Russell also painted many scenes of frontier life, although he lived well after the time of many of his portrayals. In Salute to the Robe Trade, he seems to have captured the spirit of the fur-trading era in American history. His bronze study of the mountain man Jim Bridger represents yet another famous character in the history of western commerce.

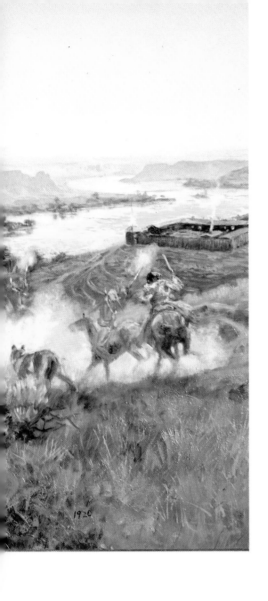

Chouteau family, whose interests covered the Lower Missouri country as far north as that occupied by the Sioux. Yet another company, however, destined to become a revolutionary force in the fur trade, was organized in St. Louis in 1821 by William H. Ashley and Andrew Henry.

In February 1822 Ashley published one of the most famous of advertisements dealing with the fur trade in America. It read:

TO ENTERPRISING YOUNG MEN: *The subscriber wishes to engage one hundred men, to ascend the River Missouri to its source, there to be employed for one, two or three years—for particulars, enquire of Major Andrew Henry, near the lead mines, in the county of Washington (who will ascend with, and command, the party) or to the subscriber at St. Louis* Wm. H. Ashley.

Most of the men participating in this venture were to be hired as "free trappers"—the first of the now-celebrated mountain men. Ashley proposed to buy their furs in the mountains at fixed prices, or approximately half their value on the St. Louis market, payment for same to be in goods instead of cash. Among those who responded to Ashley's announcement were such men as Jedediah Smith, Thomas Fitzpatrick, William Sublette, Jim Bridger, Hugh Glass, Mike Fink, and Louis Vasquez. In 1822, they traveled to the mouth of the Yellowstone and began there the construction of Fort Henry.

Many of the new men spent their first winter in outlying camps, setting a pattern that would be followed by other free trappers. Beaver were trapped in the spring and fall when pelts were at their best. Summer became the time for trading and the annual *rendezvous* over the next fifteen years.

Olaf Seltzer shows Thomas Fitzpatrick on Rock Creek in Montana in another of his "Montana in Miniature" paintings. The raccoon cap his subject wears became a popular piece of headgear with the mountain men of that time. The canoe in the painting, however, was introduced by the French and used at this time along the Upper Missouri beaver haunts; it was not usually seen farther west, where horses and mules were employed as the common means of transportation.

Perhaps one of the finest artistic portrayals of the fur-trading era in frontier America is Charles M. Russell's *Salute to the Robe Trade.* The painting pictures a group of Blackfoot Indians approaching Fort Lewis on the Missouri above the present site of Fort Benton, Montana, the principal figure astride a white pony. It is as fine a study of the northern plains Indian as has ever been attempted. Firing their guns not only as a salute to the fort but as a gesture of friendly intent—an unloaded gun being no fearful weapon—the advance party seems about to move down to the valley below, followed by a train of members of the tribe with their travois loaded down with precious furs. The central figure in this picture wears a wolf headdress indicating his probable affiliation with that clan among his people. He carries a sawed-off trade musket. The red mark of a hand is evident on the neck of his mount. Painting such a sign on a horse among most plains tribes indicated approval for a job well done or a similar show of

affection on the part of his owner, and the symbol was usually placed on the part of the animal most likely to receive pats and gestures of this kind, either the neck or the rump. The elk antler quirt carried by this rider was most commonly seen among the Indians of the northern plains.

Although Russell lived after the time when many of the events he painted occurred, he nevertheless seemed to understand the essential character of the plains Indian perhaps better than any artist before him or since. His sympathy for the Indians of his day, grown accustomed to reservation life, gave him the ability to understand their nature, and he shared something of their longing for the "Old Ways." His pictures often indicate to the viewer that the white man is always something of a stranger in Indian country.

Albert Bierstadt, on the other hand, while living in a day when the Indians still roamed freely on the western plains, viewed their wilderness world with wholly European eyes. Noted for his romantic

Of legendary American figures only the cowboy surpasses in popular appeal those tough, courageous & ambitious trapper explorers of the Jacksonian period who became known as the Mountain Men.

and heroically scaled landscapes of the western mountains, Bierstadt made his first trip to the Rockies in 1859, whence he returned to record on canvas the scenes that produced for him immediate acclaim in the East.

As is true with many artists, Bierstadt's extemporaneous studies and sketches reveal much to the student of art or history. His undated study of a mountain man, for example, reproduced here, is not at all typical of the grandiloquent landscapes for which he is known today. He presents the lonely trapper sporting a broad-brimmed hat instead of a coonskin cap. This hat was to become the distinguishing mark of the western horseman for generations to come, together with the familiar buckskin shirt and trousers, undecorated. A buffalo robe covers the trapper's saddle in this sketch, and the saddle itself is no Indian-made article but probably of California, Santa Fe, or St. Louis manufacture, with buffalo-skin *tapaderos*, or stirrup covers, of a type commonly used in mountain country but rarely depicted in works of art.

In one of his finer renderings, Charles Russell depicts the most renowned of the hearty breed of mountain men in his bronze of *Jim Bridger*. The large-brimmed hat preferred by most American trappers and the half-stock percussion cap rifle are characteristic features here. The saddle is probably of Santa Fe make, exhibiting the solid oak stirrups that originated in Mexico and were copied by American saddle manufacturers. The earlier Indian saddle used by trappers in the West was replaced after about 1820 with similar gear made in California, Santa Fe, or St. Louis, when it could be afforded.

MOUNTAIN MAN
Albert Bierstadt

ON THE FLATHEAD
C. M. Russell

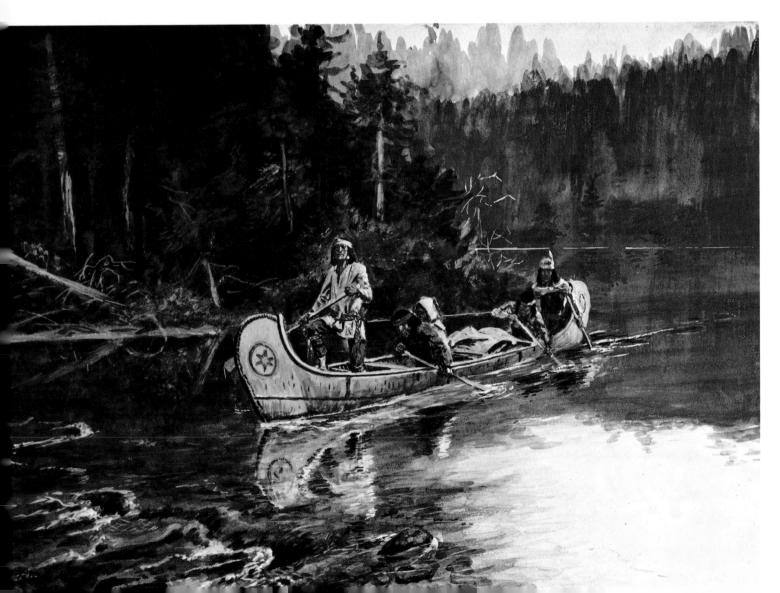

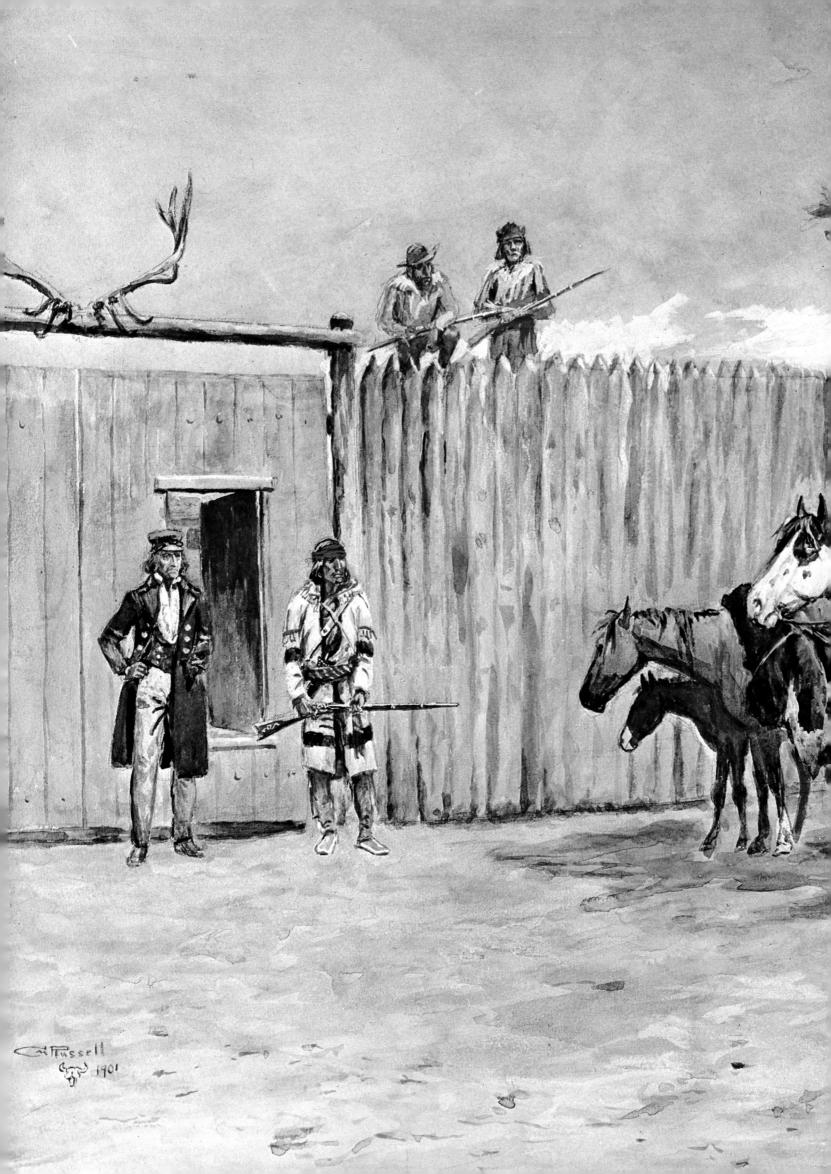

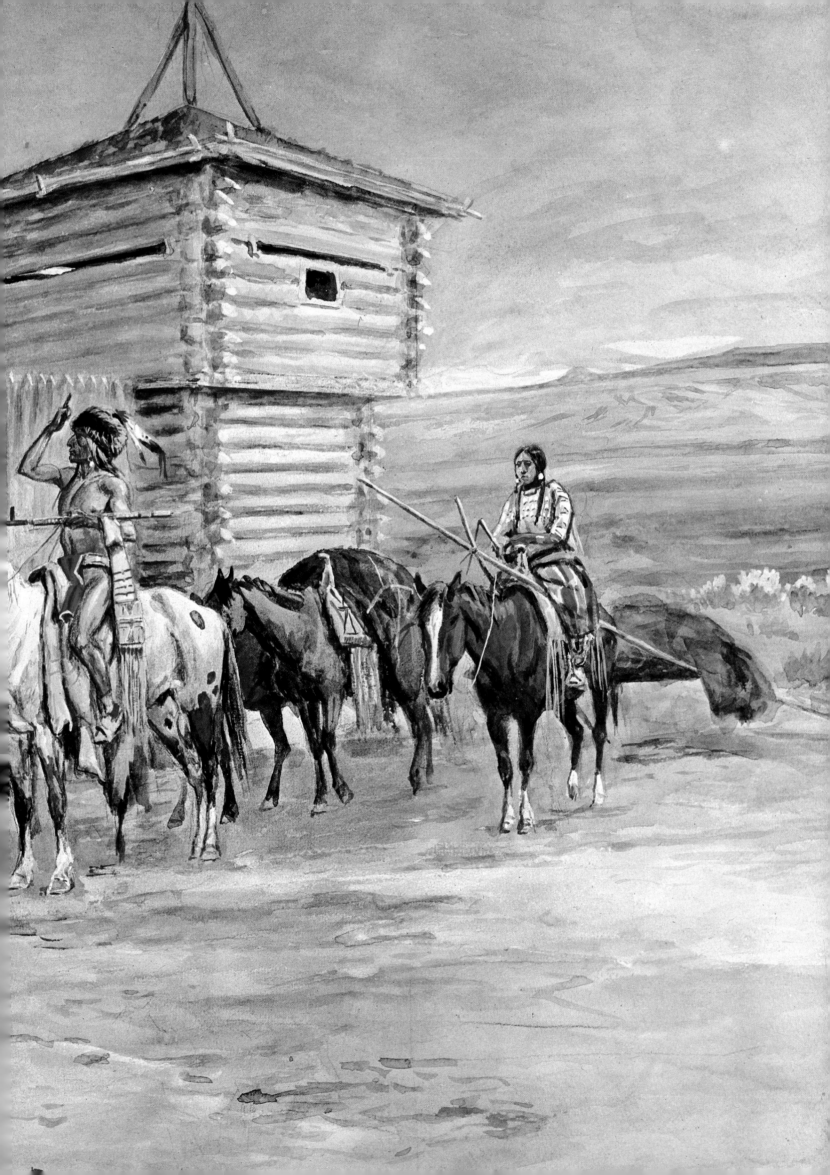

THE ROBE TRADERS (*previous page*)
C. M. Russell

Like his young associate Olaf Seltzer, Charlie Russell painted many scenes of western frontier life and history. His watercolor entitled *The Robe Traders* is yet another based upon the western fur trade of the early nineteenth century. Here he shows the leader among the group of Indians outside a trading post making the sign for trade to those within. An interesting comparison of costumes might be made between that of the white man on the left, wearing a semi-Eastern style of clothes—he is probably a riverman—and the trapper's outfit of the man on the right who wears a Hudson's Bay coat. The Blackfoot Indian with his pipe out of its bag and assembled seems ready for what usually was a lengthy and, to white men, tedious business of bargaining. An Indian customarily examined all trade items presented to him and often haggled endlessly over each piece to be traded.

FORT WILLIAM ON THE LARAMIE
A. J. Miller

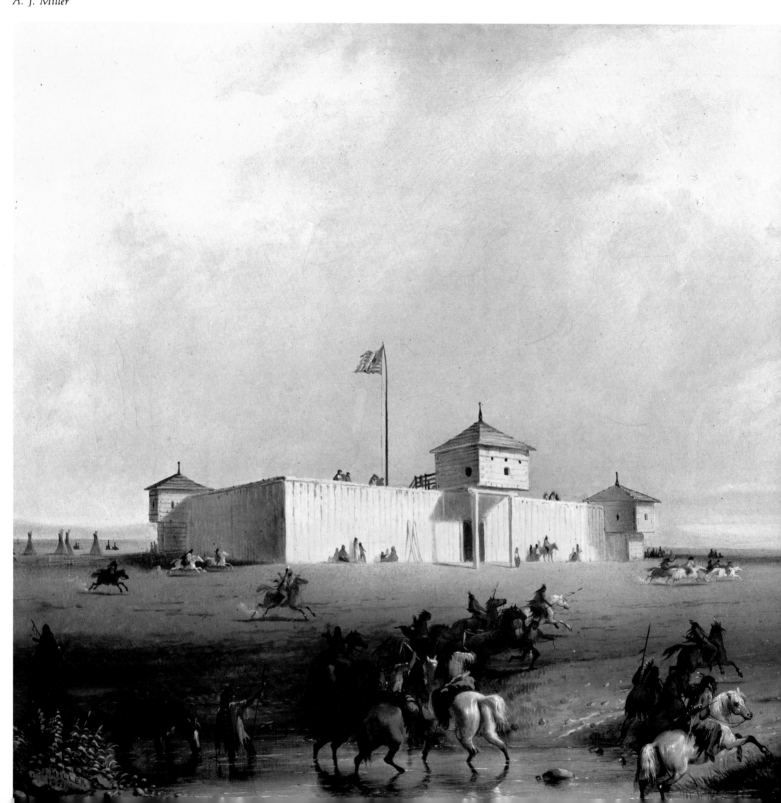

In the 1830's, during the period of decline in the fur trade, the free trappers became a force to be reckoned with insofar as the major companies were concerned. From this time forward, increasing numbers of trappers penetrated every area of the western mountains in search of beaver. Worsening conditions sent trappers into the country of the hostile Blackfoot tribes, which heretofore had been dangerous country for any mountain man to visit. For the next several years the Blackfoot country became the principal hunting grounds for all companies operating in the Rocky Mountain region. By the mid-1830's the beaver hat market in Europe was noticeably threatened by the appearance of the now familiar "top" hat made of silk.

Frontier commerce caused several posts to be built along the wilderness roads to Oregon and Santa Fe. By 1834 two were in operation along both these trails, and they were both called Fort William for a time, built by competing fur companies. One of them was built on the banks of the Laramie River in the Upper Missouri country by William Sublette and Robert Campbell. The other, more commonly known as Bent's Fort, was built by Charles and William Bent along the Arkansas within the bounds of the present state of Colorado. Both forts served a similar purpose, supplying trappers with trade goods and providing a place for the Indians and others in the region to gather and conduct business. The Bent brothers' fort—Bent's Old Fort as it came to be called years afterwards—became the most famous of all the trading posts in the Southwest, constituting for many years the only outpost on the northern branch of the Santa Fe Trail between Missouri and the mountains.

The trappers, whether independent operators or employed by one of the large trading companies, availed themselves of these posts as supply points and as a marketplace for their pelts and hides. Returning from their annual *rendezvous* in the far country, the mountain men met with the traders and the friendly Indians to socialize and barter. Such meetings were usually wild affairs for men who had been on the trail for perhaps a year or more. Horse races, rifle matches, brawling, and drinking characterized such occasions, and many remarkable exploits were exchanged in the interim.

Unlike its namesake to the north, which had been built out of sawed planks, William Bent's post on the Arkansas was carefully constructed of dried mud bricks, or adobe, covered over with an additional plastering of the same stuff. Here the Cheyenne, Arapaho, Comanche, Kiowa, and Apache came to trade. Anglo-American trappers fraternized with Spanish-American traders from Taos and Santa Fe, and military personnel on U.S. government business in that area stopped to rest and reprovision themselves. Indians normally were not admitted inside the gates, but the post extended open and friendly hospitality to all else who passed that way. Two hundred people could be billeted inside its adobe walls, if necessary, and the fort maintained a large supply of food and trade goods, particularly brass kettles, knives, blankets, tobacco, cloth, and beads. Abalone shells, powder, coffee, sugar, and flour were included among the stock items, and at the height of the season an estimated twenty thousand Indians sometimes camped in the vicinity of the post to trade.

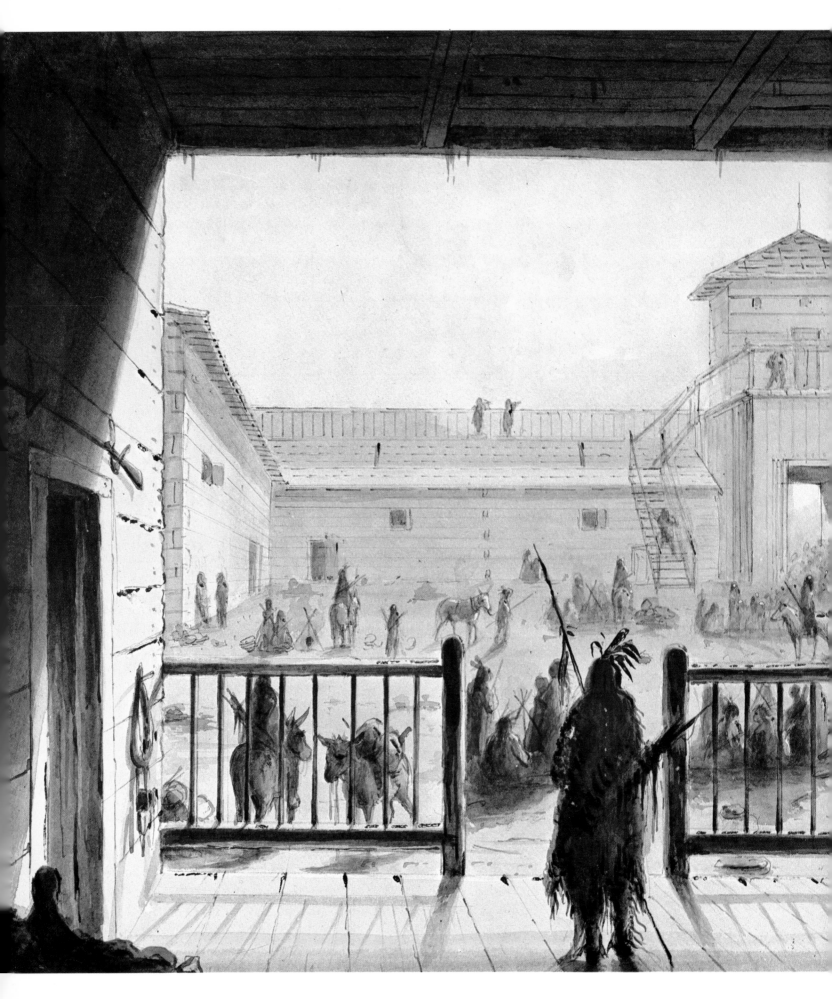

INTERIOR VIEW OF FORT WILLIAM
A. J. Miller

Many persons now noted for having played important parts in the opening of the Pacific Northwest visited Fort William on the Laramie. The Reverend Samuel Parker and Dr. Marcus Whitman, enroute to Oregon Territory to establish a mission, stopped at the fort in the spring of 1835, and Parker described in great detail a council he witnessed between the traders and approximately two thousand Oglala Sioux who had come to trade. Whitman again visited the post the following year in company with his wife and a Mrs. Henry Spalding, who were the first white women to travel over the Oregon Trail.

Sir William Drummond Stewart, a sports-loving Scottish aristocrat, visited the post on the Laramie in 1836 while on a hunting excursion to the Rockies. Returning the following summer, Stewart brought with him a young Baltimore artist named Alfred Jacob Miller to capture the scenes and sensations of life in the American wilds. Miller was the only man to record a likeness of Fort William as it stood in those days; and perhaps also the best verbal description of this post was written by the artist.

"Over the front entrance is a large block house," Miller reports, "in which is placed a cannon. The interior of the fort is about 150 feet square surrounded by small cabins whose roofs reach within three feet of the top of the palisades against which they abut; the Indians encamp in great numbers here three or four times a year bringing peltries to be exchanged for dry goods, beads, and alcohol.

"The Indians have a mortal horror of the 'big gun' which rests in the block house," he continues, "as they have witnessed the havoc produced by its loud 'talk.' They conceive it to be only asleep and have a wholesome dread of its being waked up . . .

"The interior view is from the great entrance looking west," Miller remarks, referring to a watercolor sketch he made inside the fort, "and embraces more than half the court area. When this space is filled with Indians and traders, as it is at stated periods, the scene is lively and interesting . . . A Saturnalia is held the first day and some excesses committed, but after this, trading goes briskly forward."

Alfred Jacob Miller has left what are probably some of the most vivid accounts of western fur trade as it was in the heyday of the mountain man and frontier trader. Baltimore-born and Paris-trained, a student some years previously of Thomas Sully, the twenty-seven-year-old Miller had been following a successful career as a portrait and landscape painter in New Orleans when Sir William Drummond Stewart approached him with the proposal to accompany him on his excursion to the Rockies. The offer greatly excited the young artist, for the Wild West was as foreign a place to most Americans at that time as it might seem to us today. A trip to the distant Rockies to paint what no artist at that time had yet painted was something Miller could not forego, and he lost no time in preparing to accompany Stewart and his half-breed guide and hunter, Antoine Clement, to St. Louis to join a trader's caravan on its way to Oregon.

"The expedition to the Rocky Mountains (the incidents of which journey he illustrated) took place in the spring of 1837," writes Miller in his *Rough Draughts for Notes to Indian Sketches.*

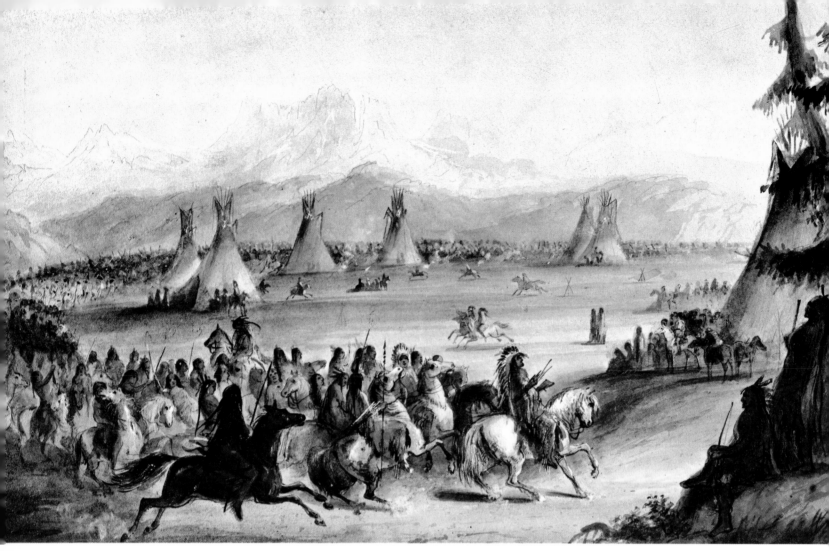

Trappers & Traders

The annual rendezvous
brought together the West's
original wild bunch; here on
some remote site picked the
year before, traders brought
supplies for barter with both
mountain men and Indians.
Whisky made the socializing
into rowdy, sometimes bloody
affairs for men who had led
a solitary existence for a
year or more.

. . . The American Fur Company, under the direction of and part proprietorship of Chouteau, Pratt and Company, of St. Louis, Missouri, sent out a large body of men, well equipped, and a number of wagons laden with valuable goods to be used as an exchange for peltries in Oregon. Capt. W. D. Stewart, an amateur travelling with a private escort of his own mileu, accompanied the expedition—impelled by curiosity to visit the American Indians in their native haunts and to join in their hunting excursions—The American Fur Co. conferring on him the entire command of the whole body, in case of difficulties with the Indians, to act in such emergencies according to his own discretion. He was perfectly competent to take charge of this responsible station, having served as a Captain in the British Army under Wellington, both in the peninsular battles and at Waterloo. . . .

Although the greater part of the equipment was obtained in St. Louis, our final preparations were made at Westport, a village at that time on the extreme frontier of the United States. Here the men were all collected together, additional mules and horses purchased and everything put into complete order for a long journey over the western wilderness. Neither bread nor salt were carried, the company subsisting on meat alone during the whole journey.

Stopping a few days at Fort William, where Miller made numerous sketches of the post and the Indians encamped about the area, the party continued on its way to a trappers' *rendezvous* on the Green River. By mid-summer they reached their final destination in the Wind River Mountains of north-central Wyoming, where Stewart had previously hunted elk and other big game. By October, Miller was back in New Orleans with an enormous portfolio of sketches, which he then set about translating into larger and more eloquent terms on canvas.

Miller exhibited a great many of his paintings in Baltimore and New York before shipping most of them off to Scotland. In 1840 he sailed for Scotland himself, and there spent considerable time decorating the hunting lodge at Murthly Castle in Perthshire, which Stewart had inherited from his brother while on his American travels. Returning again to Baltimore, Miller resumed his normal life once again, but he seems never to have forgotten his one wild adventure in the West; for again and again throughout his lifetime he turned to his portfolio of sketches, re-creating remembered scenes and painting rugged Rocky Mountain landscapes to satisfy his Eastern patrons.

Although it is not known whether he intended to publish some of his studies or write an account of his trip to the mountains, he did draft the previously mentioned manuscript of brief notes that describe approximately 167 of his watercolor studies. Filled with varied accounts of hunting buffalo, wild horses, elk, and grizzly bears, biographical sketches of traders and Indians, descriptions of prairie fires, Indian life, and the frontier in general, this volume is revealing testimony about life in the trans-Mississippi west during the early half of the last century.

Many observations of a reflective nature are found throughout this narrative, as well, and Miller's remarks on the character of the trapper and the customs of the Indian are particularly interesting.

"The trappers may be said to lead the van in the march of civilization," he writes. "From the Canadas in the North to California in the South, from the Mississippi East to the Pacific West, every river and

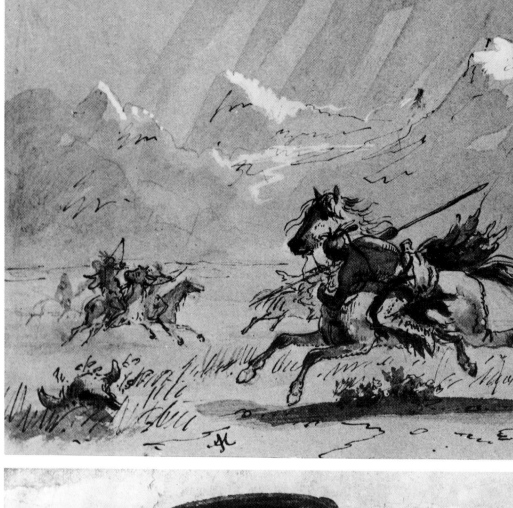

SNAKE AND SIOUX INDIANS
ON THE WARPATH
A. J. Miller

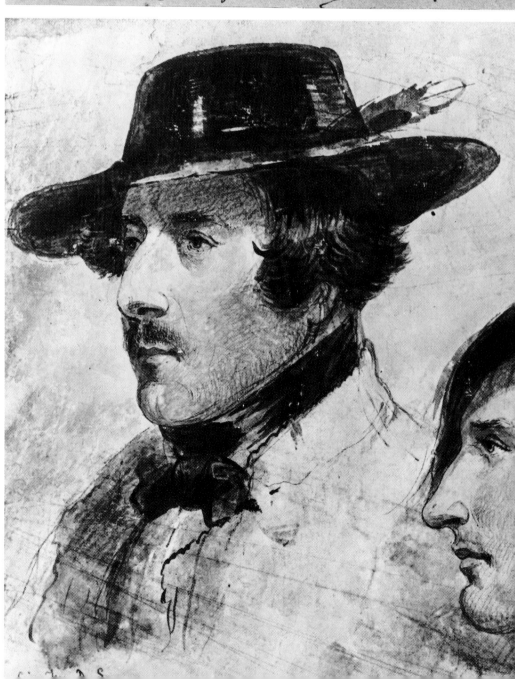

WILLIAM DRUMMOND STEWART
AND ANTOINE CLEMENT
A. J. Miller

mountain stream in all probability have been at one time or another visited and inspected by them . . . Adventurous, hardy, and self reliant, always exposed to constant danger from hostile Indians and extremes of cold and hunger, they penetrate the wilderness in all directions in pursuit of their calling."

Miller refers to the frequent marriages that took place between the trappers and the Indians about the trading post, observing that the practice of purchasing an Indian girl from her father was a common transaction often completed without the slightest consent from the girl herself. He also explains that the usual method of payment in such cases was in having the cost charged to the company's books, the trapper thereby pledging his future peltries in the beaver hunt to clear the debt. Of the trapper Miller remarks, "He is never tired of lavishing presents on his helpmate, running heedlessly in debt to accomplish this purpose." And he speaks of a specific instance depicted in a watercolor sketch he entitled "Trapper's Bride":

The price of the acquisition in this case was $600 paid in the legal tender of the country, viz: guns $100, Horse blankets $50, Red flannels $20 per yd, alcohol $64 per Gal, and sugar, tobacco, beads and all at corresponding rates . . . The trapper, half-breed or white, is considered a most desirable match—but it is conceeded that he is a ruined man after such an investment—the lady immediatly running him into unheard of extravagancies. She wants rich dresses, a horse, gorgeous saddle and trappings to cover her steed, numerous hawks bells, a pick of different colored beads and the deuce knows what besides. For this the poor devil trapper sells himself, body and soul, to the Fur Company for a number of years.

The notebook is filled with narratives of this sort, but it is hardly a more graphic account than the many sketches and watercolor studies to which it refers, a great number of which are presently included in the Gilcrease art collection and thus available for comparison. In this portfolio are portraits of Captain Stewart and Antoine Clement, as well as other individual studies and quick sketches depicting the activities of the traders, trappers, and Indians in the western regions. There are some 102 watercolors in the Gilcrease's collection of Miller's work, and twenty-seven of his oil paintings, including a self-portrait apparently painted some years after his western excursion.

Miller's comments themselves indicate that he is recalling events from out of his past at many points in the notebook. The manuscript is nowhere dated, but in the very first of his "sketches" describing the cabin of a Shawnee Indian trapper, Miller says that the man in question died in 1859—thereby indicating that the manuscript was not written prior to that date.

Certainly the remarks he makes about the Indians suggest that he is viewing them in retrospect. His somewhat melancholy observation about the happiness of man in the savage state, a note accompanying a sketch entitled "Indian Encampment," does not seem to be that of an eager, adventurous young man fresh from his travels in the West:

It is a question whether with all our boasted civilization, we enjoy more real happiness than these children of the prairies, on whom we exhaust a deal of superfluous sympathy. They would certainly not be willing, or in a hurry, to exchange with us—and are at least contented with their lot. We (generally speaking) never are. So that after toiling through a lifetime of pain and suffering, without (rarely, if ever) being able to accomplish the work before us, we go out of this world in about the same state of stupid astonishment with which we came into it.

But whatever the disappointments his later experiences in life proved to be, Miller's recollections of his summer adventure in the Rockies remain as one of the most vivid accounts of the sporting life of the Far West to have survived its inevitable passing. His record of his western experiences is unique, and his paintings continue to perpetuate a romance of the wilderness and the wild life of the Indian, trader, and bearded trapper.

INDIAN ENCAMPMENT
A. J. Miller

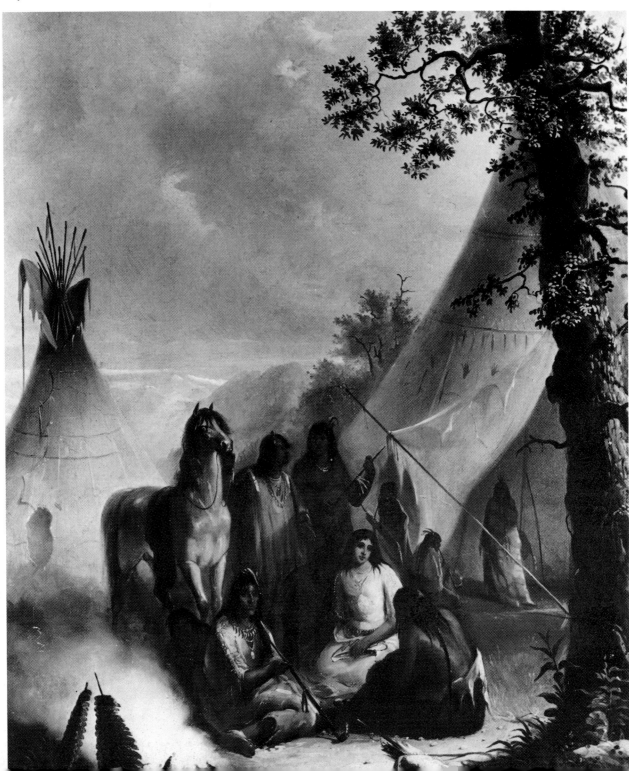

Overland Trails to Oregon & California

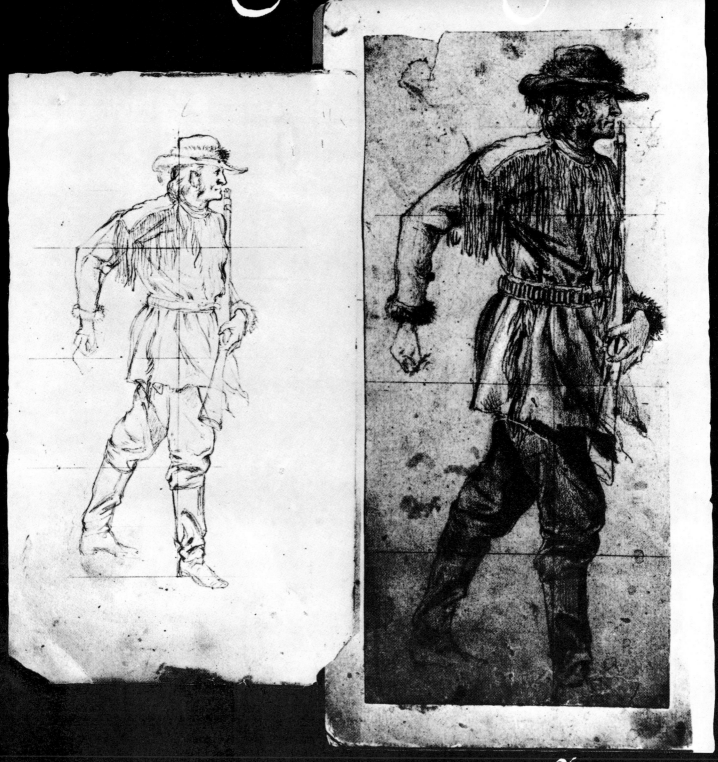

Pioneers in a Roadless Country

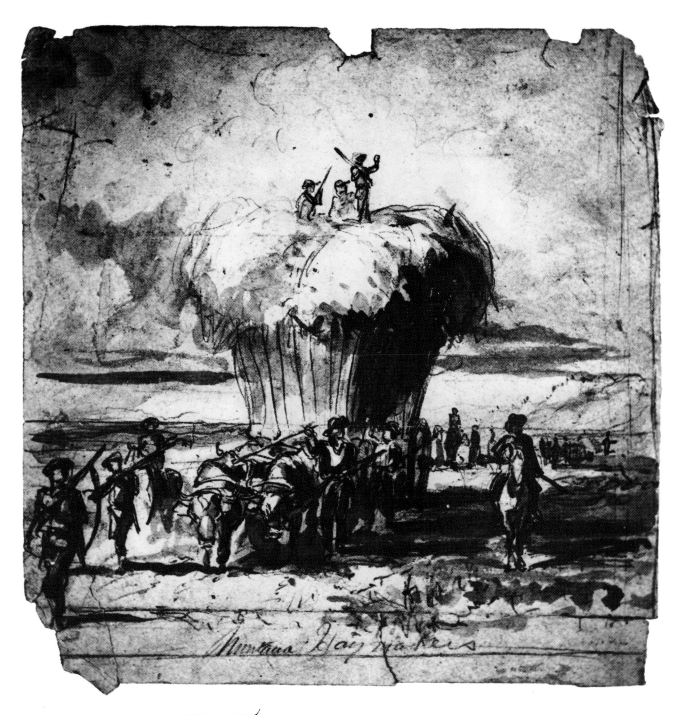

Overland Trails to Oregon & California

The invasion of the immense region west of the Mississippi occurred within a period of roughly twenty years, beginning in about 1829 and reaching its first peak in 1850. In this brief span of time, Americans crossed the wide central plains, penetrated the Rockies, and established settlements all along the Pacific coast. The contrast between this period and the preceding two hundred years that had been required to settle the eastern seaboard and the region westward to the Mississippi is indeed amazing; and the circumstance that facilitated this mighty westward leap, more than any other, perhaps, was the introduction of steam power on the Missouri River.·

Creating a vital link between the settled East and the unknown regions westward, the Missouri also provided a relatively easy transport to the Rockies and beyond in no way comparable to the previous, customarily tedious travel through the forested wilderness east of the Mississippi. Within these twenty years mentioned, beginning simultaneously with the development of a railroad system in the East and the introduction of steamboats on the western rivers, the United States

added to its territorial domains—and subsequently settled—more than a quarter million square miles in the Oregon Territory, acquired Texas and the New Mexico Territory from Old Mexico, and overran as well the intervening region between California and the Rockies in a series of migrations unparalleled in the history of Western civilization.

During the earliest days of Anglo-American settlement in the East, travelers had whenever possible used the natural waterways, often in the most primitive of craft. On land, extensive use was made of prior overland routes such as the trails made by Indians or wild animals, and travel was undertaken for the most part on foot or sometimes on horseback. As carts and wagons were built and used, these trails were widened and conveyances were adapted to the various uses to which they were put. Whether on land or water, however, transportation was facilitated by manual labor, draft animals, the wind, water currents, or other natural means until the introduction of mechanical power generated within the conveyances themselves revolutionized travel on land and water.

The adoption of steam as a means of transportation on American rivers heralded the final struggle with the natives for possession of the land east of the Mississippi; for with access to the wilderness north of the Ohio thus made easier, more and more settlers migrated inland to found towns along the waterways that soon grew into cities. Turnpikes were built to connect these frontier points with the eastern communities. Stage lines were established in the east and north, and east-bound stages passed west-bound pack trains and wagon caravans throughout this early period. Then, in 1827, the first American railroad of any significance, the Baltimore and Ohio, was begun; and in the next decade a traveler in the East might find that he could begin a journey on horseback, transfer to a steamboat, disembark at some distant point along the river to board a stagecoach, and perhaps finish his trip by rail.

Early westward travel into the unsettled regions continued to be done for the most part on horseback, with goods and supplies being transported by barge or pack horse. As the pack horse trails developed into roadways, ox- and horse-drawn carts began to appear, and slowly wagons were introduced. The farm wagons of the earlier colonists, built along the lines of those used in England or Germany, developed through necessity into the Conestoga wagon, Prairie Schooner, and stage coach identified with the settlement of the trans-Mississippi west. Mules replaced horses as pack animals in many areas of the central plains and western mountains. Burros were common in Mexican territory. Following the opening of the Santa Fe Trail, all manner of overland conveyances were used, including mule-drawn wagons, bull teams, and pack trains. Pack trains were also used extensively for the transportation of supplies to U.S. military installations in the western territories throughout the nineteenth century, while oxen customarily pulled the wagons of the settlers who crossed the wide prairies on their way to Oregon or California.

Many kinds of carts were in use throughout Canada, New England, and the southern states from earliest times, more common, perhaps, on the extreme borders of the nation both north and south. Wooden two-wheeled carts, or *carretas*, were common on the trails

MORMON HAYMAKERS
William Cary

between Chihuahua, Santa Fe, Tucson, and other points in the Spanish Southwest in the early nineteenth century. Pulled by two or three yoke of oxen, these were adaptable to many uses but eventually were replaced on the Santa Fe Trail by wagons better suited to long-distance travel.

The Red River cart, of uncertain origin, had been in use along the Canadian border as early as 1792 and continued to play an important part in the settlement of the Minnesota and North Dakota territories throughout the period of the United States' expansion west of the Mississippi. In 1812, when Scottish highlanders recruited by the fifth Earl of Selkirk arrived to colonize the Pembina settlement on the Red River of the North, this cart was already established as a vehicle for transport in that region, remaining in use, its design unchanged, for the next forty years. Made entirely of wood, it was constructed easily with only a few simple tools and thus was definitely suited to the frontier. Without the more complicated turning mechanism of a wagon, such a conveyance could go almost anywhere that a man, horse, or ox could go.

The Conestoga wagon, the use of which may be dated as early as 1755, when General Braddock used wagons as troop-supply transport in his disastrous campaign against the French at Fort Duquesne, was first manufactured in the Conestoga Valley of Pennsylvania. The design of the earlier vehicle was soon copied by settlers in Virginia and Maryland, and still later adaptations carried pioneers westward across the Rockies. Its size indicates that its principal usefulness was in the hauling of freight and its popularity as an overland conveyance never was seriously challenged by any other vehicle. Adapted to fit the particular needs of the neighborhood in which it was used, it was adopted, with only slight modifications, for all long-distance travel until after the California gold rush period of the mid-nineteenth century.

The pack mule that could negotiate the roughest country preceded the wheeled vehicle; the Red River cart with its outsized wheels adapted to prairie or swamp; the Conestoga wagon served as the prototype of all heavier vehicles traveling westward.

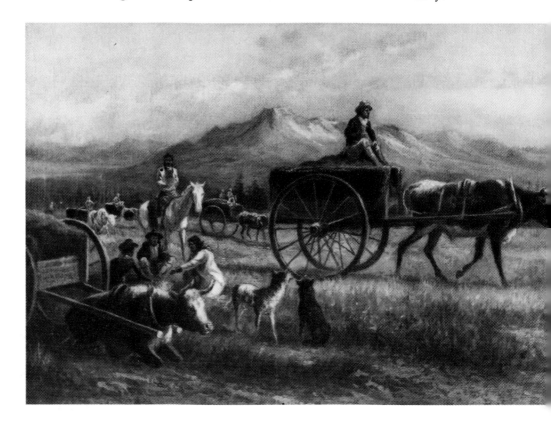

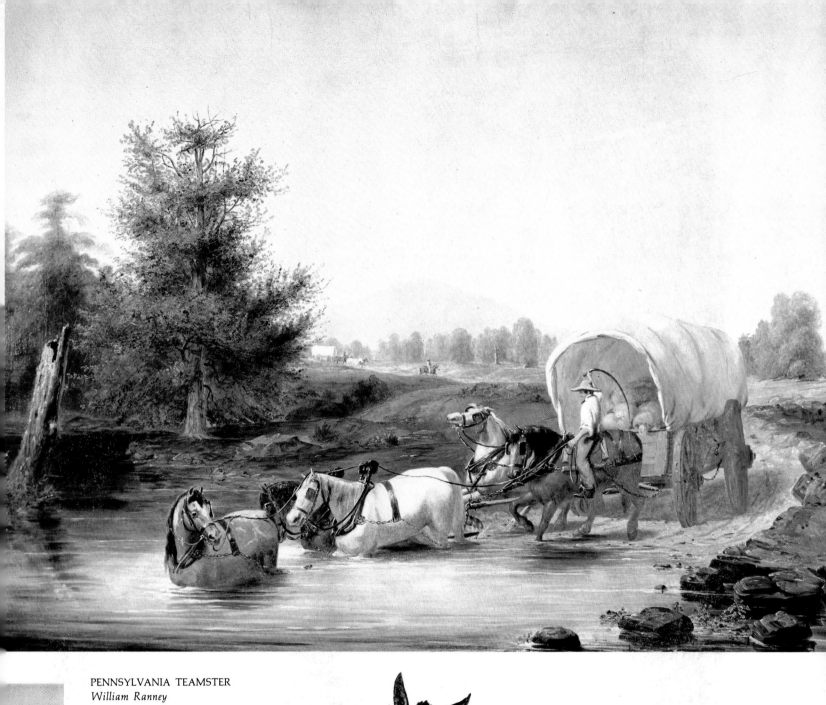

PENNSYLVANIA TEAMSTER
William Ranney

PACK MULE
Will James

RED RIVER CART
William Cary

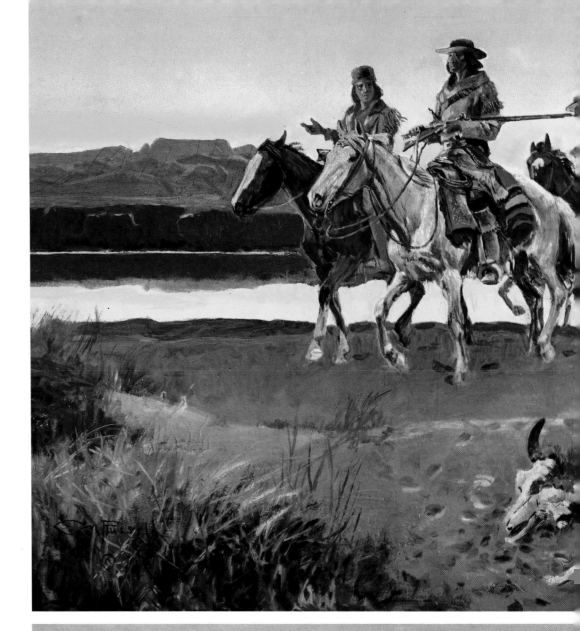

CARSON'S MEN
C. M. Russell

MIRAGE ON THE PRAIRIE *or*
TRADERS' CARAVAN
A. J. Miller

As traffic into the interior
increased, new and hardier
breeds of pack animals had
to be found. Wagons and
other equipment likewise
were adapted to the rigors
of the western trails.

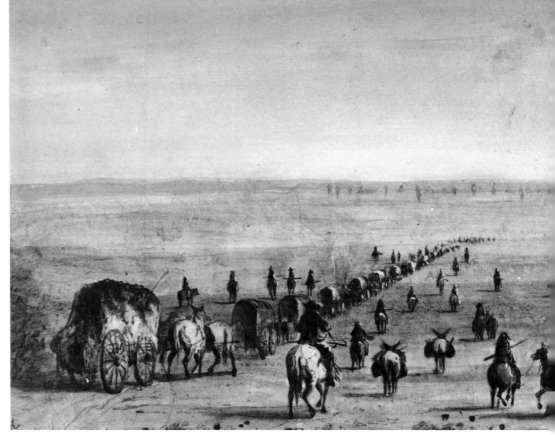

burgh—often called "Pitts teams"—were identical to the Conestoga. A variation of this model, designed by a wagon-maker named John Studebaker in Ohio in the 1830's, was first used by a younger brother on his way to California. A covered wagon like the Conestoga itself, this wagon served as the prototype of all such vehicles that traveled westward in the 1800's. Oxen soon replaced the four- and six-horse teams in Ohio, Indiana, and Illinois, although three-horse teams called "spike" teams were used to pull the now famous Prairie Schooner across the western plains. A somewhat smaller version of the heavier freighters, the schooner went by other names as well: Movers' Wagon, Settlers' Wagon, Schooner Wagon, Hoosier Wagon, and Mormon Wagon. The larger freight wagons were also variously termed Pittsburgh Wagons, Murphy Wagons, and the like, the names signifying the areas in which they were chiefly employed or the slight modifications in design by which they were distinguished.

The National Road was the chief east-west traffic artery between the Middle Atlantic states and the Ohio-Mississippi Valley region at the outset. Begun in 1811 through the Cumberland Mountains to the Ohio, this road was heavily traveled by horse-drawn wagons, chiefly Conestogas, which averaged about twelve to fifteen miles a day. Nineteenth-century artist William T. Ranney, in his painting entitled *Pennsylvania Teamster*, has depicted what is doubtless one of the heavy farm wagons common among Dutch, German, and English settlers of the period, used chiefly to carry produce from farm to town or to the grist mills. Ranney shows his teamster riding in a fashion that became standard in later years. He also shows a "spike" team being employed, with a single animal in the lead of the team, customary in the East prior to the development of the six-horse "bell" team of the 1850's.

Mules continued to be employed in trips over western mountain passes and on shorter desert crossings, but wagons soon proved to be the best all-around means of transportation on the long trails across the prairies. The advantages of wagons over mule trains were several, for wagons could carry larger and heavier amounts of freight over longer distances and did not need to be unloaded and reloaded at every stop along the way. Pack horses were also used on the trails across the northern Rockies until William Sublette first tried using wagons to haul supplies over the mountains in 1829, when he brought ten covered vehicles and two Dearborn wagons over the Oregon Trail to South Pass in the present state of Wyoming. Here, he transferred his supplies to mules for delivery to the fur trappers' *rendezvous* on the Green River, and it was another dozen years before a train of wagons actually made the journey all the way to Oregon.

The route to Santa Fe thus was the first of the famous western trails to successfully accommodate wagons. William Becknell is given the credit for being the first person to introduce them, in 1822. Wheeled vehicles had transported goods from the interior of Old Mexico previous to this time, but Becknell's Pittsburgh freighters soon replaced, for the most part, the ox carts of the Mexican traders. Wagons brought from Missouri sometimes were purchased by the Mexicans themselves and Missouri traders frequently ventured south

pull the freighters and later ten or twelve animals were assigned to each vehicle as larger and heavier wagons came into use. Capable of carrying more freight apiece, larger wagons were employed especially after 1837 to reduce import duties charged by the Mexican government on each wagon, carriage, or cart entering its territory irrespective of the amount of cargo or quality of goods carried.

In 1832, William Bent and Company, using wagons, cleared a way through Raton Pass from Santa Fe to Colorado. The following year, Bent's first fort was built on the Arkansas and soon became the principal stopover on the mountain branch of the Santa Fe Trail. By 1839, regularly scheduled caravans of sometimes a hundred wagons, leaving Missouri in the spring, arrived in Santa Fe by July, which soon became the month for the biggest selling and trading in that area. With the arrival of goods from Missouri, buyers and traders from El Paso, Sonora, and all the Mexican settlements converged on Santa Fe. By August, prices were being cut and wagons began leaving for the return trip to the States.

No posts or settlements marked the trail between Missouri and the mountains for many years, and trouble with the Indian tribes traversing the central plains often hindered east-west traffic after the 1820's. Colonel "Kit" Carson—experienced trapper, army scout, guide, and Indian fighter—was commissioned by President Polk to patrol this area and help keep the peace along the Santa Fe Trail. Military escorts frequently accompanied the traders' caravans throughout the next decade, and companies of infantry with baggage wagons pulled by oxen were common along the trail.

Charles M. Russell's painting *Carson's Men* evokes an immediate response from the modern viewer, expressing at once both the artist's romantic attachment with the past and his concern for realistic detail. Many of his paintings are re-creations of his own experiences, especially his renditions of the life of the cowboy on the open range; when attempting to re-create a historic scene, however, Russell often felt called upon to do research into the particulars to be depicted, interviewing old settlers or writing to knowledgeable friends for information.

Such a letter to the noted Montana rancher and local historian Granville Stuart was found in the collection of the late J. Frank Dobie pertaining to the types of saddles in use during the time Kit Carson rode the Santa Fe Trail. Russell asks:

Now Mr. Stuart, I am going to ask you what kind of saddles were worn in the way back times. Thirty years ago when I came West men rode a Texas tree with a low flat horn with a double cinch. The cantel had hand holts in it and the tree was bare of leather except the straps that held the cinch ring . . . sometimes they wore a canteen or pockets in front over the horn. Now if you can tell me of any saddles of an earlier period, I will thank you very much . . .

The Spanish muleteers contributed the packsaddle; who invented the "diamond hitch" to bind a variety of loads to a pack animal's back no one knows.

Russell depicted in his *Carson's Men* the Santa Fe or St. Louis saddle made for the western trade in the 1830's and 40's. Designed basically along the lines of the Mexican saddle, this type became common throughout the Rocky Mountains. A double-rigged or double-cinch saddle was preferred, called by cowmen a "Texas" saddle.

132

Engraving of a saddle from THE PRAIRIE TRAVELER,
A HANDBOOK FOR OVERLAND EXPEDITIONS, *by Randolph Marcy (London, 1863).*

ravel to and from Santa Fe in the early 1800's furnished adventure of a unique sort, and many journals of the men engaged in this commerce have since been collected and published; for unlike the trappers who preceded them, the majority of the traders were educated men who kept records and accounts of their transactions and experiences. Josiah Gregg, who wrote a lengthy volume on the subject of the Santa Fe trade published under the title *Commerce on the Prairies,* has given a very personal and detailed account of the circumstances surrounding trade and transportation in the Southwest before the advent of the Mexican War. Other traders in Arkansas and later Indian Territory also left numerous records that survive to the present time in old account books and ledgers— reports that in ordinary terms of sales figures and business statistics indicate as much about life and conditions in those early times as any of the more descriptive narratives that were written.

A glimpse into some of the old records of consignments handled by traders in the West during the first decades of the nineteenth century indicate that whisky, flour, and bullets constituted the mainstays of frontier commerce at this time. Other items, such as coffee, tobacco, molasses, gunpowder, and nails also figure prominently in some account books. William Whitfield, trader at the Creek Indian Agency along the Arkansas, handled all kinds of consumer items transported by land or water to the western trading posts in the mid-1800's. Between 1858 and 1860, thirty-seven steamboats arrived at Whitfield's landing to unload cargoes that included such things as glass, oysters, rope, putty, almonds, candy, horse collars, beans, tea, figs, cook stoves, tar, and paper.

At the outset of the Santa Fe trade, the type of goods to be transported to New Mexico were not altogether the same as those that had previously been carried over such vast distances. Therefore new means of transportation had to be devised to fit the special conditions of the overland trail. The Indians, with whom a profitable trade developed along the way, desired such things as guns, powder, lead, beads, knives, mirrors, and textiles, which they traded for furs, hides, and jerked meat or buffalo tongues. Of interest to the New Mexicans were such items as cheaply manufactured American cloth, iron and tin utensils, and any small luxuries they might be able to afford. Much of this merchandise went south into Old Mexico, for the New Mexicans had little with which to trade except hides, horses, and mules. By the same token, most of the gold and silver brought back to the States by the Santa Fe traders came from the interior of Old Mexico.

As Santa Fe commerce developed, more adaptable breeds of pack animals had to be found, selected primarily for their stamina or other qualities of endurance. The animal that finally met all the rigorous requirements of the trail was the common pack mule, which soon became as important an item of trade as anything it carried. The now famous "Missouri mule" originated in the Spanish Southwest. Josiah Gregg, best known of the Santa Fe traders, had a great deal to say about this animal. Speaking from long familiarity with his subject, he remarks in one section of his *Commerce on the Prairies:*

IMMIGRANT
O. C. Seltzer

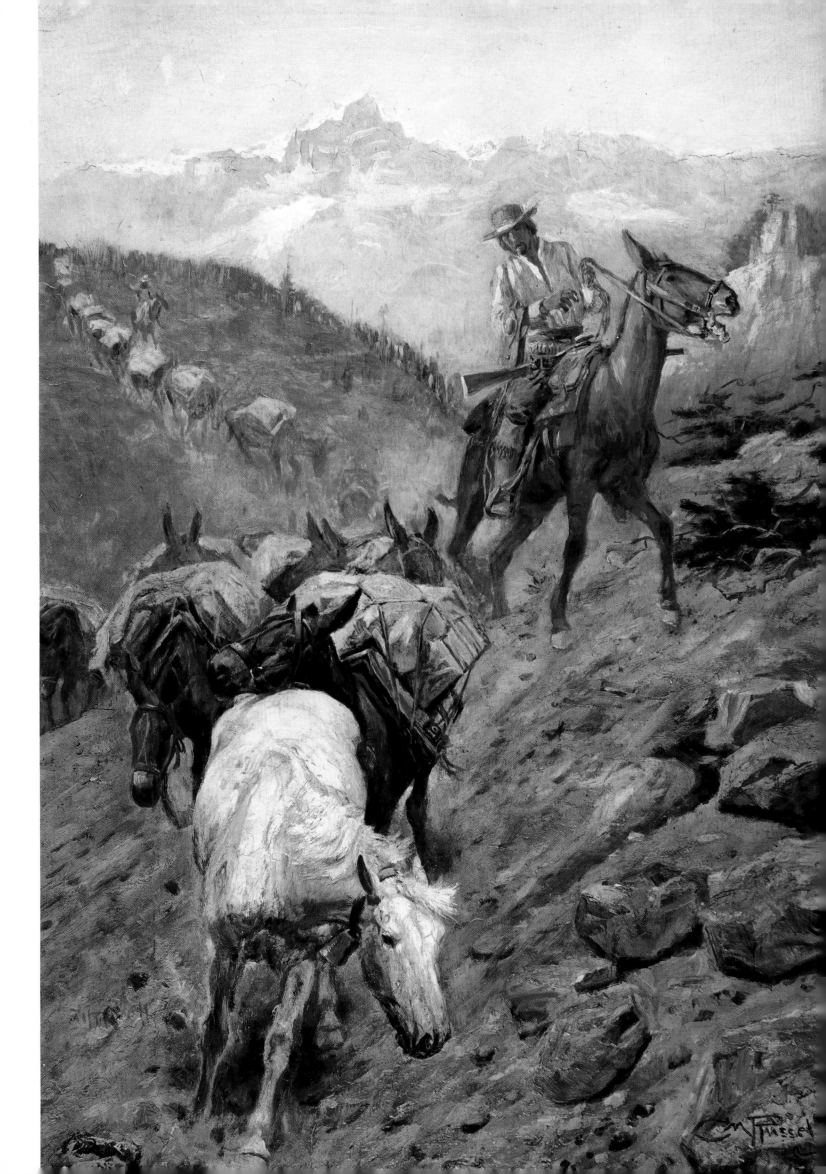

The little attention paid to the breeding of horses in New Mexico may perhaps be accounted for from the fact that, until lately, when the continued depredations of the hostile Indians discouraged them from their favorite pursuit, the people of the country had bestowed all their care in the raising of mules. This animal is in fact to the Mexican, what the camel has always been to the Arab— invaluable for the transportation of freight over sandy deserts and mountainous roads, where no other means of conveyance could be used to such advantage. This mule will travel for hundreds of miles with a load of the most bulky and unwieldy articles, weighing frequently three or four hundred pounds.

The Aparejo (or pack-saddle, if it can be so styled) is a large pad, consisting of a leathern case stuffed with hay, which covers the back of the mule and extends half way down on both sides, this is secured with a wide sea-grass bandage, with which the poor brute is so tightly laced as to reduce the middle of its body to half its natural size . . .

The muleteers contend that a tightly laced beast, will travel or at least support burdens with greater ease; and though they carry this to extreme, still we can hardly doubt that a reasonable tension supports and braces the muscles. It is necessary too for the aparejo to be firmly bound on to prevent its slipping and chafing the mule's back; indeed, with all these precautions, the back withers, and sides of the poor brute are often horribly mangled—so much so that I have seen the rib-bones bare, from day to day, while carrying a usual load of three hundred pounds!

Relating the further details of loading and lacing the pack mule before setting out on a journey, Gregg also describes the Mexican *arrieros*, or muleteers, and their life upon the dusty road:

The <u>carga</u>, if a single package, is laid across the mule's back, but when composed of two, they are placed length-wise, side by side; and being coupled with a cord, they are bound upon the aparejo with a long rope of sea-grass or rawhide, which is so skilfully and tensely twined about the packages as effectually to secure them upon the animal. The mule is at first so tightly bound that it seems scarcely able to move; but the weight of the pack soon settles the aparejo, and so loosens the girths and cords as frequently to render it necessary to tighten them again soon after getting under way. It keeps most of the muleteers actively employed during the day, to maintain the packs in condition; for they often lose their balance and sometimes fall off. This is done without detaining the atajo

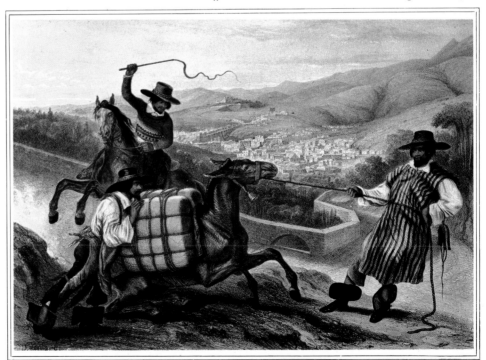

Storms, prairie fires,
buffalo stampedes,
& occasional Indian
attacks were among
the hazards faced by
travelers in the
early West.

(drove of pack-mules), the rest of which travel on while one is stopped to adjust its disordered pack. Indeed it is apt to occasion much trouble to stop a heavily laden _atajo_; for, if allowed a moment's rest, the mules are inclined to lie down, when it is with much difficulty they can rise again with their loads . . .

The day's travel is made without a nooning respite; for the consequent unloading and reloading would consume too much time; and as heavily-packed _atajo_ should rarely continue enroute more than five or six hours, the _jornada de recua_ (day's journey of a packdrove) is usually but twelve or fifteen miles.

And he concludes:

. . In this way freights are carried from point to point, and over the most rugged mountain passes . . . The cheapness of this mode of transportation arises from the very low wages paid to the _arrieros_, and the little expense incurred to feed both them and the mules. The salary of the muleteer ranges from two to five dollars a month; and as their food seldom consists of anything else except corn and _frijoles_, it can be procured at very little cost. When the _arrieros_ get any meat at all, it is generally at their own expense.

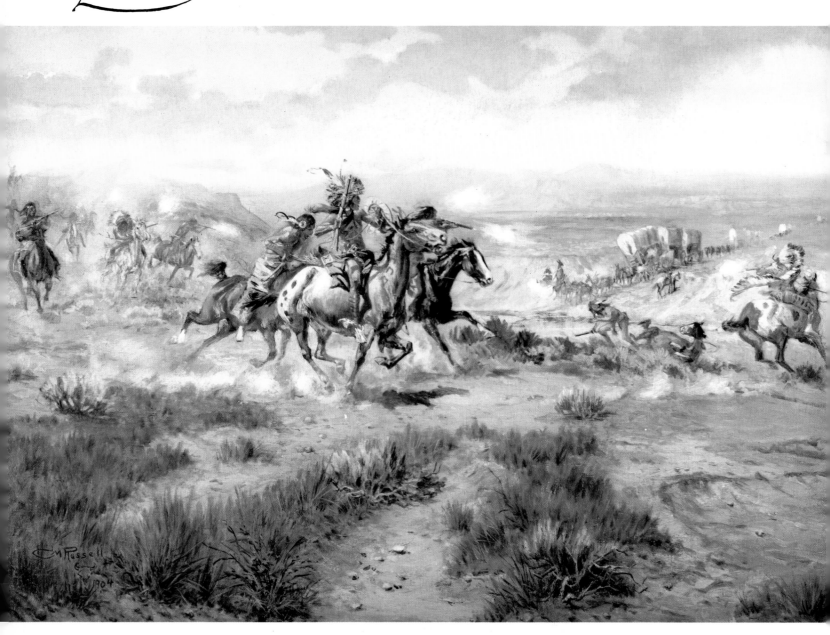

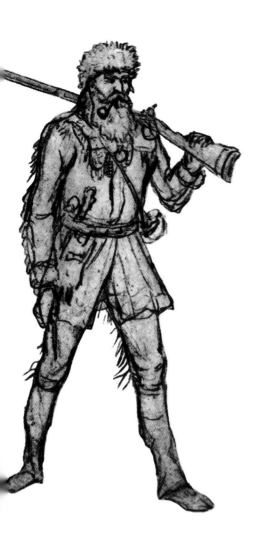

FRONTIERSMAN
William Cary

ATTACK ON THE WAGON TRAIN
C. M. Russell

The pack outfit, whether made up primarily of mules or horses, was an important part of the transportation story in the western territories. Explorers and mountain men, army and commercial freighters, miners, individuals, and small parties alike depended on the pack animal to move supplies or personal gear. The army in particular made use of pack mules in its campaigns against the plains tribes. The average pack outfit comprised about sixty pack animals, perhaps another ten "riding" mules, and a mare selected as the leader of the caravan familiarly designated the "bell mare," around whose neck was secured her ornament of office. Such "belled" animals normally were light in color because they were easier to see along dark, winding trails at night.

There were as many methods of lashing a pack to a mule or a horse as there were variations of the pack saddle itself. The most common type of hitch employed was the so-called "diamond hitch." In his paintings *The Bell Mare* or *Where Mules Wore Diamonds*, Charles Russell represented the double diamond hitch on the animals. Although hard to tie, its variations rendered it adaptable to almost any type of pack or load. Russell also shows the pack master riding a mule. Many frontiersmen preferred the surefooted mule over the more uncertain and at times skittish horse when traveling the narrow mountain trails. Mules were considered to possess superior intelligence, as well, and frequently demonstrated considerably more endurance.

The northern trail from Independence, Missouri, to the Pacific Northwest—otherwise known as the Oregon Trail—was surveyed and mapped by John C. Frémont in the early 1840's, although prior to this time it had been traveled by occasional pack trains and groups of traders or missionaries. Thomas Fitzpatrick and a party of trappers had found their way over the mountains via this route as early as 1824, and a Captain Bonneville had brought wagons, horses, cattle, and trade goods along this trail in 1832 on his way to establish a post on the Green River. Marcus Whitman, Henry Spalding, and their wives made the trip to Oregon four years later. The people made it, but the wagons did not; and it was not until 1841 that a group of fourteen wagons reached the other side of the Continental Divide, succeeded the following year by another group of eighteen wagons and a party of some one hundred people led by Elijah White who settled in the Willamette Valley.

Following the publication of Frémont's reports in 1843, the Oregon route quickly became the principal wagon road over the mountains. In the fall of that year, 120 wagons carrying 200 families reached Oregon, and within the next two years nearly 4,500 more people followed in their wake. A network of side trails and short cuts soon led southward at several points along the Oregon Trail to Utah or California. In 1847 Brigham Young and his Mormon band traveled this road from Council Bluffs to Salt Lake.

On August 14, 1848, Oregon was formally organized as a territory, but was not admitted to the Union as a full-fledged state until 1859. After gold was discovered in California in January 1848, Oregon lost many of its settlers, but gained new ones when Congress passed a law allowing 320 acres of public land free to every man who settled

on it before December 1, 1850. An extra 320 acres were allotted for a man's wife, if he had one, and wives came to be in great demand in the distant Oregon country. After 1853 the acreage allowance was reduced to 160 acres for each man, 160 acres for his wife. To satisfy these claims, settlers were required to reside on the land they selected for at least four years before acquiring permanent title.

Thousands of gold seekers bound for California followed the Oregon Trail via North Platte Valley and the South Pass through the Rockies. Bypassing Fort Hall, they turned onto the California Trail, which led across the Great Basin and, eventually, the Sierras. Forts Laramie, Bridger, and Hall served as stopping places for travelers on the western trails. At one or another of these posts, emigrants or commercial caravans could replenish supplies, make necessary repairs, and obtain information concerning conditions to be faced on the journey ahead. Fording rivers and streams with wagons and animals proved a time-consuming and often difficult task. Prairie storms, fires, buffalo stampedes, and Indian attacks also were dangers to be anticipated.

For the most part, however, the long overland journey to Oregon or California was a toilsome, tedious, unexciting business. As more and more wagons made the trip, changes were made in the shapes of the vehicles to accommodate travelers and their personal belongings instead of packaged freight. Iron axles were introduced, and lighter wagons, designed for traveling over narrow tracks and mountain passes. The Prairie Schooner, developed primarily to serve as a one-way carrier drawn by two or three yoke of oxen, was a small, light-weight wagon with an average 2,500-pound load capacity. The establishment of new routes followed the introduction of new and improved conveyances. As wagon designs underwent change, the routes also began to change. Road improvements, however, did not keep pace with the newer types of vehicles in most instances.

Wagon trains crowded trans-Mississippi trails throughout the 1850's. Settlers joined groups of gold seekers and other land seekers headed west. The selection of a wagon master to supervise and direct the caravans was vital to the success of any overland trip, and travelers sought a man with understanding and experience to take them across the plains—someone familiar with the ways of the wilderness, possessing as well the ability to handle the many situations the wagons encountered on the long passage.

Traveling to Oregon, Utah, or California in the 1850's was no simple undertaking. Such a trip required a great deal of preparation, for each family had to stock supplies for its members and provide the various utensils and other things needed when they reached the new country. Wagons and animals had to be purchased and the animals trained for the long ordeal ahead. Departure time coincided with the season when grass for the animals would be most abundant in the course of a five- or six-month journey. Many settlers chose to use the slower-moving ox teams to pull their wagons, for oxen could live off all but the most barren land. If an animal was injured or if the family ran short of food, it could be slaughtered and eaten. Ox teams needed no expensive harness. Yokes of ash or hickory usually served, easily constructed or inexpensive to buy.

SETTLERS MOVING
William Cary

With the opening of the Oregon Trail, thousands of settlers crossed the Rockies. At best, the long overland journey was a toilsome, unexciting business.

Before a wagon train set out from one or another of the points along the Mississippi or Missouri, each wagon was assigned a position in the caravan and expected to maintain that position for the duration of the trip. Traveling was slow across the miles and miles of unsettled country, and the average distance covered by a wagon caravan in a day was usually between twelve to fifteen miles. A day on the trail was only partially taken up with traveling, however. Meals had to be prepared and eaten and a two-hour grazing period around noon each day allowed for the animals. A campsite was selected early in the afternoon each day, and the train pulled into a specified formation when it reached the location selected for the night's encampment. Extra animals not used in pulling the wagons were herded along during the day while the train was in motion, gathered together and tended when the caravan halted for the night. Harnessing, unharnessing, and repairing equipment worn or damaged during the day's advance occupied much of the early evening hours. A hundred other tasks as well represented a substantial part of the daily routine on the trail.

A DOUBTFUL VISITOR
C. M. Russell

CAMPSITE
William Cary

As more wagons crossed the continent, changes in design were made to accommodate families and their personal belongings instead of packaged freight.

ormally two or four oxen were used to pull the settlers' wagons; but many families unable to equip themselves sufficiently for the long overland trip crossed the continent with only a yoke, or pair, of animals. In his painting *A Doubtful Visitor*, which imaginatively portrays what was not an uncommon encounter between a wagon train and a band of Indians, Charles M. Russell shows a modestly equipped family headed for the goldfields of Montana. Fortunately for the pioneers in this case, the bulk of the caravan is not far behind and it is not likely that the Indians intend to do them immediate harm.

The South Pass beyond the north fork of the Platte River represented the turning point for many families on the northern, or Oregon, trail. Here they turned south for California or continued on to Oregon. The point at which California-bound settlers forded the Platte came in time to be known as the "California Crossing," used not only by emigrants but also by freighters, stage lines, and, in later years, the Pony Express. Writings of early travelers in this area invariably mention this crossing and the Platte itself, regarded by many as "too thick to drink and too thin to plow." In his classic work, *The Oregon Trail*, Francis Parkman recalls his experience at this junction:

The emigrants recrossed the river, and we prepared to follow, first the heavy wagons plunged down the bank and dragged slowly over the sand beds; sometimes the hoofs of the oxen were scarcely wet by the thin sheet of water; and the next moment the river would be boiling against their sides, and eddying round the wheels. Inch by inch they receded from the shore, dwindling every moment, until at length they seemed to be floating out in the middle of the river. A more critical experiment awaited us; for our little cart was ill fitted for the passage of so swift a stream. We watched it with anxiety, till it seemed a motionless speck in the midst of the waters; and it was motionless, for it had stuck fast in the quicksand. The mules were losing their footing, the wheels were sinking deeper and deeper, and the water began to rise through the bottom and drench the goods within. All of us who had remained on the higher bank galloped to the rescue; the men jumped into the water, adding their strength to that of the mules, until by much effort the cart was extricated, and conveyed in safety across.

The treacherous Platte was well known for its shifting beds of quicksand, further described by Mark Twain at a later date as being "a mile wide and an inch deep."

William H. Jackson, widely known in his day for his remarkable photographs of the West, was also something of an artist and occasionally turned his hand to sketching and painting. Born near Peru, New York, in 1843, he early entertained himself painting local scenes and earned money making political posters and showcards for shopkeepers. In 1858, Jackson went to work for a New York photographer as a retoucher and soon launched a career in photography on his own. In 1866, determined to travel westward and with an old army friend, he hired on with a freighting company as a teamster at twenty dollars a month. As was his habit, he kept a sketchbook that he filled with the scenes of his western experiences. Later in life, he turned to these to produce a number of watercolors and a few oils, among the latter a picture entitled *California Crossing*.

Although Jackson's work is classed today as more or less "primitive" in style and execution, as an artist he was an alert and careful observer; and in this painting he has depicted a wide panorama of activity within the framework of a relatively small canvas. Wagons forming up on the near side of the river are making ready to cross, and others are already in midstream. Teams of oxen are returning from the crossing to pick up additional wagons, others are pulling the heavy-laden vehicles up on the far shore through a man-made cut in the riverbank. In the distance, wagons can be seen drawn up in a circle, while another caravan, sufficiently reorganized and recovered from the ordeal of crossing the Platte, is heading toward the horizon. All in all, it is a scene of marvelously detailed activity that can hardly be taken in at a glance.

The artist's written account of this experience is no less vivid than his pictorial record. Contained in a letter written to his parents from Salt Lake City in 1866, Jackson's commentary reads in part:

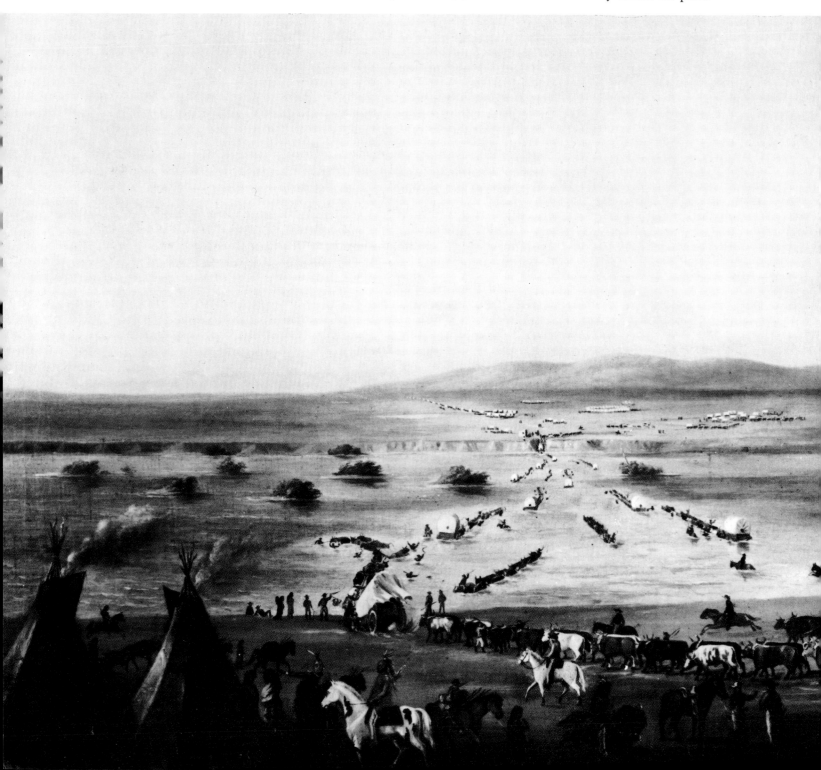

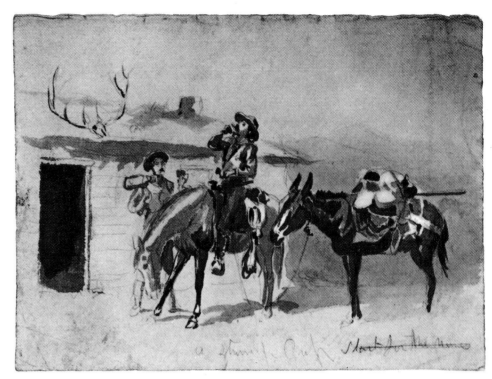

A STRONG CUP
William Cary

CALIFORNIA CROSSING
W. H. Jackson

We arrived at the crossing of the South Platte, some three miles above Julesburg on July 13th. The river at this place is more than a half a mile wide and not more than four feet deep where the current runs the deepest and strongest. There were a number of other trains gathered there, engaged in crossing or preparing to cross. The river was filled from bank to bank with teams, a dozen drivers to each, wearing but a single garment. The scene was an exciting and intensely interesting one, and it will be almost impossible for me to give you an adequate idea of it by words alone. I have a sketch, which I will send you, that will perhaps give you a better idea of what was done than my descriptions, but still conveys little of the real life and action of the scene.

For our preparations, the trailer wagons were uncoupled and to each single wagon the teams were double; Sometimes even eighteen yoke were used. The first plunge into the river was into the deepest part. The cattle were excited and reluctant to enter the water; and when we got them in, it was difficult to make them string out and pull as they should.

The river bottom is a shifty quicksand, and if the wagon is allowed to halt too long, it will sink into the sand so far as to be almost immovable. When this happens, there follows a perfect pandemonium of shouting and yelling, with cracking· of whips and thumping with sticks, as the drivers, up and down the line on both sides, urge on the floundering cattle so that there shall be no pause in their progress. And so it goes on continually all the way across, with hoarse gee-haws and whoa-haws enlivened with many shrill yip-hi-hi's . . . We were about two hours crossing one wagon with a doubled up team, so there were many recrossings to take over the fifty separate wagons of the whole outfit.

In the midst of all this hurly-burly came a band of about fifty Sioux Indians, making the crossing at the same time—big braves on little horses, squaws leading the pack ponies, dogs and papooses perched on top, and other juveniles paddling along in nature's garb only. Both sides of the river were lined up with corralled wagon trains, and the banks were crowded with groups of drivers, soldiers, and Indians interested in the proceedings.

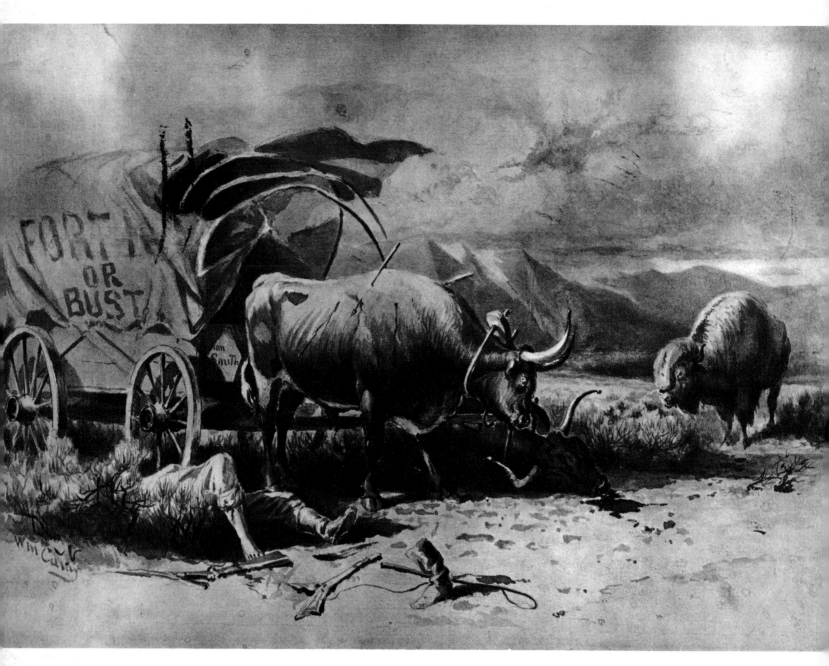

CASUALTY ON THE PLAINS
William Cary

The Indians were not always as friendly as Jackson describes in his letter.. As more and more settlers moved into Indian country, the tribes grew increasingly hostile. Contrary to the popular notion, however, it was not usual for a band of Indians to attack a large wagon train. More often they attacked smaller units or single wagons that had become separated from the main body of westward-traveling caravans for one reason or another. The dramatic aspects of such an incident are more than adequately presented in any number of paintings and lithographs of the latter years of the nineteenth century. The outcome of chance encounters between such travelers and hostile native bands is perhaps better suggested in an untitled sketch selected from among the many by William Cary in the Gilcrease collection. The action is over, the issue decided. The Indians have quit the scene, leaving behind the sole survivor of the recent, bloody skirmish: one of the pair of oxen, itself mortally wounded.

Freighting & Western Commerce
Western Enterprise Before the Railroad

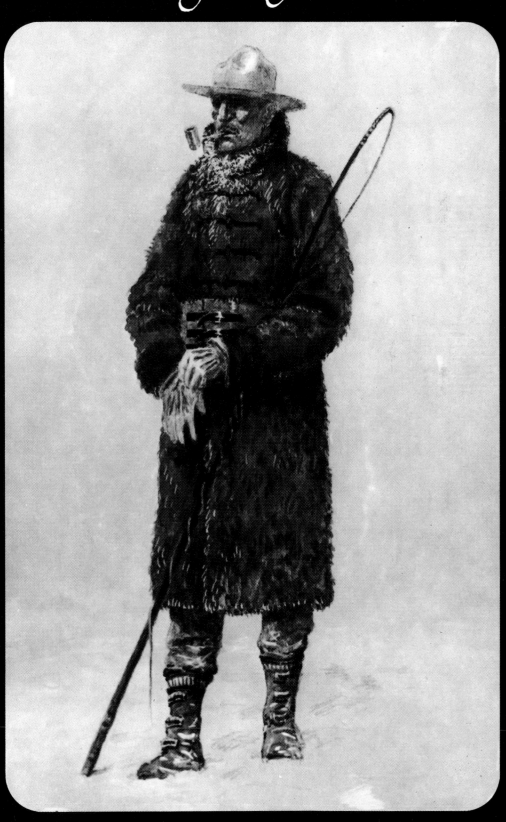

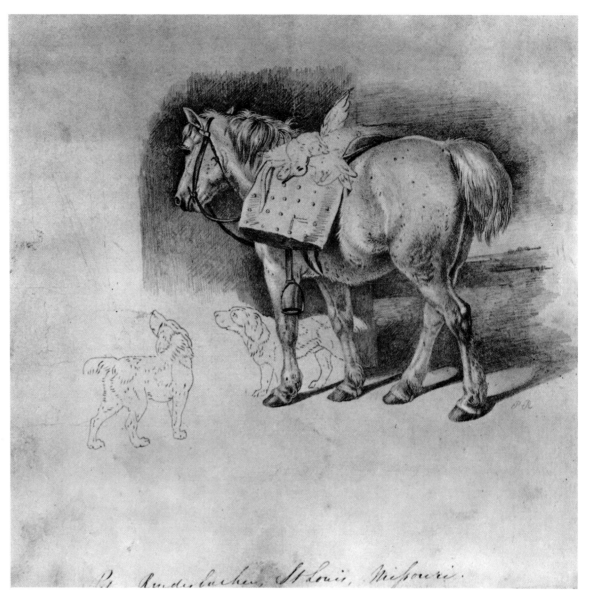

Pt. Anderbachen, St. Louis, Missouri.

Freighting & Western Commerce

By about 1850, the Conestogas that once had traveled the National Road had been replaced by railway traffic in the East. Many of these old wagons were brought by steamboat to the mouth of the Missouri River to be sold to emigrants on their way to the goldfields of California or Montana. Wagons were much in demand at several points along the western rivers and the needs of gold seekers and settlers alike stimulated the freighting business in this region. Indeed, the need for supplies on the part of settlers, miners, and soldiers in the western territories caused freighting to develop into one of the most profitable businesses on the frontier.

Communication was a problem first solved by individuals and later by organized companies such as the Pony Express. Travel and communications both were rendered easier and quicker by the establishment of regular stagecoach routes in later years. Oxen were used by the army in the 1820's and 30's to pull supply wagons while escorting traders along the Santa Fe Trail. In the 1850's, freight from Pittsburgh or Cincinnati was sent by steamboat to St. Louis and thence up the Missouri—by 1859, as far as Fort Benton. Gold was discovered in

Montana in the 1860's, and Fort Benton became the center of freighting activity in the Northwest, servicing growing settlements such as Helena, Virginia City, and Salt Lake City with supplies from the East.

Ox teams were used primarily in freighting during the gold rush of the 1860's. Conestoga-type wagons were common until the end of the American Civil War. Freighting centers such as Leavenworth, Independence, and Atchison, Kansas, prospered and grew rapidly, as did others at Omaha and Nebraska City. All sorts of manufactured items found their way across the western trails to thriving frontier and mining settlements in Montana, Colorado, and Nevada. Bar mirrors, fixtures, mine boilers, machinery, safes, and materials for the building of houses and stores were in great demand. Dry goods, hardware, and whisky were stock items upon which western commerce developed, expanded, and prospered.

Following the Mexican War, travel had increased on the Santa Fe Trail, and several men made fortunes in the freighting business supplying eastern goods to the western posts and settlements. Alexander Majors became one of the most prominent figures in the development of this commerce throughout the 1850's, contracting to bring lumber to Fort Riley as early as 1851. In 1855, Majors formed a partnership with two other men named Russell and Waddell. By the following year, this company operated between 300 and 350 wagons on the Santa Fe Trail. In 1857, Russell, Majors, and Waddell obtained another government contract to ship supplies into Utah. By 1860, this company owned three thousand wagons, forty thousand oxen, and a thousand mules and had established headquarters in Leavenworth and Nebraska City. In order to make the most profit from government contracts, Majors outlined a set of rules to be followed by freighting caravans based on his past experience in the business. These rules were used by large and small freighting companies throughout the western territories for a number of years.

Many of the bigger wagons especially designed for use on the Santa Fe Trail had been built in Missouri: vehicles such as the Murphy Wagon, which had a longer wheel base than the original Conestoga and was several boards higher on the sides to enable it to hold more freight. In later years, the mule teams used to pull these heavier wagons were driven by a man riding the near wheeler who steered the animals by means of a "jerkline" from his seat. A teamster popularly known as a "bullwhacker" drove the oxen pulling other freighters, walking alongside. Teams of ten or twelve mules often made as much as twenty miles a day on the long trip from Independence, Missouri, to Santa Fe—a distance of more than eight hundred miles.

Long caravans of freighters were divided into twenty-five-wagon units separated by two to ten miles. The wagon boss, riding a horse in the lead, had complete control over all the units of the train. An assistant responsible for keeping everything rolling maintained a constant check by moving back and forth along the train as it moved. A "skinner" was responsible for each mule team in the unit, a "bullwhacker" walked beside each team of oxen. A few outriders were assigned to handle emergencies and to help whenever needed. Others served as advance guards and flank guards to protect the wagon train from unexpected danger. With the entire outfit under the direction

147

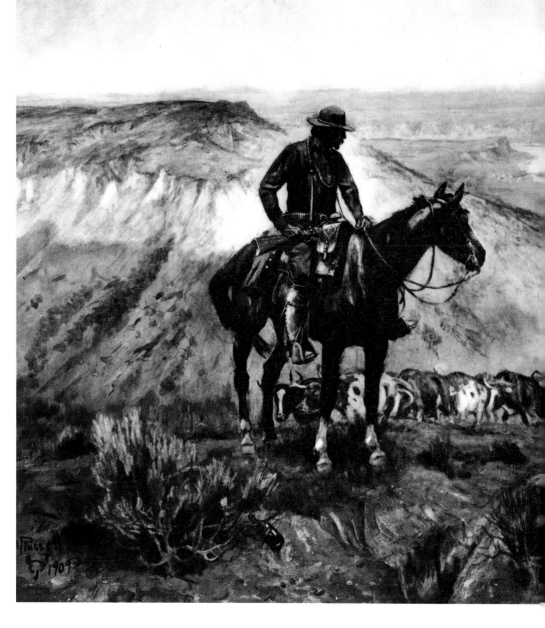

Current, sandbars, "sweepers," and even buffalo impeded the cargoes to the upper Missouri; once there, those colorful craftsmen, the bull-team wagon bosses, distributed the goods and provisions.

of the wagon master, each freighter took his turn at cooking, herding, and guarding, as well as attending to his regular duties.

From the 1820's on, freight wagons plodded westward from points of supply on the eastern fringes of the great plains region. Carrying blankets, salt beef, cooking utensils, sugar, flour, shovels, shoes, collars, and all kinds of machinery, they brought civilization in one form or another to the western wilderness. Artist Charles Russell in his painting *Wagon Boss* depicts a bull-team freighting outfit leaving Fort Benton, Montana, where goods were brought upriver on the Missouri by steamer.

By the 1860's, the Conestoga-type wagon had been replaced for the most part by the more box-like vehicles manufactured by such men as Jackson, Weber, Murphy, Schuttler, and Studebaker. Ungainly looking but ruggedly built, such wagons were designed to accommodate the jolts and twists characteristic of western frontier trails. Most weighed about a ton and stood from six to eight feet high, with a "box" about fourteen feet long, four feet wide, and from four

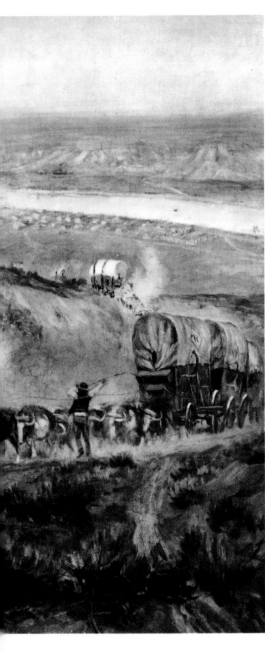

WAGON BOSS
C. M. Russell

to six feet deep. Such a wagon could carry as much as four thousand pounds. When the going was hard, oxen or bull outfits were preferred. The number of oxen varied with the load, but it was usual to see ten yoke pulling perhaps two or three wagons in tandem. The wagon boss often had charge of as many as 150 or more oxen and perhaps thirty-five men, not to mention responsibility for all wagons and supplies carried over thousands of miles of lonely, unsettled country. Russell shows his trail boss riding an Applehorn saddle, wearing "halfbreed" leggings, and carrying a Sharp's carbine rifle.

Russell's friend Olaf Seltzer was also interested in the types of men who freighted goods across the western wilderness. In his watercolor portrait entitled *The Teamster,* he has described a type common to the northern plains: a professional man as opposed to someone simply hired for the job who in most cases was anxious to make his way west however he could with the hopes of reaching the goldfields of Montana, Colorado, or California. Here Seltzer has dressed his teamster in the plainest of clothing, which includes heavy woolen pants and square-toed working boots that later gave way to the heavy work shoes of the 1880's. A woolen "hickory" shirt, plain or checked, and a soft-brimmed hat complete his outfit.

The teamster commonly walked beside the oxen under his charge on or near the left side, guiding them with the familiar "hee," "gee," "haw," and "whoa" signals, urging them on, perhaps, with various expletives and a sufficient amount of profanity to fit the particular occasion or the peculiar habits of individual animals. He was assisted in this job by a large "bull" whip ten feet or more in length, fashioned usually of braided rawhide with a long handle and a six-inch "popper" at the far end. This he wielded with authority, swinging it over the head a few times to get it under his control and then directing it forward to crack just above the ear of the animal in need of instruction.

It was a hard job. By the turn of the century, the thud and clack of oxen hoofs, the clanking of chain, and the creak of wood were gone from the western scene. Characters from other walks in life were praised in song and story, their exploits recounted in dime novels and later the moving pictures. The lowly freighter, however, has remained, like the farmer and the small-town merchant, largely ignored. A decidedly unromantic figure, he nevertheless carried the goods that served and supported the development of civilization in the settling West.

Detail from illustrated letter by O. C. Seltzer

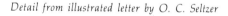

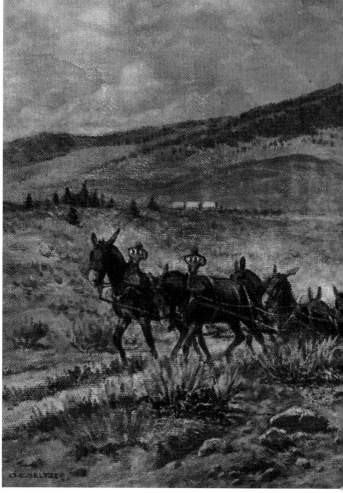

JERKLINE OUTFIT
O. C. Seltzer

THE TEAMSTER
O. C. Seltzer

Faster than the ox and tougher than the horse, the mule became the draft animal of western outfits like the "Diamond R" Freighting Company. Sometimes tougher than all three was the "mule skinner."

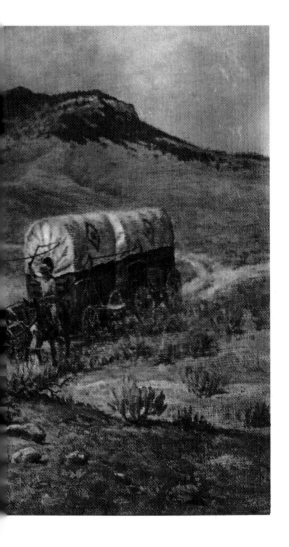

As a heavy draft animal, the horse was surpassed by both the mule and the ox. In the East, where roads were better built and good forage and shelter available, the four- and six-horse "bell" teams were adequate to almost every need. On the western plains, however, horses were unable to keep in really good condition over a long period of time because of the harshness of the climate and sparser grazing. Horses also were subject to a number of diseases to which mules or oxen were immune and had the added disadvantage of being much more subject to the depredations of marauding Indians than other draft animals.

At the outset of the Santa Fe trade, a good mule could be purchased for as little as nineteen dollars. By 1840, mules in Missouri sold for two hundred dollars to as high as four hundred a span. Combined with the relatively high outlay of money required to outfit a team of mules with harness and gear, cost limited their use primarily to prosperous freighting companies or the government. In the long run, however, the mule more than paid for the expense of his initial purchase by being durable, adaptable, and long lived.

In selecting a good team of mules, the largest pair, or span, was picked to serve as the wheelers. Next to the wagon tongue, these controlled the wagon's direction and provided the necessary holding power when going down steep inclines. The smaller, "smarter" span was placed in the leading position. It was they who passed on signals received from the driver to the entire team. The "nigh" or left leader usually was the best trained and the one who received directional orders via the jerkline in the hands of the driver astride the nigh wheeler. A long steady pull brought the team to the left. A series of short, fast jerks caused the nigh leader to turn to the right to avoid the attending, sharp pain from the bit. On sharp bends in mountain country, "swing" teams had to learn literally to jump the chain between them to the outside and back again once the turn was completed. Harness bells were sometimes of practical use in rough country, giving warning of the approaching outfit.

Olaf Seltzer depicted a jerkline outfit in a painting included in his "Western Transportation" series. He marks it as one belonging to the "Diamond R" Freighting Company, the largest in the Northwest in the nineteenth century. Every item belonging to the "Diamond R" carried its brand, including many of its wagon masters and teamsters who had the brand tattooed on their arms or chests.

The heavy immigration into California during the 1850's encouraged the rapid exchange of goods between the Atlantic and Pacific coasts. Industries such as mining, fishing, lumbering, and even some manufacturing developed, each contributing to the prosperity

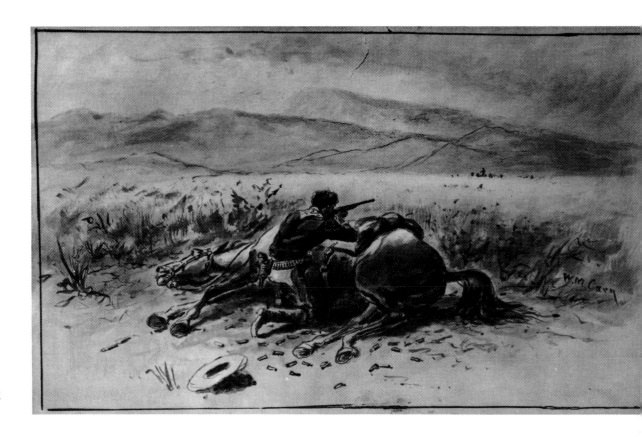

GOING IT ALONE
William Cary

and stabilization of community life in their respective locales. It wasn't the miner or prospector, however, but the farmer and businessman, who made the most substantial gains, laying the real foundations for the future in the Far West.

The expansion of industry, commerce, and agriculture directly influenced the scope and character of transportation and the freighting business in California in particular. Marked tendencies toward the formation of large-scale operations, especially in mining and ocean commerce, quickly appeared. In 1854, the California Steam Navigation Company was formed, and a month later the California Stage Company was organized. Later that same year, a similar organization in the express field was started.

Those with business foresight quickly profited from the needs of the gold seekers and others who had to have transportation and supplies. Mule trains, wagon trains, riverboats, stagecoaches, and express-lines all served the growing population in the years before the completion of the transcontinental railroad. The pack train and the wagon were indeed vital to the development of a flourishing mining industry in California and several regularly scheduled freighting lines were in operation in this region by 1854.

Express companies were organized to carry mail, since the government did not supply a dependable service to such distant locations as the West Coast settlements. Soon these express companies transported gold, small parcels, and other valuables, and issued bills of exchange. Larger firms did general banking. By 1860, some 264 express companies were in operation in California alone. Adams and Company, an Eastern-based firm, opened a branch office in San Francisco, absorbing most of the other and smaller companies by 1853. Rivaled only by Wells Fargo, also financed by Eastern capital, Adams and

The Pony Express hired only young, "skinny wiry fellows," expert riders who were willing to risk death daily to carry the U.S. mail

MULE SKINNER
O. C. Seltzer

ATTACK ON THE JERKY
O. C. Seltzer

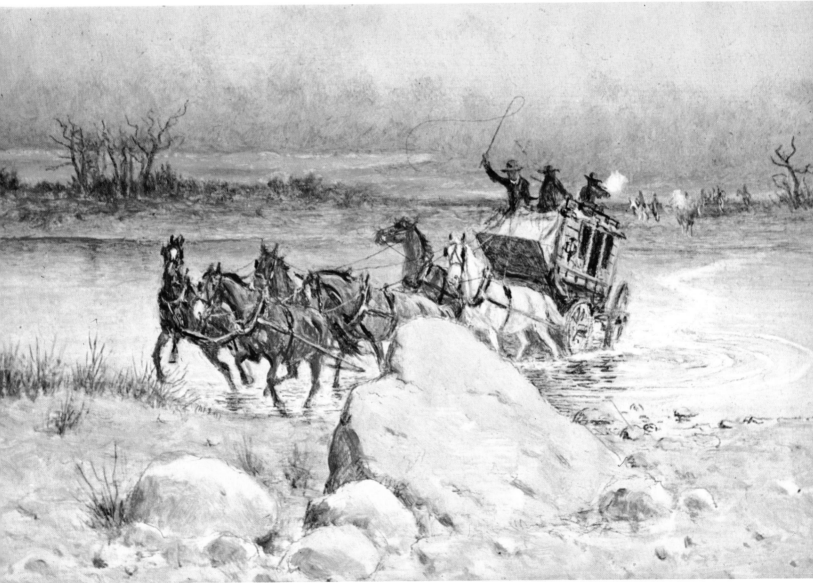

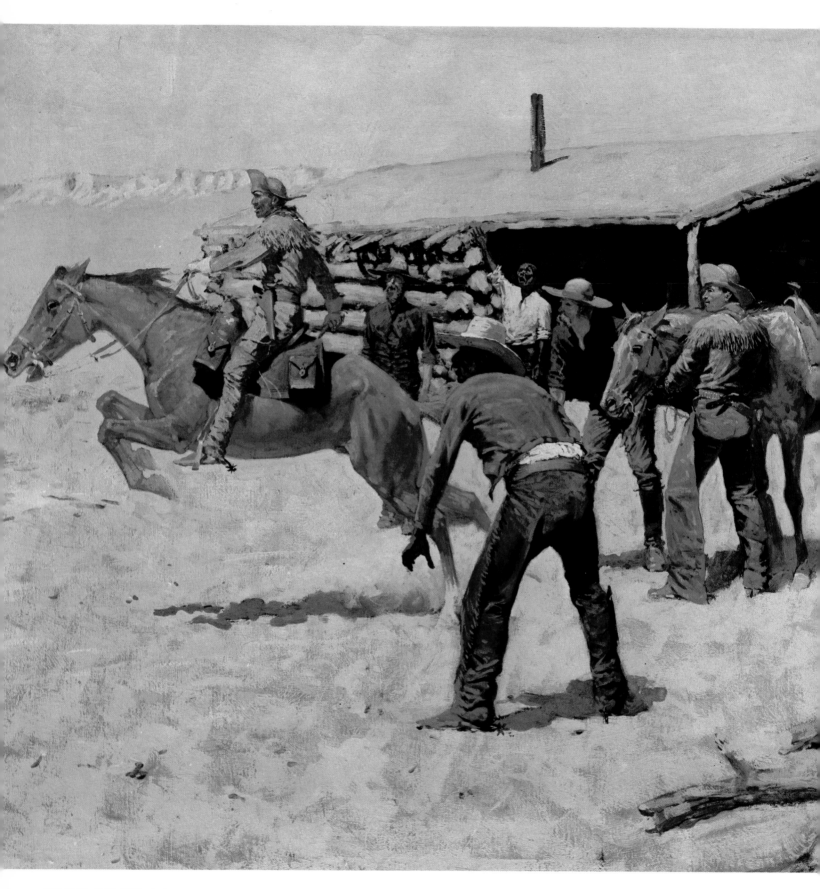

COMING AND GOING OF THE PONY EXPRESS
Frederic Remington

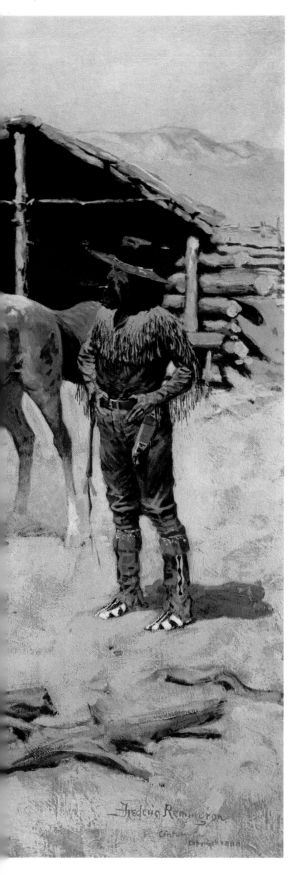

Company collapsed during the panic of 1855. Both firms established banks in the interim, transported gold dust, handled merchandise, and carried the mails. Wells Fargo survived the economic crisis of '55 to become the principal express company in the Far West.

In January 1854, the majority of the California stage lines merged to form the California Stage Company, which by 1860 was the second largest staging business in the United States, with routes all over California serviced by some 170 stations. Stage travel during the 1850's and 60's was not particularly comfortable but was dependable and maintained a regular schedule. The transport of mail by stage was in part supported by government mail contracts. The Butterfield Overland Mail provided a regular and reasonably rapid connection between California and the East until the outbreak of the Civil War.

The Pony Express, or "pony mail" as it was sometimes called, was a short-lived but nevertheless widely celebrated experiment to prove that a central overland route to California was at once the most practical and most readily available means of transcontinental communication. Eventually, the route taken by Pony Express riders influenced the location of the Pacific railroad. The idea for this unique service originated in 1854 with a California senator named William M. Gwin, who, after traveling the proposed route with B. F. Ficklen, superintendent for the Russell, Majors, and Waddell freighting firm, submitted a proposal to Congress for a fast mail service from Missouri to California. By 1860, Russell, Majors, and Waddell had chartered the Central Overland California and Pike's Peak Express, operating a freight service as well as a fast weekly overland mail service soon to become known as the Pony Express.

Starting from St. Joseph, Missouri, riders headed west traveling in relays varying from fifty to a hundred miles in length with a change of horses every fifteen or twenty miles. Eighty young men and four hundred fast horses were employed at the outset, carrying mail all the way across the central plains, the Rockies, and the deserts to Sacramento. The first rider left St. Joseph on April 3, 1860, at the same time his counterpart in California started eastward on what was to be a 1,966-mile run. By October 24 of the next year, the last link in the transcontinental telegraph was completed, bringing an abrupt end to the fast-riding pony mail service. A brief episode in the annals of western history, to be sure, the Pony Express captured the attention and the imagination of generations to come, providing the subject for many legends and oft-repeated exploits.

Only the youngest, toughest, and most daring men were encouraged to apply for jobs with the Pony Express, as an advertisement appearing in the San Francisco papers of March 1860 bears ample testimony:

WANTED: *Young skinny wiry fellows, not over eighteen. Must be expert riders willing to risk death daily. Orphans preferred. Wages $25.00 per week. Apply, Central Overland Express, Alta Building, Montgomery Street.*

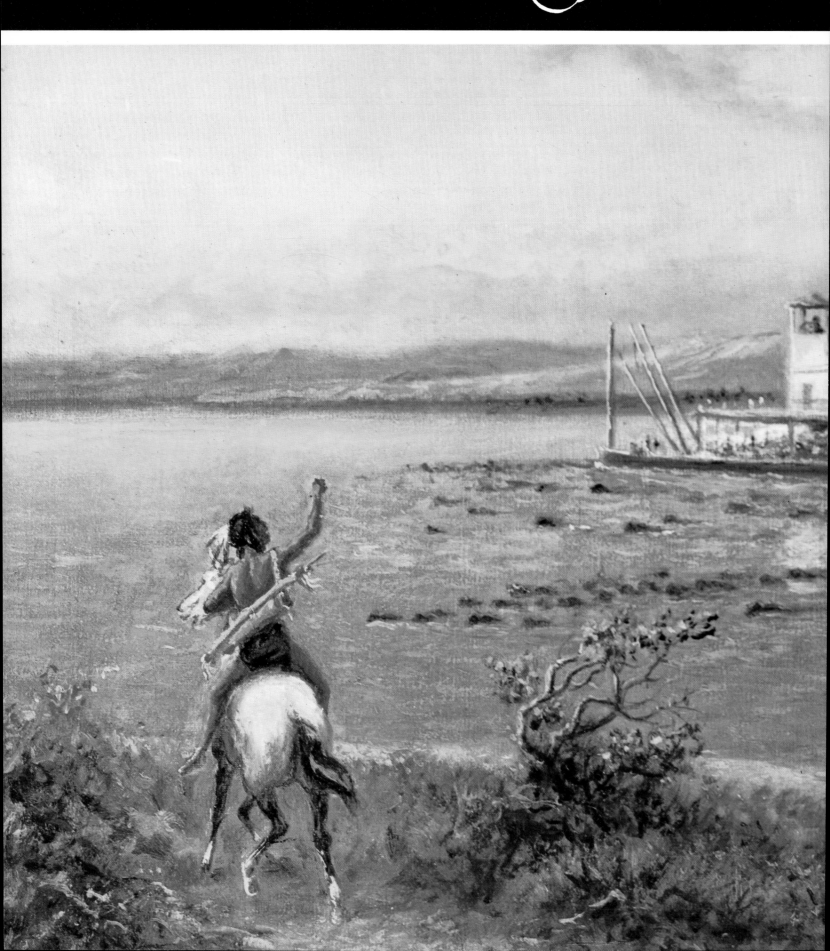

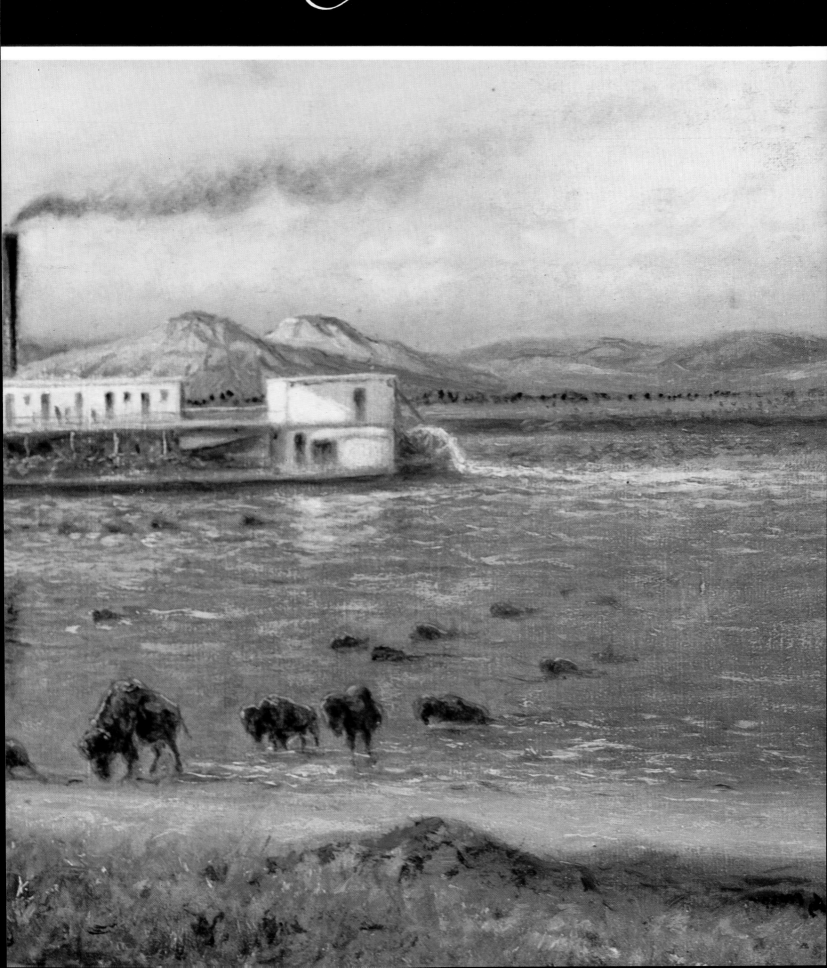

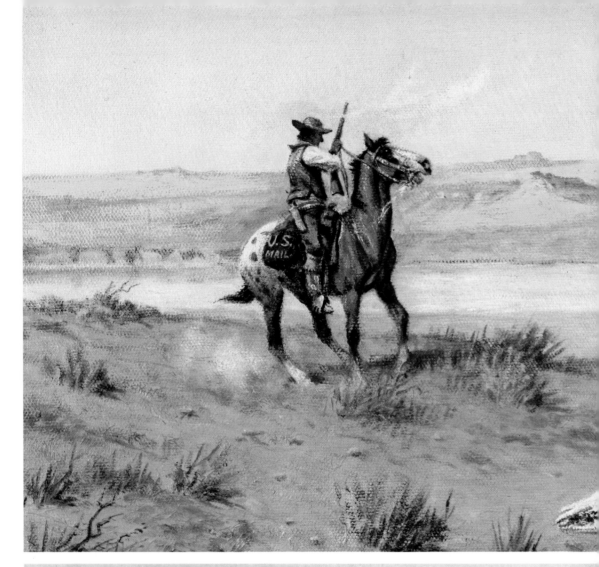

CARRYING THE U.S. MAIL
O. C. Seltzer

FREIGHTING FROM FORT BENTON
O. C. Seltzer

Mud holes, washouts, dust, Indians, and road agents made stage travel uncertain and uncomfortable at best, downright hazardous at worst.

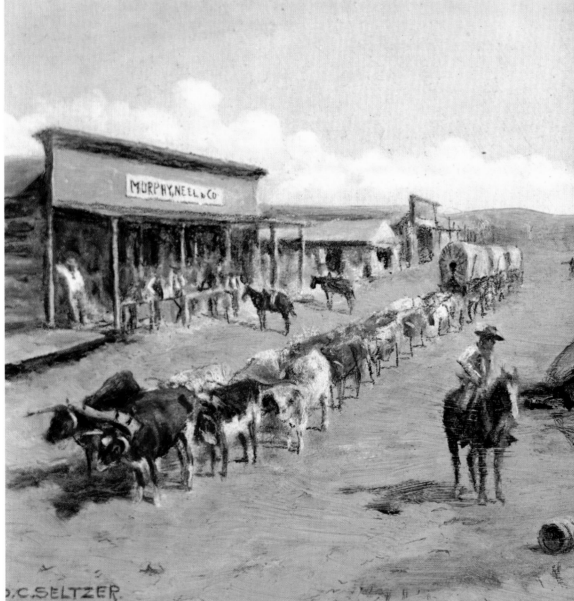

The urgency of the need is perhaps apparent by the amount of wages offered in this instance, twenty-five dollars per week being a truly phenomenal sum in those days for such employment. Nor was the reference to being prepared to "risk death daily" an exaggeration, considering the country through which many of these riders would be called upon to travel. Encounters between Pony Express riders and wandering Indian bands, as depicted by Seltzer in his oil painting *Carrying the United States Mail,* represented only one among many possible hazards to be faced in the largely unsettled western and central regions of the country at that time.

Weight also was a factor of importance with express riders. The combination of saddle, saddlebags, and bridle never exceeded fourteen pounds, and riders usually were limited to carrying only two Colt revolvers and a sheath knife for protection—or in some cases, one revolver with an extra cylinder providing a total of at most ten or twelve shots. Riders were discouraged from fighting, however, admonished instead to depend upon the speed of their carefully selected mounts in case of danger. The horses themselves averaged about fourteen hands high and weighed approximately nine hundred pounds. Riders averaged between 124 and 135 pounds.

These lightweight express riders were required to take the following oath before joining up:

I, _____ , do hereby swear, before the great and living God, that during my engagement, and while I am an employee of Russell, Majors and Waddell, I will under no circumstances use profane language; that I will drink no intoxicating liquors; that I will not quarrel or fight with any other employee of the firm, and that in every respect, I will conduct myself honestly, be faithful to my duties, and so direct all my acts so as to win the confidence of my employers. So help me God.

Pony Express saddles were especially designed for the service. Most were made by the Israel Landis Saddlery of St. Louis, Missouri, and were basically a stripped-down version of the common stock saddle in use at that time. The tree resembled the lightweight rig of the Mexican *vaquero,* and another Spanish innovation—a saddle cover known as a *mochila*—sported mail pockets. Remington shows this saddle in his famous painting *Coming and Going of the Pony Express.*

Contrary to many artistic renderings and film presentations, loose saddlebags were not used by express riders. The *mochila* had an opening for the saddle horn and the cantle and was held down by the weight of the rider. Coming into a station, it was thus a simple matter for the rider to dismount, grab the *mochila* and slap it onto a fresh horse, mount, and ride on. A rider with the Pony Express was allowed no more than about two minutes to effect such a transfer.

One rather peculiar feature of Remington's painting is the type of saddle on the horse that has been ridden into the change station. The animal is shown wearing a double-rigged saddle, or one sporting double cinches. While the double-rigged saddle may have been employed on occasion, it was by no means favored or common, single-rigged saddles being the accepted standard. But whatever may be argued or deduced concerning Remington's version of the scene, his work still manages to command the modern viewer's interest with respect to one of the epic moments in the history of the West.

*Untitled study of
a horse by W. R. Leigh*

WHY THE MAIL WAS LATE
O. E. Berninghaus

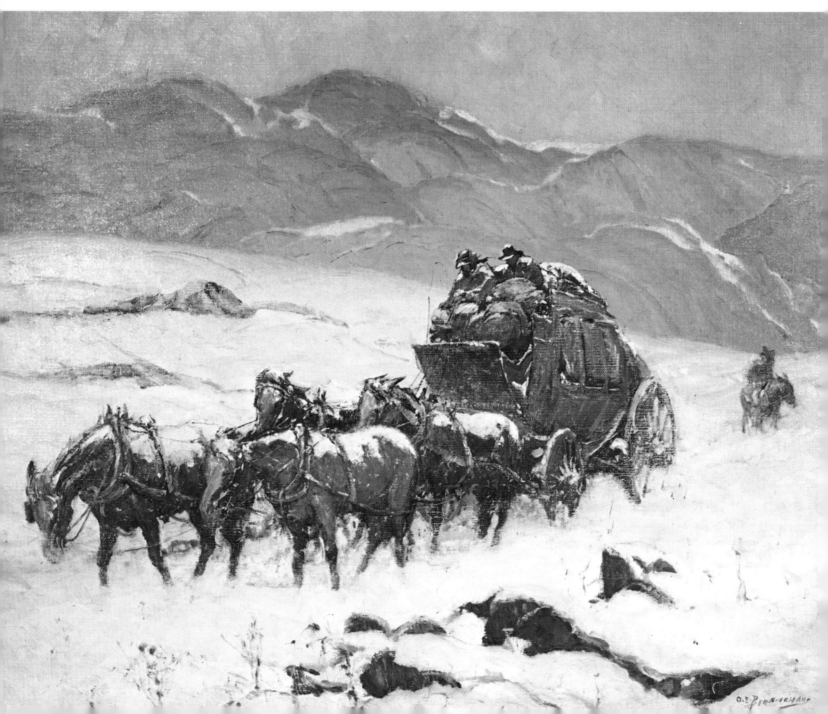

Built for service, not comfort, the stagecoach was used as a mail and passenger service vehicle throughout all parts of the West, until replaced by the faster transcontinental railroad system.

In 1848, Cincinnati, Ohio, was the western railroad terminus. Stagecoaches went no farther than St. Joseph and Independence, Missouri. Railroads and steamboats continued in use on the eastern seaboard and fast, six-horse stages carried passengers as far as the Mississippi. At this same time, the pack mule, horse, and ox cart served transportation needs on the West Coast. Lack of adequate communication facilities in the Far West prevented the news of the discovery of gold in California from spreading to most parts of the United States before about September 1848.

Half the emigrants who went to California never reached the goldfields, but remained instead to populate the growing settlements. Most of these people at the time of the 1849 gold rush were living along a frontier that extended up and down the banks of the Mississippi. More than eight thousand people left eastern American ports to attempt the long voyage to California via the southern tip of South America. Those with more money and less patience crossed the Isthmus of Panama.

By the Guadalupe-Hidalgo Treaty of 1848, California was made a possession of the United States and at that time had a population estimated roughly at about twenty thousand. San Francisco had a population of perhaps a thousand; Los Angeles was nothing but a "cattle settlement." Indeed, cattle raising was the main source of income in California during the years before the gold rush of the 1850's. El Camino Real—The King's Highway—was nothing but a trail connecting the mission settlements strung along the Pacific Coast.

By 1860, the United States was a restless giant moving ever westward. Land was free and gold, grass, and buffalo drew men deeper into the plains and mountain country. The demand for a faster mode of travel became apparent. The freight wagon and Prairie Schooner carried many people, goods, and supplies, but they were slow-moving. In the West, wagons and omnibuses continued to be used by the pioneering stageline proprietors until, from the East, came the answer to the problem of more rapid East–West transit: the overland stage-

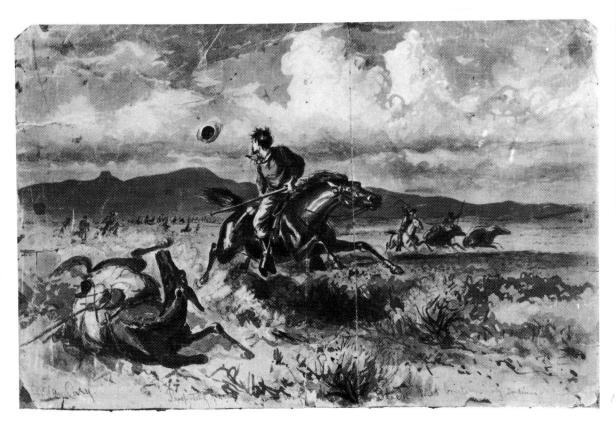

MINERS ATTACKED BY INDIANS
William Cary

THE STAGE COACH
Edward Borein

coach, the first of which arrived in California as early as the summer of 1850.

Given the name of the New Hampshire town where it was first manufactured, the famed Concord overland stage proved a boon to westward travel. Weighing over a ton, this vehicle was characterized by a construction principle in which the body of the coach rested upon "thoroughbraces," or stout leather straps attached to braces fastened to the front and rear axles. This system of suspension was superior to any other known at that time, especially suitable for traveling the rough western trails, but it also caused the body of the coach to rock or roll back and forth in a manner that once prompted Mark Twain to dub the Concord a "cradle on wheels." The swinging and swaying identified with this vehicle, though far from comfortable at times, had certain advantages over the sharp "jerk and jar" of the more rigid spring wagons.

Built of the finest materials, the Concord sported basswood panels, steamed and curved to fit a heavy ash frame. Wheel hubs were made from specially seasoned elm and rimmed with the hardest of hickory. Spokes were fashioned from oak. The oval-shaped body was a modified and enlarged form of an earlier design with enough upholstered seats to accommodate as many as nine passengers inside and places for perhaps a dozen more on top. At the rear of the coach, or sometimes in front, were what were known as "boots"—leather-covered racks made to hold mail, express, and baggage. Directly under the driver's box was another compartment, often chained and locked, which held gold dust, bullion, or other articles of high value.

The majority of these coaches were either mail coaches or the sturdy "mud wagon," both built by the Abbot-Downing Company of Concord, New Hampshire. The mail coach was listed in the company's catalogue in 1870 at a price of $1,120, complete, the mud

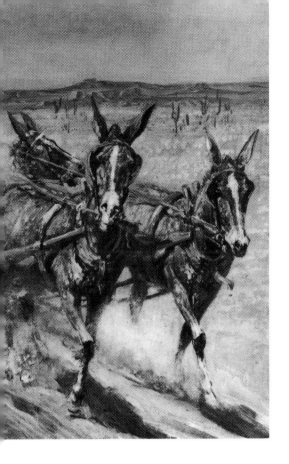

wagon at $625. Most were highly ornamented and painted in various colors, their sides decorated with gilt scrollwork, landscapes, portraits, or well-known landmarks. The wheels and undercarriage were also highly decorated. No two were alike.

The name of the company using the coach normally was painted above the door and windows, with "U.S. Mail" or "U.S.M." appearing above the door. Sometimes a driver's name was registered on the sides of the box. Many coaches were christened with individual names of their own: Prairie Queen, Argosy, and so on. Several coats of varnish were applied over the finished coach. Elegant to look at, these coaches were built for service, many continuing in use for thirty years or more in all parts of the West. The standard nine-passenger coach had two high-backed seats facing each other and a jump seat in the middle with a wide leather band providing a back rest.

Artist Ed Borein, in his painting entitled *The Stage Coach,* has depicted what was probably a coach on the line organized by the U.S. Post Office Department in 1857 running from San Antonio via the Santa Fe Trail to El Paso and thence to Yuma, where it often proceeded only under cavalry escort through hostile Apache country. Mules were used on the run from El Paso to Yuma because they were so much better suited to the rigors of the desert climate. These mule-drawn stages promptly were dubbed the "Jackass Mail" or "Jackass Express." Mail and passengers from Yuma westward continued by pack mule and muleback. The coach described in this instance is the familiar "mud" coach or wagon, which was not only a cheaper item than its more handsome counterpart, the larger Concord mail coach, but lighter and generally more adaptable to the rougher regions of the American Southwest.

Handling a six-horse hitch was no easy matter. The driver's control over his team was chiefly through the lines, six in all, separated between the fingers. Contrary to what most people have seen in today's movies, a good driver did not need to crack a whip or yell at his animals. He started them by talking to them or merely by pulling the lines up gently and then loosening them. A well-trained team would move out with a simple signal or command. The whip held in the right hand was used only in correcting an occasional unruly animal or breaking the team into a run.

Although a few stagecoaches in use in the Sierras were equipped with runners in the event of heavy snows, for the most part the common wheeled coach was used throughout the winter months. Sometimes, however, a vehicle was delayed or stalled by heavy drifts, in which case many passengers were left with the choice of staying aboard until out of the difficulty or walking to the nearest station. The late contemporary New Mexican artist Oscar Berninghaus recalls the difficulties of midwinter mountain travel in his painting *Why the Mail Was Late,* describing a big Concord mail coach halted at the top of a pass while the horses take a breather. From all indications of the load this coach is carrying and the country in which it is traveling, it seems that more than four horses would have been employed. But perhaps the artist took the liberty of eliminating at least two horses in his picture so as to effect a better composition, unaware that in so doing he was stretching a factual point.

S tages had their share of ill fortune throughout their use in the West. At best roads were rough, and at times impassable. Weather was an ever-present consideration and even when not so bad as to actually hinder the progress of the coach, it proved a source of discomfort for passengers, who complained of the cold or the heat or the dampness—or all else failing, of dust almost beyond description. Runaway teams were a frequent danger, robbery another hazard for stages carrying gold or silver shipments or payrolls. Harassment by hostile Indians was yet another factor of the trail to be considered, as evinced in Olaf Seltzer's rendition entitled *Attack on the Jerky*, included in the series of miniature oils depicting frontier life in Old Montana Territory.

At no time were conditions on the overland stage routes altogether suited for comfortable travel. While passengers might learn to put up with discomforts, harassments, and delays, to many of the men who operated the coaches and stations along the way such circumstances were accepted as a matter of course and little remarked upon. Traveling by day or night in all kinds of country and climate, they grew accustomed to the lack of civilized usages and conveniences. An old story about an alleged conversation between a driver or stock tender and a stage passenger at the old Julesburg, Colorado, station in the summer of 1863 admirably illustrates the point. While the driver sat waiting for a change of horses, so the story goes, he was observed by one of the passengers in the act of scratching himself vigorously. Watching the activity with some interest, the passenger inquired of the man if he was troubled with fleas.

"Fleas, fleas!" replied the other, "do you take me for a damned dog? There's no fleas on me. Them's lice!"

Whether it was hauling mining equipment to Colorado with a ten-yoke bull team or a piano to a saloon in a booming Montana town with a jerkline outfit, wheeled vehicles played a big part in the settlement of the West. Even the lowly farm wagon hauled many families to new homes in the new country, while in later days the stagecoach brought mail, money, and men of all sorts to the distant towns and settlements beyond the frontier. The advancement of the railroad eventually replaced most of the earlier modes of transportation, especially in the freighting line, although the overland stages continued to operate for a number of years between railroad terminals. Nat Stein, who for years was involved in the overland stage business, first as a messenger and later as an agent in Central City and Denver, Colorado, became known in time as "the poet of the stage line." His best-known poem, later a ballad, is "The High Salary Driver on the Denver City Line," which first appeared in print in 1865 and soon became a favorite song of the overland line workers. Embellished with many verses, the chorus went:

Statesmen and warriors, traders and the rest
May boast of their profession, and think it is the best;
Their state I'll never envy, I'll have you understand,
As long as I can be a driver on the jolly "overland."

Observations of the Buffalo and Other Wild Animals of the West
Hunting & Sporting Scenes

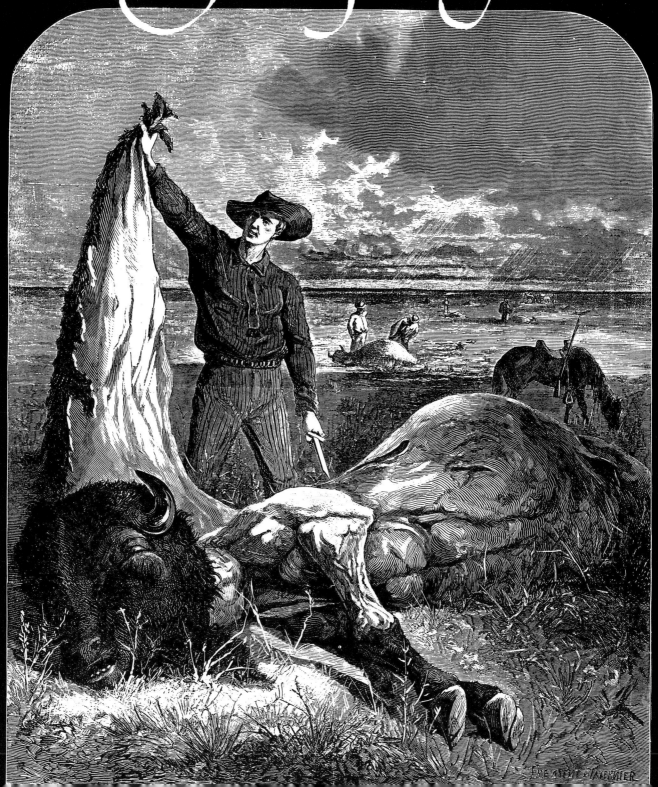

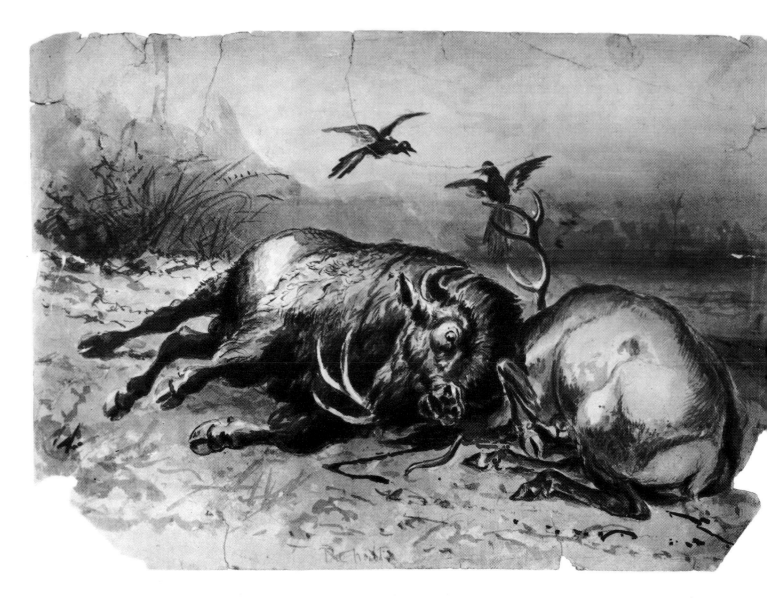

Hunting & Sporting Scenes

At the time of its discovery, the continent of North America was home to an incredible number of wild animals. Deer, antelope, and other hoofed animals ranged in countless millions along with a corresponding number of bears, wolves, coyotes, mountain lions, and lesser predators. Fur-bearing species such as the beaver, muskrat, otter, mink, and fox provided the basis for wealth in the early colonies and were responsible for the exploration of great portions of the wilderness. Damned, praised, hunted, trapped, eaten, and otherwise utilized, the wildlife of America represented one of the most valuable natural resources of the New World, one that was exploited fully throughout the history of the expanding frontier.

Especially in the trans-Mississippi west, wildlife played a vital economic role. Most numerous by far of all the larger hoofed mammals was the bison, or "buffalo" as it was called erroneously by early observers. Found originally over most of what is today the United States, Canada, and northern Mexico, its numbers have been estimated as high as one hundred and twenty-five million, although the figure is now thought to have been much lower. Naturalist William T. Hornaday estimated the bison population in the 1830's at not more than sixty million. Other statements by frontiersmen and travelers in the West in the nineteenth century indicate herds in the central plains of a size sufficient to impede the progress of wagon caravans, river craft, and trains.

SLAUGHTERED FOR THE HIDE (*previous page*)
by Paul Frenzeny and Jules Tavernier

In a letter written to Hornaday in 1871, Colonel R. I. Dodge described the size of a herd in Kansas in the following terms:

"The greatest herd on the Arkansas through which I passed could not have averaged, at rest, over fifteen or twenty individuals to the acre, but was, from my own observation, not less than 25 miles wide, and from reports of hunters and others it was about five days in passing a given point, or not less than 50 miles deep."

Elaborating on his large canvas entitled *Herd on the Move* in an exhibit catalogue in London in the 1860's, artist William Jacob Hays was quoted as saying:

By the casual observer this picture would, with hardly a second thought, be deemed an exaggeration, but those who have visited our prairies of the far west can vouch for its truthfulness, nor can canvas adequately convey the width and breadth of these innumerable hordes of bison, such as are here represented coming over a river bottom in search of water and food, their natural instincts leading them on . . . As far as the eye can reach, 'wild herds are discernible; and yet, farther behind these bluffs, over which they pour, the throng begins, covering sometimes the distance of an hundred miles. The bison collect in these immense herds during the autumn and winter. Migrating south in winter and north in summer, and so vast is their number that travelers on the plains are sometimes a week passing through a herd. They form a solid column, led by the strongest and most courageous bulls, and nothing in the form of natural obstacles seems ever to deter their onward march . . .

Little is known of Hays except that the bulk of his works representing American wildlife resulted from his one trip up the Missouri River in the summer of 1860. This particular painting he left behind in England when he returned to the States, and it was rediscovered in a small bookshop by an American, Walter P. Webb, in 1938. Four years later Webb returned to England and purchased the painting, arranging for its shipment to his home in Austin, Texas. Oilman Thomas Gilcrease met Webb in San Antonio after the war and purchased the work for the Gilcrease Institute in Tulsa.

The enormous congregation of animals in this picture probably represents the gathering of many smaller groups. Cows, calves, and young bulls usually made up such herds, with older bulls traveling about the fringes. Chiefly a plains animal, the bison was found in the mountains and woodlands as well. The largest mammal on the continent of North America, a mature bull of six years might stand six feet at the shoulder and weigh anywhere from eighteen hundred to more than two thousand pounds.

Other than man, the "buffalo" had few enemies, among whom the rangy "buffalo wolf" and the grizzly bear predominated. The rutting season occupied the months from July through September. Calves were born in April, May, or June of the following year. In common with most hoofed animals, new-born calves were able to follow their mothers about within a very few hours.

The bison represented life itself to the Indians of the great plains region. Feasting on freshly killed animals called for celebration. When fresh meat was hard to find, the Indians ate preserved meat. The most common was pemmican, made by pounding dried meat into a pulp and mixing it with buffalo fat before storing it in buffalo-skin

Untitled sketch by William Cary

The lush grasses of the great plains—the "extensive meadows" of the early British cartographers— supported vast herds of hoofed mammals, of which the bison was the most numerous.

167

bags. "Jerky" was made by cutting fresh meat into thin strips and hanging the strips in the sun to dry almost to the toughness of leather. Strips of jerky also were packed within layers of uncooked buffalo fat and berries and stored in parfleche bags or pouches.

Buffalo hide served many purposes. Animals killed during the winter months had heavy coats, suitable for making robes and blankets. Caps, mittens, and moccasins also were made from these skins. Animals taken in the spring or fall carried a lighter pelt, suitable for the making of shirts, dresses, leggings, or other light-weight garments. The skins of calves were used in the making of underclothes. Bull hides, being heavier than those of the cows, were used in manufacturing horse gear, saddle coverings, and the like. Raw strips of bullhide were used to tie war clubs or other implements to wooden hafts or handles. Dampened and sewn or wrapped in place, the rawhide thongs when dry shrank tightly and effected a firm bind. The thicker hide taken from the animal's neck or rump, also shrunk, made a tough war shield. Thin summer hides taken from cows were used in fashioning tipi covers, and the hoofs, dewclaws, and other parts of the animal served ornamental purposes.

The Indian men did all the hunting, fishing, and butchering. Only when game was killed near camp did women help dress the meat. Parflecheing and jerking meat was done by the women, however, and the dressing of skins was an important industry among all the plains tribes. A woman's worth very often was measured by the amount of her production of dressed hides. Her ability to utilize other parts of the animal in fashioning various tools and implements also was im-

Damned, praised, hunted, trapped & eaten, the wildlife of the West was exploited to the point of extinction,

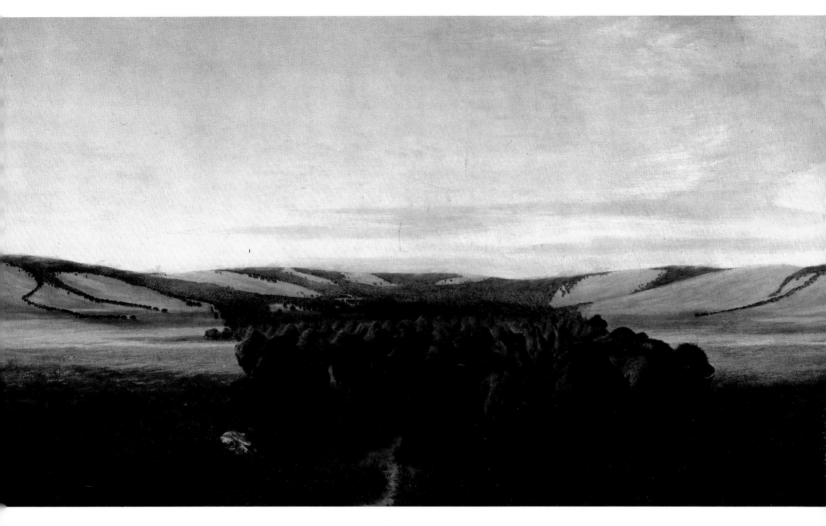

HERD ON THE MOVE
William Hays

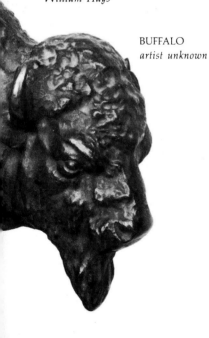

BUFFALO
artist unknown

The buffalo represented life itself to the Indians of the plains. Buffalo meat provided food, and buffalo hide was used to make garments, robes, and coverings for the Indian lodges or tipis. Even the hair of the animal was utilized to make ropes and its sinew to make thread. Agriculture, pottery-making, and other earlier, more sedentary pursuits were forgotten or adapted to the nomadic way of life of those who followed the migrating herds.

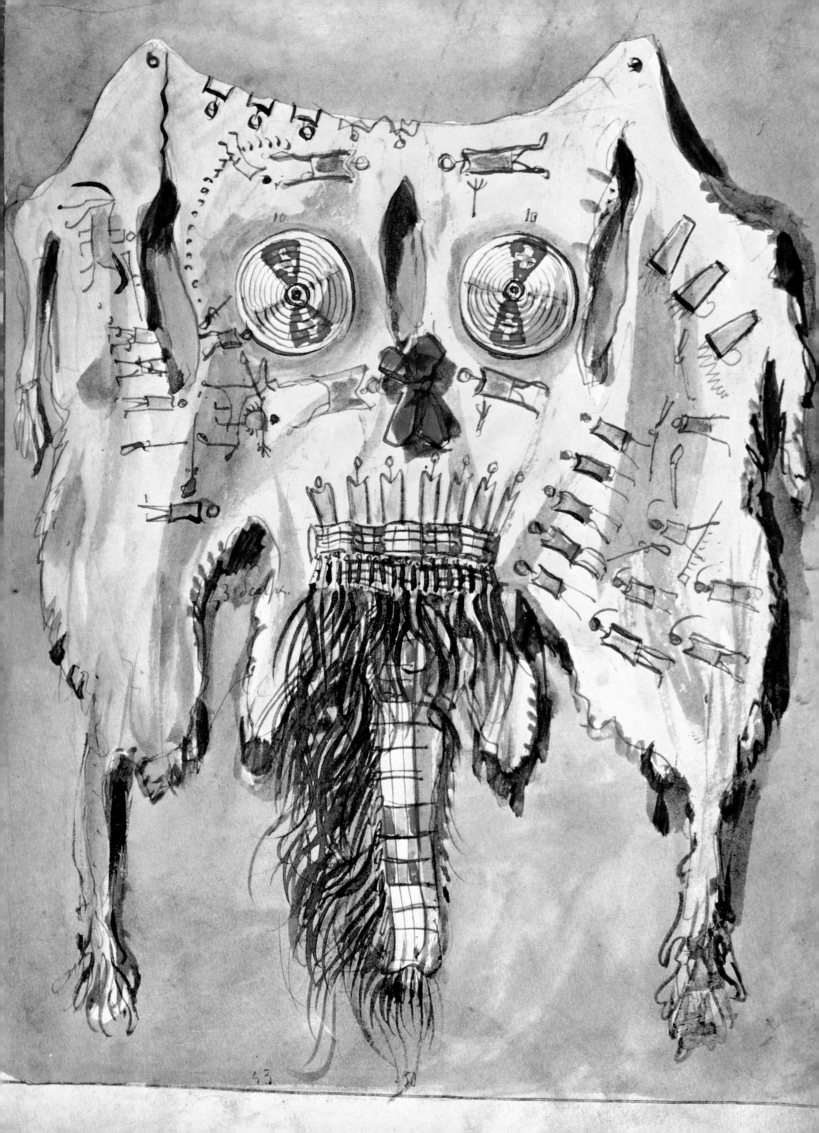

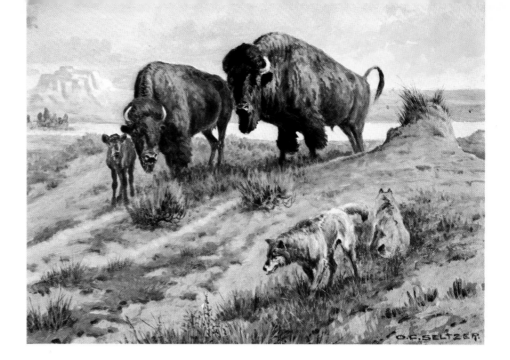

BUFFALO FAMILY
O. C. Seltzer

ORNAMENTED BUFFALO ROBE
George Catlin

portant. Bones were employed to serve as scrapers and ladles. Horns provided material for spoons and cups. Sinew was used as thread. The stomach, when cleaned, provided an excellent bag for the carrying of water or food. Buffalo dung, or "chips," constituted the universal substance for fuel on the treeless plains.

Numerous accounts of buffalo hunts by both white hunters and Indians survive among the reports published throughout the nineteenth century. Few, if any, are still alive who remember having participated in such adventures, but a few stories have been passed along by word of mouth to the present generation. From such narratives as these, a reasonably accurate picture can be reconstructed of the activities of the plains hunters in a day when the buffalo was the most populous animal in the West.

Among the Indians, scouts were sent ahead to locate the wandering herds—huge during the rutting season, small at other times of the year. When buffalo were discovered, great care was taken not to disturb them. Medicine men or priests were consulted as to the signs indicating the proper time to commence the hunt. Prayers were offered up and sweet grass or pieces of pine burned as offerings to ensure the success of the venture. Horses were rounded up to serve as pack animals and hunting equipment was readied. On the morning of the hunt itself, the camp came to life early, the hunters riding out before daylight to overtake the distant herd.

The majority of Indian plains hunters wore only moccasins and breechclouts for covering, bows and arrows being carried in the hand. A few individuals might carry guns, particularly in later days, with a powder horn slung over one shoulder and a half dozen musket balls carried in the mouth. Some riders sat on padded saddles and many rode bareback. Each horse was equipped with a simple bridle of a rope tied around its lower jaw, the opposite end let free to drag the ground so that if the rider were thrown during the hunt he could grab it. The horses were ridden from camp at an easy pace in order to save their strength for the contest ahead. Sometimes a hunter rode one horse and led his favorite "buffalo mount" behind. When the herd was spotted, the party drew up and last-minute preparations were made. Bows were strung or guns loaded, and the hunters approached the grazing animals quietly, in a closely packed formation of men and horses.

At first sight of the hunters, the buffalo usually started to run, at which point the head man gave the signal for each man to give chase. The faster horses soon caught up with the herd and pressed toward its head, where the cows and calves generally held the lead. Splitting the front ranks generally broke up the herd, enabling each hunter to single out individual animals for the kill. Such is the moment depicted by Charles M. Russell in his painting entitled *The Buffalo Hunt.*

During the progress of the hunt, later arrivals from camp immediately began the job of butchering the fallen animals. Meat was quickly packed and sent back to the campsite to be cut and dried or stored, the skins prepared, and other related matters attended to. The hunters customarily returned at dusk to feast, swap stories, and mend broken equipment. Some, of course, did not return, for accidents were frequent, as artist Frederic Remington has depicted in his portrayal of hunter and horse being upset by a charging bull entitled *Episode of a Buffalo Hunt.*

THE BUFFALO HUNT
C. M. Russell

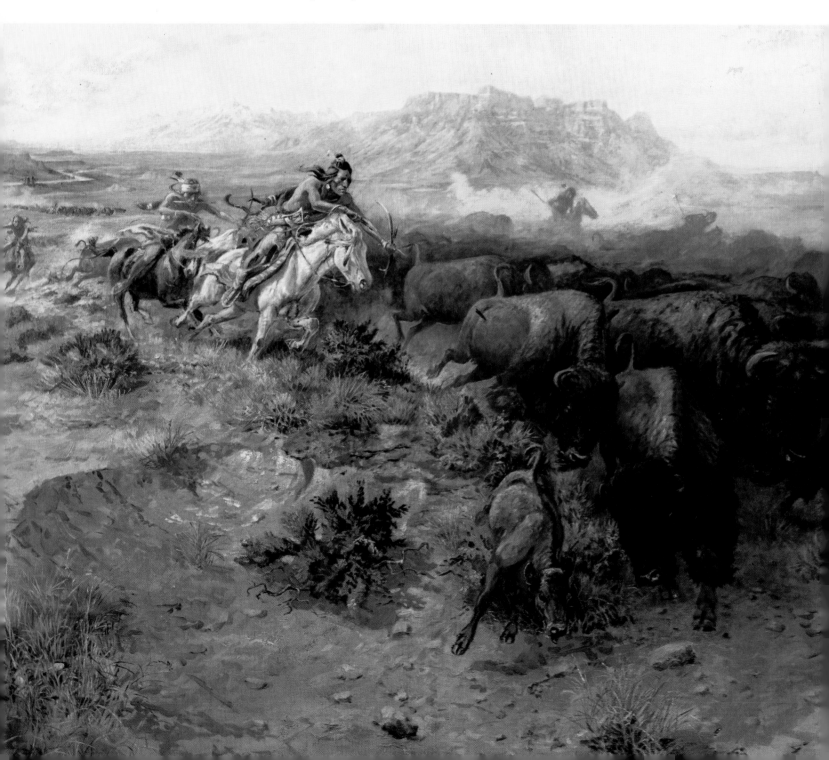

Buffalo hunting on the western plains in the nineteenth century constituted one of the chief sports for Easterners eager for adventure of a rougher sort. Few were satisfied to shoot only enough for their immediate needs, however. Early hunters followed the Indian method of running buffalo on horseback; this in itself was considered to be very sporting, if not very profitable.

On his trip to the Rockies in 1837, Alfred Jacob Miller participated in several hunts. In a manuscript preserved in the Gilcrease Library, he comments on a picture he drew of a buffalo chase near a place called Independence Rock:

In the immediate foreground of the sketch, an Indian is running a bull-buffalo;—in the middle distance on the prairie is one at bay;—a hunter is provoking and tantalizing him by feints;—he does not precisely wish to lose his life, but merely to see how closely he can go without doing so. The great mass of buffalo pursued by other hunters are making good their escape through a distant defile, while in the extreme distance, the lofty peaks of the Sweet Water mountains

EPISODE OF A BUFFALO HUNT
Frederic Remington

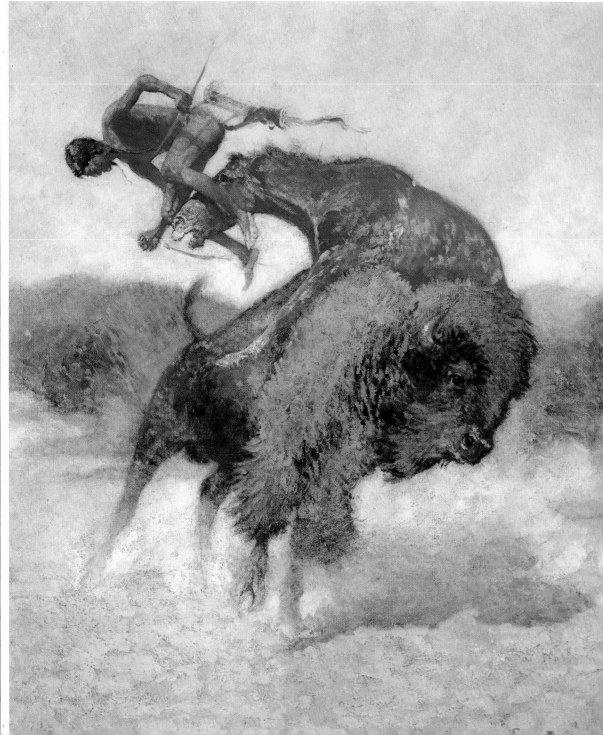

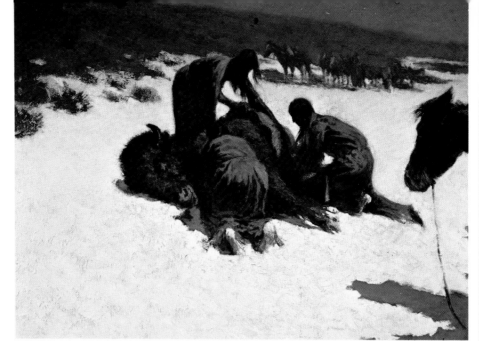

HUNGRY MOON
Frederic Remington

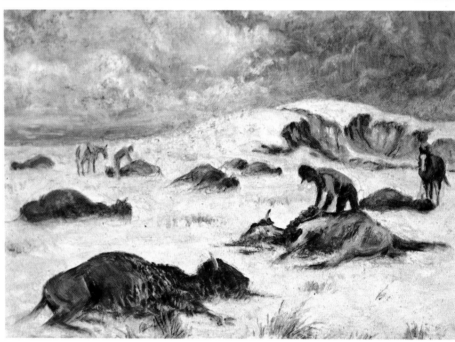

HIDE HUNTERS
O. C. Seltzer

closes in the scene. Where one party of hunters are successful, and another less fortunate they devide the spoils equally, in the most chivalric manner; the motto in vogue is "We must help one another" and we believe this is universal—at least among the whites.

In another section of his notes, Miller comments on the method of cooking and eating "the greatest morsel of the Mountains"—that is, the hump ribs of the buffalo.

"The fire is often made from the bois de vache (buffalo waste)," he says, "but as we had the best of all sauces, viz: most ungovernable appetites, and most impatient disposition for the same roasting operation, the circumstance did not affect us in the least . . .

"The hump ribs were put on a stick as a spit with one end in the ground, and leaning over the fire . . ."

Professional hunters, of whom there were many in the latter half of the century, preferred to call themselves buffalo "runners" despite the fact that they seldom chased their quarry. From all walks of life, these runners presented a varied assortment of men: ex-soldiers, ex-trappers, store clerks, cowboys, all out to "get rich fast" on the

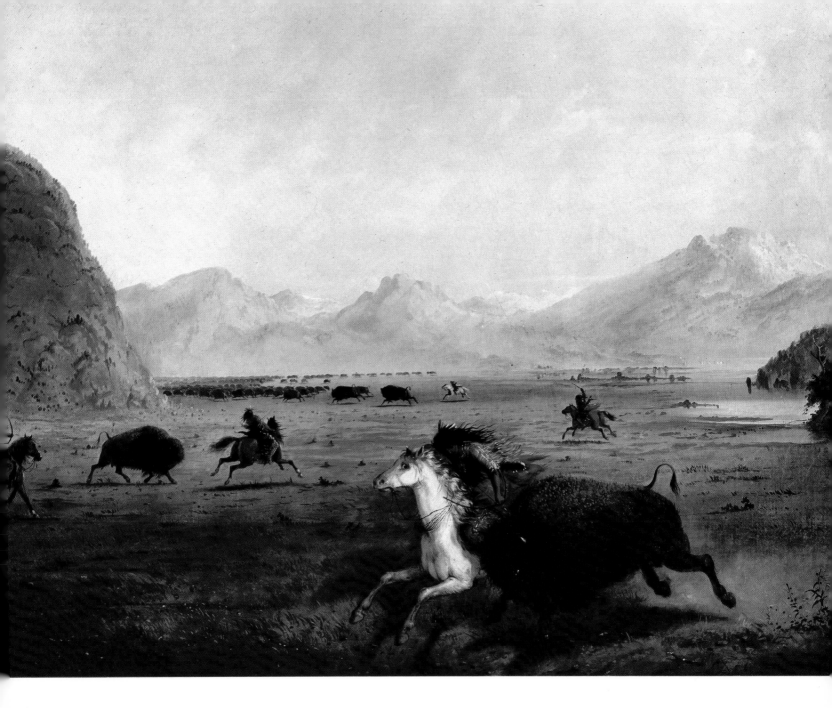

BUFFALO HUNT
A. J. Miller

The slaughter of the buffalo by white hide hunters, who left the carcasses to the wolves and scavengers, literally starved out the Indians of the plains.

buffalo range. Estimates of the number of hunters vary as much as the number of the buffalo, but twenty thousand is not too high a figure during the mid-1870's if one includes not only the hunters but also the skinners, drivers, cooks, and others who attended the buffalo harvest.

Buffalo hunting crews might consist of only a couple of men, or a large organization employing a number of men selected for various specialized jobs. The early-day professionals undoubtedly carried an assortment of guns: old cap-and-ball revolvers, Kentucky rifles, smooth-bore muskets, and various carbines of Civil War vintage such as the 56-caliber seven-shot Spencer. Later hunters used the big Sharps and Remington buffalo guns. These were the finest weapons available for the purpose and in simplicity and quality of workmanship were never surpassed. Buffalo hunters also demanded the finest grade gun powder, some importing their favorite brands from England. The majority did their own loading, preferred calibers being 40-70, 40-90, and later the 45/120/550 Sharps. The 45-70 and 45-90 were also common calibers on the buffalo ranges. Most of these were single-shot weapons

175

Untitled sketch by William Cary

BUFFALO HUNT ON SNOWSHOES / *George Catlin*

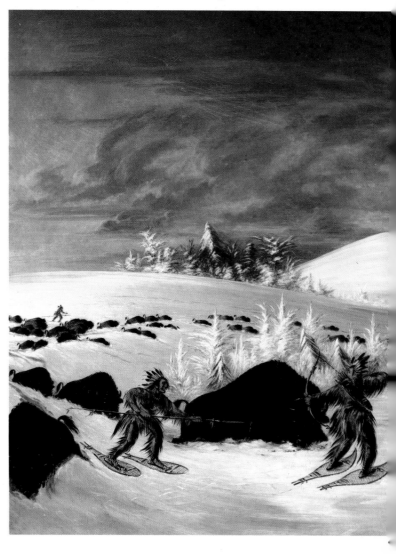

BUFFALO HUNT IN WINTER
William Cary

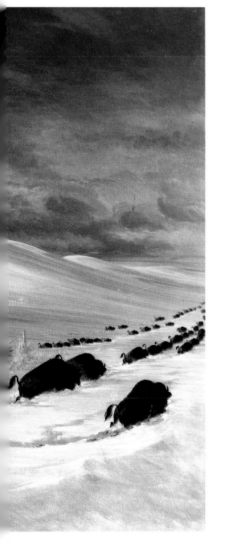

with double-set triggers that could be adjusted to fire at the slightest touch.

Shooting of buffalo by professionals usually was made from a "stand," where the hunter had the advantage of a good view of a herd at an approximate distance of three hundred yards or less. Impossible to wield from a standing position, the long-range buffalo gun was cradled in a forked stick fashioned for the purpose, or held prone, and the firing was done from a kneeling or prone position. The object, of course, was to kill as many buffalo as possible before the main portion of the herd panicked.

One of the marks of a professional buffalo hunter was his ability to drop as many animals as close together as possible in order to save his skinners the necessity of wandering at random over the prairies to retrieve the hides. A good hunter dropped only as many animals as his skinners could handle in the course of a day. Skinning a buffalo was a hard, dirty job. A man hired for this work under the hot sun of the open plains had to contend with swarms of flies, wrestling a wet hide that might weigh as much as 150 pounds. After skinning the carcasses, the skinner and his helpers loaded the hides into wagons to be taken to camp, where they were staked out on the ground, fleshy side up, dried, rolled lengthwise, and tied in lots of ten to a bundle. When loaded with six to eight thousand pounds of skins, the wagons were driven to the markets in places such as Dodge City, Kansas, where buyers paid from two to three dollars apiece for hides in top condition.

A professional hunter with a first class outfit might make three or four thousand dollars a year during the height of the hide-hunting season. The majority did not fare that well, but the lure of quick money brought many into the area just after the Civil War. When the buffalo began to disappear, their bones provided a ready source of cash when shipped to factories in the East, where they were used in the making of phosphates and fertilizer. Before the end of the century, scarcely a trace of the buffalo remained to testify to the existence of the millions reported only decades before.

It is generally believed that the Anglo-American hunters alone pursued the buffalo for profit; but the Indian also appreciated the value of the buffalo's hide as a trade item, as George Catlin bore witness in his remarks relating to his painting of a group of Indians hunting buffalo in midwinter.

"The snow in these regions often lies during the winter to the depth of three and four feet," he writes with respect to conditions on the north-central plains, "being blown away from the tops and sides of the hills in many places, which are left bare for the buffaloes to graze upon, whilst it is drifted in the hollows and ravines to a very great depth, and rendered almost entirely impassable to those huge animals, which, when closely pursued by their enemies, endeavor to plunge through it."

He continues:

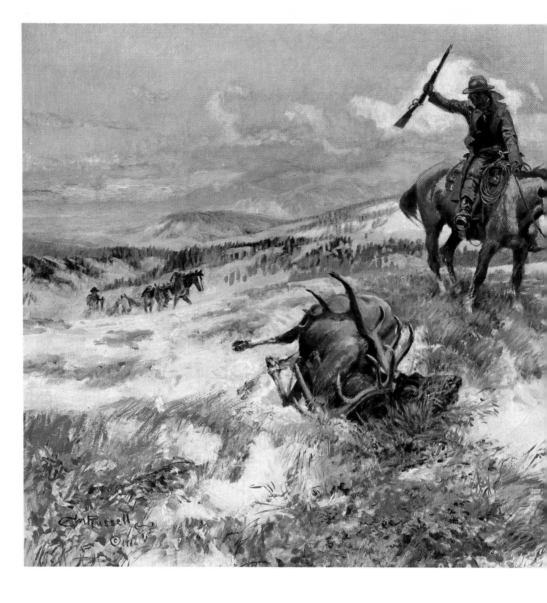

WHERE TRACKS SPELL MEAT
C. M. Russell

But they are soon wedged in and almost unable to move, where they fall an easy prey to the Indian, who runs up lightly upon his snow shoes and drives his lance into their hearts. The skins are then stripped off, to be sold to the fur traders, and the carcasses left to be devoured by the wolves. This is the season in which the greatest number of these animals are destroyed for their robes—they are most easily killed at this time, and their hair or fur being longer and more abundant, gives greater value to the robe. The Indians generally kill and dry meat enough in the fall, when it is fat and juicy, to last them through the winter; so that they have little other object for this unlimited slaughter, amid the drifts of snow, than that of procuring their robes for traffic with the traders.

No one imagined, either Indian or white man, that the great herds would ever be significantly depleted. There were a few, however, who saw in the widespread and unrestricted slaughter of the bison a positive threat to its continued existence. In February 1872, a California legislator introduced a Senate resolution to the effect that "the committee on territories be directed to inquire into the expediency of enacting a law for the protection of the buffalo, elk, antelope and other useful animals running wild in the territories of the United States against indiscriminate slaughter and extermination . . ." Bills in various forms were introduced between 1872 and 1876 in an attempt to protect the rapidly disappearing species. Lost in committee or defeated outright, most of these were never heard of again.

In 1887, William T. Hornaday reported that to the best of his knowledge there remained approximately 1,091 head of buffalo on the great plains, either wild or in captivity, a number that contrasts sharply with his earlier estimates. Individual states or territories west of the Mississippi enacted laws from this time forward to protect the game animals in their respective districts, but in most cases were unable to enforce such legislation. Thus it was many years before effective steps finally were taken to preserve the remnants of the once incalculable herds that had roamed the West. The results of this last-ditch conservation effort may be seen today in a few areas, principally in government preserves or national parks such as Yellowstone, the Wichita Mountains Wildlife Refuge in southeastern Oklahoma, and the Montana Bison Range.

It is practically beyond the powers of modern-day Americans to conceive of the swift and almost total destruction of what was once one of this continent's most populous species of wildlife.

"There were literally millions of buffalo," recalled an old-timer named Frank Mayer of Fairplay, Colorado, in an interview before his death in 1954. "They didn't belong to anybody. If you could kill them, what they brought was yours. They were walking gold pieces.

"He walked. He had a hide. The hide was worth money," he concluded, summing up the circumstances that led to the incredible destruction of the buffalo in the last century. "I was young. I could shoot. I liked to hunt . . . Wouldn't you have done the same thing if you had been in my place?"

It is practically beyond the imagination of most Americans to realize how swift and almost total was the destruction of the great multitudes of America's wildlife in the nineteenth century.

BUFFALO AND PRAIRIE WOLF
O. C. Seltzer

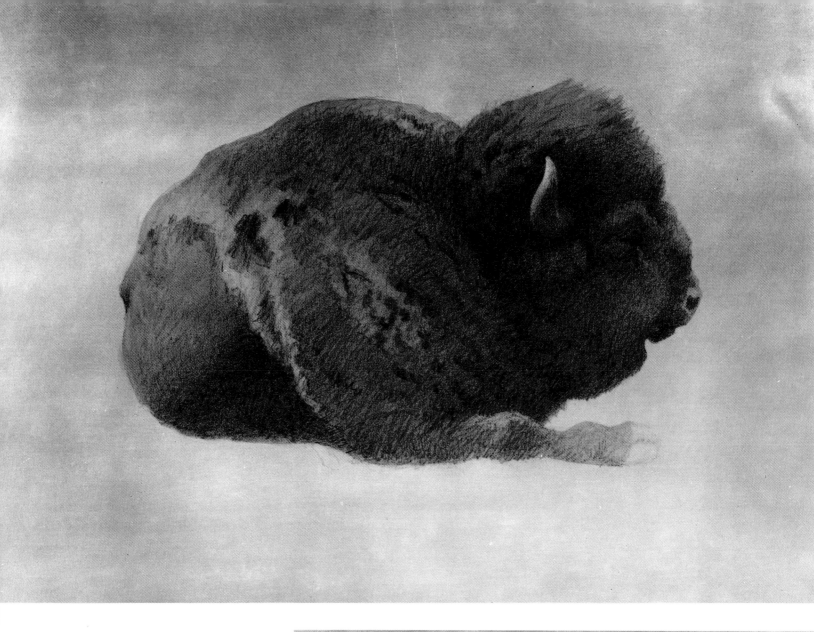

All the hoofed mammals, in competition with the stockman's cattle and horses for grass, fell victim to advancing civilization in the Far West.

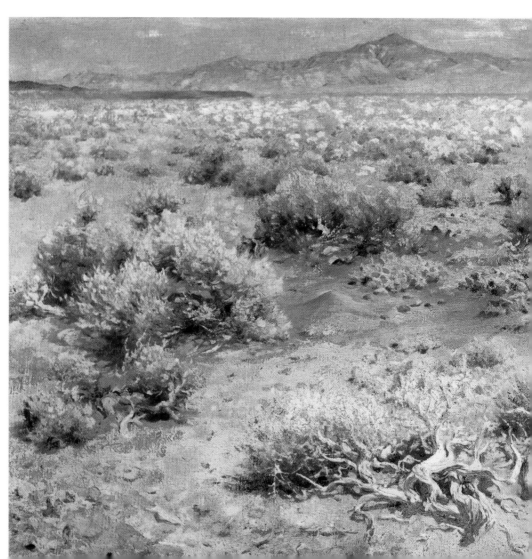

Untitled study of a buffalo by W. R. Leigh

Untitled study by W. R. Leigh

The buffalo was of primary importance in the economic history of the West—food to the frontiersman, money to the hide hunter, and a way of life to the Indian of the plains. Its existence and eventual disappearance greatly affected the settlement of the trans-Mississippi wilderness. From about 1840 through the 1880's, hunting the buffalo and game of all kinds was a legitimate occupation for many kinds of men. Irreparable damage to wildlife populations was the result of allowing this practice to continue even after there was no longer any real need for it.

A source of livelihood for several generations of Anglo-Americans in the course of their westward march across the continent, members of the widespread deer family likewise provided not only food and clothing for the settlers, but also material for other common necessities. The enactment of laws limiting a hunter to one buck and making it illegal to sell venison finally brought a halt to the wholesale destruction of the whitetail deer in the East, ensuring its eventual comeback in that area. In the West, the killing of game continued unchecked. Here it was that professional hunters and sportsmen alike ventured to take their toll of diminishing species. Particularly in the 1870's and 1880's, the Far West was regarded as the "Big Game Hunters' Paradise."

Most sought after were the hoofed animals. Until the market hunters began to deplete the herds on a significant scale, hunting was done primarily for the sake of procuring food, except for those few military men or foreign travelers who hunted for sport. As a sport, hunting did not come into vogue for the average American until the railroads spanned the continent. At that time, rifle manufacturers began producing repeating rifles, and hunting for sport began to assume the aspects of a veritable industry in the West.

The term *wapiti*, a Shawnee word meaning "white rump," was applied by these people to the large animal carelessly designated as an "elk" by early pioneers in America. A handsomely proportioned beast, the *wapiti* ranged throughout North America in earlier centuries and was particularly abundant on the plains and in areas of the Rocky Mountains.

With the buffalo, the "elk" also fell before the onslaught of settlement in the nineteenth century. By 1895 it had virtually disappeared in most of its former range, reduced to approximately a hundred thousand animals located in the north-central Rockies. Most had been killed for their meat and hides, or by avid sportsmen desiring their magnificent antlers as trophies. Thousands more died as their natural range was taken over by cattlemen and farmers. Countless numbers were killed for the sake of their teeth to serve as ornaments.

The Indians had hunted the elk for its teeth in earlier days, as well as for its hide, "with which they make leggings, giving it a rich tint by a peculiar process of smoking," as Alfred Jacob Miller reported in one of his commentaries.

"They form of it also sacks to carry their pemmican and jerked meat," he says, "and from the horns they make their most efficient bows; the herds of elk rarely number more than 400 or 500."

MEAT'S NOT MEAT TILL IT'S IN THE PAN
C. M. Russell

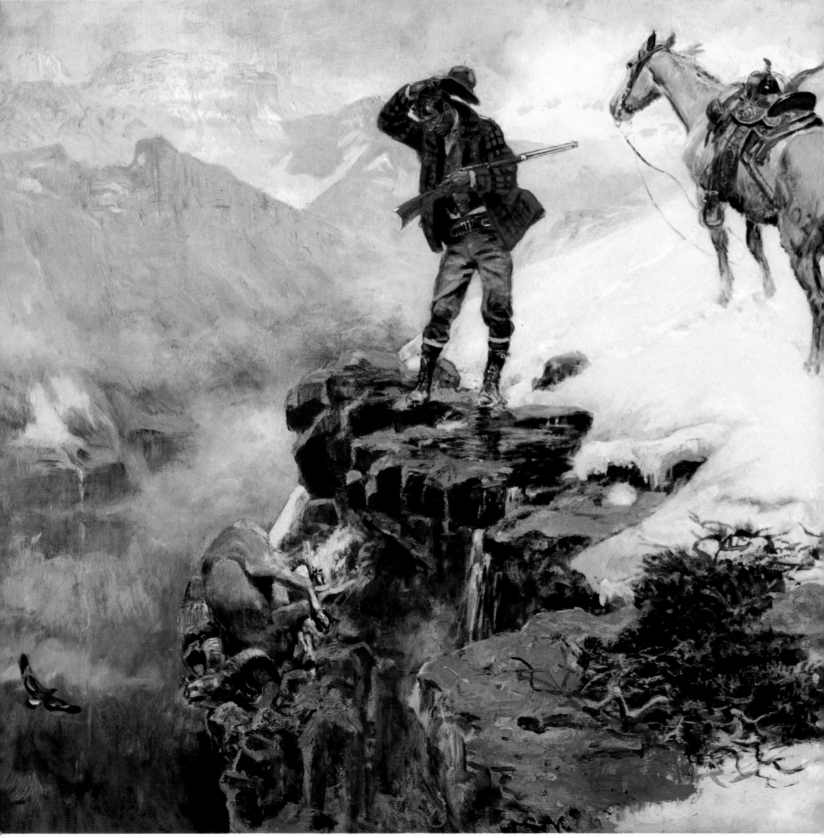

BETTER THAN BACON
C. M. Russell

About seventy-five years later, William T. Hornaday wrote, "It is probable that within a few years the elk will disappear from all localities wherein it is not rigidly protected." His figure for the total number of *wapiti* in North America in 1912 was about 54,850. Today, however, as a result of careful government management, the number of this species has increased to nearly four hundred thousand.

In contrast to the proud and dignified *wapiti* is the American pronghorn antelope of the Southwest, which in Coronado's day mixed among the herds of buffalo in numbers estimated at upwards of fifty million. Actually more of a deer or a goat than a true antelope, this small, shy creature fell victim to advancing civilization along with other grass eaters of the western plains in competition with livestock and farming in that region. Today some two hundred thousand roam the western reserves. Long of leg, the pronghorn has been clocked at speeds as high as sixty miles per hour for short distances. Both sexes have horns that are shed annually and renewed each fall. The hair of the white rump patch, raised when the pronghorn is alarmed, acts as a distress signal to others of its kind. Along with its distinctive horns, this is one of the animal's most distinguishing characteristics.

Plains Indians formerly hunted the pronghorn from ambush. Wolves and coyotes, unable to maintain the speed necessary to overtake the animal, pursued it in packs in relays until the quarry fell exhausted. Among white hunters of a later day, a pronghorn sometimes was taken by attracting its attention to a white handkerchief fixed to the end of a stick or rifle waved from cover. Tempted by curiosity to approach within range of the hidden hunter, the pronghorn was quickly brought down.

In the latter decades of the nineteenth century, when cattle grazed over most of the central plains, an occasional deer or antelope presented a welcome change in the diet of a cowboy tired of his steady fare of beans and bacon. The discovery of a small herd of pronghorn such as that portrayed in the watercolor sketch by the cowboy illustrator Charlie Russell gave the lonesome herder on the open range something else to think about; and in anybody's book, fresh antelope meat was "better than bacon."

Many of Russell's canvases depict western hunting scenes in a day when most of the larger game animals had retreated to the less frequented regions of the high Rockies. In his *Meat's Not Meat Till It's in the Pan*, he comments upon the difficulties of pursuing and killing

183

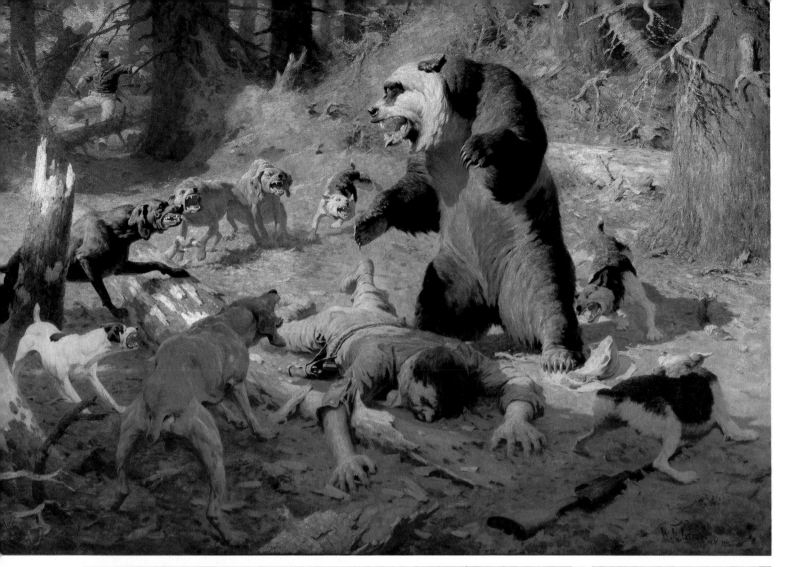

PRAIRIE WOLF
O. C. Seltzer

A CLOSE CALL
W. R. Leigh

STUDY OF A GRIZZLY
W. R. Leigh

The grizzly bear was hunted by sportsmen & settlers alike, & along with the "buffalo wolf," was soon regarded as an outlaw by farmers & stockmen.

the bighorn sheep. Its keen eyesight and remarkable ability to scale almost perpendicular cliffs and peaks protected it for years, until the introduction of long-range weapons equipped with powerful scopes considerably reduced its natural advantage over those who sought its life. With the advancement of civilization, bands became isolated from one another and inbreeding and disease took a high toll of the intrepid mountain sheep.

Of all the so-called big game animals of North America, however, none has become the subject of more stories, legends, and commentary than the awesome and much-maligned grizzly bear. Dreaded by Indian and settler alike, ruthlessly persecuted by cattlemen, sportsmen, and professional hunters, this great beast had a reputation that remains undiminished in the annals of frontier history.

The Indians of the western plains and mountains referred to him as "great-grandfather," or "cousin," or simply, "old man in a fur coat." Early trappers familiarly designated him "Old Ephraim." Science has given him the formidable name of *Ursus horribilis*, classifying him among the world's largest carnivores. At one time inhabiting the western half of North America from central Mexico to the northwest tip of the continent, grizzlies today are rarely found outside the confines of the national parks in the United States.

When Coronado marched north through portions of western Oklahoma and Kansas, he must have seen a few of these great bears. Baron de Lahontan, however, in his *New Voyages to North America*, published in 1703, is credited with having made the first mention of what may have been the grizzly.

"The reddish bears are mischievous creatures," he reports, "for they fall fiercely upon the huntsmen, whereas the black ones fly from 'em. The former sort are less, and more nimble, than the latter."

From this doubtful record we go to Samuel Hearne's *Journey to the Northern Ocean* (1769–72) for the earliest reliable account concerning this animal.

"Brown bears are, I believe, never found in the North-Indian territories," he remarks in his journal dated July 1771, "but I saw the skin of an enormous grizzled bear at the tents of the Esquimaux at the Copper River; and many of them are said to breed not very remote from that part."

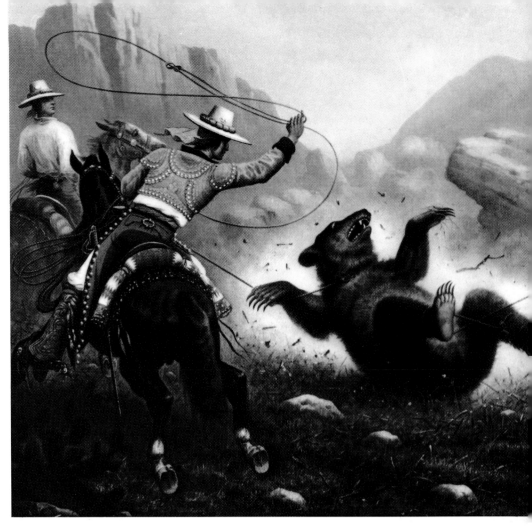

ROPING A WILD GRIZZLY
James Walker

The California vaqueros, and adventurous cowboys in other parts of the West, sometimes hunted the great bear the hard way.

Sir Alexander Mackenzie, during his canoe voyage in 1793 along the northern rivers, remarked in his journal that "the Indians entertain great apprehension of this kind of bear, which is called the grizzly bear, and they never venture to attack it but in a party of at least 3 or 4."

And in 1820 Major Stephen Long recorded:

"Notwithstanding the formidable character of this bear, we have not made use of any precautions against their attacks, and although they have been several times prowling about us in the night, they have not evinced any disposition to attack us at this season."

This is, indeed, a carefully worded commentary upon the uncertain character of the beast.

Frontier history is filled with accounts of battles between man and the grizzly, and all sections of the West abound in legends pertaining to famous grizzlies of the past whose exploits are still repeated whenever hunters gather to invade the animal's former range. Accused of being a killer of sheep and cattle, the wild grizzly was, in fact, almost ninety per cent vegetarian, with grass, roots, berries, nuts, insects, honey, and fish constituting the bulk of his diet. That grizzlies killed buffalo on occasion is documented in more than one instance; however, generally in the early spring, when the buffalo were weaker and disadvantaged by remaining heavy snows.

George Catlin painted several bear "portraits," among which is a scene representing a pair of grizzlies in the act of killing a rare white buffalo. Highly prized by white hunters and Indians alike, albino

186

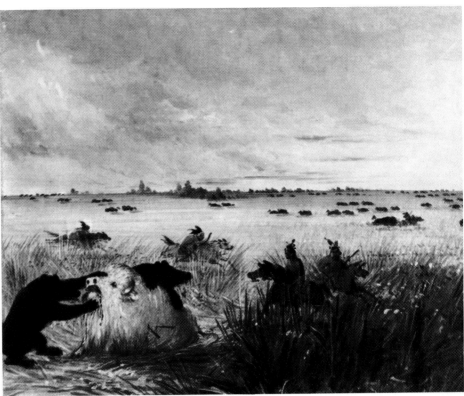

GRIZZLIES KILLING A WHITE BUFFALO
George Catlin

buffalo were extremely rare and considered sacred to the plains tribes. Great ceremony was attached to the killing and dressing of such an animal, although scant ceremony attends the bears' attack depicted by Catlin, who appears to have felt that grizzlies very much resembled pigs. This comparison was common among many frontiersmen, who associated bears with pigs perhaps because of both animals' diversified eating habits.

In later years, when such buffalo killers became cattle killers, the fate of these great bears was sealed and the grizzly became a hated word among stockmen throughout the West. Ranchers from Colorado to California campaigned ruthlessly for its extermination, and the grizzly soon ceased to frequent many areas of his former range.

While virtually extinct today, the animal known as the Sonora grizzly was a considerable nuisance to the mission ranchers in California during colonial days. Records from this period suggest that bears destroyed a lot of beef and that a single blow from a grizzly's paw could break the neck of a full-grown steer. The California *vaquero*, or cowboy, proud of his abilities, delighted in the opportunity to throw a rope on so formidable a foe. This was no simple maneuver, for at the first whiff of the grizzly's scent, most horses became unmanageable. Two ropes around the bear's neck, pulling in opposite directions, generally kept the bear from attacking either of the horses or the men involved in this tug-of-war, leaving a third rider free to put his loop over the beast's hind legs. If all went well and no accidents occurred, the *vaqueros* had themselves a bear, although getting him back home was often something else again.

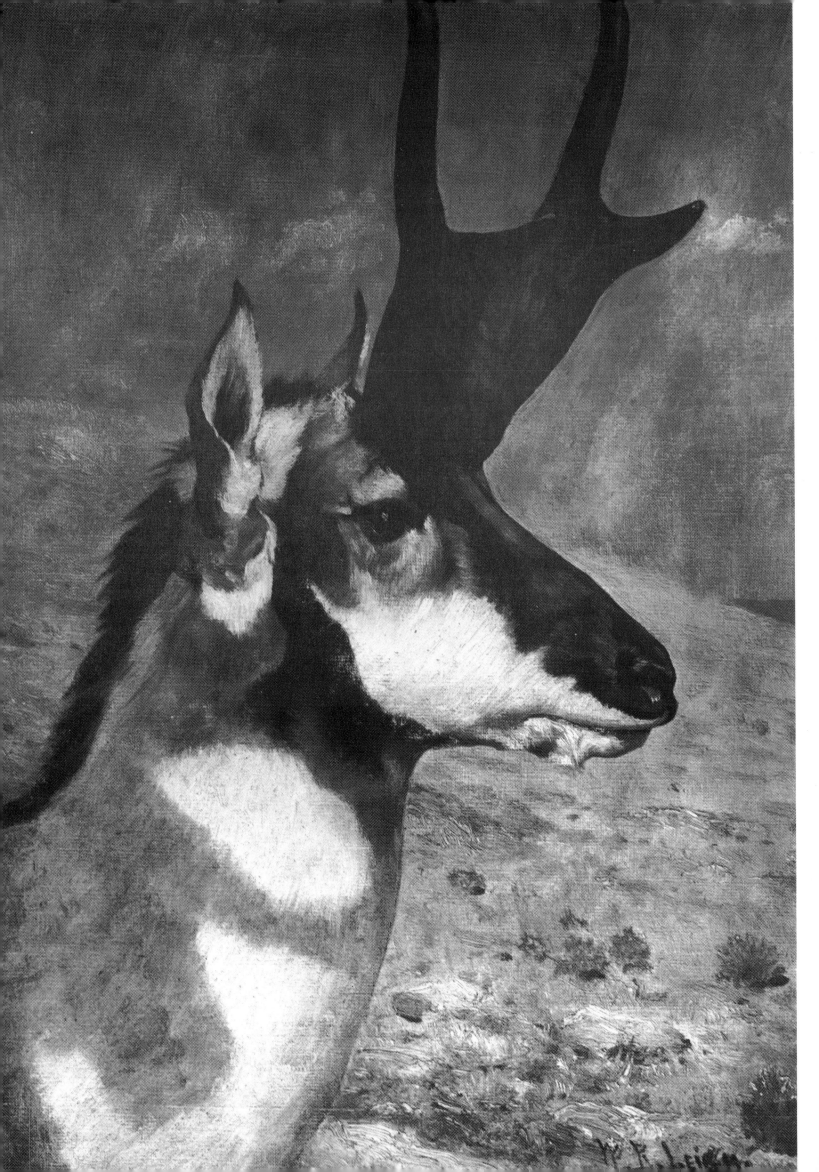

Studies of the grey wolf by W. R. Leigh

PRONGHORN HEAD STUDY
W. R. Leigh

Among the many studies by contemporary artist William R. Leigh are those depicting various wild animals in the West. Some of these served to assist Leigh in rendering the details pictured in his larger, finished works, which were produced in his New York studio.

Unlike his later counterpart on the cattle ranches of the Rockies, the Spanish cowboy did not kill his quarry, but essayed to take it back to the ranch or pueblo, where its strength and fighting ability could be pitted against those of the bull in the public arena. Especially in the Spanish Southwest, such spectator sports as bear-and-bull fights were very popular, despite the fact that the bull almost invariably lost.

Reports of grizzly bears attacking men are rife in Western lore despite the fact that actual encounters of this nature were by no means common and seldom occurred without the bear's having been provoked in some manner. Undoubtedly, more nonsense has been written on the big bear's viciousness than on any other subject associated with his habits. William R. Leigh's painting entitled *A Close Call*, however, is based on a supposed actual incident that occurred during a bear hunt near Cody, Wyoming, in 1912.

Visiting in this area during one of his frequent western excursions, the artist accompanied the director of the Colorado Museum of Natural History, J. D. Figgins, on a hunt for grizzly specimens so that he might make studies of any bears discovered or taken. At this time it was lawful to trail bears with dogs, and the artist made numerous studies of these as well as the bear that was brought to bay. Back in his New York studio, Leigh set about to re-create his recent experience, recording on canvas the dramatic moment when the hounded grizzly turned to attack his pursuers.

In the artist's studio collection, presently owned by the Gilcrease Institute, are a number of Leigh's studies for this picture, done during and after this particular western trip. Other and related studies and photographs are characteristically scattered throughout the Leigh studio material, now reassembled and displayed to the public in the Leigh Gallery at Gilcrease—works in pencil, ink, and oil that served as references for the artist when he undertook to compose his larger, finished canvases. A page from one of his sketchbooks contains several partially finished studies in pencil and in ink of the animal known as the grey or "timber" wolf. Sharing with the grizzly one of the worst reputations among the animals of the West, the wolf and his smaller cousin, the coyote, are still today regarded primarily as the "outlaws" of the animal kingdom, hated by modern stockmen regardless of the fact that, in the coyote's case, little damage is actually done to cattle or sheep.

Indeed, the coyote is considered today by biologists to be very important in the natural scheme of things, helping to maintain that precarious balance between various species of wildlife in the less populated areas, feeding on rodents and other pests. The same cannot be said of the wolf, particularly as he is remembered from former days. The history of western settlements is studded with the names of infamous, almost legendary, stock killers. Ranchers in the old days, and sometimes today as well, hired men known as "wolfers," who with trained packs of dogs hunted down and killed wolves or coyotes that preyed on range stock. In the last century, these professional hunters made a fairly good living collecting bounties paid them for their services.

Mountain lions were also hunted with dogs, the great cats being feared by cattlemen and horsemen alike. An elusive animal even in the days before hunting eliminated him from most of his former habitat, the mountain lion, puma, cougar, painter, catamount, or whatever he may have been called locally, is today seldom seen in any but the most isolated and uninhabited areas of the remaining wilderness.

Big game animals and small, fur bearers, predators, and harmless species all played a part in the settlement of the American wilderness. Most were destroyed in the process, relentlessly hunted for sport or profit until today they are found only where conscientiously protected by law. A few species, such as wolves, coyotes, bobcats, and certain hawks and owls, are still considered pests, with bounties being paid for their pelts. However, even the predators in some areas are coming under protective laws in an effort to preserve them.

The closing decades of the nineteenth century were the darkest in the history of wildlife in America. The few regulations with regard to hunting that were in existence at that time were seldom enforced, and many animals were pushed to the brink of extinction. Selling wild game was carried on openly, even in those states that had prohibited this commerce; and it was only through the concerted efforts of a few farsighted naturalists and sportsmen that such regulations were at last enforced, shorter hunting seasons initiated, and lower bag limits established, thereby ensuring the future existence of most of the game animals that survive to the present day.

From Sea to Shining Sea
From the Hudson to the High Sierras

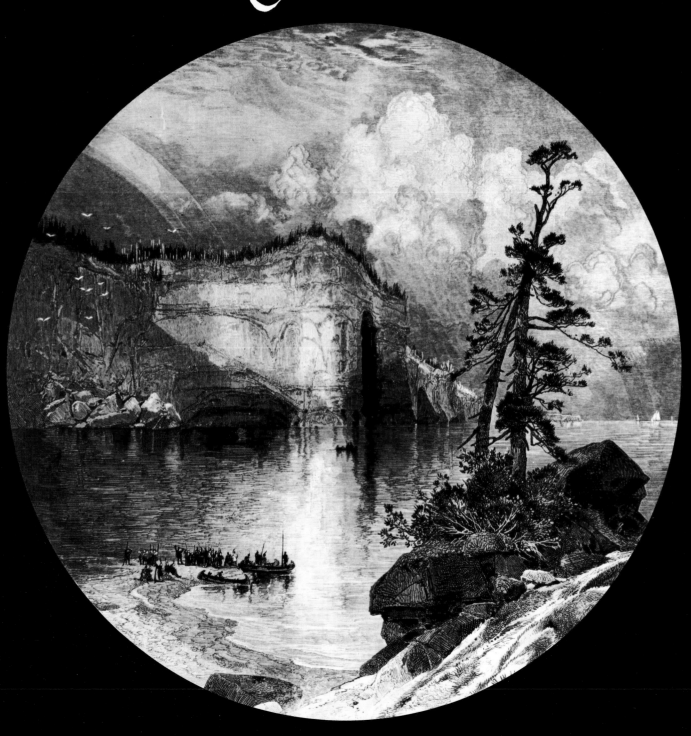

From the Hudson to the High Sierras

It is recognized today, of course, that those who first documented life on the American frontier left us a priceless commentary on the people and conditions of those times. In attempting to evaluate or compare their reports, however, we would do well to keep in mind the differing purposes that prompted the nineteenth-century explorer, pioneer, trader, journalist, or artist to travel westward. Daniel Webster earlier in the century had proclaimed the interior of North America to be a vast wasteland unsuited to the support of civilization. This notion prevailed for many years, until the observations of those who traversed the western wilderness began to be published and distributed in the East. Following in the footsteps of the explorers and scientists, the nature artists and inheritors of the Hudson River School of American landscape painting ventured westward. Their pictures of a grand and spacious wilderness prompted new interest in the West and, in time, helped to bring about an appreciation for the wild beauty of the land and concern for its diminishing reserve of natural resources.

IOWA GULCH, COLORADO
Thomas Moran

Alfred Jacob Miller was particularly enthusiastic in his descriptions of the Far West, declaring it to be a wonderland that in time would rival even the famous sites of Italy or ancient Egypt as an attraction for wealthy travelers.

He once remarked with reference to its mountain lakes and lofty peaks that "the time is rapidly approaching when villas and hotels will rise on the shores of these charming sheets of water—and when railways are carried through the South Pass, they will inevitably become not only the 'grand tour' but the Grand Highway of this celestial empire."

German-born Albert Bierstadt echoed much the same sentiment in his grandiose scenes of the Rockies and the Sierras. A native of Düsseldorf, Bierstadt had spent his youth in the United States but in the 1850's returned to Europe to study painting, acquiring a taste for the heroic that became the hallmark of his career. Back again in America, in 1858 he joined a military expedition on its way to lay out an overland wagon route from Fort Laramie to the Pacific. Spending the summer sketching in the Wind River and Shoshone country, which Miller had viewed twenty-one years before, he produced on his return to the East a number of spectacular works that received considerable attention when they were exhibited at the National Academy of Art in 1860.

Bierstadt thought on a grand scale, and his love of the dramatic can be seen especially in his larger canvases such as *Sierra Nevada Morning*. Decidedly operatic in its rendition of mists and clouds boiling up above a towering range of Gothic peaks, the painting's effect is further heightened by the contrasting scene of tranquillity below, where three deer venture to cross a sunstruck clearing along the edge of a mountain lake. Here is an interpretation of the far wilderness that in its day contradicted the popular belief in the West as a harsh and alien region. Other romanticists followed Bierstadt's lead and, slowly but surely, the notion of the western half of the continent as the "Great American Desert" began to change.

The actual, immediate effect of exploration narratives on Americans in the nineteenth century is difficult to measure today; yet it is reasonable to suppose that the views of those who accompanied caravans to the western territories helped to open eastern eyes at least to some extent to the wonders of the Far West. In 1855, the United States Senate published the first in a series of reports on the surveys that had been made up to that time to determine the most practical route for a railroad from the Mississippi to the Pacific Ocean. Here, again, the western-traveling artist rendered a definite and valuable service, for these surveys necessarily were filled with every type of information descriptive of the land and its inhabitants.

John Mix Stanley, who spent ten years in the West, was one of those who contributed to the government's reports, accompanying Isaac Stevens on his northwestern railroad survey in 1853 as draftsman for that expedition. Others such as R. H. Kern, A. H. Campbell, and Charles Koppel illustrated railroad reports or, like the West Point graduate Seth Eastman, prepared material to supplement other and related accounts on conditions among the western Indian tribes.

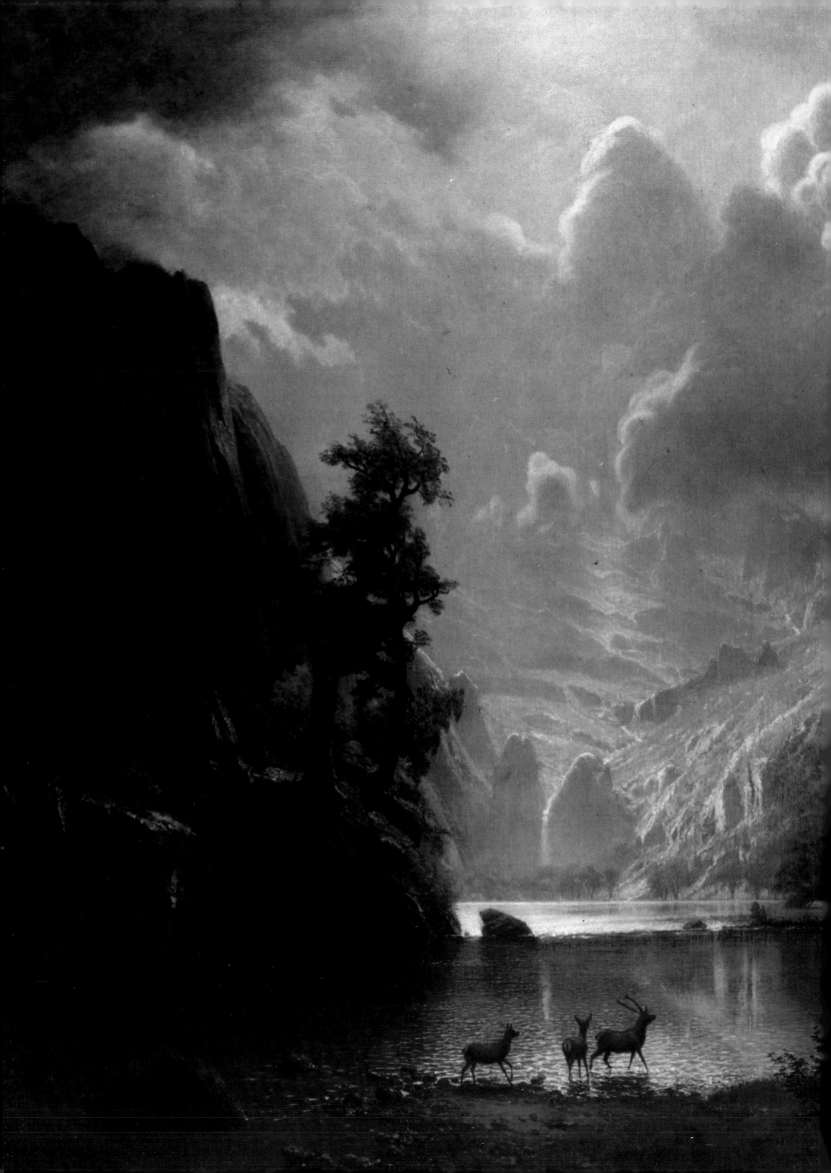

SIERRA NEVADA MORNING
(previous page) Albert Bierstadt

Whether or not the average American actually read these reports is of no great importance, for the trails across the wilderness were marked and the country mapped and described; and the artists' conceptions of the nature of the land beyond the frontiers of the United States continued to encourage and support, or at least reflect, the official interest in the settlement of the West that increasingly manifested itself throughout the latter half of the century.

Attempts to find a way around or across the sprawling continent of North America had occupied the energies of individuals and governments since the earliest days of exploration in the New World. As early as 1497, John Cabot had sought its northern limits, and soon after Frenchmen had explored the St. Lawrence River in hopes of discovering a "Northwest Passage" to the Pacific. Captain James Cook's voyages along the northwestern coasts of America in 1776 finally squelched for all time the hope of finding a natural waterway connecting the two great oceans. At the same time his search was in progress, however, the scientific discoveries and inventions associated with the industrial revolution were taking place in Europe. Thus only a few years separated the last attempts to find a way across America

ACROSS THE CONTINENT: WESTWARD THE COURSE OF EMPIRE TAKES ITS WAY
F. F. Palmer, published by Currier and Ives

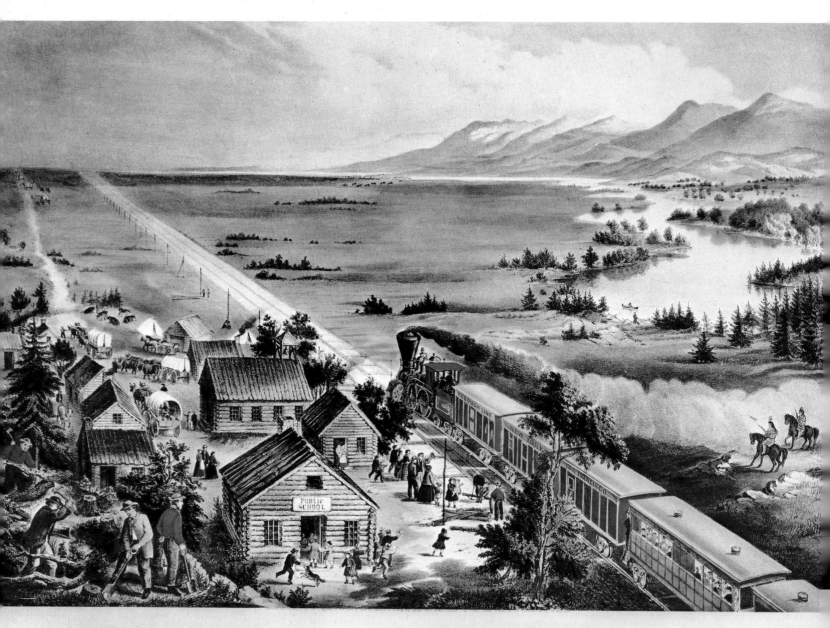

ACROSS THE CONTINENT.
WESTWARD THE COURSE OF EMPIRE TAKES ITS WAY

by water and the invention of the first practical steam-powered locomotive in England.

The first successful steam locomotive, designed and built by Richard Trevithick, pulled a line of cars over a tramway in England in 1804. By 1830, interest in America in steam locomotion was sufficient to encourage several men to make the attempt at locomotive construction. In 1828, Charles Carroll, one of the signers of the Declaration of Independence, broke ground for the first railway of any consequence in America: the Baltimore and Ohio. Within six years, the familiar steam engine of the nineteenth century—with its horizontal boiler, stack in front, steam dome in the rear, four drive-wheels, and a four-wheel leading truck—had been successfully designed and launched.

The years between 1830 and 1855 encompass the most active period of growth of the railroad in America. During this short span of time, rails spread over most of the northeastern quarter of the nation, penetrated the less settled South, and by 1854 had ventured west of the Mississippi. The explorations of John C. Frémont and the lobbying of his father-in-law, Thomas Hart Benton of Missouri, himself an ardent promoter of a federally financed Pacific railway, brought to

"LIGHTNING EXPRESS" TRAINS
LEAVING THE JUNCTION
F. F. Palmer, published by Currier and Ives

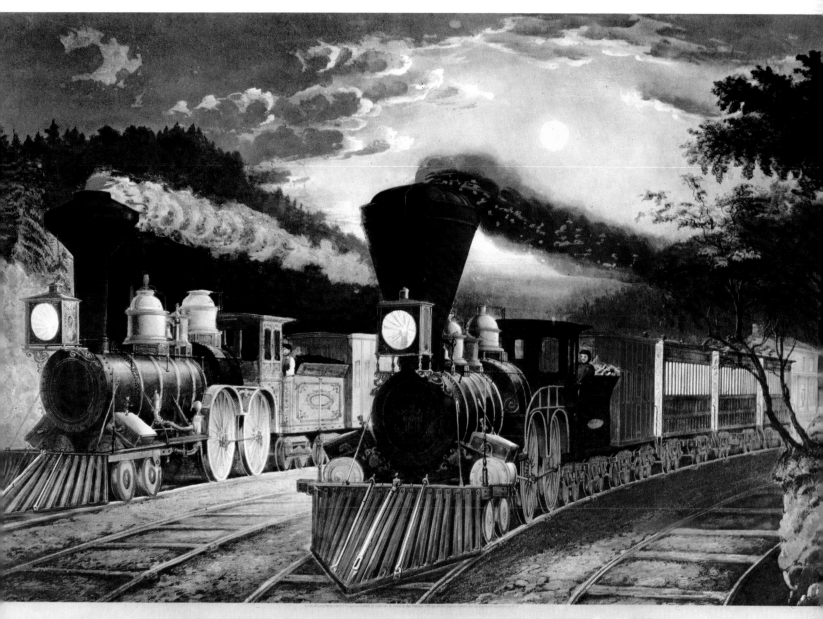

THE "LIGHTNING EXPRESS" TRAINS.

The Far West was
not truly open until
the railroads came.

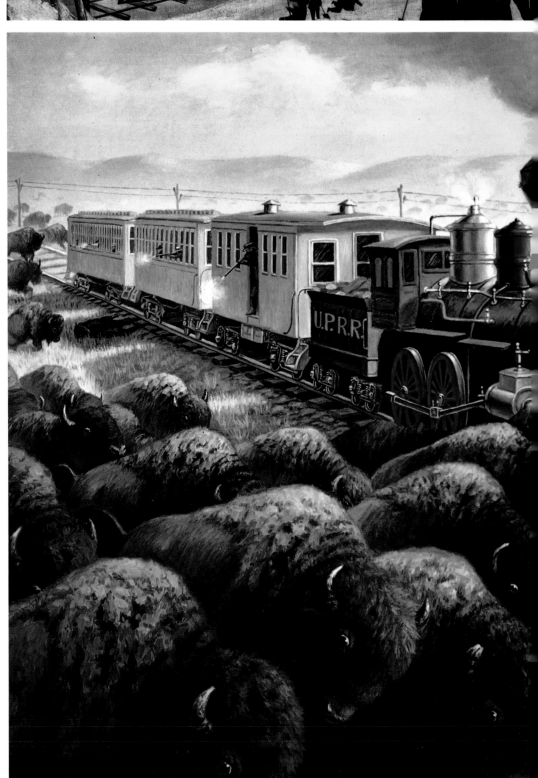

SNOW SHEDS ON THE CENTRAL PACIFIC
Joseph Becker

the attention of Congress the feasibility of building a railway from the Mississippi to the Pacific Ocean. It was not until the discovery of gold in California in 1848, however, that Congress began to entertain more than a mild interest in any kind of western railroad.

Several different routes were proposed following the publication of the government's survey reports in 1855. As interest in a Pacific railway intensified, regional politics entered the picture, effectively blocking government aid to further trans-Mississippi railroad construction until the outbreak of the Civil War. Meanwhile, Grenville M. Dodge, future chief engineer of the Union Pacific railway construction, surveyed a route for the Mississippi and Missouri Railroad from Rock Island, Illinois, across Iowa toward the present Council Bluffs. Later forced to abandon the project, Dodge remained at Council Bluffs, where he collected information from emigrants and traders regarding the best routes across the Rockies to the Pacific, reporting his findings to the director of the Rock Island Railroad, which by 1858 had absorbed the Mississippi-Missouri Company. His information received little attention at that time, but he was directed to begin laying a roadbed between Council Bluffs and Iowa City to the East.

With the declaration of war between the states in 1861, further plans for a Pacific railway were postponed except for Dodge's proposed Union Pacific route, which President Lincoln viewed as a vital factor in helping to hold the western territories to the Union. Lincoln previously had talked with Dodge at Council Bluffs in 1859, interested at that time in learning all he could with respect to routes across the central plains. In 1863, Dodge reported to Washington to discuss again the Forty-second Parallel route with the President. In the spring of the following year, the Pacific railway was formally inaugurated, Mr. Lincoln designating Omaha as the eastern terminus of what was to be the first transcontinental railway in America.

Surveying parties were sent out to map the route over which the railroad would be laid and construction began almost immediately. Parties of hunters were hired to procure game for the builders, who labored steadily on the rails. Numberless herds of bison yet roamed the plains and several now-famous frontier personalities made their living for a time hunting these animals for the Union Pacific crews. Some of these men, or others hired expressly for the purpose, provided protection as well from the Indians encountered along the route who sometimes gave trouble to the railroad builders; for the native tribes, fearing the advance of the white man's civilization, dreaded the intrusion of the shining rails of steel across their ancestral hunting lands.

"Our Indian troubles commenced in 1864," remarks Dodge in his published account, *How We Built the Union Pacific Railway,* "and lasted until the tracks joined at Promontory. We lost most of our men and stock while building from Fort Kearney to Bitter Creek. At that time every mile of road had to be surveyed, graded, tied, and bridged under military protection." He continues:

A HOLD UP
Robert Lindneux

GLORY OF THE CANYON
Thomas Moran

LOWER FALLS OF THE YELLOWSTONE
Thomas Moran

The order to every surveying corps, grading, bridging, and tie outfit was never to run when attacked. All were required to be armed, and I do not know that the order was disobeyed in a single instance, nor did I ever hear that the Indians had driven a party permanently from its work. I remember one occasion when they swooped down on a grading outfit in sight of the end of the track. The Government Commission to examine that section of the completed road had just arrived, and the Commissioners witnessed the fight.

The graders had their arms stacked on the cut. The Indians leaped from the ravines and, springing upon the workmen before they could reach their arms, cut loose the stock and caused a panic.. General Frank P. Blair, General Simpson and Dr. White were the Commissioners, and they showed their grit by running to my car for arms to aid in the fight. We did not fail to benefit from this experience, for, on returning to the East the Commission dwelt earnestly on the necessity of our being protected.

Untitled pencil study by Thomas Moran

Increasing numbers of journalists and artists traveled westward by rail in the 1870's. Their reports of the scenic splendors of that far country stirred interest in many quarters of the expanding nation.

All the investigations Dodge had carried out nearly ten years earlier came to his aid in determining the best route across the mountains to California: and it was to California that the Union Pacific was bound. In 1862 specifications had provided that the Central Pacific building eastward from California should build only to the California line. However, this was modified in 1864 to provide a meeting point some 150 miles east of the California border, and in 1866 the roads from California and Omaha were directed to continue building from their respective points until they met. The part played by the Central Pacific often fails to be mentioned in accounts of the building of the transcontinental railway, the usual reference being to the Union Pacific alone. The two companies were separate organizations, however, and remained so throughout their existence.

After the discovery of the "gang plank" to the summit of the Black Hills in eastern Wyoming, Dodge's survey parties located the break in the Continental Divide surrounding the Wyoming basin— a break in the range of the Rockies that eliminated any real mountain railroading along the entire line. By the fall of 1867 the rails had reached the summit of the Black Hills, and in 1868 the survey had been extended to the California line, with the intention of meeting the Central Pacific at Humboldt Wells, 217 miles west of Ogden, Utah. The Central Pacific built too fast for the Union Pacific, however, and the two lines finally met instead at Promontory Point in the spring of 1869, some fifty miles west of Ogden.

"The Central Pacific had made wonderful progress coming east, and we abandoned the work from Promontory to Humboldt Wells," continues Dodge in his memoirs. Describing the last leg of the race between the two railroad companies, he says:

Between Ogden and Promontory each company graded a line running side by side, and in some places one line was right above the other. The laborers upon the Central Pacific were Chinamen, while ours were Irishmen, and there was much ill-feeling between them. Our Irishmen were in the habit of firing their blasts in the cuts without giving warning to the Chinamen on the Central Pacific working right above them. From this cause several Chinamen were severely hurt. Complaint was made to me by the Central Pacific people, and I endeavored

to have the contractors bring all hostilities to a close, but, for some reason or other, they failed to do so. One day the Chinamen, appreciating the situation, put in what is called a "grave" on their work, and when the Irishmen right under them were all at work let go their blast and buried several of our men. This brought about a truce at once. From that time the Irish laborors showed due respect for the Chinamen, and there was no further trouble.

The two lines were joined on May 10, 1869, and except for a small gap, the rails joined the Atlantic and the Pacific oceans. The Union Pacific–Central Pacific was only the first of several transcontinental railways to be built in the next several years. The Northern Pacific, Great Northern, Santa Fe, Southern Pacific, and later the Milwaukee Railroad either built to the coast or combined with other roads to form a line through from the Mississippi Valley to the Pacific. In Canada, the Canadian Pacific was constructed with even more interest concerning access to the Orient than was apparent in the building of U.S. railways. It might be noted, however, that the first point on the Pacific Ocean reached by the Atcheson, Topeka, and Santa Fe was at Guaymas, Mexico. Much was made at that time of the fact that this point was several hundred miles closer to certain Oriental ports than either San Francisco or Los Angeles, and before the introduction of synthetics changed the world of fashion in the present century, there was lively competition between the transcontinental railways in shipping raw silk to eastern U.S. markets in the fastest possible time.

American commerce and industry and the westward development of the nation itself accelerated rapidly as the result of the completion of the first transcontinental railway. Communication between the eastern and western portions of the country brought about many swift and permanent changes as settlements spread out along the railroad right-of-way across the sparsely inhabited central prairies. Headquarters for the shipment of cattle to eastern markets were soon set up at several points, and booming "cow-towns" grew up on the Kansas plains to compete with lumber and mining settlements farther west for the manufactured goods brought from Pittsburgh, Cincinnati, and other industrial centers. Products from the Far East were shipped more cheaply and easily overland from California by rail than by the older, established ocean routes, and many fortunes were made in the next few decades on the basis of this fact.

An awakening sense of unity and national purpose was perhaps one of the most significant results of the transcontinental railroad. Merchants, newspapermen, and curious travelers alike crossed the continent to trade, settle, or return to the East with new profits or experiences, providing the Eastern public with material aplenty to keep their interest in the West alive. The railroads themselves promoted many ventures to encourage western travel in the 1870's and 1880's. No efforts were spared to provide passengers with comforts, and large hotels were built at several points along the way, recalling Alfred Jacob Miller's prediction some years before that the West would one day become a veritable mecca for American and European tourists.

AMERICAN RAILROAD SCENE: SNOW BOUND
published by Currier and Ives

LOWER FALLS OF ADAM CREEK
Thomas Moran

The artist Thomas Moran accompanied the Hayden Survey of the Yellowstone country, and his paintings of its wonders helped significantly to publicize the need for the first of the great national parks.

he first travelers to tempt fate on the Pacific railway did not enjoy all the conveniences accorded those who boarded west-bound trains in the latter decades of the century, and transcontinental travel, especially across certain sections of the unsettled wilderness or at particular seasons of the year, continued for some time to be difficult, uncomfortable, and uncertain. Migrating herds of bison occasionally delayed trains for hours on the central prairies in the 1870's, during which time passengers and crew alike were forced to wait out the interval of their passage. Not a few aboard the train made sport of shooting at the shaggy beasts as they thundered across the tracks. Incidents of this kind were by no means uncommon in the earlier days of rail travel in the West and provided an exciting interruption to an otherwise tedious trip. Robert Lindneux's re-creation of such an incident, which he entitled *A Hold Up*, though somewhat imaginatively rendered, is no exaggeration if reports from that period may be believed.

Attempts by Indians to halt the progress of trains were not as common as we are led to believe by more romantic accounts. By and large, natural hazards presented the most serious difficulties to be anticipated in the course of transcontinental travel and continued to plague engineers and building crews. Floods sometimes covered tracks or washed out bridges. Mountain passes often proved difficult and sometimes dangerous to maneuver, particularly in bad weather. Heavy snows in winter halted many a train on the unprotected plains or the foothills of the Rockies and the Sierras. Time schedules in such cases proved almost impossible to meet, and travel to and from New York and California, even under the most favorable conditions, frequently consisted of a series of unavoidable stops matched by successive, determined attempts to make up for lost time. If accident or breakdown occasioned serious delay, passengers and crew together might be forced to await the eventual arrival of another train to be rescued from their difficulty.

English journalist W. F. Rae has left a very detailed record of his journey from New York to California on the much talked about "Pacific Railway" in 1869. Published in serial form in the New York *Daily News* and in book form under the title *Westward by Rail* by D. Appleton and Company in 1871, his account is well worth the reading, containing as it does not only an interesting description of transcontinental travel but also a critical narrative by an appreciative foreigner with respect to the cities, people, and conditions characteristic of the United States at that time. His delight with the luxurious furnishings, food, and accommodations aboard a Pullman Palace Car—"combined drawing-room, dining room, and bedroom on wheels"—is more than somewhat offset by his description of the journey itself, concerning which he remarks at one point in his narrative:

But it was not enough to lessen the tedium and misery of a long railway journey by merely providing soft-cushioned seats by day, clean and most comfortable beds at night, and well cooked meals for those who chose to order them. The western railroads over which these cars were destined to run had sometimes been constructed far too hastily to be smooth . . .

MOOSE
H. H. Shrady

Untitled lithograph by Thomas Moran

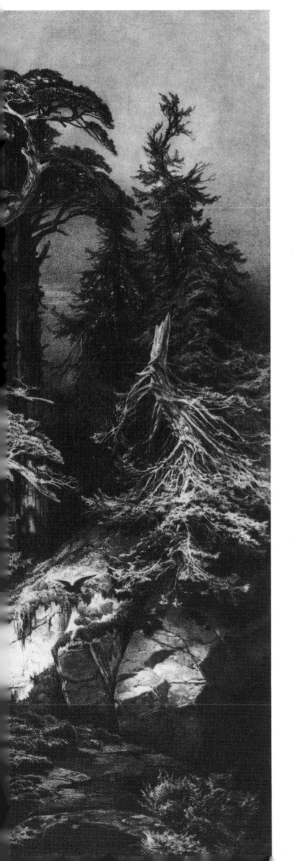

The quality of the railroad construction in general occasioned more than one comment of this kind. Of the bridge across the Mississippi some five hours out of Chicago, Rae recalls doubtfully:

This bridge is nearly a mile in length, and is constructed partly of wood and partly of iron. The structure has a very unsubstantial appearance, and, as it creaks and sways while the train passes over it, the deep and rapid stream beneath flashes over the mind . . .

He is only slightly more relieved to reflect on his safe passage over yet another of the railroad's wooden spans farther west in the vicinity of the present Sherman, Wyoming. He writes:

The train descends by its own weight the rapid incline which leads to the Laramie Plains. Three miles westward of Sherman the line crosses Dale Creek on one of those wooden bridges which appear so unsubstantial, yet are said to be so strong. It is 650 feet long and 126 feet high. The trestle work of which it consists resembles the scaffolding erected for the purpose of painting the outside of a London house. An enthusiastic writer terms this bridge "the grandest feature of the road," and commends it for its "light, airy, and graceful appearance." The contractors are said to boast of having erected it in the short space of thirty days. It is not stated how many days the bridge will bear the strain almost hourly put upon it. More than one passenger who would rather lose a fine view than risk a broken neck breathes more freely, and gives audible expression to his satisfaction, once the cars have passed in safety over this remarkable wooden structure.

Much of Rae's narrative consists of descriptions of the country through which he has passed or accounts of frequent stops along the way to accommodate passengers and take on fuel. Some miles beyond Sherman and nearing the Continental Divide, he made special note in his journal of a place known as Carbon Station:

Here the company's workmen made a discovery which has helped to fill the company's coffers. During the construction of the line a seam of coal was cut through. This was literally a godsend. It had been feared that all the fuel used along the line would have to be transported from the remote East. In this locality wood is very scarce, and the carriage of coal would have been costly. However, the discovery of a coalfield at Carbon settled the fuel question at once and forever. The quality of the coal is first-class, and the quantity practically unlimited. Two hundred tons a day are extracted with ease. Not only is the coal burned in the locomotives, but it is also supplied to the stations along the line, being sent as far eastwards as Omaha. Nor is this the only coalfield which has been discovered and worked at a profit. In other parts of the Territory large fields of coal have been proved to exist, while iron ore of the richest kind abounds in the vicinity of the coal. Thus the Black Hills which have been regarded as yielding nothing but dark pine and have been more notable heretofore for their picturesqueness than their mineral treasures, may hereafter become the center of an industry in coal and iron as important as any upon the continent.

Rae ends this portion of his narrative with a description of the remarkable scenery typical of the country he observed in passing west of the above-mentioned fueling station:

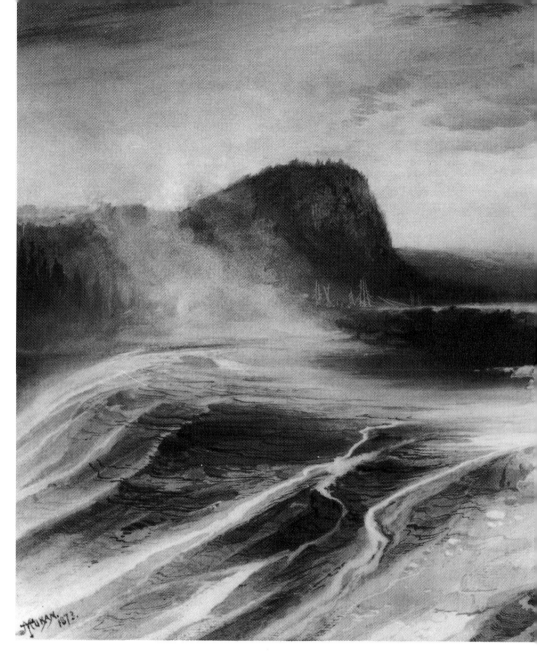

BLUE SPRING, LOWER GEYSER
BASIN, YELLOWSTONE
Thomas Moran

*rom this point the line passes through elevated land on either side,
till a wild gorge is entered a few miles to the east of Fort Steele.
The mountains which stretch away from the mouth of the gorge seem
destined to guard its entrance. They have the look of battlements
carefully wrought and prepared to withstand a siege. The beholder naturally
expects to see sentinels keeping watch on the top, and cannon protruding over
the sides. It is difficult to believe that these escarpments have been cut by no
mortal hand, but are due to the action of the warring elements on the friable
red rock . . . This point is 191 miles west of Sherman, and 1,034 miles distant
from Sacramento. The height above the level of the sea is more than 1,000 feet
less than at Sherman, yet the configuration of the country is such as to constitute
this as the watershed, whence the stream which runs East falls into the Atlantic,
and the stream which runs West falls into the Pacific.*

Such reports on the scenic splendors of the far western country,
coupled with rumors of rich, untapped deposits of valuable ores in the
mountains, stirred men's interest throughout the nation. Rae's
travelogue itself was only one of many private narratives of the kind
widely read by the American public. Other journalists, sightseers, and
businessmen as well availed themselves of the opportunity afforded
by the railroad to view the wonders of the American wilderness. The

208

scenes depicted by Rudolph Cronau, another German-born painter, reproduced in his folio *Von Wunderland zu Wunderland* in Leipzig in the 1880's, reflect the growing sentiments of both Europeans and Americans on the glories of the Far West.

During the latter half of the 1860's and throughout the 1870's, Congress authorized successive explorations of the West. Particularly during President Grant's terms of office, such activities occupied a large share of the government's attention. The Northern Boundary Survey to determine the international line between the United States and Canada was initiated during this administration; and of equal importance, perhaps, a geological investigation that was to have far-reaching consequences was undertaken in northwestern Wyoming in an area known as Yellowstone by Professor F. V. Hayden.

Earlier in the century, fur trappers had wandered through this little-known region, but their stories of steaming springs, geysers, and fantastic rock formations had been regarded merely as another species of Tall Tales that characterized so many reports of the West during that period. Following the discovery of gold in western Montana in the 1860's, adventurous white men again had roamed the Tetons and the upper Yellowstone River region. In their haste to lay claim to hidden fortune, however, few of these men expressed interest in the bizarre beauty of that distant place.

Nevertheless, some people in Montana Territory became curious concerning the tales of strange geological activity in the area. D. E. Folsom thought it worth investigating, and together with two friends braved the dangers of a then current Indian uprising to travel south into the Yellowstone country in 1869. What Folsom discovered there and later told to his associates in Washington encouraged new interest in the region, and in 1870 an official investigation of Yellowstone was announced by the government.

Dr. F. V. Hayden was selected to head this investigation as its chief geologist, and among those he took with him on his trip to the Rockies was an English-born artist, Thomas Moran, and a photographer, William Henry Jackson. While Hayden and his party systematically mapped the area, other men in Montana and Washington speculated on a revolutionary idea: that of persuading the government of the United States to set aside this region as a "natural park," to be preserved forever in its natural state.

By the time Hayden returned to Washington, a bill to this effect was already before Congress. With his new knowledge of the territory, he was called before the assembly to help determine the boundaries of such a park and, more importantly, to assist in lobbying for passage of the bill. Surprisingly non-partisan in character for those politic-ridden times, this bill involved one of the most carefully worked out campaigns in Congressional history to effect its passage. Its sponsors approached and talked personally to every member of Congress. There was a great deal of talk about the beauty of Yellowstone, and Hayden quickly called forth the sketches and watercolors especially prepared by Moran to document his reports. Together with Jackson's photographs, they presented indisputable evidence that the wonders of Yellowstone were, in fact, as real and as wonderful as he had insisted.

A copy of the initial publication of Hayden's *Survey of Yellowstone Park* is preserved in the Gilcrease Library. Illuminated with chromo-lithographs based on watercolors done by Moran in 1871, it is considered rare among books of the Far West because of the small number of copies which were printed and the manner in which Moran's pictures were reproduced. An imperial folio of these same Moran studies is also included in the oversize books and folio section of the museum's archives. Published by L. Prang and Company of Boston in 1876, it contains a selection of fifteen color prints tipped on sheets of matboard gathered in loose-leaf form under one cover.

Both Hayden–Moran volumes mentioned were published by Prang and Company in 1876. A bookdealer's advertisement pasted on the inside cover of one of these portfolios reads: "A complete and perfect copy . . . with the lapse of nearly a century, the known complete sets are possibly only one or two. The work ranks as one of the great pictorial prizes of Western Americana, and much geographical and geological information is included in the text Hayden prepared to accompany this folio of prints."

Seventeen of Moran's original watercolor studies of the Yellowstone country, many of which are featured in the Hayden report, are included in the Gilcrease Institute's collection of this artist's work, as well as two other watercolor renderings of Rocky Mountain scenery and thirty-four variously sized oils. Twenty-two folio boxes containing some 641 of Moran's pencil, wash, and watercolor sketches are also located in the art storage area of the museum, supplemented by an assortment of letters, note pads, sketchbooks, and other material preserved in the manuscript files of the Gilcrease Library.

"I have always held," wrote Moran to Hayden on March 11, 1872, "that the grandest, most beautiful, or wonderful in Nature, would, in capable hands, make the grandest, most beautiful or wonderful pictures, and that the business of a great painter should be the representation of great scenes in Nature."

Entranced with this concept, Moran continued from the time of his first trip to Yellowstone until his death in 1926 to travel widely throughout America, projecting through the medium of his paintings his vision of the American wilderness that made him one of the most famous artists of his day. His large canvas of the Grand Canyon of the Yellowstone attracted a large and curious throng to Clinton Hall in New York City when it was first exhibited there in 1872. Directors of the Northern Pacific Railroad, members of the press, critics, and fellow artists alike came to view the seven- by twelve-foot panorama before it was sent to Washington to hang in the galleries of Congress.

Moran's pictures soon commanded great sums, and during his lifetime most of his favorite sketching areas were set aside as national parks. Working with surprising energy until well up in years, he continued to express his personal love for the primitive splendor of the American West. His first impressions of the Yellowstone, however, retained a hold on his imagination that lasted as long as he lived, for here he had realized his life's ambition, and as a result of his excursion with the Hayden Survey, achieved his first public notice as an artist.

Warfare on the Western Plains
Troopers West

W.R.LEIGH

Troopers West

For nearly three centuries, the Indians fought stubbornly against white intrusion into their ancestral lands, resisting each successive advance of the Anglo-American frontier westward with a determination born of despair. Sometimes this resistance culminated in major battles of considerable consequence. More frequent, however, were the lesser-known skirmishes between the red man and the white fought all along the line of frontier settlements throughout the eighteenth and nineteenth centuries. Forced to give way, foot by foot and mile by mile, the natives fled ever westward or were engulfed by those who overran their ancient hunting preserves and killed off all the game. Inevitably, the plains and mountain strongholds of the Far West became the theater into which the struggle was finally carried, for by the middle of the last century there was no other area into which the battered tribes could retreat, no other place where game was still abundant, no quarter of the continent remaining into which the white man had not penetrated.

THE SERGEANT (*previous page*)
Frederic Remington

Today the marks left on the vast battleground of the West are difficult to distinguish. Nature and man together have nearly obliterated all evidences of former conflict. Here and there the ruins of an old adobe fort yet mark the passing line of Anglo-American penetration into the wilderness of a hundred years ago. A tarnished button with its eagle and shield stamped with the letter "C," an empty rifle cartridge case, or a steel arrowhead discovered in the dust may offer mute testimony to those with eyes sharp enough to detect them. A former cantonment turned into a museum now serves the modern tourist in his short pants and sunglasses as he shuffles through to glance with doubtful interest on the relics of another day. Nothing at all remains of the sound and clash of battle waged between a fierce, free people of the plains and the men sent west to subdue them.

The hostility of the tribes east of the Mississippi during the War of 1812 left in its wake the conviction on the part of many that the white man and the Indian could never live peaceably together. Most of the Indian nations at the time continued to abide by the terms of former treaties with the United States. Even so, there remained certain elements among them who had never wholly accepted this state of affairs—restive factions headed by angry men who refused to submit to the humiliations of these earlier agreements.

In 1825, Secretary of War John C. Calhoun proposed a solution to the problem to Congress: remove all tribes residing within the limits of the United States to territory west of the Ninety-fifth Meridian. Calhoun's suggestion became the policy of President James Monroe's administration. Later expanded by legislation enacted during Andrew Jackson's term of office, this policy resulted in the passage of the Indian Removal Act of 1830.

Two years later, the post of Commissioner of Indian Affairs was created within the War Department. The Indian Trade and Intercourse Act of 1834 defined as "Indian Country" all the area west of the Mississippi River with the exception of Louisiana, Missouri, and Arkansas. In 1838, Congress again more specifically defined as "Indian Territory" a large area that included most of present-day Oklahoma and a portion of southern Kansas. Here were resettled, after much trouble and suffering, the majority of those groups of native peoples occupying parts of Georgia, Alabama, Tennessee, Kentucky, Illinois, Wisconsin, and Minnesota.

The country west of the Mississippi selected for the resettlement of the displaced Indians from the southeastern United States lay within the southern range of the "wild" plains tribes, most of whom followed a nomadic way of life in pursuit of the numberless, migrating herds of bison that grazed the central prairies. These people resented the coming of the immigrants from the East and soon began to make life difficult for them and for the soldiers, traders, and missionaries who followed in their wake. To check or control the activities of these roving, warlike bands along its western frontier, the United States earlier had established several outposts on the plains. Most of these served as supply stations or military bases for raids against the Indians, although some of the forts in Indian Territory

were built initially to provide a measure of protection for the Indians themselves—in particular those newly arrived in the region.

Many councils were held within the walls of these scattered installations in a day when the U.S. government was attempting to make its influence felt in that distant, unsettled region. Diplomatic missions sallied forth into Indian country, and amicable agreements were secured with some of the plains tribes. Age-old tribal conflicts among the Indians themselves complicated the problems of frontier defense, however, and mutual hostility increasingly characterized Indian-white relations in this region despite the admonitions of such men as Jonathan Bell, Secretary of War, who, in commenting on conditions along the Arkansas frontier in 1841, wrote that "as a means of preserving permanent peace with the Indians . . . there is more to be effected by a strict observance of the obligations of justice and humanity in our relations with them than upon any amount of regular military force assigned to that district."

Forts Gibson and Towson had been built as early as 1824 on the Arkansas frontier. Fort Washita, and in Kansas, Fort Leavenworth, were established shortly thereafter. Together with posts such as Fort Snelling in Minnesota and Fort Jessup to the south in Louisiana, these settlements marked the frontline of defense along what came to be known as the "permanent Indian frontier" in the second quarter of the nineteenth century. No white man was permitted to reside beyond this line without a special license from the government.

Realizing the necessity for keeping peace along its western borders, Congress in 1832 authorized the formation of a battalion of mounted rangers comprising some six companies to patrol this entire area. The main strength of this unit was intended at the time for immediate service against Black Hawk's renegades in the Old Northwest, but three companies were dispatched by General Winfield Scott to Fort Gibson in Indian Territory. Increased to regimental size the following year, this mounted unit was designated as the First United States Dragoons under the command of Colonel Henry Dodge with Lieutenant-Colonel Stephen W. Kearny acting as second-in-command. A young officer named Jefferson Davis was assigned as adjutant.

Recruited in western New York, Pennsylvania, and the Great Lakes region, these men were enlisted, according to the words of Secretary of War Lewis Cass, "to scour the prairies, to astonish the natives, and to satisfy them that further hostilities will lead to their destruction." They were also to check on the activities of the various hostile nations west of the Mississippi and "to endeavor by peaceable remonstrances to establish permanent tranquility."

Lacking uniforms or sufficient ammunition to supply all their muskets, the newly recruited dragoons were assembled at Jefferson Barracks near St. Louis, Missouri, on October 11, 1833. From here they set out across the autumn prairies on a journey of some five hundred miles to the Three Forks area on the Arkansas; it took them a little under ten weeks. Arriving at Fort Gibson only to find that the post had no room to accommodate their number, they set up a makeshift camp on a river sandbar, where they spent the long winter of 1833-4 awaiting supplies for the campaign of the following year.

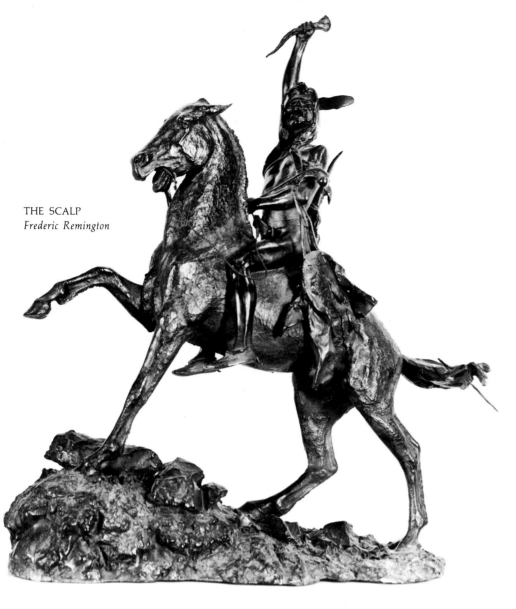

THE SCALP
Frederic Remington

For centuries the Indians fought against white intrusion into their hunting lands. To keep peace along its western borders, the U.S. government authorized the formation of a battalion of mounted rangers to patrol this area. Designated as the First United States Dragoons, this unit was the first of its kind in U.S. military history.

U.S. DRAGOONS MEETING COMANCHES
George Catlin

FORT GIBSON, INDIAN TERRITORY
Vincent Colyer

Duty required the soldier in the West to accustom himself to inconvenience & hardship in the post as well as in the field

The diary of a Sergeant Hugh Evans of Company "G" includes a lively report of his first experience in the West. The official journal of Lieutenant Wheelock, later published in a report to the Twenty-third Congress, embodies a more exacting account of the seven hundred-mile campaign undertaken by the First Dragoons across the scorching summer plains the following year. The heat, exhaustion, and lack of adequate food and water took several lives during this initial foray into Comanche and Pawnee country. The horses, too, suffered from the difficult river crossings, pushing through the "Cross Timbers" to the west, and galloping unshod over the sharp ridges of the Arbuckle Mountains in the general vicinity of the Texas border.

George Catlin, the artist who accompanied this expedition, also wrote of the hardship and misery encountered by the unseasoned horse soldiers, remarking some time afterward in a letter that "this expedition has cost the U. S. heavily, in money and lives, for 50 or 60 dragoons died from the lurking poison within the beautiful scenes we passed over . . ."

An indefatigable traveler and reporter, Catlin also left what may be the only pictorial record of the U.S. cavalryman in the West of this early period. Only a few days out from the fort, the detachment was approached by a group of Comanche, who attempted to amaze the troopers with a display of horsemanship. A small herd of buffalo grazing on a nearly hilltop was rounded up and driven through the middle of the advancing line of dragoons. The incident provoked more hilarity than concern and Catlin quickly dismounted to sketch the curious episode.

In his painting *U.S. Dragoons Meeting Comanches,* Catlin does not show much detail with respect to the soldiers' uniforms and equipment. Historians unacquainted with the wider range of his work are apt to criticize it on the basis of such hasty studies as being at best

FORT GIBSON
Vinson Lackey

U.S. CAVALRY OFFICER
O. C. Seltzer

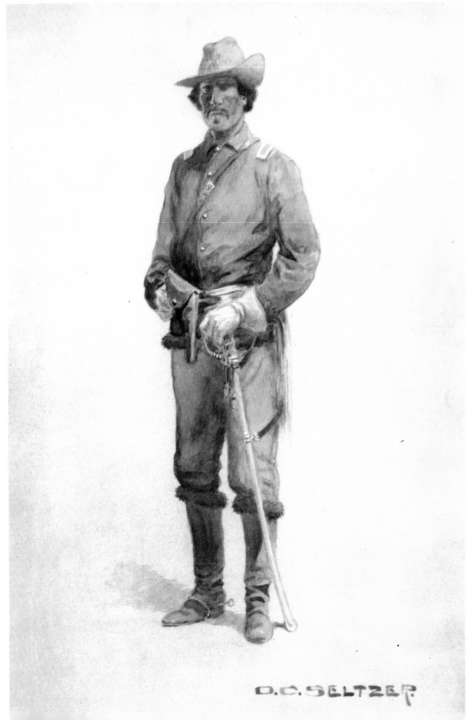

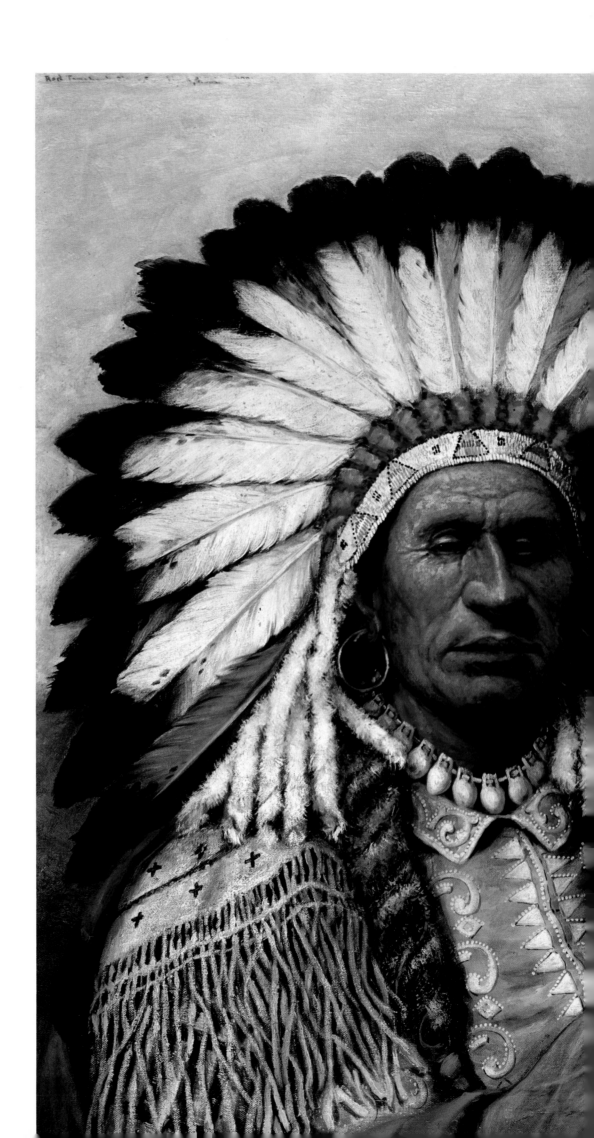

RED TOMAHAWK
H. H. Cross

crude. His purpose in affecting this particular style, however, if indeed it can be called that, was simply to preserve his impression of the moment, and not to produce a studio piece.

Some 570 officers and men died at Fort Gibson during the first decade of its existence, earning for the post the dubious distinction of "graveyard of the army." Built by a detachment of the Seventh infantry under Colonel Matthew Arbuckle at the point where the Verdigris and Grand rivers join the Arkansas, Gibson was for several years the only U.S. post between the Arkansas frontier and the Mexican provinces to the west. Commanding the three principal waterways in the area, it served as the only seat of government in a largely ungovernable region and offered protection to the ever-increasing populations of emigrant tribes moving into the country.

When first built, the fort consisted only of a few log buildings that served as barracks, commissary, guardhouse, and storerooms. A wooden stockade surrounded the encampment in the manner of the smaller military compounds of the period. In his reconstructed view dating almost a hundred years later, Vinson Lackey shows the fort as it was in the 1840's after it had been moved to a point somewhat above its original location on the bluffs overlooking the valley below. When Vincent Colyer visited the area in the 1860's, he saw virtually the same facility, but his sketchy description of the place in a small watercolor that survives to the present does not tell us a great deal about the over-all plan of the post itself. Lackey's research has provided us with a better idea of how it must have looked as one might imagine it viewed from above. For all its attention to the fort's physical plan, however, his painting conveys little impression of life and conditions about a frontier outpost in the 1840's. It is a historian's careful re-creation, presented from an architect's viewpoint.

The forts in Indian Territory played a vital role in protecting the southern borders of the Indian nations on the frontier that divided the United States from Mexico. Many posts such as Forts McCulloch, Wayne, and Washita served as stations for opposing forces during the Civil War and as bases for raids against the renegade Indians after the war. Many councils were held within the walls of these installations during the years of Indian warfare on the southern plains. Here, also, the treaties of peace were negotiated and, in later years, the reservations units came for provisions and supplies.

Garrison life during those early years in the West was far from pleasant. Rude barracks offered scant protection from the elements. Roofs leaked, rooms were cold and drafty, and more often than not, bedding and other equipment had to be covered with buffalo robes during rainy weather. Winter evenings were spent confined to quarters, the men conjuring up any kind of amusement they could think of. Card games were common, money scarce. Reading material was obtained from the post library, which might list no more than a half dozen books, *Robinson Crusoe* reportedly being the favorite. Dances were sometimes held, in which the dragoons, infantrymen, and visiting Osage or Creek Indians joined. Music at such times was provided by a cracked fiddle, an old banjo, or a succession of blats from the regimental bugler generously accompanied by army or Indian yells.

219

Many who served on the southern plains during this period of border vigilance left accounts of their experiences in this lonely region. Ethan Allen Hitchcock, grandson of the Revolutionary War hero, filled numerous diaries during the years he spent in Indian Territory as an official observer of tribal conditions. Others, such as assistant army surgeon Rodney Glisan, kept private journals, which in Glisan's case were later incorporated into a published account of his experiences in the West. Having camped out for some months while the temporary garrison to which he was attached was in the process of moving to its permanent quarters, Glisan remarks, however, that ". . . two years' residence in this country with little else to eat besides game, has changed my enthusiasm for it a great deal, and I now almost loathe wild ducks, geese, turkeys, grouse, etc."

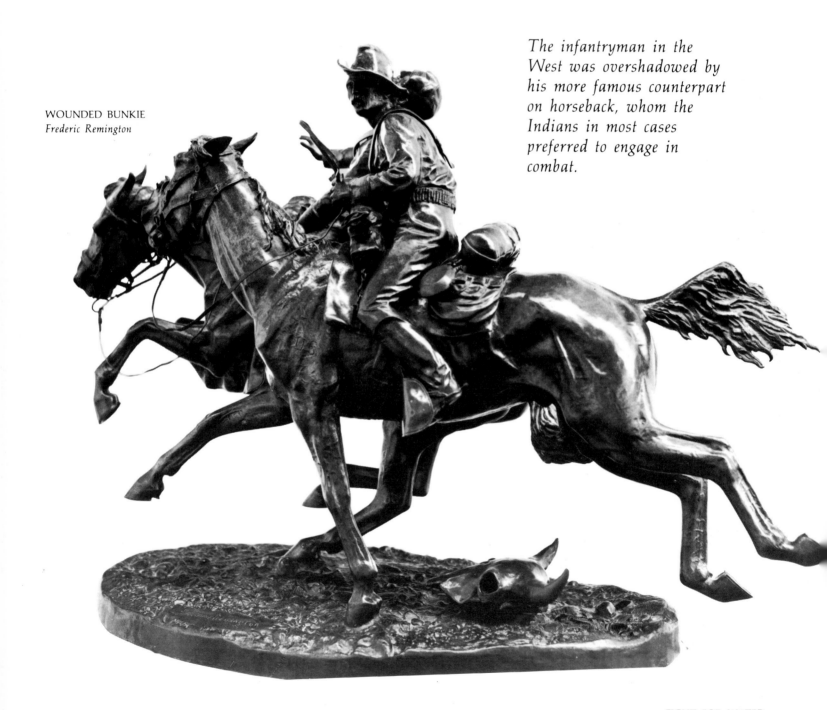

WOUNDED BUNKIE
Frederic Remington

The infantryman in the West was overshadowed by his more famous counterpart on horseback, whom the Indians in most cases preferred to engage in combat.

FIGHT FOR WATER
Charles Schreyvogel

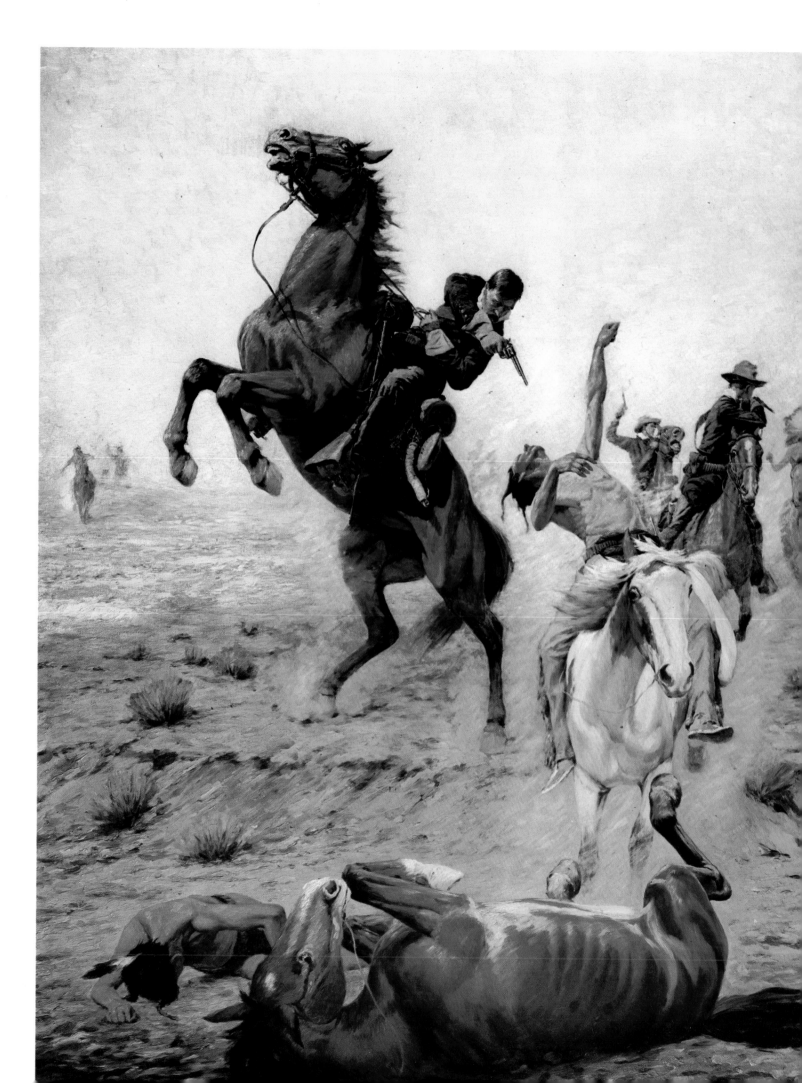

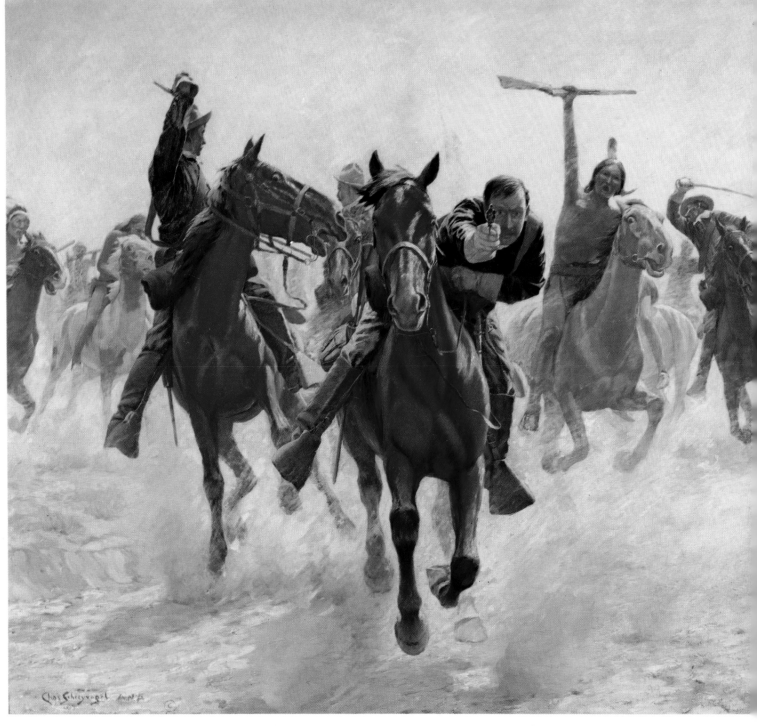

BREAKING THROUGH THE LINES
Charles Schreyvogel

Civil War in the East interrupted the unchanging routine along the line of frontier stations in the West. Called away to serve the Union or Confederate armies, many soldiers left the western posts, or staying, became involved in the battles that broke out along the border country. In any event, Indian affairs were forgotten for the moment as the nation became embroiled in the most bitter controversy of its brief history.

Forts Gibson and Smith were in Confederate hands at the outbreak of the war between the states, but by the end of 1863 both were back under Union control despite their distance from Kansas or Missouri. Confederate troops raided far into Missouri to the east of these stations, but, generally speaking, the Arkansas River marked the boundaries of opposing forces to the south and west. Both before and after these posts were recaptured by Union troops, several skirmishes were fought along the Grand River. One of these near Locust Grove in the northeastern corner of the present state of Oklahoma netted some unexpected Indian reinforcements for the Union command, which already included an Indian regiment.

Among Indians engaged in warfare, there was no such thing as surrender, and battles were usually brief and bloody

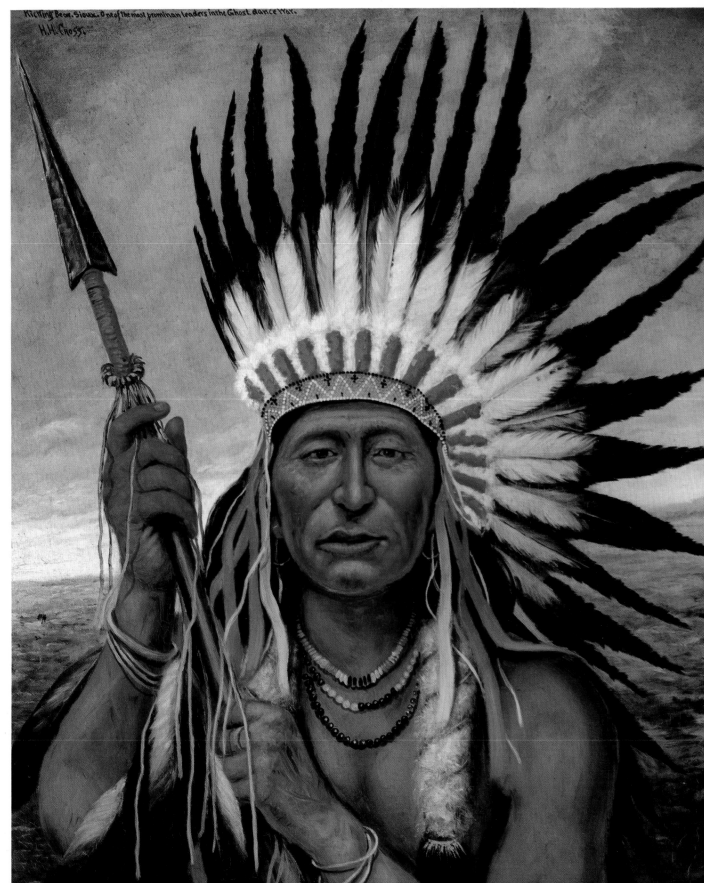

KICKING BEAR
H. H. Cross

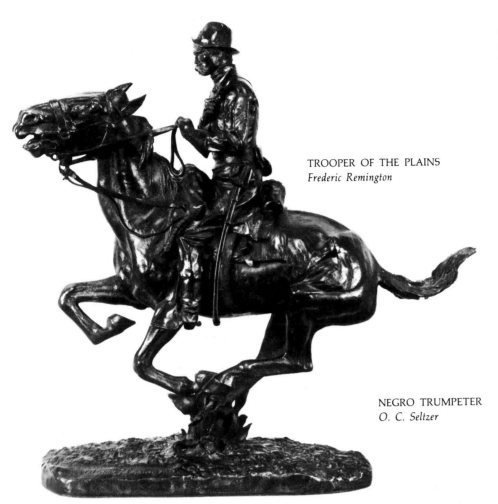

TROOPER OF THE PLAINS
Frederic Remington

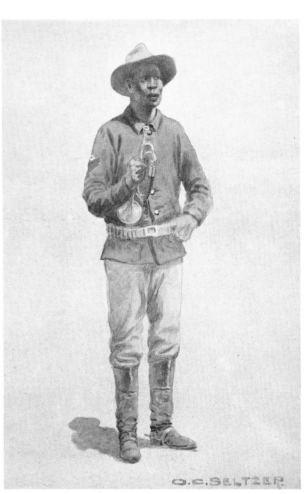

NEGRO TRUMPETER
O. C. Seltzer

BATTLE OF WAR BONNET CREEK
Frederic Remington

he majority of the Indian nations to the west, meanwhile, profited during the period in which the white man warred against himself, regaining something of their old position of dominance on the plains. Tension between Indian and white man had increased to the point of violence on several fronts, and following the war, the United States' attention again was forcibly drawn to conditions beyond the Mississippi.

The destruction of a wagon train near Denver, Colorado, in 1864, had prompted swift retaliation on the part of a local group calling themselves the "100 Days Volunteers" led by Colonel John Chivington, a fanatical ex-preacher turned soldier. More than three hundred Indians were killed as the result of Chivington's attack on an unsuspecting camp of Cheyenne and Arapaho situated by Sand Creek in eastern Colorado, among whom 225 were women and children. Chivington escaped a court martial only by virtue of being discharged from duty before a court could be convened. The Sand Creek massacre was not forgotten by the plains people, however, who determined to combine forces for a bloody campaign of revenge against white settlements, which the regular army was soon called upon to deal with. For the next twenty-five years, the U.S. horse soldier had his job cut out for him.

The presence of military installations and the action of U.S. cavalry troops effected many changes on the Indian frontier of the last century. The plains tribes themselves adopted many of the tactics of the horse soldiers, launching frequent raids on settlements, which were sometimes successful in temporarily cutting communications in the area but, in the end, only resulted in the introduction of more troops to maintain U.S. influence on the western plains. Indian Territory continued to be a principal theater of activity, becoming in time the area to which the defeated plains tribes were consigned to reservations in the western half of the territory, on land taken from the "Civilized Tribes" (the Cherokee, Creek, Choctaw, Chickasaw, and Seminole), who had sided with the Confederacy.

Throughout this area and across the plains the U.S. cavalry carried on a relentless, grueling police action, curbing the hostility of the Comanche, Kiowa, Apache, and allied tribes that lived off the buffalo and cherished the roving plains life. The government of the United States attempted to negotiate treaties in which the boundaries of Indian lands were at least temporarily defined. As these treaties were seldom kept, the Indians seldom remained peaceable for any length of time and little accommodation existed between them and the rapidly expanding American nation to the east. The tribes continued to resist every advance into their territory, whether by soldiers, buffalo hunters, the railroad, ranchers, or farmers. Leading their people in the fight against civilization were chiefs such as Kicking Bear, Satanta, and in later years, Geronimo. In command of American cavalry regiments were some of America's most celebrated generals: Philip Sheridan, Alfred Howe Terry, and George Armstrong Custer.

For officers, the first years in the West following the Civil War were ones of uneasiness. Many who had previously held high brevet or temporary rank were reduced to lesser, permanent rank. Ex-

Untitled studies in pencil by W. R. Leigh

Confederate officers at first were not allowed to hold commissions in the frontier army, although this restriction was later removed. In the ranks were many "galvanized Yankees" as well—prisoners of war who had joined prior to the end of hostilities between the states, preferring frontier duty to the life of a prison camp. Many stayed in the West following the peace at Appomattox rather than return as civilians to life in the destitute South. Captains became privates, ex-colonels served as corporals and sergeants.

Recent European immigrants made up a large part of the postwar frontier army—Irish, German, Italian, French, and other nationals represented in approximately that order. Negroes also played an important part in activities of this period, and a number of Indians drawn from various clans or tribes served the army as scouts. From 1865 to 1890, an odd conglomeration of men fought in the Indian wars: farm boys, store clerks, a few criminal types, men running from their wives or from boredom or failure, and not a few looking for free

passage to the goldfields in the western territories, who often deserted at the first opportunity. Many of these men today would be classified as unfit for active service—men with only one eye, one leg, or one arm, whose feet were minus toes and hands were without fingers. Nevertheless, they served and, in most cases, served well.

The soldier continued to write of his experiences on the frontier, providing in his letters and official reports more material for review than any other figure in the history of the settling West, with the possible exception of the cowboy—whose story, more often than not, was told by someone else. The majority of chroniclers of army life were officers, although many were civilians contracted to army duty: surgeons, teamsters, or in later years, newspaper correspondents, government observers, or artists such as Frederic Remington, Charles Schreyvogel, and Rufus Zogbaum. Among these latter types, many of whom were totally unaccustomed to life in the saddle, the discomforts suffered were of a kind unknown to the seasoned trooper. After a hard ride of some thirty miles with a cavalry unit in the 1880's, Frederic Remington reportedly complained to the troop commander: "Captain, I've got the heart of a cavalryman, but the behind of a nursemaid."

With a heavy force of men, most of whom were battle-seasoned veterans of the recent civil conflict, frontier duty was a rough, hard-swearing, devil-take-it affair. Drinking, gambling, and chasing women were the principal off-duty pastimes. Nevertheless, a high sense of honor, gallantry, and tradition marked the character of the frontier officer and enlisted man alike. Many regiments boasted of long and illustrious records dating back to Revolutionary War days. Battle honors were displayed on regimental colors, regimental customs adhered to, regimental songs proudly sung. Theirs was a kind of *esprit de corps* that few military branches could match today.

The infantryman in the West, overshadowed perhaps by his more famous counterpart on horseback, actually was more feared by the Indians than the cavalry. In most cases the Indians preferred to engage horsemen like themselves than face the volleys fired by the disciplined foot soldiers. Artillery seldom proved to be a vital factor in the Indian campaigns if only because it frequently hampered troop movements in the field against the highly mobile plains warriors.

Frederic Remington spent a good deal of time campaigning with the Indian-fighting army. During the 1880's and 90's his illustrations of military life and articles on military subjects published in *Century* magazine and other periodicals combined to give the Eastern reader an excellent idea of the character of the frontier army during a period when all too little attention was paid to it. In his bronze sculpture *Trooper of the Plains* Remington reflects back on the cavalryman as he probably looked shortly after the Civil War, wearing the short jacket of that period. The forage cap had given way by this time to a black felt with a large brim considered more suitable to the climate of the West. The trooper's boots as depicted by Remington are of the "Jefferson" type, although taller boots shortly came into use to provide more protection for the rider. The saber, cap pouch, carbine cartridge box, carbine sling, and holster shown are also of Civil War vintage.

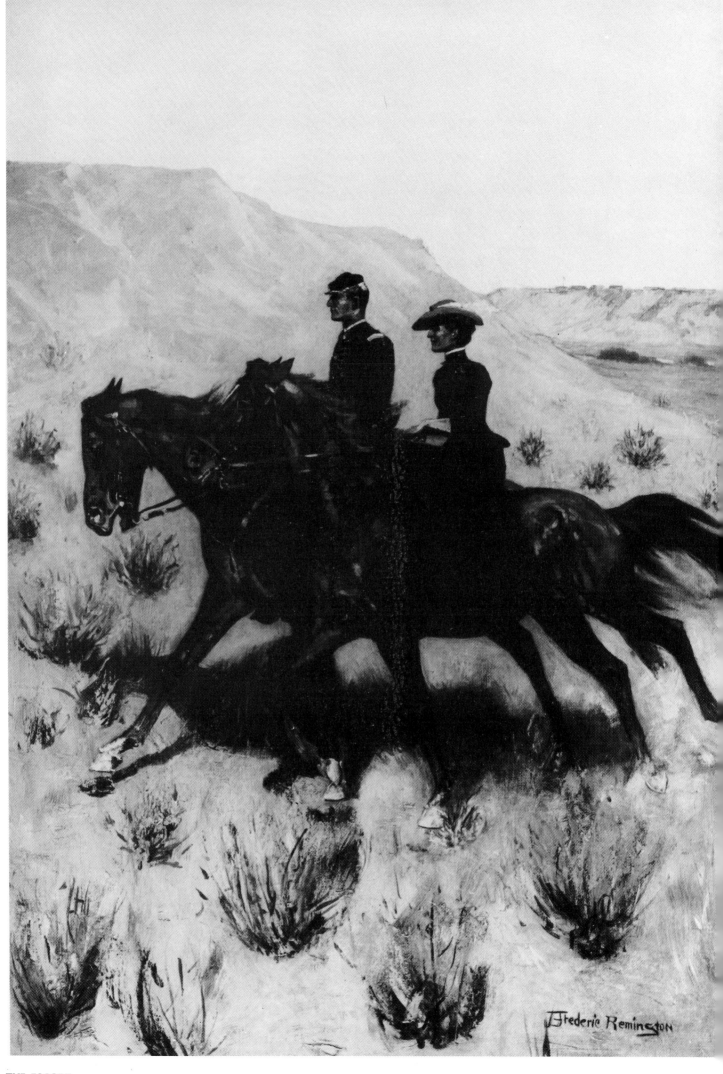

THE ESCORT
Frederic Remington

The trooper's horse, here, is representative of the type favored by cavalrymen in the West, standing approximately fifteen hands high and weighing anywhere from 950 to 1,100 pounds. As a good infantryman took care of his foot gear, so the cavalryman his horse. The ideal cavalry mount possessed a gentle disposition, a good mouth, regular and easy gaits, and sufficient nerve without being considered "nervous." An animal from four to six years of age was the average, although horses of all kinds, sizes, ages, and dispositions were seen on the frontier.

Remington has presented his cavalryman riding a "military seat" recommended as the position to maintain on horseback for all-around military action. Some cavalrymen varied this somewhat by effecting what was known as the "forked seat," in which case the stirrup straps were lengthened to enable the rider to stand up while his mount was in motion. The forked seat was often used during charges, affording easier employment of weapons.

The average weight of the cavalryman's pack and saddle was about ninety pounds and usually contained extra ammunition or additional clothing as dictated by the season. Another twenty pounds might be added to the pack of a trooper, who himself generally weighed no more than about 150 pounds. Many men were heavier, to be sure, but the Indian-fighting cavalry had few fat men in its ranks.

Many women went west with their soldier husbands, making the most of their chosen lot and striving to maintain some semblance of civilization under the primitive conditions that normally existed at a military post. Some stayed only a little while, only too glad to return East to a more comfortable life. The majority remained, however, to cook and wash while their men rode off to campaign in the field to the tune of "The Girl I Left Behind." Life was anything but easy at a military station on the far frontier. Relaxation, when there was time for it, consisted of gossip, theatrics, dances, card parties, and the like. Younger sisters or sisters-in-law were frequent visitors to the army garrisons, often married soon after their arrival. The wives of the enlisted men usually supplemented their husbands' army pay by doing the post laundry. Their quarters were commonly called "suds row" or simply "sudsville."

Most army wives learned to ride and shoot, sometimes becoming extremely skilled. They were expected to commit suicide if they fell into Indian hands, and if it was thought that a woman lacked the resolution to kill herself in such an extremity, a trusted orderly or friend was charged with the solemn task. As a whole, army women disregarded the Indians they happened to come into contact with around the forts and were carefully instructed never to show fear before them.

Regard for the feminine proprieties was maintained, despite the rougher features of communal living at the fort, as several anecdotes from the period attest to. Frederic Remington may have had such a story in mind when he painted the black and white oil on canvas entitled *The Escort:* The story tells of an Alice Baldwin, who, accompanied by a young officer during an afternoon's ride, was discovered by a band of hostile Indians and pursued. Racing toward the nearby post, Miss Baldwin's saddle girth broke. Immediately she shifted her

position, throwing a leg across her mount and riding astride without breaking pace, fretting all the while that her legs were exposed. With quite enough trouble on his mind, her escort shouted, "Damn your legs, ma'm, I've got to get you home!" It is said that they made it safely to the post.

Fear of Indians and the discomforts of outpost living were not the only troubles that plagued these women. Rattlesnakes, insects, and rats were rampant in the compound, and wolves and coyotes posed a fear, if not a real threat. In officers' quarters, a second lieutenant's wife put up with one room and a kitchen; an additional room accrued with each advancement in her husband's rank. If all went well and, in ten or fifteen years, a man made captain, his wife might have three rooms and a kitchen, provided, of course, that a new ranking officer did not move onto the post and displace them from their quarters. Bearing children on the frontier was at best risky. Most women went east to give birth if they could afford it. Others depended upon the post surgeon, Indian women, or other white women at the fort. The mortality rate was high. As Captain Frederick William Benteen once wrote in a letter to a friend: "I lost four children in following the call of the trumpet."

Troopers West

THE LAST DROP
Charles Schreyvogel

Frontier posts were small garrisons, for the most part, built to accommodate no more than about a hundred men. The earlier ones built in the 1860's generally were walled about with palisades and bastions, but experience soon proved that Indians rarely attacked a fort, preferring to meet the soldiers on horseback. As a result, most posts built after the late 1860's were not enclosed. The average compound included officers' quarters, both married and unmarried, normally located on the north perimeter of the parade ground opposite the company barracks. The officers' mess and kitchen were separate from the company mess and kitchen. Housing for enlisted men and laundresses, post adjutant hospital, and a guardhouse, powder magazine, and facilities for the post harness maker, saddler, and baker occupied other areas, as did the commissary, quartermaster's storehouse and office, the stables and corral, granary, blacksmith's shop, ice house, and sutler's store, if the establishment was large enough to include all these facilities. A post garden and a cemetery were maintained beyond the compound itself. Barracks varied from the large, two-storied structures with shingled roofs and glass windows to the long log or plank buildings of the crudest sort. More comfortable accommodations of adobe with walls sometimes three feet thick were usual in the Southwest.

To the cavalry trooper, his horse was more important to him than practically anything else, and Western-bred animals with mustang blood soon replaced the Eastern-bred mounts, which required in general more attention. Whenever possible, individual groups or regiments rode horses all of the same color and came to be distinguished accordingly—the "gray troop," the "bay troop," and so on. Stables were often better built than barracks, each horse having a separate stall and a window for ventilation. Stable call came regularly, twice a day, at which time the stables were cleaned and the animals groomed. The average horse ate fourteen pounds of hay and twelve pounds of grain in a day when not in the field. Because of the care these horses received, it was not uncommon in later years to find animals that had served the army until the age of twenty-five years or older.

In his bronze of a trooper in the field giving his last drop of water to his mount, Charles Schreyvogel clearly describes the McClellan saddle of the 1880's with a Springfield single-shot carbine in its boot. This carbine served the cavalry from about 1874 until the Spanish-American War in 1898. The McClellan saddle, with but a very few changes, was used by American troopers from the time of the Civil War until 1954, when the last horse and mule outfits were mustered out of the army, and it was undoubtedly the finest cavalry saddle ever made. Its saddlebags were designed to carry a currycomb, brush, extra ammunition, horseshoes, and other utilitarian items. A fourteen-inch picket pin and a picket rope attached to the halter were snapped to one of the brass rings on the left side. Across the cantle back of the seat, a blanket roll was carried with a canvas feed bag over the left end and a poncho rolled over the other. A canteen and tin drinking cup were snapped onto another ring and tied down with a cantle tie-strap. Across the pommel at the front of the saddle, a rolled canvas "dog" tent was tied. The carbine boot, as shown, was strapped to the

right side of the saddle. The cavalryman carried his saber. Small wonder that plains Indian horsemen, with their notable lack of gear, were regarded as "light cavalry" by U.S. troopers, or that the Indian in turn sometimes laughed at his overburdened, blue-coated adversary with the "long knives."

Under the unwritten terms of Indian warfare there was no such thing as surrender in the generally acknowledged sense. If captured, or if he surrendered, during the Civil War, a prisoner had been assured a good chance of surviving. This same soldier fighting Indians on the western plains, however, could look forward only to immediate death or, worse, prolonged torture.

More often than not, a trooper captured in the manner depicted by Remington would not be taken any great distance. Expecting pursuit, the Indians usually killed prisoners taken in the field soon after capture. There were few prisoners taken on either side during the Indian wars, and those soldiers caught were either taken by surprise or found wounded. Most troopers saved a last round in their revolvers for such an emergency to be used against themselves.

MISSING
Frederic Remington

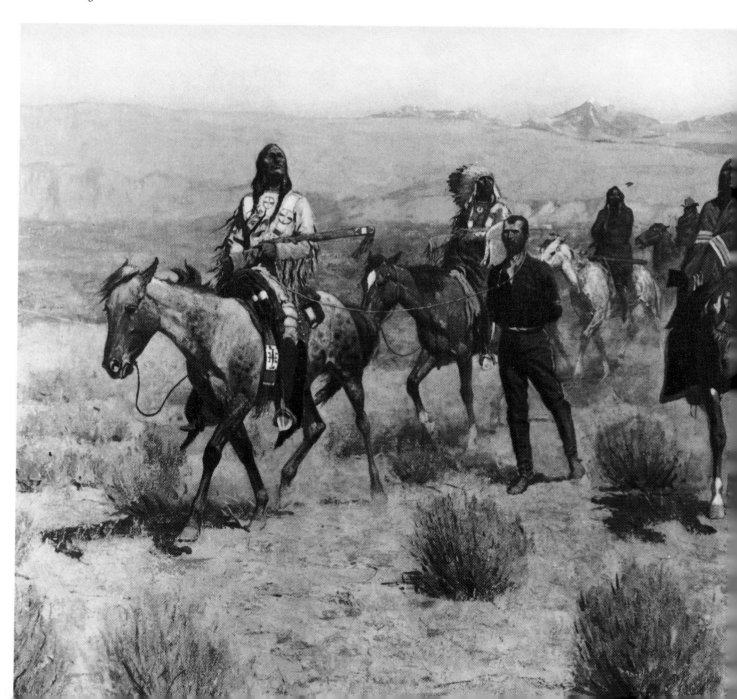

ntrigued by army life on the Indian frontier, Frederic Remington left a body of pictures and commentary that firmly established his reputation as a reporter in this field. His lively works on canvas or in bronze develop general themes or characters for the most part, unlike those of Schreyvogel or Seltzer, who more often were interested in specific, historical events. In his painting entitled *The Messenger*, for example, Remington exhibits his obvious knowledge of the uniforms and equipment worn or used by cavalrymen in the late 1870's or early 1880's, but the scene he presents is not meant to be identified by date or place and might serve to illustrate any similar incident, which was common enough in the West.

In his *Arrest of the Scout*, he dramatizes another episode of life on the frontier. In this case, the picture, an oil done in tones of black and white, appeared originally as an illustration in his book *Crooked Trails*, and depicts the arrest of an innocent Indian scout in connection with a murder committed by a Chiricahua Apache named Lone Wolf. In both works, he shows the variety of uniforms worn by the frontier army. In the first instance, the trooper bearing a message

THE MESSENGER
Frederic Remington

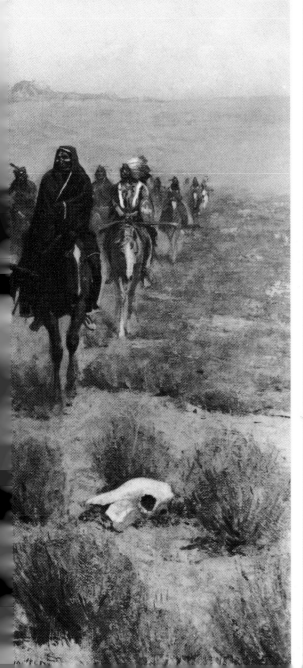

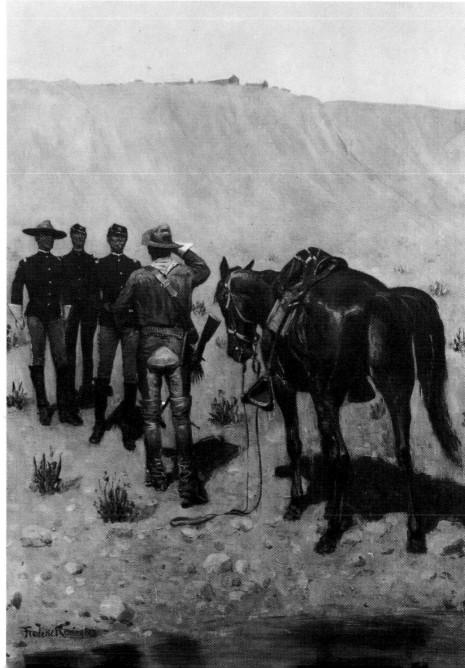

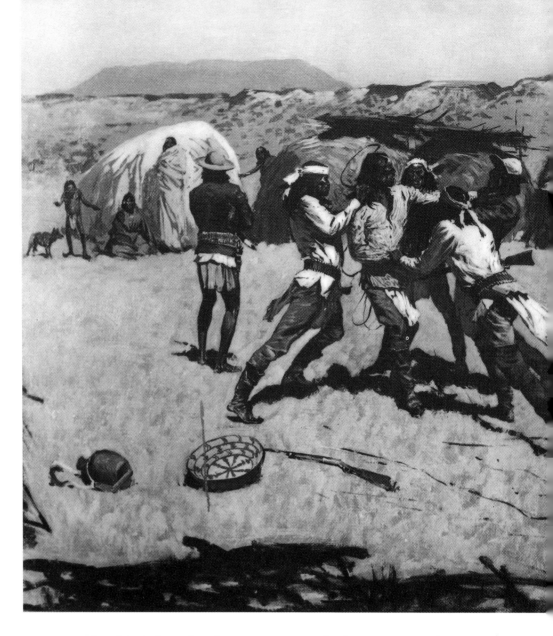

His attention to the portrayal of uniforms, equipment, and other details in his pictures makes Frederic Remington one of America's most important chroniclers of life in the West after the Civil War.

ARREST OF THE SCOUT
Frederic Remington

wears a pair of britches that have gray pony hide sewn into the seat and inside the legs. His boots are of a type common during the 1870's, while those of the officers in the background receiving his report became regulation in the 1880's.

In the latter illustration, the waylaid Indian scout is shown in the field dress worn by such men while on police duty on an Apache reservation, a combination of military and Indian items and personal gear. Remington's attention to detail reveals his concern for "realism" in his works. Added to his sense of the dramatic or, in some instances, humor, his pictures are convincing.

Olaf Seltzer shared Remington's enthusiasm for Western life, although many of the scenes and characters he portrayed were well before his time. Like Vinson Lackey, he carefully researched his subjects and succeeded in producing a valuable documentary on those episodes in the past otherwise difficult to picture or recall. His series of miniature oils commissioned by the late collector Philip Cole are among his most distinctive contributions to a growing library of Western lore. He also produced other series for his wealthy patron, in particular a set of watercolor portraits that he called "Characters of the Old West."

The *Negro Trumpeter* is one of these, and it calls attention to a little-known figure in the annals of frontier history. Following the end of the Civil War, Negro units were authorized for the regular army,

234

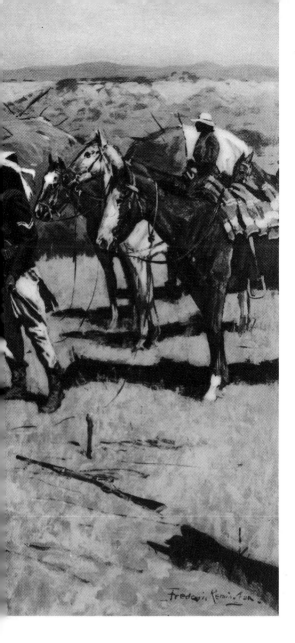

recruited mainly from among ex-slaves in the South or volunteers who had served with the Union army during the war. Commanded by white officers, the Negro soldiers comprised the Ninth and Tenth cavalry and the Twenty-fourth and Twenty-fifth infantry units. Called "buffalo soldiers" by the Indians and "brunettes" by Anglo-American troopers, these Negro regiments campaigned for nearly twenty-four years on the plains throughout Texas, New Mexico, and Arizona, in the mountains of Colorado, and as far north as the Dakotas. The Ninth and Tenth cavalry regiments held the lowest record of desertions of any in the West at that time. Drunkenness, a major problem with many units, was almost unknown among these men. Frederic Remington's favorite regiment was the Tenth cavalry, and he campaigned with them on a number of occasions and wrote about them in his articles.

Charles Schreyvogel established his reputation at the beginning of the present century on the history of the Indian wars. Born in New York City in 1861, he realized his ambition to portray the Indian-fighting army when he took his first trip west in 1893. He made a second trip in 1900, at which time he collected various specimens of army gear and other items to be used as models for equipment reproduced in his large, action-packed canvases. One work devoted to an episode in the Custer epic, however, occasioned criticism from several quarters, primarily from Frederic Remington, who felt obliged to call attention to several defects in Schreyvogel's reconstruction of history.

Entitled *Custer's Demand* and based on an incident that occurred during the campaign of 1868–9 in Indian Territory, Schreyvogel's panoramic painting was reproduced in the New York Sunday *Herald* on April 19, 1903. Almost immediately it came under attack by

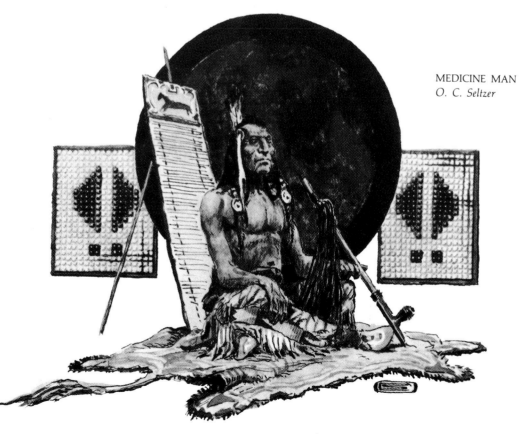

MEDICINE MAN
O. C. Seltzer

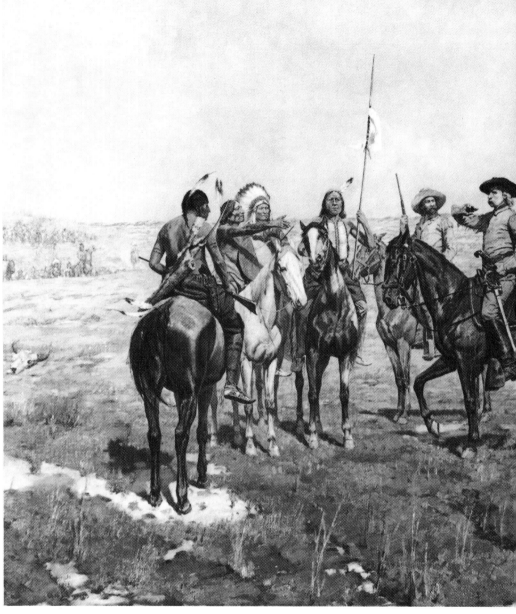

CUSTER'S DEMAND (*and detail*)
Charles Schreyvogel

Remington, who was considered at that time to be the foremost authority on western army lore. Remington challenged the picture on several points, chiefly its lack of authenticity with respect to the types of uniforms and equipment shown. The cartridge belts worn by the Indians, for example, were of a type evolved in Texas in the late 1870's and not generally in use until the 1880's. The Sioux war bonnet worn by the principal figure among the Indians was almost unknown on the southern plains at this time. The white campaign hat, according to Remington, was not worn until many years afterward. The boots worn by Custer were not adopted by the U.S. cavalry until March 14, 1887.

"Crosby wears leggins which were not in general use until after 1890," continued Remington in a newspaper interview. "The color of Colonel Crosby's pantaloons was not known until adopted in 1875 . . .

"Now the picture as a whole is very good for a man to do who knows only what Schreyvogel does know about such matters, but as for history—my comments will speak for themselves."

236

emington was right on most points of his criticism. The cartridge belt, adopted first by buffalo hunters and soldiers in the 1880's, did not come into general use until some ten years later. In the 1860's and 70's most weapons were still of the percussion type, and ammunition was carried in boxes or pouches.

As for the comment regarding Custer's hat and boots, Remington might have qualified himself somewhat, for in the 1860's a variety of nonregulation items were worn by men in the field. Remington himself reveals his knowledge of this fact in many of his own canvases. The leggings worn by Crosby in this case were not known until the 1890's, although a style closely resembling them was worn in Custer's day. The same is true of Custer's boots: they are a type not adopted until 1887. However, many officers who could afford to do so wore custom-made footgear that in some instances closely resembled those shown by Schreyvogel. In all probability, Schreyvogel had a pair of the later regulation boots in his studio collection, which he used as models for this painting.

Remington's criticisms were answered by none other than Custer's widow, Elizabeth Custer, in a letter published by the *Herald* shortly thereafter. She commended the picture's composition and harmony and the likenesses of those represented. She also commented on the costumes of the Indians, in particular the war bonnet and shield, and remarked that items very much like those described in the painting had been presented to her husband by chiefs at this time. Remington replied to the effect that Schreyvogel was hiding behind Mrs. Custer's skirts and offered a hundred dollars to charity if Colonel Schuyler Crosby would verify that he never saw a pair of trousers of the color and type depicted in the painting worn by units of the regular army at that time.

Crosby, while generally supporting Schreyvogel's work, admitted that the trousers shown were of the wrong color. He insisted, nevertheless, that he had worn leggings similar to the kind described as early as 1863 and that he had seen many war bonnets among the Indians on that day when Custer had demanded the return of the renegade bands to their reservations. On other points brought up by Remington, he remained noncommittal, summing up the whole weight of the argument with words to the effect that "neither Mr. Remington nor Mr. Schreyvogel were there, and I myself have forgotten."

The debate today is of small importance, but it does emphasize the seriousness with which Western historians and painters of historical subjects yet regard their investigations into the events of the past. The Remington–Schreyvogel quarrel sheds no light on the character or the importance to history of men like Custer. Indeed, it is likely to remain a controversial subject for as long as men delve into the "facts" of history whether Custer was a hero or a villain. As for the Dakota campaign of 1876, it may be that Custer, if given the choice, would have preferred to die in the course of such a battle than to live longer and make less of a mark for himself. It does seem hard, now, to imagine what history would have said of him had he lived out his last days in a veterans' home.

uster's part in the much-debated battle along the Little Big Horn River has been told so many times that it need not be repeated here. Suffice to say that his incredible run of luck in his western campaigns at last ran out. Hundreds of Sioux and Cheyenne rose up to meet him from out of the seemingly empty Montana hills, surrounded his detachment and utterly overwhelmed it. Custer was thirty-six years old when he died. With him died his brother Tom, recipient of two medals of honor, another brother named Boston, a nephew by the name of Armstrong Reed, and a brother-in-law, James Calhoun.

In the aftermath of the Little Big Horn disaster, the nation mourned its fallen heroes and loudly voiced its protests concerning the causes that had contributed to so dreadful a defeat at the hands of the Dakota Sioux and Cheyenne. The fact that the United States was in the midst of celebrating its Centennial with an exposition honoring its industrial growth and development as a nation made it no easier for Americans to accept defeat on the frontier by what were regarded at that time as nomadic savages.

From that time forward, the army determined to dog the trail of the Indians responsible for the defeat. In the months and years to come, the troopers experienced hard campaigning at its worst. To the south, cavalry units rode against the Apache bands led by Geronimo and Nahche. In Montana, the survivors of Marcus A. Reno and William Benteen's commands, their ranks augmented by new recruits, pursued the Sioux, Cheyenne, and other northern tribes, forcing them finally to surrender or face annihilation. The war was finally carried into the land of the Nez Percé, at peace with the white man since their first meeting with Lewis and Clark at the beginning of the century. Threatened with the same fate as that of their brothers to the east, they also gathered strength to resist. United States troops, amazed at the tactical prowess of their leader, Chief Joseph, defeated them only at great cost and trouble. Opposed by overwhelming forces, Chief Joseph at last surrendered to General Nelson Miles.

In the Southwest, the Apache revolted, and U.S. soldiers were still required to maintain order on several fronts. But the contest was over. Pressed to discard their old ways and traditions and adopt the white man's culture, most of the once proud tribes reluctantly complied, retaining whatever they could of their traditions and integrating them to a greater or lesser extent into their new, and unwelcome, sedentary existence. Some continued to serve the army as scouts, such as the group of Cheyenne stationed at Fort Reno, Indian Territory, in the 1880's, useful in keeping tabs on their still restless people in the area. Comanche chief Quanah Parker, once a leader of fighting bands, was instrumental in helping his people adjust to the new way of life, teaching them the principles of ranching and farming.

Of the old days of warfare on the plains, only an echo remained.

Western Characters

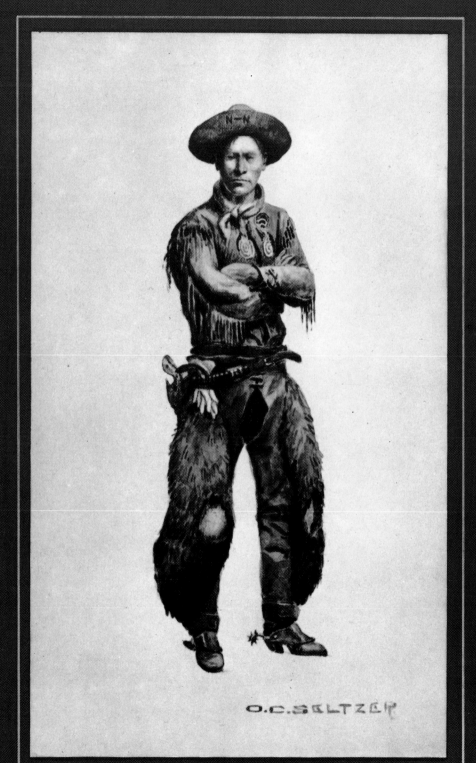

O.C.SELTZER

Winners of the West

Western Characters

Throughout the history of government-sponsored exploration of the West, first military men and then civilian experts were employed to carry out the task. In nearly all instances, information about the inland areas of the continent was the chief aim, although Congress expressed an increasing interest in the establishment of wagon roads and railroad routes to the Pacific, especially after the discovery of gold in California. Between 1840 and 1880, investigations of all the western territories were undertaken and innumerable volumes compiled by those who were engaged in the various surveys. The interests of geology, ethnology, and natural history were secondary to those of transportation, commerce, and the determination of international boundaries; nevertheless, the information obtained with respect to natural conditions and available soil and mineral resources did much to promote interest in the settlement of the trans-Mississippi wilderness.

During the first half of the nineteenth century, the United States discovered itself as a nation. The people in the East, having established a secure foothold on the land, were hard at work developing a busy and prosperous society. As population increased, so did the demands of civilization, and multitudes of Americans pressed westward toward

the ever-beckoning frontier. Some traveled by wagon, others by horseback; and many walked across the wilderness with packs on their backs or pulled their worldly belongings behind them in handmade carts. The experiences they reported were common in many respects. Rich or poor, law-abiding or adventurous, they pressed on toward their respective goals. Many perished along the way from disease or accident, and pathetic markers on hastily dug graves stood as reminders of the hardships to be met with on the western trails.

The number of those who crossed the Atlantic to study law, politics, science, or the arts from European tutors likewise increased during the 1840's and 50's. Their techniques acquired, these men returned to the United States to participate in the vigorous life of a westward-expanding nation, praising the accomplishments and the qualities of character they felt to be so peculiarly "American." Several American painters developed their talents in the schools of Germany or Holland, where they became acquainted with the manner in which northern European artists traditionally recorded the life of their times. These artists made successful careers back home painting scenes and subjects reflective of American activity and culture.

Eastman Johnson, George Caleb Bingham, and Edward Henry are among those who came to prominence during this period. George Durrie was also active, creating quiet views of rural life and industry along the edge of the settling frontier. Emanuel Gottlieb Leutze, painter of historical scenes and portraits, having returned to his native Germany in 1840 to study at the famed Düsseldorf Academy, was called back to Washington in 1859 to execute a mural in the House of Representatives. Christened *Westward the Course of Empire Takes Its Way*, this highly romanticized portrayal of America's surging westward movement, with its group of sturdy pioneers boldly advancing into the wilderness, strongly appealed to a self-conscious nation convinced of its "manifest destiny."

News of the discovery of gold in 1848 near present-day Sacramento, California, had an almost immediate and explosive effect on America's western development. Within a year nearly 81,000 people in the United States and several foreign countries left their accustomed occupations and ways of life to seek their fortunes in the distant goldfields. Some sailed to California by way of Cape Horn, and others crossed the Isthmus of Panama. By far the largest number traveled overland via the California Trail and across the rugged Sierras. Most were unfamiliar with the wilderness and its hazards. Storms, river crossings, heat, and cold claimed many lives. Asiatic cholera, dysentery, and Rocky Mountain fever added to the toll of casualties. Despite the many who died on the trail, a surprising number managed the trip successfully, and a few found treasure enough to satisfy even the most fevered imagination.

Early arrivals worked with pick, shovel, and shallow pans along the gravel beds of rushing California streams. Placer mining of this type rapidly gave way to more profitable methods, however, as shafts probed richer veins or lodes deep in the earth itself. Clusters of tents and roughly built shacks rapidly grew into sprawling towns in several mining districts, and the populations in some areas increased tenfold as more and more treasure hunters poured into the raw, new country.

BUFFALO BILL AND HIS DOG
F. MacMonnies

"Civilization approaches the Indian with a Bible in one hand, a treaty in the other, a bludgeon under her arm, and a barrel of whisky in her wagon."

WESTWARD THE COURSE OF EMPIRE
Emanuel Leutze

The pursuit of wealth brought many to venture beyond the wild frontier. It was a long time before some men began to realize that there might be a limit to the seemingly endless supply of America's natural resources.

WOOD HAWK
O. C. Seltzer

Although the "forty-niners" are generally pictured as grizzled, hard-bitten old men of decidedly solitary habits, in reality most of them were young men in their twenties, or even younger. Reared on the fringes of settlement, with little education and few family attachments, they welcomed the opportunity for adventure and the chance to make their fortunes. Hard drinkers, gamblers, and lawless characters also were numbered among the gold seekers of the 1850's, as well as men from respectable professions. Regardless of background or upbringing, they adapted quickly to life in their new environs, as writer Richard Harding Davis noted in his book *The West from a Car-Window*, remarking that it was indeed surprising how quickly "well-bred youths as one constantly meets in the mining camps and ranches of the West can give up the comforts and habits of years and fit into their surroundings."

The Far West to the average Easterner at this time was about as remote and storied a place as it is to most Americans today. The Indians of the East, subdued or assimilated, generally were ignored, or else fondly remembered as the "Noble Redman" in popular romances. "The only good Indian is a dead one" was, in the main, a frontier adage. The army in the West, on the other hand, was looked upon as a society of misfits, renegades, and cutthroats.

New England in particular had its share of Indian "sympathizers," whose views were strongly felt in the halls of Congress. Political and social intervention was rife in governmental circles, and much zeal on the part of reforming elements was directed against the sale of guns, ammunition, and whisky to the western tribes. Treaties made in the meantime, tempered by pressures from powerful lobbies representing Eastern trading firms and land companies, proved in practice to be more beneficial to those interests; and it was the army on the frontier that took the brunt of the trouble that inevitably followed. As one cavalry officer in the West is said to have summed up the situation: "Civilization approaches the Indian with a Bible in one hand, a treaty in the other, a bludgeon under her arm, and a barrel of whisky in her wagon."

As early as 1819 Congress had authorized President Monroe to employ persons of "good moral character" to instruct the Indians in agriculture and to "teach the children reading, writing, and arithmetic," appropriating funds in the amount of ten thousand dollars annually to support this work. The authorization did not specifically include converting the Indians to Christianity; nevertheless, the mission societies at this time were almost the only organizations interested in the program.

Between 1820 and 1860, approximately seventy missions were established in Indian Territory alone. The committees back home at first had little idea of the problems to be faced by the mission teacher in the wilderness. Difficulties of communication or travel were particularly hard on the women and children of mission families, and little seems to have been done beforehand to prepare them for rough living conditions and strange languages and customs. Among the churches there was little agreement on the importance of secular instruction, and the majority of the brethren at home probably envisioned the missioner as going forth to save souls. In the field the situation proved

PROSPECTOR'S DEPARTURE
J. J. Ray

CIRCUIT RIDER
O. C. Seltzer

GRANGER
O. C. Seltzer

The Far West to the average Easterner in the nineteenth century was about as remote and storied a place as it seems to most of us today. Few were familiar with the land or the hazards involved in traveling across the unsettled interior.

otherwise. The schools rather than the churches became the center of missionary activity in the West, for the Indians as a rule understood the value of the "white man's learning" more readily than they grasped the concepts of sin and salvation.

The white man, too, was included in the missionary picture, although preaching on the frontier often required the employment of unorthodox methods. Ministers of the Gospel quickly realized that they must adapt their message to people living in widely scattered settlements; and as in earlier days along the Colonial frontier, the circuit rider became a familiar figure in the West. Many sermons were delivered in saloons, with a hat being passed around for donations. In Austin, Nevada, the Methodist congregation received donations of mining stock that the pastor put into the "Methodist Mining Company." Selling shares of stock in the East, he was thus able to build one of the finest churches in the state. Generally speaking, churchmen in mining camps fared better than their counterparts in other frontier communities.

With the passage in 1862 of the Homestead Act, a new flood of immigrants spread across the face of the wilderness. The act provided that any citizen or prospective citizen at least twenty-one years of age, who had never borne arms against the United States, could file for

CIRCUIT RIDER
O. C. Seltzer

GRANGER
O. C. Seltzer

160 acres of government land in the West. The fee for filing such a claim of intent was ten dollars, plus a registration fee that normally did not exceed another ten. The party thus registered was expected to move onto his tract of land and to make specified improvements within six months of the filing date. After occupying the land for a period of five years, he was entitled to receive a patent on it. Prior to this time government land had been made available, but earlier acts had been more loosely written and many fraudulent claims had resulted.

The railroads also offered land along their right-of-ways to prospective settlers, the usual practice of the government being to grant land to the railroads as an encouragement to expand into the western territories. The railroad, in turn, promoting the use of its lines, sold numbered sections along respective routes for from three to five dollars an acre, with extremely liberal arrangements for payment. Many such sections were sold abroad to prospective immigrants. Railroad agents, offering easy passage by rail to the "Promised Land," sponsored several colonies in this way.

Most Europeans came with the hope of getting rich quickly and then returning home. Others came wanting only to build a better life than they had. The majority were disappointed to some degree. Some

SLUICER
O. C. Seltzer

PLACER MINER
O. C. Seltzer

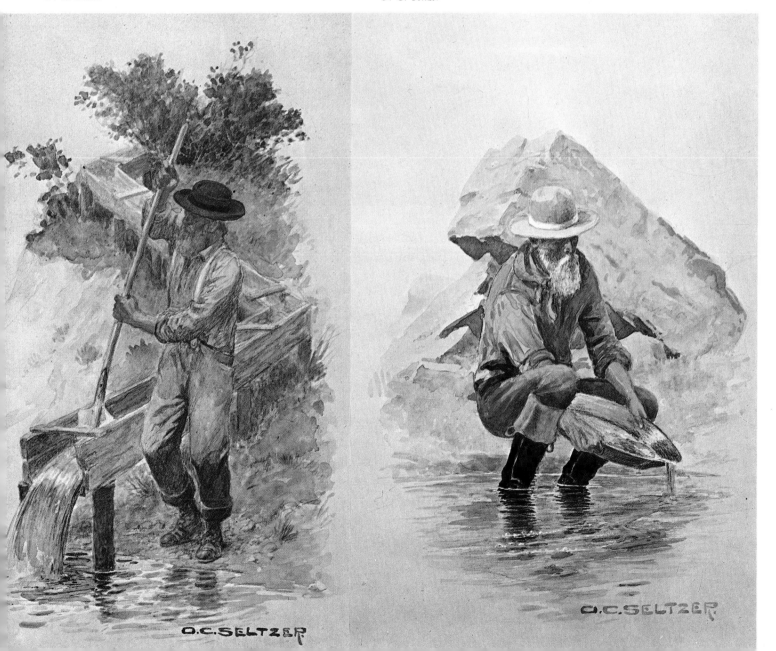

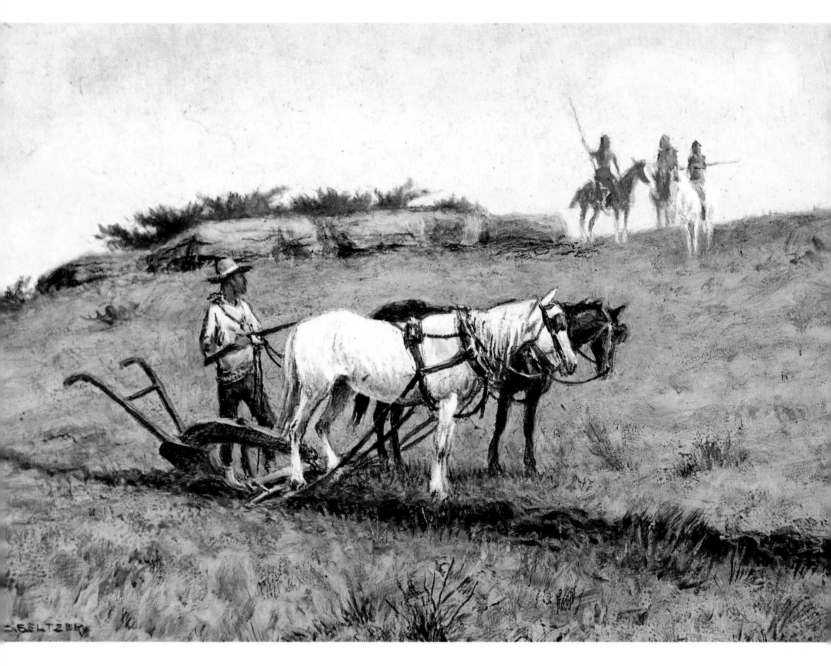

FIRST FURROW
O. C. Seltzer

Although the Western adventurer, whether farmer, townsman, or prospector, is often pictured as a tough, grizzled old man, in reality most were young men, often in their teens or twenties.

quit, but the stubborn endured. They stayed and they built a new life and future from the materials the land provided.

On the prairies, the most common dwelling was the "sod" house, or "soddy" as it was sometimes called, made of topsoil or "sod" cut into strips approximately eighteen inches long and three or four inches deep, which were laid in "brick fashion" up to a height of about seven feet to form the walls. A forked pole was set at either end to hold the roof ridge pole. Other poles covered with brush and sod created the roof. Floors were packed earth, and windows were covered with oiled paper, or glass if it could be obtained.

Other dwellings built by settlers on the treeless plains were called "dugouts"—simply holes dug into the ground and covered over with sod roofs—and "bankhouses," which were built into a convenient hillside. Later on, as the homesteader "proved up" his claim and prospered, if he prospered, he built a home of a more permanent construction styled in some instances after elaborate Eastern or European types of architecture.

248

CATTLE RUSTLER
O. C. Seltzer

A familiar sight on the plains in the latter half of the nineteenth century was a farmer with his team of horses pulling a "breaking plow" like the one depicted by Montana illustrator Olaf Seltzer. The Indians of the plains, who lived by hunting, could not understand such a man who thus cut the soil and turned the grass upside down. The "sod buster" was likewise hated by stockmen, who contended that the plains country was not suited to this type of agriculture, an opinion not altogether absent today in certain parts of the West. Notwithstanding, the "nesters" came in what seemed an unending stream, with their families, schools, and churches to transform the wilderness.

Not all women who traveled westward were of the heroic type suggested by Olaf Seltzer in his study entitled *Pioneer Mother.* Among them were women who possessed education and refinement, and even some who decked themselves out in the latest French fashions; but more often to be seen were rural types wearing sunbonnets stiffened with cardboard or starch made from potato water, with heavy work shoes or boots on their feet. With most pioneer women, a calico dress was the almost universal costume, usually sporting a high collar and long sleeves. Except for extreme individualists such as Calamity Jane, no woman wore men's pants or rode astride a horse.

In general, frontiersmen conceived of only two classes of women: good and bad. The latter were called by a variety of titles: "soiled doves," "ladies of the evening," "scarlet women," or "fancy women," according to the section of the country in which they plied their trade. A "good" woman's name never was to be mentioned in the gambling dens and sporting houses, and when possible, these more delicate types were protected from hearing about or seeing the "public" women, or even knowing of their existence. Sentimentality for women ran high in predominantly male settlements, and mountains, mines, horses, and wagons were named for sweethearts or local favorites. A source of some pride in early years, prostitutes became embarrassing as communities settled down. Laws finally were passed in many towns restricting the activities of the "fancy women," usually at the behest of the local married women's group or religious organization.

Carrie Adell Strahorn, in her book *Fifteen Thousand Miles by Stage,* observed the following attitude of men toward women in the frontier town of Cheyenne, Wyoming:

I never saw them stand in knots and make remarks about passing ladies. If a woman chanced to pass a saloon where a lot of men were lolling about the entrance, she could pass quietly along without hesitation, for every man of them would be out of sight before she reached them. I saw that happen so often from the windows of the hotel that I knew it was not simply a chance circumstance, and that ladies were shown a deference by those outcasts of society that proved them not lost beyond recall if the right influences were used.

Her use of the term "outcasts of society" reflects the Eastern view commonly held at that time with respect to men on the frontier, whether they were mountain men of an earlier period, buffalo hunters, miners, teamsters, or soldiers.

Seltzer's rendering of a dance hall girl of the 1880's is perhaps as fondly imagined as his portrait of the pioneer mother; and both are reminiscent of the Hollywood types in films of the 1930's. The impor-

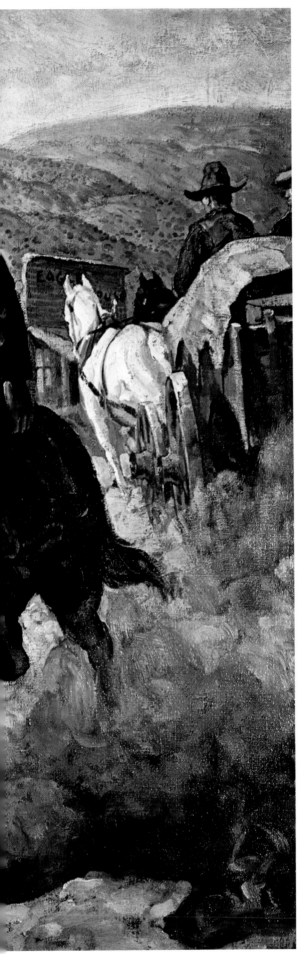

tance of the civilizing role played by such women in the West should not be underestimated, however. Many a cowboy or miner who almost never washed or shaved often would cut his hair, take a bath, and douse himself with lilac water for the sake of the "sporting girls" he might chance to meet in town. It was frequently the case that the saloon or brothel was the closest thing to a home that many of these men knew. The sometimes lavish interiors of such establishments, with their imported wallpaper, woodcarved decorations, crystal chandeliers, and additional musical refinements contrasted sharply, if not agreeably, with the harsh existence of the western mines and trails.

The saloon as well supplied other services to the community, for it was here that a stranger in search of information about the town or the region went to place his inquiries. Saloons also served as the one stop in town where employers might find available men for hire, as is still the case today in some small ranching and farming communities. A man could try his luck at various games of chance such as roulette, blackjack, and faro. A few of the more elaborate saloons boasted a dance floor, a piano player, or perhaps even an orchestra. In later days such beer halls and barrooms gave way to the more opulent opera houses of a kind that proliferated throughout the western states before the end of the century, as tastes became more refined and entertainments more sedate.

The frontier represented a society of extremes; and while it brought out the best in some men, it brought out the worst in others. The horse thief was the most hated of all criminal types in the settling West. In many locales he was judged to be worse than a murderer, for a man's reliance on his horse was paramount in a region where harsh climate and long distances between towns were the rule. When caught, the horse thief was dealt with in rather quick fashion, hanging being his usual fate. Cattle rustlers, though not considered in quite so bad a light, usually were similarly dispatched.

Volunteer groups of citizens frequently organized or appointed committees to deal with the lawless elements in some communities. At times such groups proved to be more successful as law enforcers than elected officials, although in most instances they disbanded when local law enforcement agencies gained sufficient strength to protect citizens and property. In his *Vigilante Ways,* Olaf Seltzer again portrays a characteristic scene from this period—the "necktie party." During the 1860's in southwestern Montana, vigilante groups hanged twenty-two of the region's worst criminals in six weeks. Those still at large were warned to quit the territory or decided privately to leave.

O. C. SELTZER

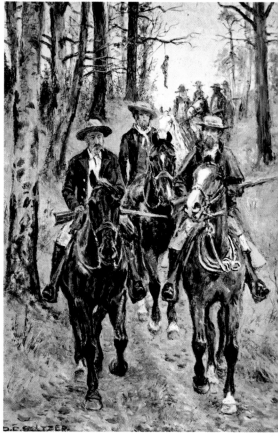

VIGILANTE WAYS
O. C. Seltzer

HOLDUP MAN
O. C. Seltzer

Many frontier towns were given names indicative of their lawlessness. Dodge City, Kansas, called "the wickedest city in America," also was described as a place where a man "could break all the Ten Commandments in one night . . ." The majority of town disturbances, however, could be considered as merely disturbances of the peace, and many citizens felt the simplest way to handle certain of these situations was to let them "take care of themselves." Only as a community grew in size was more pressure brought to bear upon law enforcement officials to curb occasional violence. Usually a first step was to insist that all men entering a town check their weapons with the local sheriff. Ordinances regulating the business hours of saloons and gambling halls soon followed. Any arguments concerning the matter might be met by a marshal or deputy carrying a sawed-off shotgun, or "scatter-gun," as additional persuasion.

Although it never was a popular weapon in the West, the shotgun, particularly the sawed-off variety, *was* used by hold-up men and lawmen alike during the 1860's and 70's. At short range it was a deadly weapon that could virtually cut a man in two. Wells Fargo guards customarily carried ten-gauge, sawed-off shotguns of English manufacture until they were later equipped with Winchesters.

The term "gunman" usually was applied to a man outside the law, while "gunfighter" was used to describe a peace officer who was proficient in the use of his trusty "sidearm." The wearing of a gun had a tendency to magnify the personality traits of a man who, lawfully or unlawfully, lived by the gun. On the frontier, most able-bodied men and boys carried weapons of one kind or another, born as they were of a highly individualistic era in a country where little or no law enforcement existed. Many who had grown up during the Civil War found it hard to adjust to the quieter time that followed. Liquor, wounded pride, or a minor disagreement, followed by a fast ride out of town from real or imagined consequences, started many a potential gunman on his way.

Not every man who carried a gun was proficient in its use. It took a great deal of practice to become a good shot, and ammunition was costly. Only outlaws and peace officers spent the money and took the time to become expert. Fights at close range were most often deadly, whether a man was a good shot or not; for within fifteen feet or so, even a poor shot could do a lot of damage.

Remarking on this subject, author Richard H. Davis recalls an incident he observed in the silver-mining town of Creede, Colorado, which was in reality more common than the celebrated Main Street shoot-out. "There were some very good shots at Creede," he says, "and some very bad ones. Of these latter was Mr. James Powers, who emptied his revolver and Rab Brother's store at the same time without doing any damage. He explained that he was 'crowded and wanted more room.'"

From 1866 to 1882 the exploits of the James brothers and their gang of Missouri border raiders were recounted throughout the country. For sixteen years the best detectives of the Pinkerton Agency and many sheriffs and marshals were unable to catch them. In the end, a traitor in Jesse's own camp killed him; his brother Frank surrendered the following year. Woven of fact and fiction, stories of the James gang

WILD BILL HICKOK
H. H. Cross

Whether men or animals,
the legendary outlaws of the Wild West
are assured a place in American history

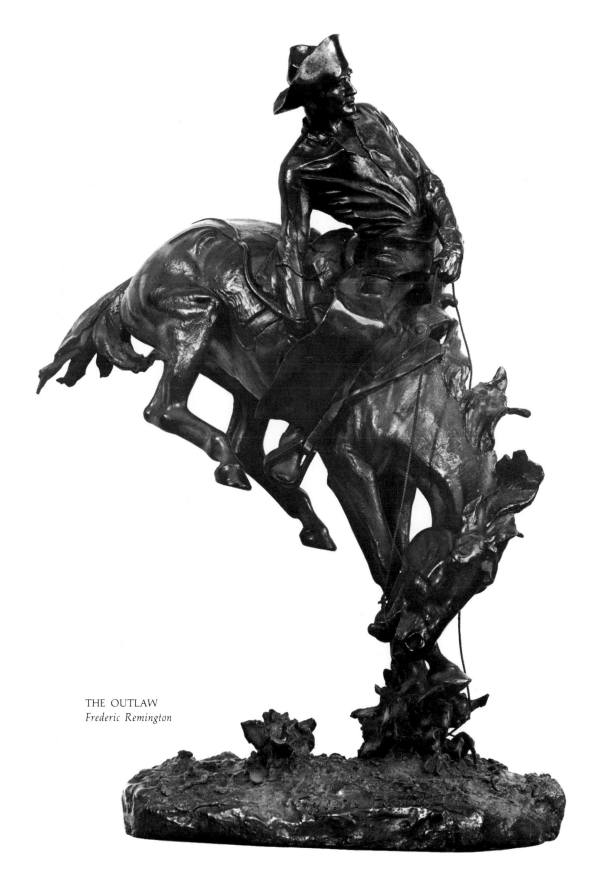

THE OUTLAW
Frederic Remington

BUFFALO BILL ON CHARLIE
William Cary

Untitled ink and wash sketch by William Cary

THE JAMES GANG
N. C. Wyeth

Many ordinary men
and women made up the
population of the West in the
latter half of the nineteenth
century. They have since
become the subject of more
careful study by contemporary
artists and historians.

DANCE HALL GIRL
O. C. Seltzer

PIONEER MOTHER
O. C. Seltzer

received widespread publicity, and the now familiar legend of the Western outlaw became firmly established as a part of America's frontier epic.

During this period the most popular hand gun was the Colt revolver, 1860 model. Manufactured as a 44-caliber six-shooter, the cylinder of this weapon was loaded from the front with paper cartridges, or loose powder-and-ball percussion caps were fitted to nipples at the rear of each chamber.

The first Colt cartridge-loading pistol was issued in 1873: the famous "Model P," which was a 45-caliber centerfire "six-gun." Like its prototype, it was a single-action weapon requiring that the hammer be pulled back and locked before firing. This gun became the official sidearm of the U.S. cavalry until after the Spanish-American War. Names previously connected with the old-style Colt were passed on to the new model: "hog leg," "thumb buster," "plow handle," "equalizer," and so forth. The name that finally prevailed was that of "peacemaker." A myth built up around its use, and although much of the myth was invented at a later time and applied to frontier usage, there was a core of truth to the stories about the Colt .45 and the hardy men who carried it.

Most pistols or revolvers were carried in open holsters that covered a good part of the weapon itself. Occasionally they were tucked into waistbands, belts, or sashes. More important than the celebrated "quick draw" was the ability to aim and fire with sufficient deliberation to accomplish the purpose, and the successful gunfighter usually aimed and fired with great care.

Marshal of Abilene, Kansas, during its early days as a "wide open" cowtown, James Butler Hickok was a controversial figure whom recent historians have tended to downgrade. Hickok's predecessor, Tom Smith, a man of unquestioned bravery and good character, tried to keep the peace without carrying a gun and was shot while serving a warrant on a wanted man. Hickok's policy was more realistic in dealing with suspected criminals: shoot first and investigate afterward. Hickok met his death as a result of his own carelessness, being gunned down from behind while sitting at a poker table in a Deadwood saloon.

The adverse living conditions prevalent on the frontier were not always conducive to fine manners or neat appearances. The following account was written after the writer visited a hide hunter's camp in the 1870's. The conditions described are similar to those in the camps of cowboys, miners, and other men of the period; and even with today's modern equipment, hunters in camp for two or more weeks will approach a similar state.

In place of the buckskin suit of the mountain hunter, the buffalo hunter goes clad in a coarse dress of canvas, stiffened with blood and grease. His hair often goes uncut and uncombed for months together, and his hands are frequently unwashed for many days. The culinary apparatus of the whole party consists of a single large coffee pot, a "dutch oven," and a skillet, and the table set, of a tin cup to each man, and the latter vessel often consisting merely of a battered fruit can. Each man's hunting knife not only does duty in butchering the buffalo, but is the sole implement used in dispatching his food, supplying the places of spoon and fork as well as knife. The bill of fare consists of strong coffee, often

THE JUDGE
O. C. Seltzer

without milk or sugar, "yeast-powder bread," and buffalo meat fried in buffalo tallow. When the meal is cooked, the party encircles the skillet, dip their bread in the fat, and eat their meat with their fingers. When bread fails, as often happens, "buffalo straight," or buffalo meat alone, affords them nourishing sustenance. Occasionally, however, the fare is varied with the addition of potatoes and canned fruits. They sleep generally in the open air, in winter as well as summer, subjected to every inclemency of the weather. As may well be imagined, the buffalo hunter, at the end of the season, is by no means prepossessing in appearance, being, in addition to his filthy aspect, a paradise for hordes of nameless parasites. They are yet a rollicking set, and occasionally include men of intelligence who formerly possessed an ordinary degree of refinement. Generally none are more conscious of their unfitness for civilized society than themselves, and after a few years of such free border life they can hardly be induced to abandon it and resume the restraints of civilization.

Doubtless, the majority of those who ventured westward during the latter half of the nineteenth century were men or women considered novices to the rough life of the frontier. Having heard of the opportunities to be had in the new country out West, few were actually prepared to face some of the trying experiences that we know to have been theirs. Having heard the stories about Indians, wild animals, and other hazards of the wilderness, many equipped themselves in preparation for eventualities about which they knew little. Accidental shootings were as common as other mishaps associated with hunting, traveling, or living in a wild country for people accustomed to the more orderly life of the East. Those who stayed adjusted to the new circumstances and environment. Those who decided to return home after a time carried with them a rich store of experiences that often waxed richer in the telling.

Europeans of rank and distinction frequently availed themselves of the opportunity to see the American West and to participate in its sporting amusements. Prince Maximilian of Wied, Captain William Drummond Stewart, and many others visited the western plains and mountains in the days before settlement and industry penetrated that region. The buffalo hunt staged for the benefit of the Grand Duke Alexis of Russia during his visit in 1871–2 is typical of the sort of thing that occurred when a famous guest was treated to the best that "Western hospitality" had to offer.

Safaris of such magnitude were by no means common, and perhaps for that reason alone the incident retains a prominent place in the annals of frontier lore. Understandably, a number of tales since have developed from the episode, most of them exaggerated. Commissioned to do several historical canvases documenting the life of William F. Cody, Charles Russell memorialized this particular event in his painting Running Buffalo. Custer is not included in this re-creation, but the figures of General Sheridan, Grand Duke Alexis, and "Buffalo Bill" are easily identifiable.

Cody re-enacted this episode many times in later years when he toured the United States with his famed Wild West show. Indeed, more than any other man of his time, he fixed on the imaginations of his countrymen an image of the West that persists to this day. Personifying the romance of the frontier for millions of Americans

Rough living conditions on the western frontier were not conducive to the maintenance of fine manners and personal appearance. Many adjusted to their circumstances and environment, others returned home with stories of adventure.

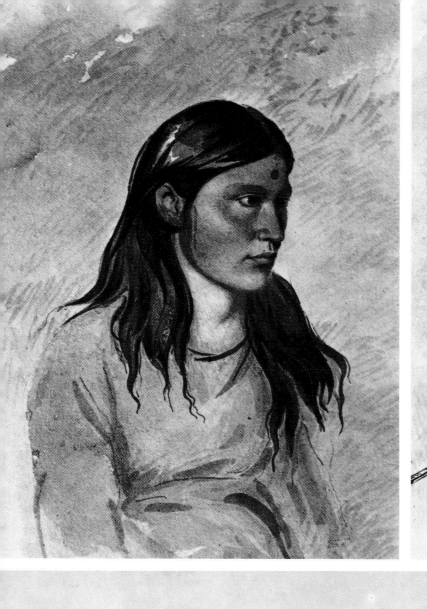
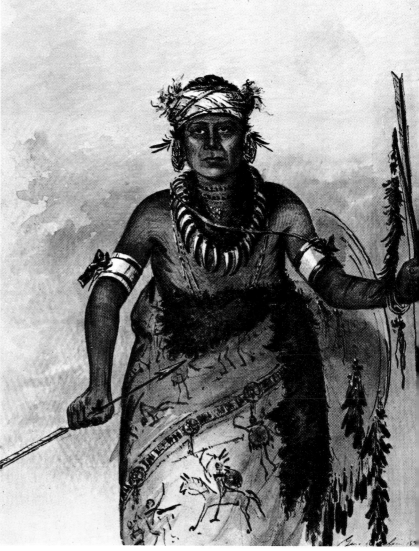
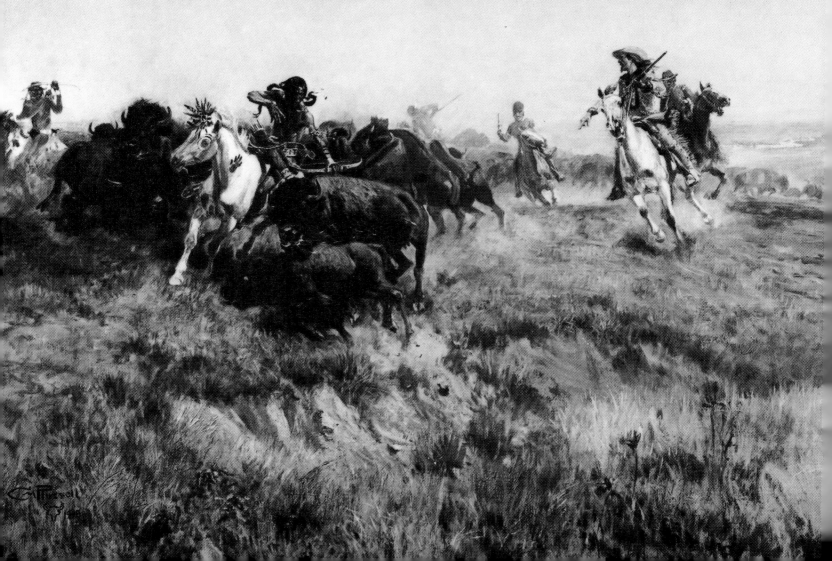

In depicting the people and
activities associated with the
settlement of the American
West, the artist or journalist
usually preferred to portray
the exploits of the more
famous frontier personalities.
The Indian, the buffalo, and
the buffalo hunter still personify
that romantic period to
millions of Americans.

WIN-PAN-TO-MEE, THE WHITE WEASEL
George Catlin

NOTCH-EE-NIN-GA, SON OF WHITE CLOUD
George Catlin

RUNNING BUFFALO
C. M. Russell

who never ventured west of Cincinnati or St. Louis, he remains as one of the nation's best known and, at the same time, most controversial Western figures.

As an older man, he is reported to have drunk to excess, and the modern student of history feels bound to discount much of what was said of him as well as what he said of himself. Writer E. H. Brininstool reveals his own opinion of the man in a letter sent to Dr. Philip G. Cole, Olaf Seltzer's patron and collaborator, from Los Angeles in May 1933. Aware that Cole was at that time considering the incorporation of several scenes illustrative of Cody's life in his "Montana in Miniature" picture series, Brininstool comments:

Let me give you one tip right now before you make a big mistake. You say you are having Seltzer paint you a picture depicting Bill Cody killing Yellow Hand. IT NEVER HAPPENED. Bill Cody had no more to do with the killing of Yellow Hand than you or I did . . . Several troopers with the 5th Cavalry also claim that THEY killed Yellow Hand. Gen. King himself—whom I knew mighty well—told me "I did not see any duel between Cody and Yellow Hand" . . .

I can give you no information regarding the other events you mention that Seltzer is to paint for you—but gee, don't let him have Bill Cody doing something which never happened!!! . . . Cody was a great showman—all will concede to that . . . He was genial, open-handed, a "good feller" and a royal entertainer. Beyond that, well, the less said the better. Ask any old timer like Cook or Luke North. Remember—don't take MY word for any of this.

Despite this advice, Seltzer painted a scene depicting the alleged duel between Cody and Yellow Hand, including it in his remarkable series based on events in Old Montana history.

Of the less celebrated individuals who made up the population of the settling West in the 1870's and 80's, school teachers, newspaper editors, and various professional or business types actually had more to do with the shaping of society than the rougher or more romantic characters one always hears about. Hard-working citizens such as the storekeeper, livery operator, or blacksmith represented the sturdier fabric of the frontier community. The familiar anvil, forge, and bellows, and the not-so-familiar cutting nippers, box-leg vise, hoof parer, cinch cutters, and other assorted tools marked the business site of the frontier "smithy." In addition to shoeing horses, the blacksmith did all-round mechanic and repair work. He could fix a wheel or mend a broken plow as readily as build a wagon or fashion farm implements and household utensils. His shop frequently was the region's center for horse trading and a clearing house for ranch and farm gossip, where youngbloods swapped stories about their horses or their girls. The soot and sparks from glowing metal, the ring of his anvil, the smell of burning hoof under a hot horseshoe all marked the "smithy's" shop as an exclusively masculine meeting place.

It could be said of many frontier towns, whether mining town, cowtown, or railroad center, that what they often lacked in size or sophistication they more than made up for in character. Many began as merely a collection of tents or rough-hewn log structures. As more and more people arrived, frame structures appeared and false-fronted

stores lined the main thoroughfare. Later houses and hotels, and in time occasional mansions of brick or stone, characterized the more prosperous or settled communities. Almost all such towns faced the natural hazards of fire and flood in a day when whale oil or kerosene lamps provided the only lighting and many towns were built with no thought given to location in relation to spring runoff or flash flooding. Most such hardships, however, were endured as a matter of course by frontier people, and many stories grew out of them.

The conquest of nature was a part of the business of being a frontiersman or a pioneer, and there were many who went west to carve empires for themselves out of a hostile wilderness. The bankers, store owners, and others likewise came to build new lives or new prosperity. Many remained "frontiersmen" in spirit, and there were others who remained frontiersmen in fact, as well, and always moved ahead of advancing civilization. These were among a restless breed that normally did not remain long in any one community, lovers of "wide open spaces" who could not abide town life until age caught up with them.

Commerce and industry caused the development of the towns to progress beyond the frontier or backwoods level. As the westward movement slowed to a stop toward the end of the century, the land, the people, and the towns altered considerably. As a man with a span of horses and a wagon or coach lost the U.S. mail contract to another who owned a Model-T Ford truck, an era died. There are those, however, who feel that the spirit of the frontier did not wholly die, and still lives in the offspring of those who settled the American West.

Such a spirit dies, perhaps, a little with each passing generation, or is sometimes reborn with a new challenge to be faced. It is still discernible in many second- or third-generation Westerners: a self-assurance, pride, and confidence born of a frontier spirit and a Western heritage.

Illustrated envelope by C. M. Russell

Maker of the Cattle Culture
The Cowboy

grand Boeuf du royaume
D'Anemar En amerique.

The Cowboy

It is doubtful whether any character in the chronicles of modern history has inspired more literary comment or provided more material for paintings, film portrayals, or promotional gimmicks and gimcracks than the American cowboy. Good, bad, or indifferent, his image is very much with us and his reputation continues to grow. It might be worthwhile to speculate on the various reasons for this phenomenon, but the fact that the cowboy of frontier fame was, first and foremost, a horseman has a great deal to do with it. For throughout the ages, the man on horseback has managed to remain somewhat above and apart from his pedestrian contemporaries.

Ask the majority of Americans today where they think the cowboy originated and most will probably reply "in Texas, of course." A few might even be able to suggest a date sometime shortly before the onset of the American Civil War. Yet cowboys were working cattle on American soil nearly eighty years before their kind appeared in Texas. Known as *vaqueros* on the vast ranchlands of California, these Spanish herders used equipment and developed methods of handling livestock that are in use to the present day. The modern cowboy still rides the same basic type of saddle, and the old Spanish *vaquero*'s vocabulary

BRONCO BUSTER (*previous page*)
Frederic Remington

266

of terms is an inseparable part of the present-day Western idiom. Such words as "mustang," from the Spanish *mesteño* ("wild"), "lariat" from *la reata*, and *rodeo*, changed only in its pronunciation, are familiar terms today. Even today the name *vaquero* is still used in some parts of the Southwest to designate a cowboy.

The American cowboy's now celebrated story actually had its beginning with the arrival of the Spaniards to the continent of North America in 1519. Before that time, neither the cow nor the horse as we know it inhabited the Americas. Columbus had introduced the horse to this hemisphere in 1495, when he sent mounted soldiers to put down an Indian uprising on the island of Hispaniola; but it is Coronado who is credited with having brought the first domesticated animals to the North American mainland when he traveled across the prairies of present-day Kansas and Oklahoma in search of the rumored "cities of Cibola," trailing approximately five hundred head of cattle, thousands of sheep, goats, hogs, and, of course, horses in his wake.

These first horses were descended from the Barb horse that had been introduced to Europe by the Moors from Africa during their long occupation of the Spanish peninsula prior to 1492. Much of the Moorish style and skill in the handling of horses thus was acquired by the Spaniards, who brought to America a knowledge of horsemanship later adopted by the Anglo-American cowboy of popular western fame. The cattle brought over in the sixteenth century were also of Moorish stock, for the most part, or of a breed of Andalusian "black cattle" called *ganado prieto*, much in demand by American colonists up and down the Atlantic seaboard. The animal observed in Canada by artist Charles de Granville undoubtedly was of the same strain, a breed from which the fighting bulls of Mexico were later developed.

The cattle industry developed rapidly in the New World, for missioners were quick to follow in the steps of the Spanish explorers, establishing settlements throughout Mexico and later along the Pacific coast of California. Cattle introduced to these areas quickly multiplied on the lush grasslands. Spanish law at first did not permit the Indians the use of horses. As cattle herds increased, however, landowners began to train their native laborers to serve as *vaqueros*, or cow herders, a job that could only be performed on horseback.

Certainly no more picturesque horsemen ever graced the North American landscape than the Spanish-American *vaquero, ranchero,* or *hacendado*. A hand-colored lithograph dating from the 1840's presents a good likeness of these men in terms expressive of the period. Although Mexican in origin, the picture serves as well to identify similar types in California.

The *vaquero* by the late eighteenth century had discarded the heavy Spanish war saddle of former times and rode upon a *silla vaquero*, or Mexican saddle, which featured a horn better suited to the holding of wild or half-wild stock. Highly ornamented, the saddles of that period often were fashioned out of soft wooden frames and a poor grade of leather, not really useful for heavy work. These deficiencies were corrected in subsequent decades and between 1820 and 1840 perhaps the finest saddles ever made in North America were produced, possessing a simple grace, elegance, and quality of workmanship not equaled since.

GRAND BOEUF DU NOUVEAU D'ANEMAR EN AMERIQUE
attributed to Charles Bécard de Granville

HACENDADO Y SU MAYORDOMO
F. Lehnert

he figures represented in the Mexican print include the *hacendado*, or wealthy landowner; his lady, decked out in the best finery of the period; and his *mayordomo*, or manager. A corporal, or foreman, appears in the background. The *ranchero* at left carries suspended from the rear of his saddle horn a set of *armas*, prototype of the more familiar "chaps" used by riders today to protect their legs when traveling through heavy brush or cactus. His poncho, or, as it is sometimes called, serape or *capa*, is rolled and tied behind the cantle of the saddle. The *hacendado* in the foreground wears his. The flanks of the *ranchero's* horse, left, are covered with an *anquera*, which came in a variety of designs. Here also are seen the *tapaderos*, or stirrup covers called "taps" by later American cowboys, decorated with the colorful stitching characteristic of Mexican and California horse gear.

The *ranchero* is shown wearing his hair long, bound with a silk kerchief. The *hacendado's* hair is cut short in a style that was popular during the late eighteenth and early nineteenth century. In keeping with his status as a gentleman, he does not wear *armas,* but trousers that button down the side, customarily left unbuttoned from the knee down to provide more ease and comfort when he is on horseback and to show off, as well, the highly decorated leather *botas* and red Spanish sash with which trousers of this type usually were bound. The saddle of this dandy is covered with a *coraza,* a covering separate from the saddle frame featuring holes cut to accommodate the horn and cantle, laced as shown in the illustration.

Such saddle covers were embellished as a rule with colorful designs in silk laced with gold or silver threads. There were also saddle covers for specific occasions. The *mochila* was a larger version that appeared again much later on Anglo-American gear, some types being removable and others permanently attached. The cowboy of the western plains country knew this combination seat and cover as a "Ma Hubbard" saddle.

Hides and tallow constituted the basis for the cattle business in California during the Spanish colonial, or mission, period. At this time, the Spanish government's prohibition against all commerce with foreign nations was enforced throughout its American possessions. Notwithstanding, foreign adventurers looked with interest on any and all commercial prospects in these regions. Ships experiencing difficulties of one kind or another often put into Spanish-American ports, with the result that a certain exchange of goods developed and, under increasing local sanction, brought relief to the commercially starved missions and *presidios* (forts). Traders from New England, Europe, and even China brought manufactured goods to the Spanish colonies to barter for local products or occasional sea otter pelts, a commodity

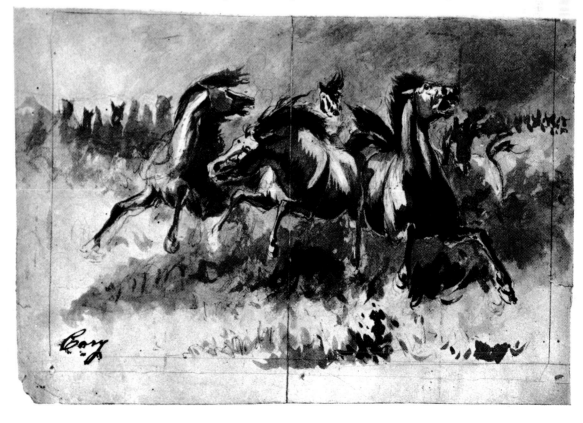

Untitled sketch of wild horses by William Cary

Roping wild animals was also
considered a challenging amusement
and, as with all other sports carried out
on the back of a horse, extremely popular.

CHASSE AUX BISONS
Yves

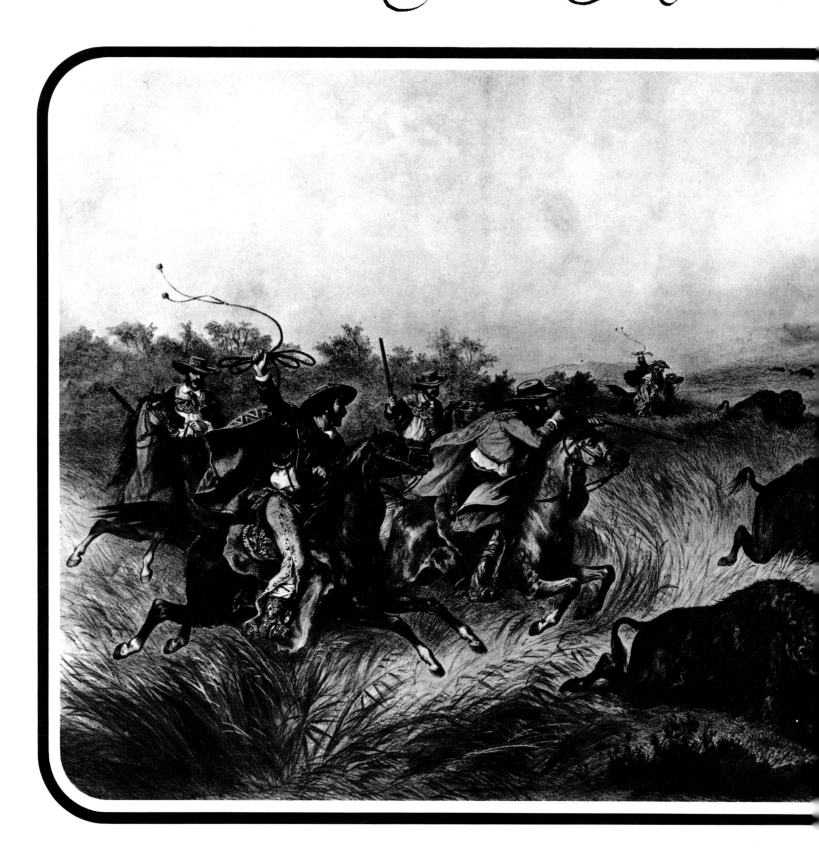

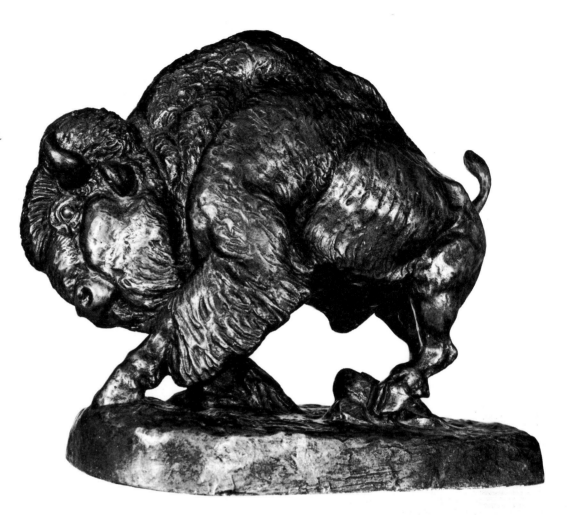

BUFFALO BULL
W. R. Leigh

that did not represent any great enterprise due to the competition of Russian and English fur hunters plying the California coastal waters. Cow hides were worth an average of two dollars in trade, and with thousands of cattle in Mexico and California, this area received its first real economic boost.

In Texas during the eighteenth century, immense herds of cattle were being raised on the mission ranches in the vicinity of San Antonio. By about the year 1775 it was reported that stock on the Espírito Santo Mission near the present Goliad, Texas, ran in excess of forty thousand head. Here it was that the famous Texas longhorn later developed in an environment demanding both vitality and endurance. Here, as well, originated another familiar figure in the annals of Mexican history: the *charro,* as he was called, primarily a gentleman and a cowboy only incidentally, forerunner of a breed of hard-riding, fast-roping men who were to play a prominent part in the development of the American frontier.

Another picture, produced when Mexico was under nominal French rule (1864–7), depicts a group of native *charros* engaged in one of their many sports. True to his general nature, the Mexican *charro* considered no game too rough nor bet too risky to be attempted. Among the more popular pastimes of this sort were races, roping contests, and wild horse hunts.

A peculiar detail in this French lithograph is the type of *botas* revealed beneath the pants of the riders in hot pursuit of a group of buffalo. More peculiar still is the representation of the use of the *bolo,* a kind of catch-rope featuring weighted balls attached with rawhide, which were thrown at the legs of an animal being pursued. Such equipment as this is normally associated with the *gaucho* of the South American pampas; and while the Mexican horsemen of this time may have known of the *bolo,* it did not come into common use in the north.

Artist James Walker (1819–89) devoted much of his career to the portrayal of the Spanish horseman and cowboy, in particular the California *vaquero.* He is noted for his attention to distinctive features of individual costume, although his interest did not always extend to his subjects' horse gear or other equipment. In a painting entitled *Roping Wild Horses,* he shows his *vaqueros* using *las reatas largas,* or "the long ropes." Made of rawhide, these braided *reatas* came in four, six, and sometimes eight strands often a hundred feet or more in length, or nearly three times longer than the "lariats" used by American cowboys at a later time.

With thousands of cattle to manage and unnumbered herds of

The raising of livestock in the Southwest ushered in the era of the cowboy, whose skills in the handling of cattle and horses developed on the vast ranchlands of California, Mexico, and Texas.

BURNING RANCH AND DRIVING OFF CATTLE
William Cary

mesteños, or "mustangs," running wild, the California ranch hand had sufficient opportunity to develop his several abilities. His skill in rope handling was not to be equaled by riders anywhere else in the world. His speed in roping, if necessary, was not so important to him as his method or style. It was not that he was a "tricky" roper, but rather that he loved to exhibit his skill in an art that is still the trademark of Mexican ropers.

The *vaquero* in the colonial period was also what is known today as a "dally" roper: that is, he usually made his throw and, while bringing his horse to a stop, took several turns with his *reata* around the horn of his saddle instead of tying it "hard and fast" in the manner of Texas cowhands of a later period. In his *Vaqueros Roping Horses in a Corral,* James Walker shows his central figure demonstrating this method of taking "dallies" around the saddle horn.

The Spanish colonial period is looked back on today as one of the most colorful in California's history. Many episodes of colonial life have been preserved in song and story, and a number of romances have been based on the adventures of the rancher and cowboy in that day. As stockmen have learned down through the years, however, booming success in the cattle business is at times uncertain and short-lived. The cattle industry in California proved to be no exception.

ROPING WILD HORSES
James Walker

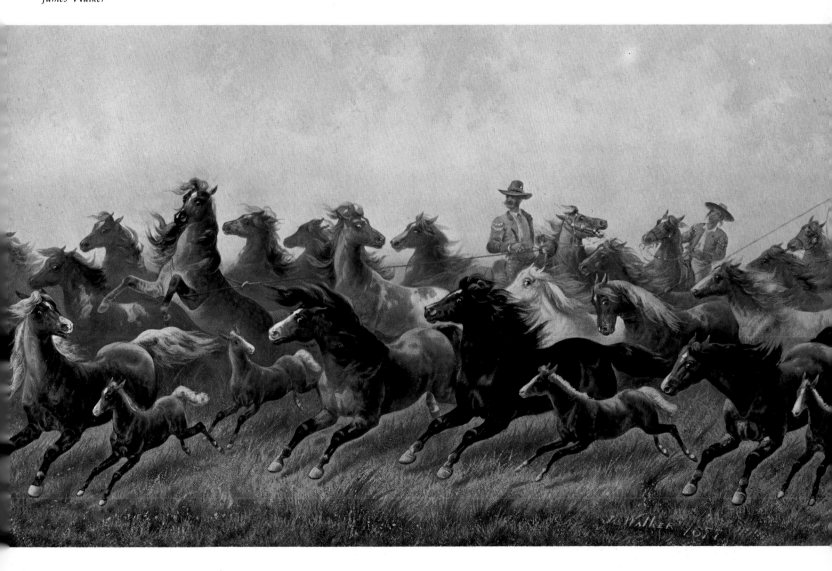

fortune to the great California spreads. Wells and springs dried up and for season after season the ranges lay at the mercy of burning summer skies. Thousands of wild horses competed with other stock on the already over-grazed grasslands. Cattle starved, and died of diseases; surplus stock had to be gotten rid of.

Cow hides were still worth something on the market but wild horses brought no profit, so a large-scale slaughter of the mustangs was inaugurated. Driven into corrals, the branded animals were cut out from among the rest, which were promptly killed with lances. Hundreds more were driven over cliffs into the sea, and other measures, equally desperate, were executed in an attempt to save the dwindling range lands. Still the dry years persisted, and it became apparent that the once-thriving California settlements were headed for certain disaster.

VAQUEROS ROPING HORSES IN A CORRAL
James Walker

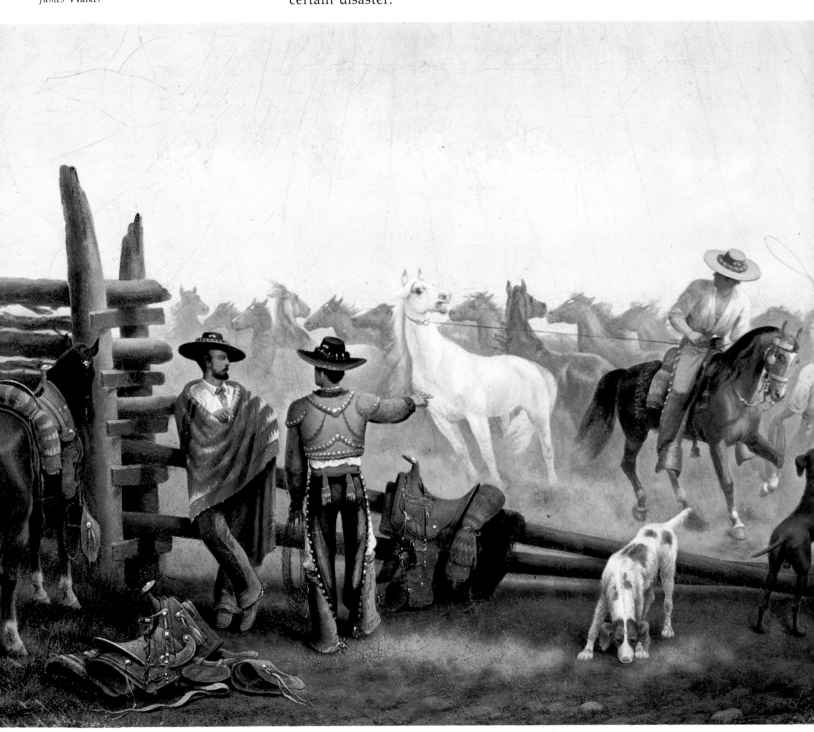

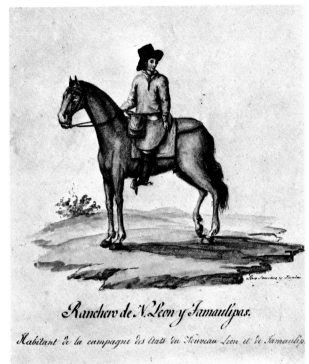

RANCHERO
Lino Sanchez y Tapia

Meanwhile, in 1811 Mexico fell into the throes of revolution, a state in which it continued to exist, intermittently, throughout most of the nineteenth century. California remained loyal to Spain, until 1822, when allegiance was finally given to Mexico. By 1834 most of the mission properties were secularized and the land opened for settlement. The Indians in the area, released from the supervision of their Franciscan and Dominican tutors, responded with violence, looting, burning, and slaughtering thousands of cattle. The formerly peaceful *presidios* fell into ruin, and the hard-working *vaquero*, out of a job, had to look elsewhere for employment.

In 1848 California was ceded to the United States as a prize of the Mexican War. The discovery of gold that same year brought a great wave of fortune hunters into the territory. Almost overnight California changed from a sparsely inhabited region of ranch lands and wilderness into one of the busiest territories west of the Mississippi. The *vaquero* of former days virtually disappeared, although his type continued to survive in Baja California, and, of course, in Mexico.

With the gold rush fever of the 1850's came adventurers, outlaws, miners, and settlers. Soon a demand for commercial foodstuffs, principally beef, existed in an area that once had been cursed with more cattle than it knew what to do with. This growing market attracted attention in other quarters of the country, and in places as far away as Texas, enterprising men began to round up the straggling remnants of herds of Spanish cattle that roamed unchecked over the wild expanses of that region.

The country south from the Nueces River to the Rio Grande and east to the Gulf of Mexico was for the most part *brasada* brush country—hot, dry, full of mesquite and thorny thickets—ideal breeding ground for the thousands of rangy scrub animals that soon were to provide the foundation for one of the largest industries in the history of the American Southwest. Here, as well, came a new American character destined to carry on the old traditions of California's *vaqueros*: the Texas cowboy.

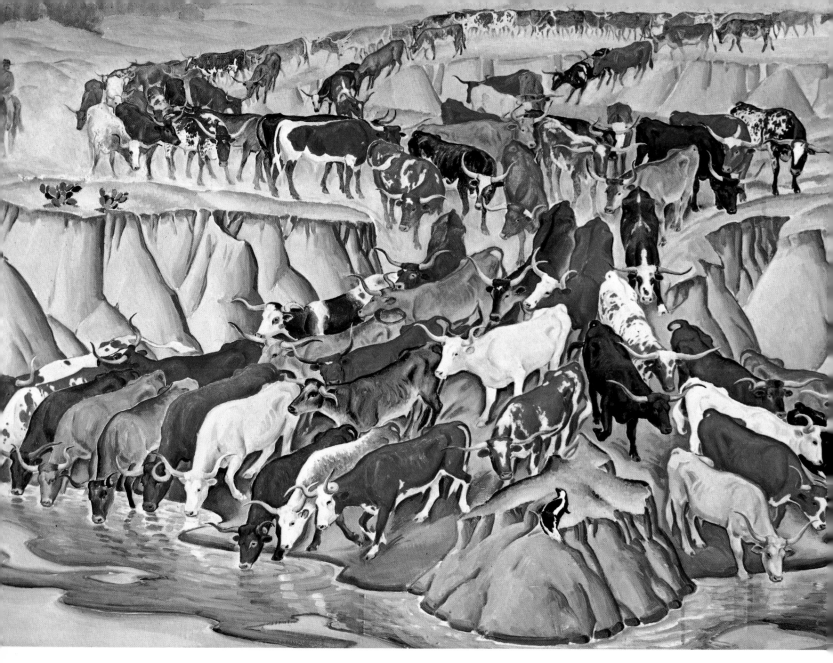

LONGHORNS WATERING ON A CATTLE DRIVE
Ila McAfee

Possibly the earliest illustration of these early Texas cow herders is that done by artist Sanchez y Tapia, who accompanied the Jean Louis Berlandier survey of the Texas border in 1828. While neither the artist nor Berlandier was the best of draftsmen, they have provided us with invaluable testimony regarding the appearance of the Texans of their times. In this instance, the herder's hat looks more like a "top" hat but is probably a homemade article, unlike the traditional *poblano* with its larger brim and lower crown.

The jacket worn by this man is suggestive of the buckskin-fringed garments worn by Tennessee and Kentucky woodsmen who came into Texas about this time. Across his lap rests a rifle encased in a buckskin scabbard. While the rest of his garb appears to be modified Mexican in style—with the possible exception of his boots—his saddle seems to be of California, Sante Fe, or St. Louis manufacture similar to those used by Rocky Mountain trappers of a later date.

In this drawing may be seen, as well, the first indications of the use of chaps among Texas cowmen. Here the leggings are suspended from the rider's saddle, Mexican style, however, rather than worn by

276

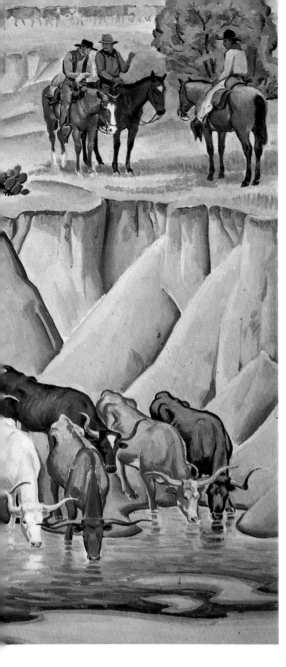

him as a regular part of his apparel, as was done at a later time. His taps and heavy boots probably afforded him sufficient protection most of the time and, in any case, were not so cumbersome as the old Mexican *armas*.

The American Civil War brought a halt, at least temporarily, to further developments in the Texas cattle business. With only a relatively small market within the bounds of the Confederate states, many ranchers reduced their herds and cattle again were allowed to scatter abroad. With the South destitute and paper currency and bonds issued during the war declared worthless, these milling herds on the Texas plains proved to be the state's one asset.

The real demand for beef in the mid-nineteenth century lay farther north, where new towns were in the making. Railroad workers by the thousands were coming into the central plains, the buffalo herds were dwindling, and both the reservation Indians and the army troops sent to control them needed beef. New ranches springing up in Kansas needed stock and the recent gold boom in the Pike's Peak section of what is now Colorado added yet more demands for cattle. The Texans had cattle in abundance and the guts to gamble on a long shot.

The job of hunting down the longhorns was a difficult one for the Texas cowmen of the postwar period. Most of these wild, range-bred animals until broken to the trail were about as much trouble to round up and drive as a thousand head of elk might be imagined to be. Possessing muscle, stamina, and speed, the longhorn was not expected to furnish the choice beef to which Americans are accustomed today.

THE STAMPEDE
Frederic Remington

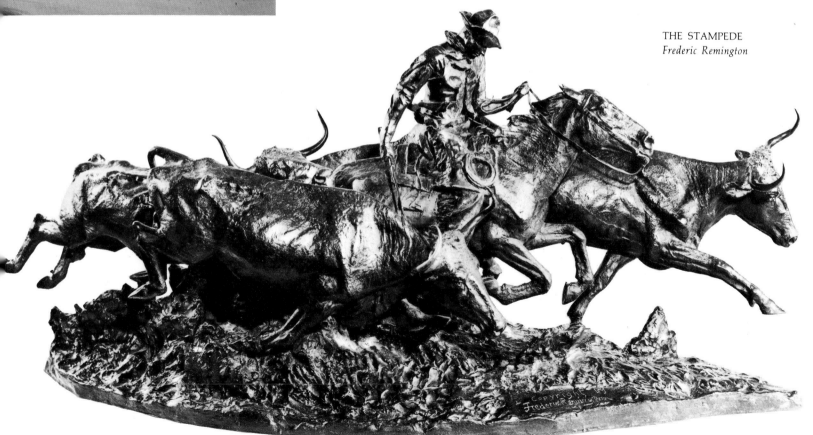

THE HERD
Frank Reaugh

"More tail than beef," they were herded together and after much work headed toward the shipping points in eastern Kansas or Missouri.

Very few, if any, old cowboys are left today who worked with the old breed of longhorn cattle. Several good accounts of the animal exist, however, *The Longhorns* by the late J. Frank Dobie perhaps serving as the finest study made to date. In art, the oil painting by Ila McAfee entitled *Longhorns Watering on a Cattle Drive* illustrates, with excellent composition, the great range in color common among the Texas longhorns of the last century. Reds, brindles, duns, browns, "yellow bellies," blacks, and others are shown. The large span of horn, from which the longhorn gets its name, also warrants attention. Some horns reached a length of six feet from tip to tip, although four feet was the average for most steers.

When a longhorn reached the approximate age of eight years, his horns usually took on a ragged, scaled texture that marked him from then on as a "mossy horn." This term was used in later years to describe any longhorn. Frank Reaugh, an artist who specialized in the painting of the longhorn at the beginning of the present century, shows them at their best, perhaps, in his picture called *The Herd*. Depicting a rugged breed, which has since passed into history except as a novelty, the artist indicates the inborn alertness suggestive of the wild animals they really were.

278

During the period of the great Texas trail drives, the cattle-man was king in the central states and territories. In 1867, the Kansas Pacific Railroad reached Abilene, Kansas, and it was decided that here would be the main receiving and shipping point for Texas cattle on their way to eastern and northern markets. Shipping yards were built, scales installed, offices established. Roughly 35,000 head of longhorns came up from Texas in 1868. The following year more than 150,000 reached the Kansas railheads.

Meanwhile, it was discovered that the Texas longhorn, though ac-climated to the southern ranges, could survive as well the hard winters in the north, and the cattle boom spread the length and breadth of the western and central sections of the country. Trail towns such as Abilene, Wichita, Ellsworth, Dodge, and Great Bend boomed and prospered, and young boys from farms and cities in the East came to the West to try their luck at being cowboys. Several of the famous old cattle trails were established at this time: the Chisholm, the Good-night Loving, the Northern, the Pecos, the Shawnee, and others. Con-ditions along these right-of-ways gradually improved, and more and more men climbed on the cattleman's bandwagon.

As with any other breed of men, good cowboys were as often "made" as born. Being able to get the most out of his horse or an old steer required a kind of knowledge and self-confidence that not every

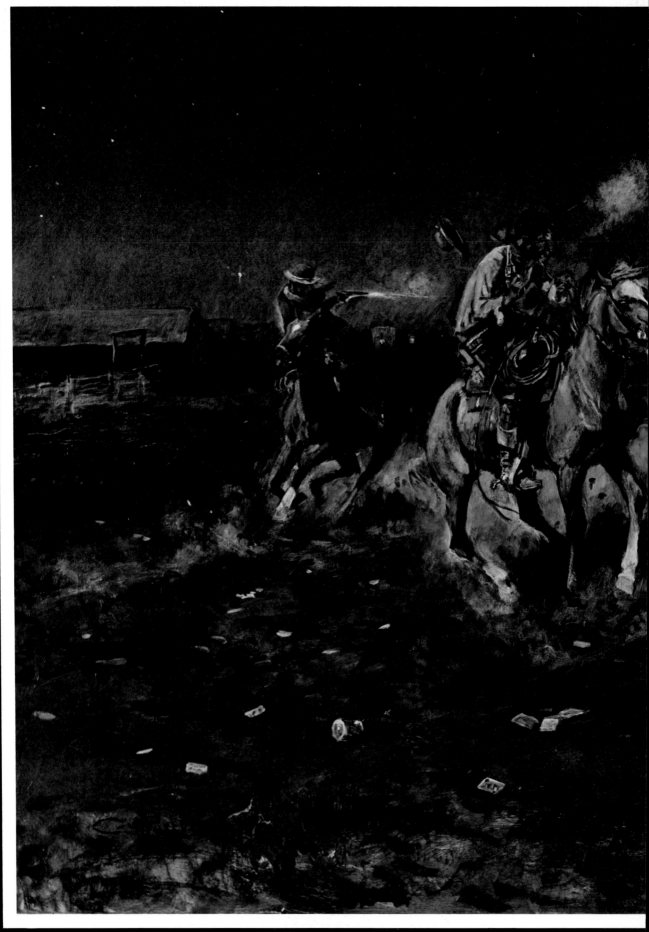

When Guns Speak Death Settles Disputes

C. M. Russell

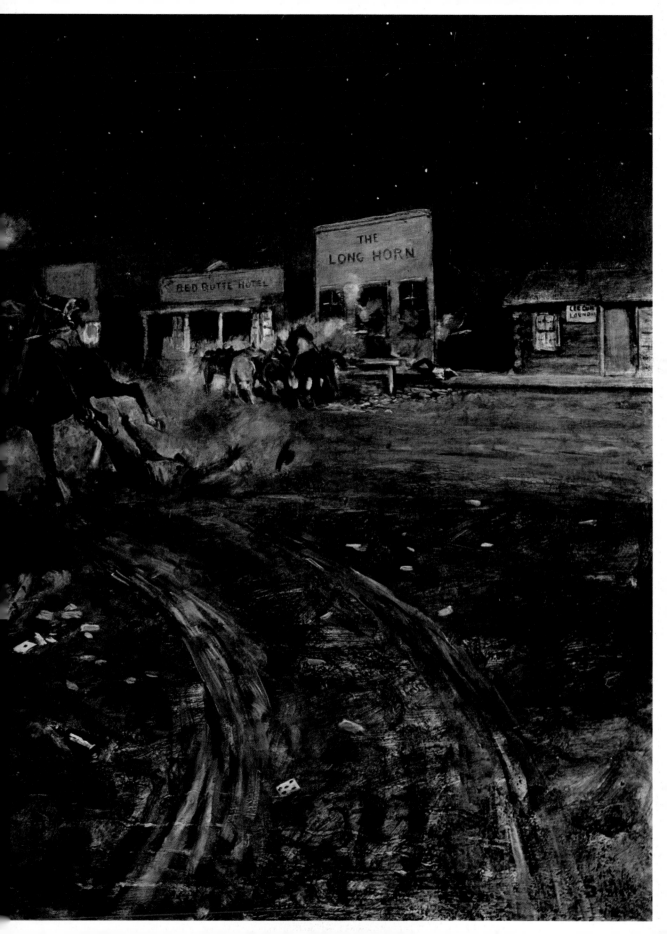

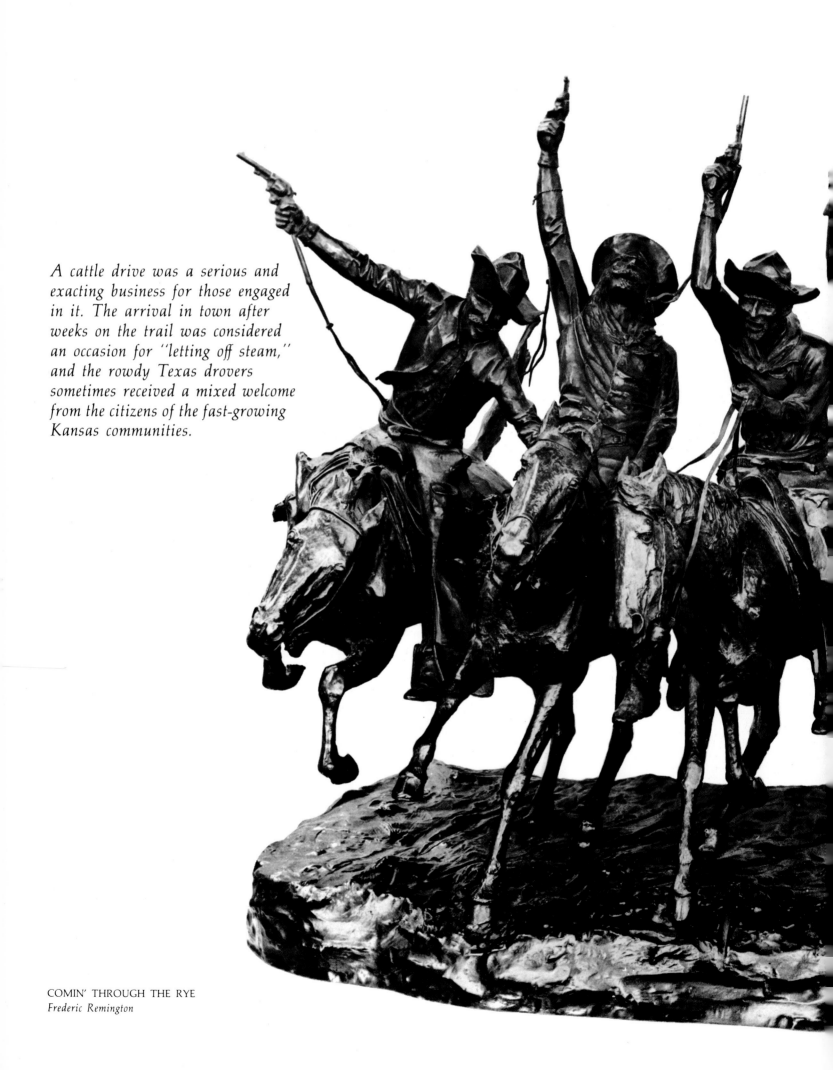

A cattle drive was a serious and exacting business for those engaged in it. The arrival in town after weeks on the trail was considered an occasion for "letting off steam," and the rowdy Texas drovers sometimes received a mixed welcome from the citizens of the fast-growing Kansas communities.

COMIN' THROUGH THE RYE
Frederic Remington

man could manage. In the saddle for twelve or more hours a day, the cowboy necessarily acquired the knack of becoming almost a part of the animal he rode; and the ability to move cattle where he wanted them to go without running all the "beef" off them or wearing out his horse was only one of the qualities that made him a top hand.

Arriving on the outskirts of a trail town after weeks in the saddle, the Texas drovers often entered shouting and shooting, announcing to all that Texas had arrived. Many came to town on payday or the day after with as much money as some of them were likely ever to see. Most dollars ended up in the pockets of the local citizens, who were more than willing to take them. Very little of the trail driver's hard-earned wages ever found its way back to Texas.

Most cowboys were restless after weeks on the cattle trail, ready for sport or trouble, often one and the same. While the scene depicted by artist Charles M. Russell in *When Guns Speak, Death Settles Disputes* was not as common as now shown in television series or Western films, it was by no means an unusual occurrence. It took a lot of practice to become really good with a six-gun, however, and most cowboys simply didn't have the time. While most did better with a carbine, revolvers were carried in open holsters, although military types with flaps were also used. There was little shooting from the hip and probably no fanning of the hammer with the palm, Hollywood style. Most shootouts were at close range and instantaneous. The "call out" and the long walk down Main Street were as rare as an English saddle.

Although all types of revolvers were employed, after about 1873 the favorite was the 45-caliber, single-action Colt. Prior to this time, the army 44-caliber, navy 36-caliber, and the Remington percussion cap revolver were among the favorite weapons. The hammer usually rested on an empty chamber for safety's sake.

Many of the Texas cowhands were hardened to fighting, having reached manhood during the Civil War years. Calloused with regard to suffering, whether their own or someone else's, these men were not likely to avoid an encounter when one presented itself. Because of a few ill-chosen words, the wrong turn of a card, a woman, or just "for the hell of it," these men were frequently ready to take the town apart. For some, fighting was simply a release from tension or a form of relaxation rather than an expression of a "mean" nature.

Not all drovers were "blowing off steam" when they engaged in gun battles or barroom brawls; nor were all who came into the trail towns working cowboys. Some were drifters who would join a trail outfit for a time, thereby earning for the cowboy an even worse reputation than he already had among the cow towns to the north; however, most such men skirted civilization.

This was the day when there were plenty of cattle and a rancher minded his neighbor's stock as well as his own. No fences as yet marked individual boundaries, and stock belonging to several owners commonly grazed together. As beef began to be worth more, however, a certain carelessness with respect to branding became evident. Cows carrying one brand followed by a calf carrying another man's mark made for trouble at times, and cattlemen had to establish certain rules to govern the practice. Rustling became a profitable, if chancy, venture for some and the cattle business in general became more complicated.

The rancher soon learned to keep books and accounts. Statements listing the number of cattle to be shipped were required at marketing points and inspectors were hired to check brands and the condition of stock in general. In the meantime, barbed wire was introduced to the western plains around 1875. Hated by most old cattlemen, wire fences brought an end to the open range.

As the cattle industry developed into a booming business, the cowboy and his occupation acquired a particular pattern that included its own special set of rules. Most of these were unwritten to be sure, but adhered to with strict conformity nonetheless. Bringing a bronc to breakfast, as depicted by Charles Russell, was one of the things a cowboy "didn't do." The minute details of an outraged camp cook, an upset fire, smoke, ashes, and the attendant confusion are all registered in this scene with a feeling for action and sense of humor that are among the distinguishing marks of this cowboy-artist's work.

In his now-famous painting *Jerked Down*, Russell shows another action-packed scene, in this case illustrating the problems sometimes

Latter-day artists such as O. C. Seltzer and C. M. Russell depicted many episodes in the life of the cowboy. Russell in particular was familiar with the subject, recalling many incidents out of his own experience as a young cowhand in Montana.

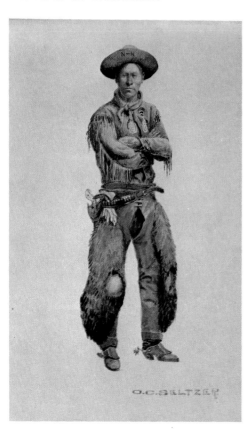

HORSE WRANGLER
O. C. Seltzer

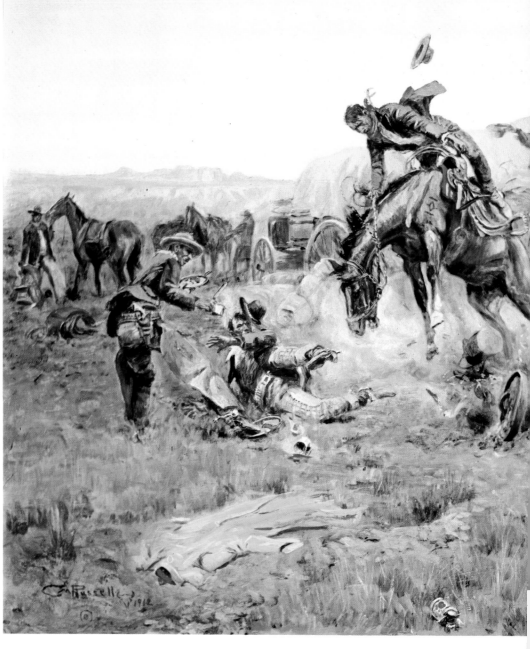

CAMP COOK'S TROUBLES
C. M. Russell

encountered by a cowboy using the "hard and fast" means of roping an old range cow. The Montana boys have their hands full; the rider on the black baldfaced pony is out of the game, while his partner comes up to lend a hand and a third cowboy approaches with his loop ready in case it's needed. The man with the main problem on the end of his rope has shifted his weight to help his horse.

On this rider, Russell shows a piece of clothing once common but seldom if ever seen today—a pair of riding pants with soft pony hide sewn into the seat and inside the legs. The cowboy is sitting on what looks like a Miles City rig or saddle and is using a hackamore with a *fiador*, or as Americans call it, a "Theodore," attached. This last item consists of a piece of cotton rope that acts as a throat-latch, making the hackamore a halter, suggesting that the pony he rides is still being trained to the ways of cows. The second rider is wearing "chinks," or short chaps, and sports bearskin- or angora-covered saddlebags. His yellow slicker, or raincoat, also called a "fish," is tied behind the cantle of his saddle.

Modern economics and communications have pretty much equalized the cowboy in all sections of the nation. It is difficult today, for example, to tell from what particular part of the country a man comes by the rig he rides or the type of lariat he carries. Not more than fifty years ago, variety still existed. A cowboy riding a "double-rigged" outfit—that is, a saddle with two cinches—when in a part of the country where single rigs were common would have been regarded with some suspicion.

If any single item stands out among the working cowboy's tools, it is the lariat, rope, string, *reata,* lasso, or whatever else you choose to call it. There were commonly two types—one made of rawhide and familiar to California cowmen, the other woven of manila, hemp, linen, cotton, sisal, or recently, nylon, in use in the central and mountain states. In roping, again, there were two classifications or methods. The use of the short lariat tied "hard and fast" to the saddle horn when roping a steer was and still is predominant throughout the central plains and mountain states. The use of the longer *reata* familiar to the old California *vaqueros* is still seen in the "dally" country along the Pacific coastal states, Utah, Nevada, parts of Arizona, and New Mexico.

With the shorter lariat, catches on cattle or horses were made up close and fast. The dally roper threw his rope at a longer distance, picking his time and playing the animal. Arguments about the merits of the two systems are very much alive yet today and get about as far as arguments over Scotch versus Bourbon. However, with the rodeo setting the pace for modern cowboys, the dally method and the long throws are pretty much dead issues.

Artist Edward Borein knew his subjects well. Born in San Leandro, California, in 1873, he worked as a *vaquero* from Mexico to Montana. Although he did not receive formal instruction in art, Borein is among the most popular of today's Western painters. Growing up in the tradition of the old California, he knew the pride a roping artist had in his work and the intricacies of the Figure 8, the *piale,* the *mangana,* and other difficult throws.

He is better known for his etchings than his oils. His skill in a delicate medium is clearly illustrated in his print entitled, simply,

Untitled sketch
W. R. Leigh

*Like many illustrators of
their time, Russell, Remington,
and Leigh took pains to record
the details descriptive of cowboy
dress and equipment. Their
pictures convey in a convincing
manner both the spirit and
activity of Western ranching,
as well as the character
of the cowboy himself.*

Trail Driver. Here, as Borein saw him in all his former glory, is the California cowboy of the 1890's with his creased hat, chaps, long *reata*, "center fire" saddle, long taps, braided, tied reins ending in a quirt, and all the other markings that distinguished the West or Gulf Coast *vaquero* from the Texas plains or Rocky Mountain cowboy Charlie Russell knew. Other equipment used by these two types included the hackamore, called *jaquima* by the Mexican *vaquero*, which is basically a bridle without a bit, with reins of braided horsehair. The hackamore, in the hands of a gentle trainer with a knowledge of horses and sufficient patience, could be used over a period of time to turn out a smart, quick, easy-reining cow horse.

There have always been rustlers in the cattle country. Even today, thousands of dollars in beef are lost each year to the modern, mobilized rustler and his closed van or truck. His counterpart of years ago, however, operated on a simpler level, taking stolen animals to a market where their brand was not known or checked too closely. Many rustlers became adept "rewrite artists" as they were called then, working over the original brand to conform to a new pattern. The forger's tools were simple. A "running iron" short enough to carry inside a boot, rolled up in a slicker, or otherwise concealed, might do. A cinch ring held by two green branches from a tree, when heated, made an ideal running iron with which the artist literally drew the brand. In the early days many cattle were branded by legitimate

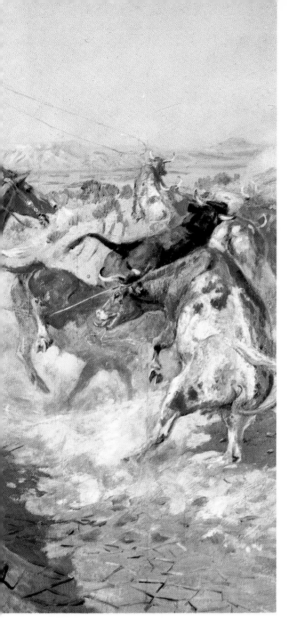

JERKED DOWN
C. M. Russell

stockmen with a running iron, but due to pressure from the rewrite rustler, most states outlawed the use of a running iron. Today, the average branding iron is about three feet long and generally referred to as a stamp iron. As the name implies, the brand is literally stamped on, and when properly done, sears the hair and surface of the hide, which forms a scab that shortly peels, leaving a mark over which new hair will not grow.

Another method used by the rustlers in the old days was the "cold brand." This was accomplished by applying the hot iron quickly to the hide of a steer through a wet blanket or sack. Although the superficial appearance of both brands was the same, cold branding burned the hair but did not leave a permanent scar; thus the animal could later be cut out from the herd and rebranded with the thief's iron. Because of the endless variety of methods used by rustlers to modify or obliterate legitimate brands, the honest stockman tried equally as hard to design a brand that would be difficult or impossible to change. Notching or cropping the ears of his cattle was adopted by more than one rancher and is a practice common today. Such notches are registered just as other types of brands serving as the cattleman's trademark. In former days the size of a man's brand might vary greatly, those applied with a running iron sometimes covering the whole side of a steer. Today the average stamp brand is anywhere from three to six inches wide, horse brands being customarily somewhat smaller. As in the past, the most popular spot for a brand is the left side or hip.

Before fencing, there had been little attempt to upgrade the quality of breeding stock, with scrub bulls as well as good blooded stock allowed to roam at will. With the advent of barbed wire, which made fencing practical over vast expanses, cattlemen began to keep an eye on stock types and many ranchers initiated breeding programs aimed at improving kinds of beef cattle. Before the close of the century, many new and improved breeds had replaced the wild cattle of former days.

On the northern ranges, shorthorns, Herefords, and other newly developed breeds slowly replaced the longhorns in regions where the long blue-stem grass came up to a horse's belly and the shorter buffalo grass dried in the ground to provide winter forage. It might be interesting to speculate on what Major Stephen Long would have said if he could have seen this great cattle country in the 1880's—a region that in 1819 he had reported to be almost wholly unfit for cultivation or habitation "by a people depending on agriculture."

Many cattlemen in the area would have agreed with Long's statement insofar as cultivation was concerned. "God made this to be cow country" was the sentiment expressed by the ranchers of that day, men who, in many instances, would back up their belief in no uncertain terms.

By the mid-1880's, the buffalo had disappeared from the prairies and the cattle had the range land to themselves. Stories spread throughout the East about the fortunes to be made in the "beef bonanza" in the West. Grass was free, range land belonged either to the state or the federal government, and only a small amount of capital was needed to invest in the cattle business in those booming years.

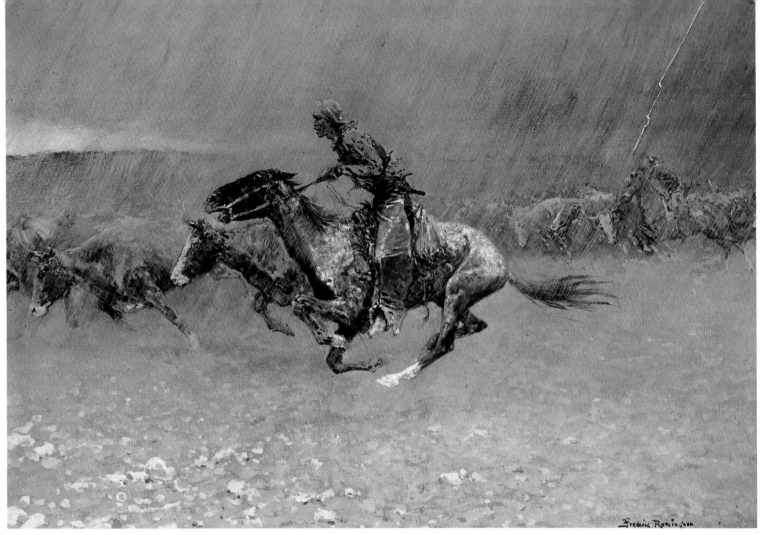

STAMPEDED BY LIGHTNING
Frederic Remington

Like many other types of men, good cowboys were as often "made" as born.

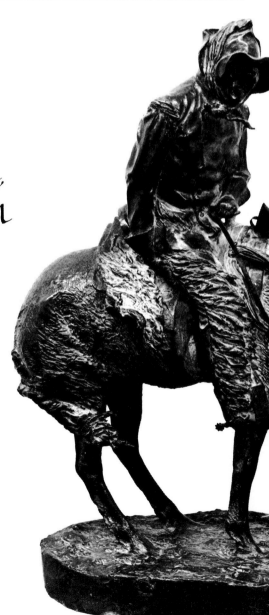

A rancher needed only to register his brand and the extent of his range, and he was in business. While he held no legal title to much of the land on which his cattle grazed, he often maintained his territorial rights with the aid of force or gun play. Success often depended upon that most important of commodities—water—and the man who controlled the water resources of an area controlled its future development. Foreign investors, principally Scottish or English, rushed headlong into the cattle business, and the get-rich-quick schemes that had brought so many adventurers into the West in former days now brought many more.

In time, however, ranges that should have supported half the number of cattle became critically overstocked. Grazing became increasingly poor. The passage of the Homestead Act had brought into the area the farmer and his plow, which cut the very life out of the grasslands, and sheepmen came with their "woolies" in great flocks, which ate the grass down to the roots if kept in one location for too long a time. "What they didn't eat, they cut up with their hooves," recalled one old rancher in later days.

Two major blizzards devastated the plains in 1886–7, one in December and the other in January. The latter storm continued without letup for more than a week, and the hungry cattle, denied access to the sparse grasses beneath the ice and snow, began to strip everything within reach: sagebrush, low branches, anything they could find to eat along the creek bottoms and sheltered spots. Stockmen were utterly helpless against such forces. Few had stacked up any hay against such an eventuality, and cowboys, confined for days on end to their bunkhouses, ventured forth to cut trails through the snow and ice, cutting down trees to afford some little forage for the stricken cattle. Nothing really helped, however. Each day an increasing number of frozen carcasses was discovered.

The spring roundup of 1887 was not the gay affair of former years. Cattlemen and cowboys alike had experienced one of the worst blows that the cattle business was ever likely to know. Losses as high as ninety per cent were not uncommon. The only healthy animals on the ranges that spring were the coyotes and the wolves. With the stench of dead cattle in their nostrils, the hardier cattlemen took another notch in their belts and set about to begin all over again, much wiser men; but the great period of the open range and the western beef bonanza was definitely over.

The large herds of the past decades would be no more. Cattlemen now realized that hay would have to be stored to carry stock through future winters. Fences would have to be maintained, wells dug, windmills and ponds built, and better beef animals brought into the area to build up better herds. The old Texas longhorn, lean and hard to manage, would never again be worth the expense and trouble of his upkeep or getting him to market. An era had ended.

Probably no other picture of its kind better sums up the trail-driving period in the history of the American cattle industry than

THE NORTHER
Frederic Remington

289

Frederic Remington's *The Stampede*, or, as it is known today, *Stampeded by Lightning*. The subject of more than one of the artist's works, not the least of which was a bronze sculpture entitled *Caught in a Stampede*, the last he ever designed, the incident described is as successful a blend of truth and poetry as Remington ever achieved. In a letter to its original purchaser, now in the manuscript files of the Gilcrease Library, Remington remarked with respect to this piece:

My dear Mr. Schofield:

My friend Wygatt says you have concluded to uphold my hand in my work by standing for "The Stampede." Regarding that picture, long ago when I was a boy I have had a few realities of that kind burned into my brain and I have at least a dozen times tried to perpetuate the impressions on canvas but have failed and burned up the results. At last I concluded to pass the present canvas as being as near the thing as I am likely to come . . . I think the animal man was never called on to do a more desperate deed than running in the night with longhorns taking the country as it came and with the cattle splitting out behind him, all as mad as the thunder and lightning above him, while the cut banks and dog holes wait below. Nature is merciless. Thanking you and hoping you may derive pleasure from my efforts, I am yours faithfully: Frederic Remington

The hazards of the trail and the rough life of the cowboy dramatized here represent more than an exercise of the artist's imagination, for the threat of stampede was a very real concern with any cowhand who ever trailed a herd across the western plains. Depending on the herd, of course, it often took very little to "spook" the whole bunch into headlong panic. A coyote's yelp, the rattling of cooking pans from the chuck wagon, a startled jackrabbit, a horse's whinny, a sneeze, or, as in this instance, a bolt of lightning—almost anything of an abrupt nature might startle a nervous longhorn. When pandemonium resulted, about the only thing the cowboy could do was ride "hell bent for leather" toward the head of the thundering herd, yelling to turn the leaders, gradually wearing them down until the panic subsided and they were settled down to milling among themselves again. Sometimes he was successful, sometimes not; and more than one drover suffered injury or even lost his life in the attempt to halt a stampede.

Many a cowboy who couldn't carry a tune in a bucket became a regular troubadour during the long months on the trail, singing not only to break the monotony of life on the open range, but also to calm the herd at night. Most of these songs, sentimental in nature, had uncounted verses and numerous versions that varied with the locale, some originating as poems that were set to simple tunes popular at the time. The cow puncher's life, his longings and laments, his recounted adventures on the trail are among the usual themes. "John Gardner's Trail Herd," "The Old Chisholm Trail," "When the Work's All Done This Fall," and many other songs speak of the tribulations of a cowboy's lot and the dangers of cattle on the run.

One of the best known of these ballads is "Lasca" by Frank Desprez. Recounting a cowhand's love for a girl, this poem features an encounter at the Alamo, a stabbing, and a stampede in which the girl, Lasca, loses her life while trying to shield her lover from the oncoming herd. It closes with the most tender verses of any cowboy ballad:

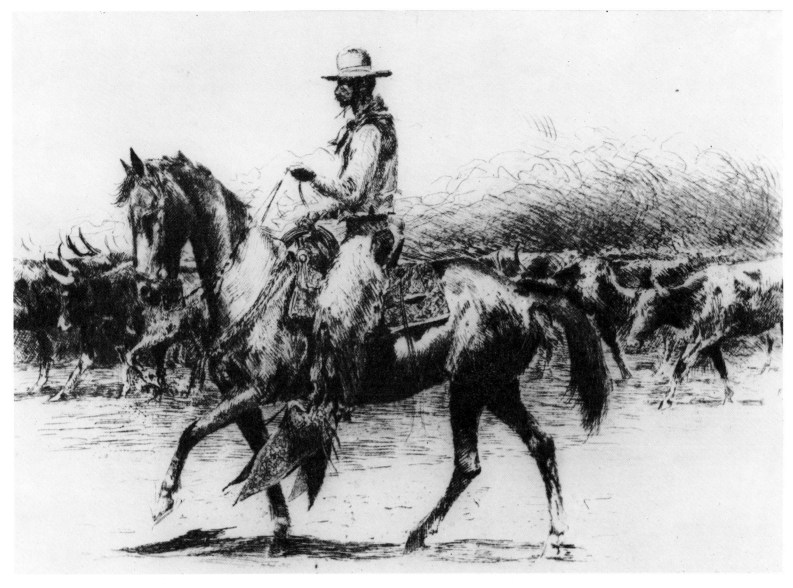

TRAIL DRIVER/*Edward Borein*

Tasca
by Frank Desprez

I gouged out a grave a few feet deep, and there in the earth's arms
I laid her to sleep;
And there she is lying, and no one knows;
And the summer shines, and the winter snows.

For many a day the flowers have spread a pall of petals over her head;
And the little grey hawk hangs aloft in the air,
and the coyote trots here and there;

And the black snake glides and glitters and slides
into the rift of a cottonwood tree;
And the buzzard sails on, and comes, and is gone,
stately and still, like a ship at sea.

And I wonder why I do not care for the things that are,
like the things that were.
Does half my heart lie buried there in Texas,
down by the Rio Grande?

Considering the broader spectrum of America's development as a nation, the cowboy played a short, swift part; but the character and the legend seem destined to be with us for a long time to come. With all his faults, the cow puncher, horse wrangler, or drover was distinctly "American." The cattle, the horses, and the methods of managing them have changed some since the trail-driving days of the 1870's and 80's. The grinding of gearshifts and the whir of helicopter rotors have now become familiar sounds in the cow country. Even so, there are still cowboys who just naturally prefer to follow the older ways of life, who will lead a horse to the saddle instead of carrying the saddle to the horse.

The ranges will never again see twenty thousand branded calves on the open range or drives of a thousand miles to distant market. Fences notwithstanding, there are still ranches today of a hundred thousand acres or more, cowboys who still work cattle off a horse, and a few old cattlemen who cling to a few of the traditional ways of working stock. A Colorado cowman of the old school, when questioned recently as to why he was not using branding chutes, said, "Hell, as long as I can find boys who can sit a horse and use a rope, that's the way she'll be done on this outfit."

COW SKULL AND MEADOWLARK
O. C. Seltzer

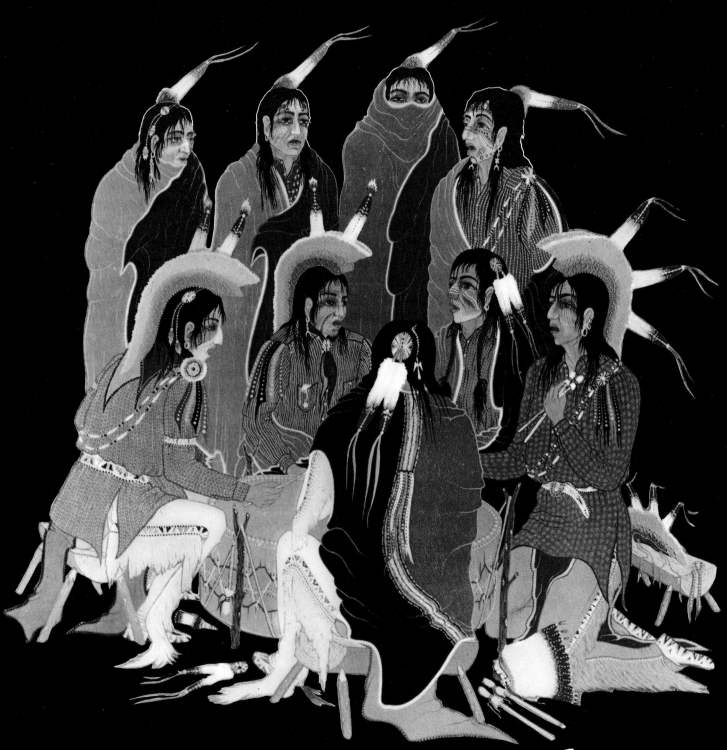

Romance & Realism
The Old West Revisited

Romance & Realism

<p>Living in an industrialized society in the mid-twentieth century, we find it difficult to imagine life as it was along the wilderness frontier in America. Indeed, it is hard to recapture now the experiences of that eventful period in the past or even to picture the land and its people more than a hundred years ago. Therefore, we turn more and more to the surviving accounts of those who first explored the western wilds; and perhaps none recall those bygone days more vividly than the pictorial reports of the nineteenth-century artists who, in the company of government scouting parties or traders' caravans, crossed the trackless prairies and explored the distant mountains, and in their sketches, watercolors, and oils recorded their impressions of that primitive land.</p>

The continuing regard for these early observers almost solely in light of their local or regional importance, however, has caused many scholars to forego study of their reports as works of art. Only in the last ten or fifteen years, in fact, has any attempt been made to evaluate the accomplishments of the nineteenth-century illustrator in such terms, while the work of the frontier artist in particular has been ignored by nearly all except a few western buffs or writers of western history who look on such material only as pictorial evidence for their various publications.

SINGERS FOR THE DANCE (*previous page*)
Woodrow Crumbo

Admittedly, not every work in the portfolios of the western artists is important for critical or aesthetic reasons. Most of them are, nonetheless, examples of characteristic trends or developments in American life, works that reflect aspects of an earlier cultural heritage. In reporting the circumstances of their times, they also speak in the language of their times, whenever they were produced, translated into the peculiar vocabulary of the artist. Thus, it is as works of art that they must be interpreted if they are to be understood.

Our consciousness of the past, the present, ourselves, may be realized in many different ways. Every scientific discovery adds to our understanding of the world in which we live. Each surviving letter, commentary, or report provides another piece of intelligence by which we maintain the continuity of human experience. Likewise, every painting, sculpture, piece of music, or volume of literature attests to something: to an observation, a view, a re-creation, a creative idea.

Only scattered tracts remain today of the wilderness from which this nation derived its initial strength and purpose, and nothing at all of the wild frontier where so much of the romance of the immediate past was written. Yet the records surviving from that period, whatever else they may represent, continue to provide a specific reference of importance to any who would investigate the social or cultural history of the United States, affording as well an insight into the attitudes and aspirations of former generations who settled this land, created its government and its institutions, and determined its future.

It is important that we have this insight into the past: to see what we can of the world envisioned by our ancestors. Who we are and where we came from interest us today. Thus we should acknowledge our indebtedness to those who set down their accounts of frontier life, in their various formal or informal, deliberate or accidental ways, particularly those artists and journalists who consciously and methodically made a record of their experiences.

Capturing scenes of a savage life beyond the fringes of civilization, these men produced a unique documentary of an era that will continue to live in our imaginations. They revealed not only the circumstances but also the character of their times; and without this store of facts, fancies, folklore, forms, and imageries, we otherwise might hold uncertain or erroneous opinions respecting the dreams and achievements of that vanished generation, as well as uncertain or erroneous opinions regarding ourselves today.

The latter decades of the nineteenth century witnessed a great many changes in American culture and society. In the West, the occupations of the trader, trapper, and Indian fighter gave way almost overnight to those of the ranger, cattleman, and lawman. Railroad, ranching, and mining interests soon dominated the economy of the western plains and mountain states; and with the termination of the frontier, the wild, free life of the mountain man and the buffalo hunter became a thing of the past. In the East, too, life changed drastically, as industrialization grew. Many artists and writers at this time went West to escape those turbulent cities, and many also went to Europe to gain perspective.

WALPI, FIRST MESA
W. R. Leigh

295

Zane Grey and later Owen Wister found much to write about in the western states and territories, setting the pace for a whole new brand of American literature based on the frontier theme. Frederic Remington also found what he was looking for in the West, registering on canvas some of the last glimpses of the U.S. cavalry on the plains before it too passed into the annals of American military history. James McNeill Whistler and John Singer Sargent, on the other hand, established reputations in Europe as sophisticated artists whose scenes and portraits were sought by wealthy compatriots shopping for art in Old World capitals. Winslow Homer and George Inness returned home from their foreign studies to pursue their own distinctive paths of development: the one painting American life in vivid, visual terms, the other the American landscape with an eye to the larger significance of things seen in nature.

Contrasting with this latter approach, a school of American "realist" painters and writers evolved, a leading proponent of which was Thomas Eakins. An old-school technician, Eakins followed a naturalistic philosophy. Truth, not beauty, was his avowed goal, and the objectivity with which he recorded life in his native Philadelphia somewhat offended the Victorian sensibilities of his day in its departure from the more sentimental interpretations of the Hudson River and Düsseldorf painters of pre-Civil War times.

A full-length portrait of the noted American ethnologist Frank Hamilton Cushing survives as one of his largest canvases in the collection of the Gilcrease Institute. Executed in 1895, the painting shows Cushing dressed in the costume of a priest of a Zuñi sacred fraternity into which he had been initiated during his studies among the southwestern tribes. Sharing Eakins's concern for realism in his portrayal, Cushing helped the artist convert a portion of his studio into a replica of a room inside a Zuñi dwelling.

Few Americans at this time gave much thought to native cultural achievement, much less to the events of the recent past. Business had become the chief challenge for aggressive individuals and a number of men became fantastically wealthy. Demonstrating their good fortune in all manner of extravagant ways, some built palatial townhouses or suburban mansions where they frequently entertained on a scale rivaling the magnificence of the courts of Europe. As monarchs and merchant princes of earlier centuries had done, some of these men began to acquire grandiose collections of art or other material objects indicative of success and cultural acumen.

Surprisingly, perhaps, many documents pertaining to the early history of this hemisphere remained in European archives, ignored by the majority of Americans abroad at this time, who were looking for more sensational items to take back home to Boston, Philadelphia, and Pittsburgh. There were a few, however, who realized the significance of the material they came across in their travels. Soon valuable folio editions of the works of naturalists and other observers of the early American frontier scene found their way back to their respective points of origin. Reports of discovery and exploration in the New World were retrieved from forgotten corners of England or Spain. Accounts of conquest or archeological investigation in Central

BEAD WORKER
O. C. Seltzer

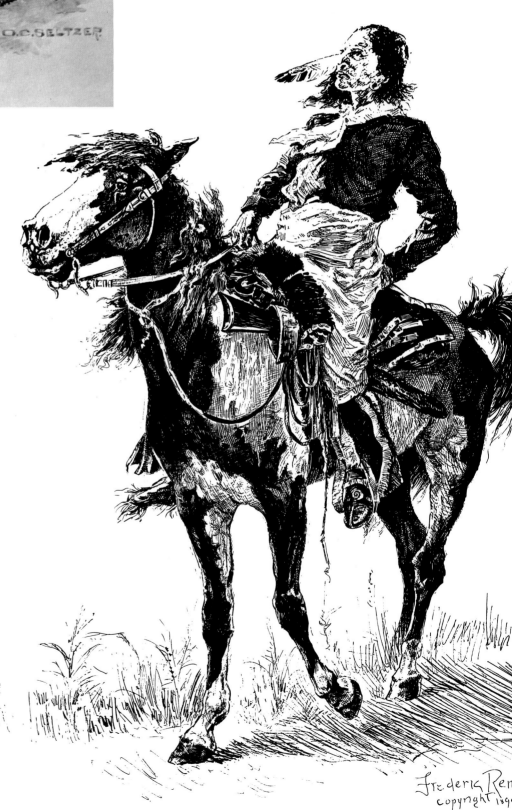

Frederic Ren
copyright 189

GOVERNMENT SCOUT
O. C. Seltzer

COMANCHE SCOUT
Frederic Remington

or South America were delivered into the hands of collectors whose interests were of a more scholarly bent, and through their efforts some of the most important collections of historical materials in the United States were founded.

Officers and men stationed at various western military installations at this time continued to collect Indian costumes, ornaments, and other Indian-made items, either for study or identification or simply as souvenirs, a practice that contributed to many of the finer early collections of this kind seen today in museums around the country. Interest in Indian manufacture was not then always the same as interest in aboriginal culture as such, however, and much of the material dating from this period shows this lack of appreciation.

The way of life of the American Indian had been altered radically as a result of the European conquest of the continent. The introduction of metals and other new materials in the eighteenth and nineteenth centuries had effected changes in the designs and working techniques of aboriginal craftsmen even as the advent of Western civilization had influenced their cultural expression generally. Glass traders' beads replaced dyed porcupine quills as a decorative medium, expanding design ideas and allowing for an enrichment of costume impractical if not altogether impossible before. However, stone sculpture almost disappeared during the historic period, and metal pots and pans virtually eliminated pottery and baskets.

As a method of recording the passage of time or events, the hide-painting tradition among the plains tribes dwindled away with a corresponding reduction in the supply of available hides. It survived for only a little while in the form of a continuing narrative described in pen and ink or watercolor across the pages of government ledger books by reservation Indians.

Unfortunately, today's viewer cannot read the message in all these graphic commentaries, although he can grasp the dominant impression of the artist-recorders' longing for days gone by.

A pen-and-ink study of a Comanche scout observed near Fort Sill, Indian Territory, by Frederic Remington shows the southern plains horseman as he appeared during this latter period of cultural transition. Having already adopted the white man's ways, this rider wears American clothes and uses U.S. manufactured weapons and horse gear. This sketch was used by Theodore Dodge as an illustration in his *Riders of Many Lands*, published in 1894. Dodge refers in his text to the particulars represented in this drawing, remarking that:

The Comanche is fond of gay clothes and has a trick of wrapping a sheet around his body, doubling in the ends, and letting the rest fall about his legs . . . He uses a Texas cowboy's tree, a wooden stirrup into which he thrusts his foot about as far as a fox hunter . . . Between him and his saddle, he packs all his extra blankets and most of his other plunder, so that he is sometimes perched high above his mount. For a bridle and bit, he uses whatever he can beg, borrow, or steal.

Gilbert Gaul's painting *Issuing Government Beef* is even more descriptive of the decline of the plains culture in the closing years of the nineteenth century. Forced at last to rely on rations of food from the U.S. government, the once fierce plainsmen are shown dressed in

299

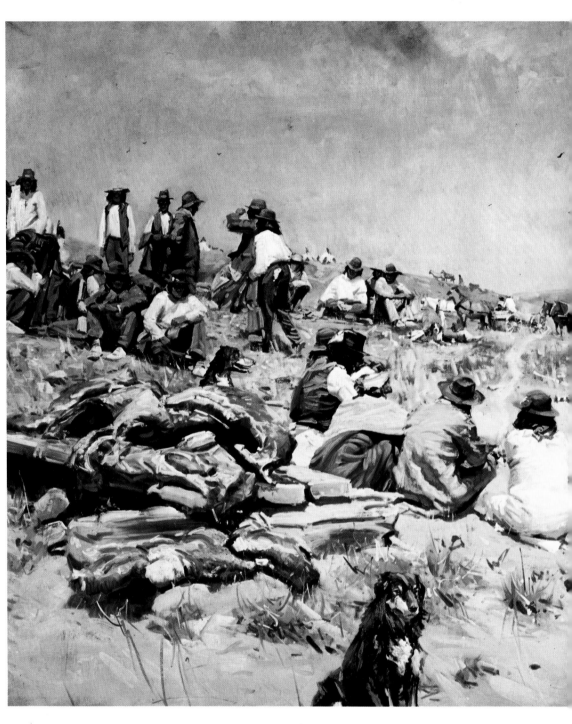

Aware that they were witnessing a passing era, the artists in the West attempted to preserve what they could of the changing scene. A sense of history is especially evident in the works of those who joined the influx of people to the western territories following the Civil War.

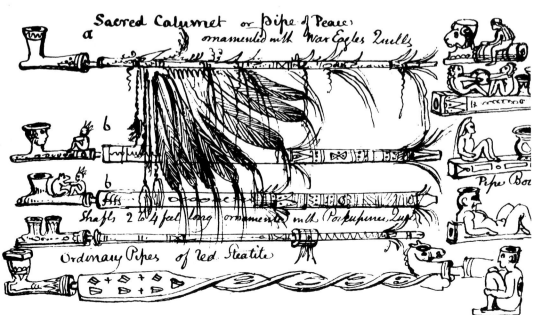

ISSUING GOVERNMENT BEEF
W. Gilbert Gaul

Pen and ink drawings by George Catlin
from the artist's field sketchbook

the castoff clothes of their conquerors. A few feathers, a pipe, and a parfleche bag are all that remain to recall former days when the Indian rode freely upon the prairies, hunting the buffalo and engaging in intermittent warfare.

The desire to capture something of the changing character of western life prompted several painters to settle in or around the Indian village of Taos, New Mexico, toward the end of the century. Here one of the more famous American artists colonies was formed. Compared with what might be called the mainstream of American creativity at this time, the works of these men seem very conservative today, and it is not always remembered that they too were exponents of the "new realism" that influenced American thinking.

Joseph Henry Sharp first happened on Taos in 1893 while on a sketching trip through the West. A few years later, he returned to establish residence and continued to spend his summers in this area, painting the Indians and the scenery of New Mexico. Exhibiting in the Paris Exposition of 1900, he received international recognition for his Indian portrayals. That same year, Congress acquired a collection of Sharp's portraits and installed them in the Smithsonian.

Through the auspices of President Theodore Roosevelt, the government built a small cabin and studio for Sharp near the old Custer battlefield near the Crow Agency in Montana. Here he spent several winters painting the inhabitants of the area, documenting their life and waning culture. Nearly all the noted Indian personalities of the time sat for Sharp, including a number of men who were reputed to have engaged in the Battle of Little Big Horn in 1876. The artist observed with sympathy the Indians' customs and rituals, and his personal acquaintance with his subjects enabled him to capture the mood of a people in the throes of cultural transition. Imbued with that quality of "truth" and attention to detail that makes them of value to the modern ethnologist, works such as *Story of the War Robe* or *Chant to the War Bonnet* illustrate the attitude of a people holding fast to the last vestiges of a dying tradition in a world not of their own making.

The Southwest proved an attraction for others such as Oscar Berninghaus, who visited the area in 1899 after a railway brakeman told him of the little Mexican town and Indian pueblo lying at the foot of Taos Mountain. His work as a commercial illustrator in St. Louis had resulted in several commissions from the railroads for illustrated pamphlets describing the scenic wonders observable along the various western routes. The country was new to Berninghaus, and wherever he went, he liked what he saw: the mountains rising abruptly from the desert floor, the twisted pines, the cactus, the golden groves of aspen yellowing in the autumn sun.

Many of his pictures record the activities of the local farmers and ranchers at their daily round of tasks: scenes of people gathering in the village on market day and numerous other commentaries on the life typical of that time and place.

Berninghaus expressed his feeling for Taos in a newspaper interview in 1913 by saying:

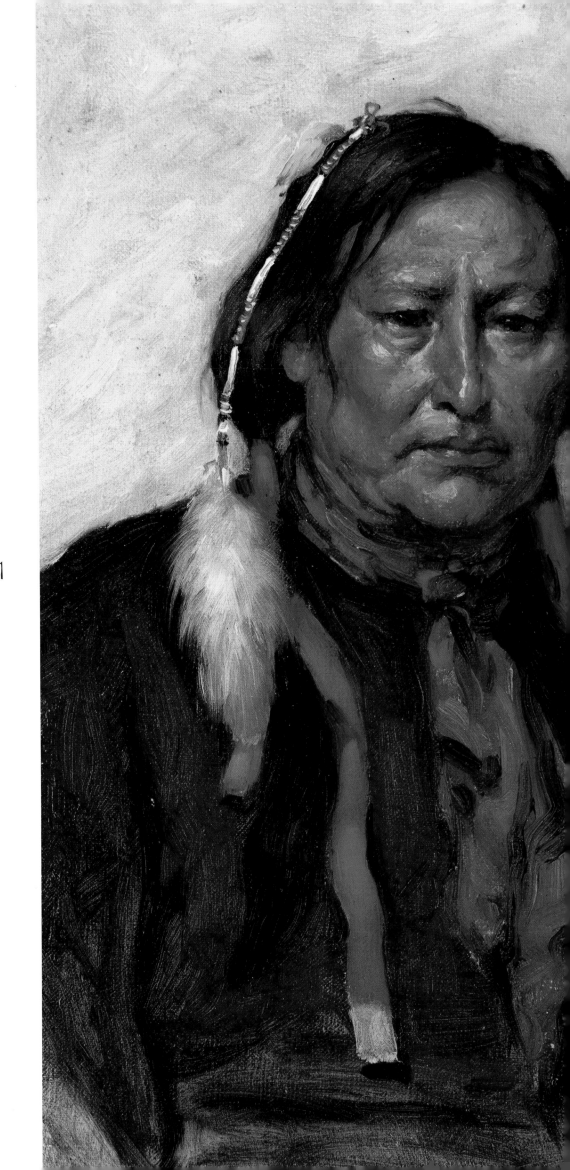

Several American artists settled at the close of the century near the Indian village of Taos, New Mexico, where they found a rich source of subject matter for depiction

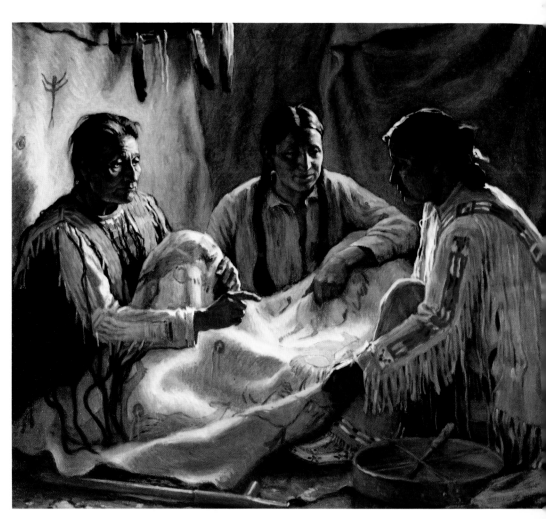

STORY OF THE WAR ROBE / *J. H. Sharp*

This is a splendid country for an artist because there are more varieties of atmosphere here than I have found in any other place. Up in the hills one can get the right setting for old trapping pictures. There are many varieties of sage and cactus for background, according to the elevation you choose. The Taos Indians are a splendid type; in fact, the best I have ever seen, and if one wants to paint Mexican pictures, he can get a background near Taos just as picturesque as any spot in Old Mexico.

Before his death in 1952 at the age of seventy-eight, he again remarked on the work of those who had settled in the Southwest to paint:

I think the colony in Taos is doing much for American art. From it I think will come a distinctive art, something definitely American—and I don't mean that such will be the case because the American Indian and his environment are the subjects. But the canvases that come from Taos are as definitely American as anything can be. We have had French, Dutch, Italian, German art. Now we must have American art. I feel that from Taos will come that art.

Generally speaking, the Taos painters were not given to writing manifestoes on technique. They promoted no new "ism" and, in a day when artists were vocally expressive concerning what art "should be," most of these men were surprisingly silent. Each shared with the other only the fact that in the American Southwest he had found an environment suited to his own special talent or feelings.

SPOTTED ELK
J. H. Sharp

303

Along with many who visited this area, Ernest L. Blumenschein shared an interest in the American Indian as artistic subject matter. His acquaintance with Joseph Sharp in Paris led to his trip to New Mexico in 1898 with Bert Phillips, another artist friend, where he discovered what was to prove the overwhelming enchantment of the place. In later years, another of Blumenschein's friends was Oklahoma oilman Thomas Gilcrease, who, like the artist, was vitally interested in all things Indian. Prodigious collector of records and materials relating to past American civilizations and cultures, Gilcrease responded to Blumenschein's portrayals of a people living in close communion with nature.

The artist's insight into the spiritual side of Indian life is evident in those paintings in which he attempted to illustrate this aspect of primitive culture, painting in his own distinctive manner the almost untranslatable attitudes and beliefs characteristic of America's aboriginal past. His *Moon, Morning Star, and Evening Star* is such an example. Portraying a native ceremonial, the event described takes place in the plaza of a village and shows dancers symbolically attired to represent various animal spirits on either side of an open space wherein are scattered the products of the field. The sacred Indian signs for the moon, morning star, and evening star are boldly positioned at the top of the canvas to indicate to the viewer that the scene is one of elemental religious significance.

The artist in the American West went there for a number of different reasons, usually to record scenes never before recorded or to document the action associated with life along the western trails and among the scattered settlements. Preoccupation with natural history or an interest in landscape painting prompted several to explore the western wilds. A special "sense of history" is particularly evident in the works of those who, following the Civil War, joined the influx of journalists to the western areas of the nation. Aware that they were witnessing the passing of an era, these men set about to preserve what they could of a rapidly changing scene, describing its people and their occupations with a realism and sense of detail that we readily respond to today.

"As long as there are such pictures and books as Remington's," Zane Grey once remarked, "Americans will remember the heritage of the dim frontier." And in something of the same vein, Perriton Maxwell, Eastern art critic, wrote with regard to Remington's work:

"It is a matter of self-congratulation that in ringing down the final curtain on the great Wild West drama, the relentless course of empire has left us at least one auditor with skill and enthusiasm and courage enough to perpetuate on canvas and in enduring bronze the most inspiring phases of its colorful existence."

Even Theodore Roosevelt, writing about the artist in *Pearson's* magazine, said in an article published in 1907, "He is, of course, one of the most typical artists we have ever had, and he has portrayed a most characteristic and yet vanishing type of American life. The soldier, the cowboy, and the rancher, the Indian, the horses and cattle of the plains, will live in his pictures and bronzes, I verily believe, for all time."

MOON, MORNING STAR, EVENING STAR
E. L. Blumenschein

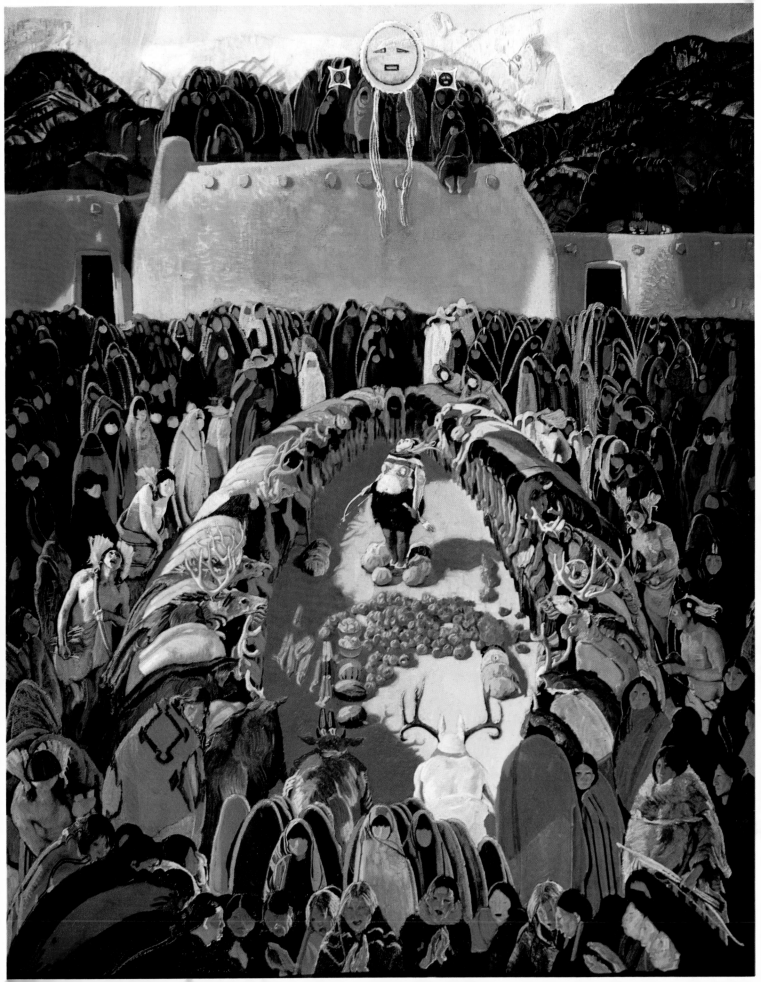

Not all painters at this time attempted to document the physical aspects of primitive culture. Some, like E. L. Blumenschein, observed the Indians' mental attitudes, translating these into terms expressive of the religious beliefs of a nature-oriented people.

ENCHANTED FOREST
E. L. Blumenschein

Charlie Russell was another who portrayed the changing times, establishing himself as one of the more familiar interpreters of the latter-day Western scene. Russell loved the life of the West and, looking backward instead of forward in his work, painted it more in the manner of how he "felt about it" and the way it used to be than simply as it was in his day. As the technological advances of the twentieth century changed forever the world he knew, Russell held fast to his memories of the old days on the open range; and in his steps followed other "cowboy artists" and western storytellers—men such as Edward Borein, Will James, Olaf Seltzer, and William Robinson Leigh.

"My work has been called 'documentary,' " remarked W. R. Leigh in a radio interview in 1939. "This I feel to be the finest of compliments, for I have devoted a lifetime to re-creating natural studies and have endeavored, above all else, to paint with fidelity to nature."

During the major part of his very active career, Leigh's chief ambition was to "paint America," especially the American West. In his book *My America,* he recalls his early years, relating that after studying for some time abroad in Germany and France, he had become tired of European subjects and longed to return home to search for new material.

"At all costs I had hoped to avoid illustrating, yet it seems as if I were doomed to do it," he writes of his first months as a struggling young artist in New York City. "I went to Scribners Magazine, in anticipation of which emergency I had provided myself with several black-and-white compositions."

The art editor of Scribners gave him a job illustrating articles on United States history—"a thing as I would never in a thousand years have selected of my own accord to do," he commented later. Then in 1906 Leigh made his first trip west.

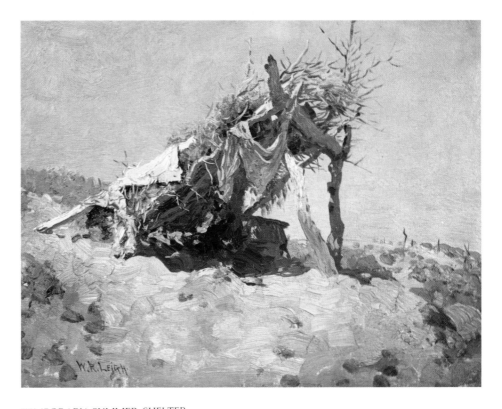

TEMPORARY SUMMER SHELTER
W. R. Leigh

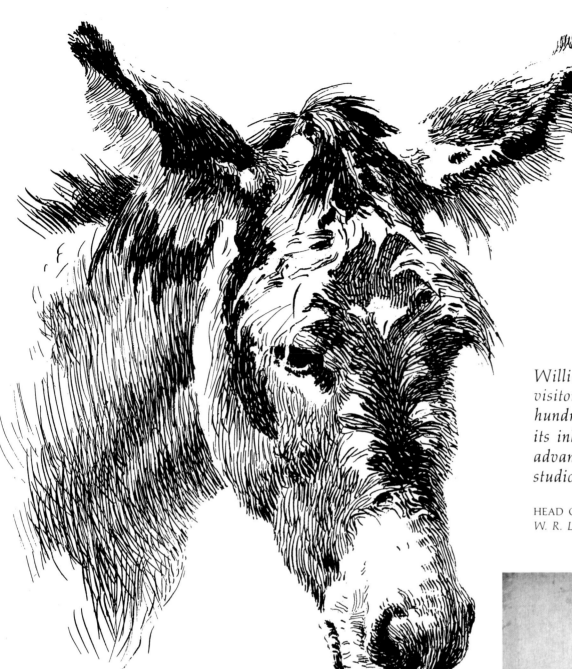

W.R LEIGH.

William R. Leigh was a frequent visitor to the West and produced hundreds of studies of the land and its inhabitants. These he used to advantage in creating his larger studio works.

HEAD OF A BURRO
W. R. Leigh

Untitled study by W. R. Leigh

J wanted to go to the West," he continues in his autobiography, "to acquaint myself with our frontier, with the purpose of devoting my life to depicting the activities of the Indians, cattlemen, soldiers, and pioneers."

Working his way from New York to Chicago, he finally talked an official of the Santa Fe Railroad into giving him free passage to New Mexico in exchange for a painting to be delivered later. Satisfied with the results of this arrangement, the company ordered several more pictures, thereby providing the artist with sufficient funds to enable him to remain for some months in the dusty Southwest.

In Laguna, New Mexico, Leigh records that he began to realize for the first time his earlier ambition to acquaint himself with the Western scene. Remembering his first weeks there, he writes:

I was eager to waste no time whatever; I saw that I needed studies of everything, the vegetation, the rocks, the plains, the mesas, the sky, the Indians and their dwellings . . . I found it almost impossible to get any of the Indians at Laguna to let me paint them . . . the old Indians when I walked through the village looked at me with hatred. I had done nothing; my mere presence infuriated them; I was very careful not to afford grounds or excuse of any kind for complaint on their part . . .

The women wore red blankets issued to them by the Government; the red contrasted marvelously with their black hair. It seemed as if it would be impossible to add, or take away, anything to heighten the fabulous picturesqueness—color, line, massing, distribution—everything was perfect!

 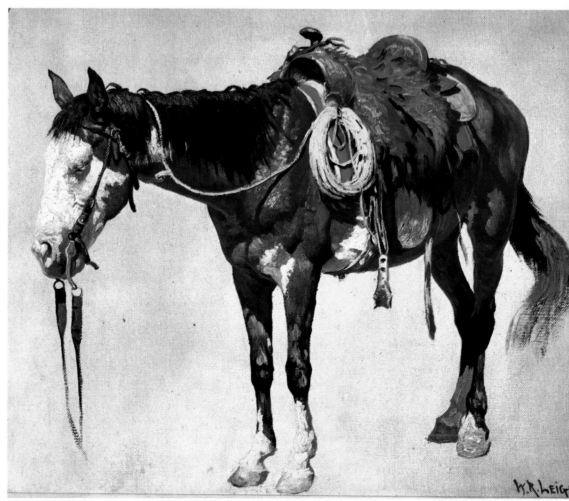

Untitled study by W. R. Leigh

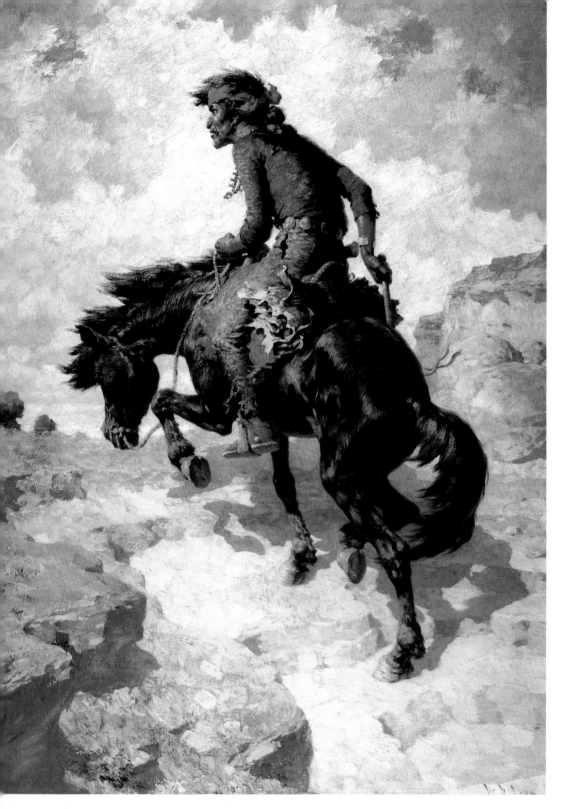

UP WHERE THE BIG WINDS BLOW
W. R. Leigh

Leigh considered himself a realist and strict documentarian. However, his pictures portray some of the most romantic aspects of life in the American West, both past and present.

BRONC RIDER
W. R. Leigh

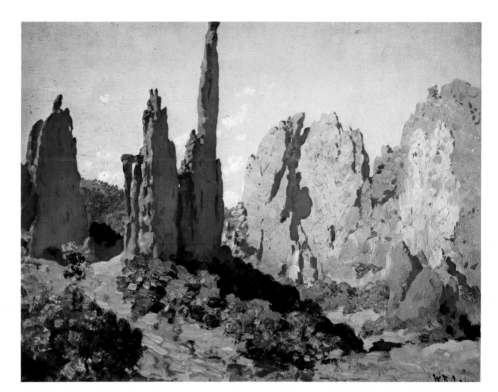

GARDEN OF THE GODS
W. R. Leigh

Returning to New York after spending another two weeks sketching in the vicinity of the Grand Canyon of the Colorado, Leigh remarked that his entire horizon had been revamped. "Hereafter," he concludes, "I was in the West as often as I could earn enough money to take me there."

Leigh reported the West with a decidedly personal flair: its canyons and rocky pinnacles, deserts, badlands, sagebrush, and tumbleweed. Many of his studies served as reference material for backgrounds or other details in larger works featuring portrayals of ranchers, soldiers, Indians, and episodes of Western life in general. An excellent technician, Leigh probably was the best trained of any of the painters of the West in those days. He was not, however, the student of Western lore that Frederic Remington had been, nor did he have that familiar association with the country and its subjects evident in Charlie Russell's work.

"He's no parlor car artist," wrote Thomas Moran, referring to Leigh in an article published in the *Christian Science Monitor* in June 1913. Indeed, he was not, for he often selected some of the most rugged and inaccessible areas of the remaining wilderness as his sketching sites, camping out for weeks at a time amid a clutter of easels, paints, and camping gear along the rim of the Grand Canyon or in the Painted Desert. He looked on the landscape and registered his feeling for its vast expanse and range of color, endeavoring to put down on his canvases something of the wonder he felt for the primitive beauty of the country.

By 1920, Leigh was participating in shows with other well-known Western painters of the time, including Russell, Blumenschein, Irving Couse, and Frank Tenney Johnson. He continued to seek out his favorite sketching sites and to draw upon them for his subject matter.

Returning from a summer's outing, he brought back not only painted studies but also an assortment of natural specimens and artifacts that served him later as models or "props" to be copied and incorporated into his finished works, most of which were done in his New York studio. His frequent referral to photographs for information on details of a particular scene or subject is evident through an examination of his studio files, which include camera studies of all kinds.

In 1924 Babcock Galleries held an exhibition of Leigh's oil studies featuring both landscape and figure sketches done from life. One reporter at this show summed it up in the following manner:

There is no pretense in this exhibition beyond being just what it is stated on the cover of the catalogue to be—"Original Studies." It shows the artist at close grips with the pictorial data of the prairie trail and ranch enclosure. Here he has his sleeves rolled up, so to speak, and has got down to the serious business of recording just how a Sioux strawberry-roan looks under the midday sun, or how a Hopi burro or a Navaho goat stands when the afternoon is drawing to a close. There are numbers of carefully made portrait studies of Zuni Indians and several landscape notes of particularly noteworthy skies and such, but it is in the animal studies that Mr. Leigh is at his best. Here he sits in the saddle with the best of them, sure of his subject and of himself.

Anatomical horse studies by W. R. Leigh

WESTERN PONIES
W. R. Leigh

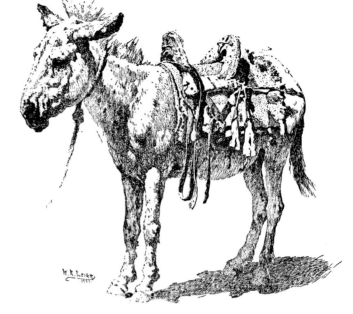

NAVAJO BURRO
W. R. Leigh

An unexcelled draftsman, W. R. Leigh was one of the best trained artists to visit the American West. Concerned primarily with subject matter, he felt that "method and technique are important, but what is objectified in a work of art remains of primary importance."

The critics did not always praise Leigh's work. Comparing it to that of Charles Russell, one New York reviewer observed:

"Charlie Russell is not as good a painter as William Leigh, but he is a greater artist of the West because he knows the West. Russell always has something to say, and when one has a message and knows how to express it, technique becomes a secondary consideration."

In something of the same vein, another visitor to one of Leigh's New York exhibitions remarked:

Pictorially, the Leigh exhibition is admirable. But it is no truthful disclosure of the West as it is or as it was. The horses, which are everywhere, are not the horses that we know in the plains and hills. I remember quarrelling with Remington because he used a Kodak to get "an impression" of a bronco, a range pony, or an outlaw horse of the round-up "in action." But Remington was right, where—to my way of thinking—Mr. Leigh is wrong. Given a scene or incident, and Leigh paints a horse to fit his purpose. And, as I have said, the horse of his picture is not the horse of Western reality.

It is a horse, but no artistic dexterity can dismount a New York policeman and put a cowboy in the same saddle on the same animal and show the town-trained animal galloping to head-off the nomad Indian. I never saw a "fat" Indian pony. I wonder where Mr. Leigh got the well-fed mounts upon which he places his Indian warriors . . . Some of them look like circus horses. And they are as well-painted as they seem to be well-fed.

Over the years, Leigh's studio on West Fifty-seventh Street came to be a source of wonder to those who visited it. One described it as resembling a "Western prop room" and that suspended from the walls were "bleached skulls of buffalo, mountain sheep, and horses, scattered over the floor are Navajo rugs and displayed elsewhere about the apartment are tomahawks, war clubs, arrows, and other relics of a past chapter of the history of the prairies.

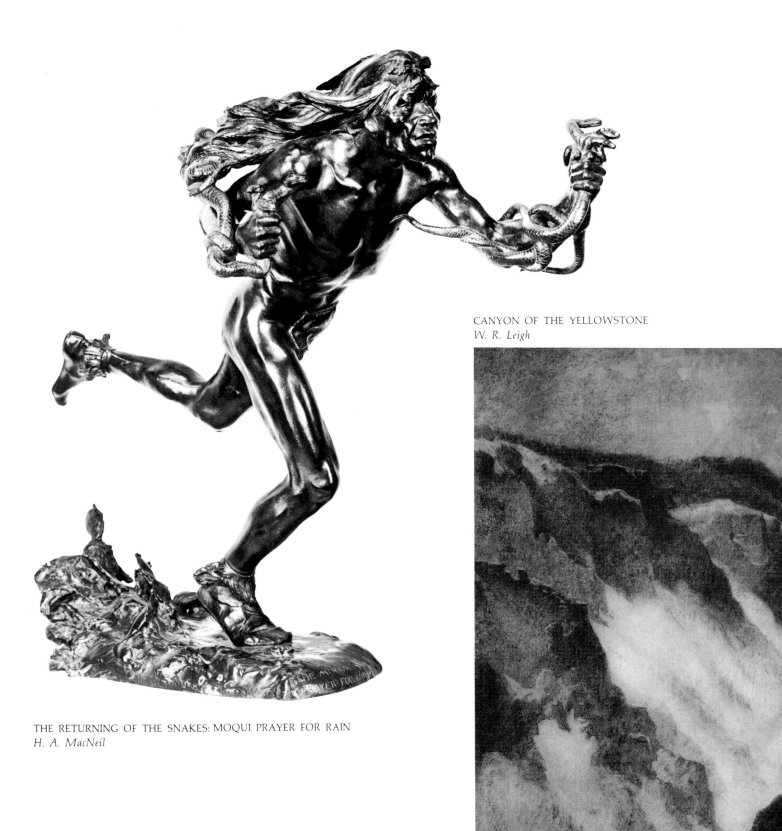

THE RETURNING OF THE SNAKES: MOQUI PRAYER FOR RAIN
H. A. MacNeil

CANYON OF THE YELLOWSTONE
W. R. Leigh

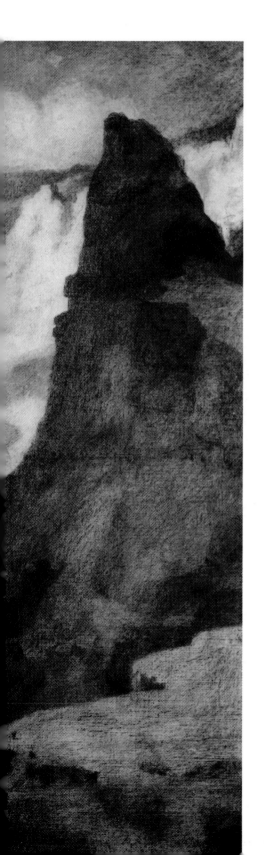

*T*hese," he concludes, "threaten to take up all the working space." Another editorial published at a later date recalls that Leigh, then "a tall, soldierly-straight man" affected a "snowy-white mustache and goatee to complement his whitening hair, and his resemblance to Buffalo Bill Cody is often commented upon."

The greatest single exhibition of his work took place at the Grand Central Art Galleries in 1956, the year following his death. Called upon this occasion the "Ninetieth Anniversary Roundup," it included 161 works in various media, and one piece of sculpture in bronze, the only piece of this kind ever attempted by this artist. Summing up the work of a lifetime for a man who is now regarded as having been "the last of the painters of the Old West," this show encompassed the whole range of his interests and success as a reporter of the American Western scene, past and present.

Leigh's purpose and viewpoint are clearly expressed in his work, both as an artist and as a writer. In his accounts of himself, he invariably referred to his intention to "re-create natural scenes." Yet his larger, history-oriented canvases suggest a man with somewhat more of an emotional than a logical turn of mind: he was a dramatist rather than, strictly speaking, a historian. It may be that every historian is a dramatist, or at least to some degree, unconsciously, a romanticist. Certainly for Leigh, the history of the frontier was a fondly remembered thing. He prided himself on his realism; he painted a romance, nonetheless. For Leigh the romance of the West was as real as it is for many of us today; and herein may lie much of the appeal that his works continue to have for a large audience of contemporary viewers.

Today, of course, we do not look to the West in expectation of new worlds to conquer, but for recreation, scenic views, clean air, and wide-open spaces. American artists and writers still seek in its scenery and subject matter new forms to describe or old experiences to reflect upon; but not all are interested in its history. For many, the present and the past are one and the same insofar as the West is concerned.

It might be remarked that perhaps the majority of those who documented life on the American frontier, at whatever time and for whatever purpose, perpetuated a romance: that romance and the love of adventure which were, in themselves, vital factors promoting the growth of the United States, especially in the nineteenth century. Thus the commentaries that reflect something of these qualities may be expected to represent its history in terms as accurate, in their way, as any modern historian's careful reconstruction of events.

Like their literary counterparts, the artists who observed life in the West during the latter decades of the nineteenth century admittedly preferred to depict scenes of action or the exploits of celebrated personalities than spend their efforts in portraying the more commonplace activities typical of most American frontiersmen. As a result, the pictorial record that has come down to us exhibits many more scenes descriptive of the life of the Indian or the trooper than that of the homesteader, railroad section crewman, storekeeper, or pioneering woman, all of whom also personified the period.

Whatever the final verdict, the question of romantic versus realistic interpretation of history forms the subject of yet another review written by a visitor to one of W. R. Leigh's exhibitions in New York as early as 1918. Commenting on what he feels to be the heart of the matter regarding history as translated into artistic terms, this critic has concluded:

Leigh's are the kind of pictures that strongly appeal to the people of an Eastern city whose energy is only partly used up by the feeble excitements of Wall Street and its tributaries. Such people get a sense of physical power and something of the zest of physical adventure in seeing horses pick their way along a dangerous trail, Indian chieftains pushing over great hills, famous hunters at grips with the now extinct bison, the whole panorama of the picturesque West . . .

Here we have that touch of sophistication always to be found in the wild when placed among tame surroundings. The West is East, seen from the Eastern angle, whatever pains are taken to put truth into the local color and history into the episode. The plain truth is that the West cannot be painted. It is just as much a state of mind as Boston, but it is a state of mind that changes as it comes within range of the artist's method of expression. Such material as Mr. Leigh and other painters are furnishing is, however, capital illustration of the "Book of the West," full of legends and adventure . . .

PRAIRIE WOLF AND COW'S SKULL
O. C. Seltzer

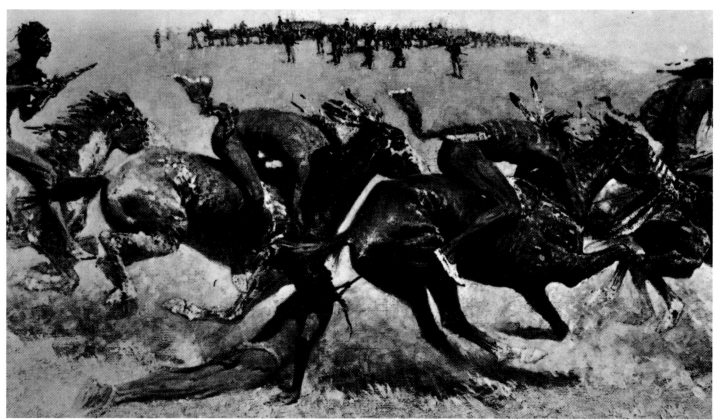

Listing of Artists & Works

Audubon, John James

1785–1851 Born in Haiti and educated in France, John James Audubon established his importance as a naturalist and wildlife painter with the publication of his monumental Birds of America (London, 1827–38). Settling in New York in 1842, he continued to work on a subsequent volume entitled The Viviparous Quadrupeds of North America, making a trip to the headwaters of the Missouri River in 1843. He died before completing the Quadrupeds folio, which was published by his son John Woodhouse Audubon in 1854.

WILD TURKEY / 28
Unsigned. No date. Oil on canvas 45 x 33 inches. Ex-collection: Mrs. Morris Tyler, New Haven, Connecticut.

STANLEY or COOPER'S HAWKS / 33
Unsigned. No date. Oil on canvas 39 x 26 inches. Ex-collection: Mrs. Morris Tyler, New Haven, Connecticut.

Becker, Joseph

1841–? A commercial engraver for New York publisher Frank Leslie, Joseph Becker served as head of Leslie's art department from 1875 to about 1900, during which time he produced numerous newspaper illustrations. He is remembered today chiefly for his depictions of the activities of the Chinese railroad workers in California, which were made following a trip westward on the newly completed transcontinental railroad in 1869.

SNOW SHEDS ON THE CENTRAL PACIFIC / 198
Unsigned. No date. Oil on canvas 19 x 26 inches.

Berninghaus, Oscar Edmund

1874–1952 Born in St. Louis, where he worked for a time as a commercial artist, O. E. Berninghaus first visited the American Southwest in 1899 while on an assignment for the Santa Fe Railroad. He later returned to Taos, New Mexico, where he finally settled in 1923. He was one of the founders of the Taos Society of Artists.

WHY THE MAIL WAS LATE / 160
Signed lower right, O. E. Berninghaus. No date. Oil on canvas 25 x 30 inches. Ex-collection: Dr. Philip G. Cole, Tarrytown, New York.

Bierstadt, Albert

1830–1902 Born near Düsseldorf, Germany, Albert Bierstadt grew up in the United States and later studied art at the famed Düsseldorf Academy. In 1858 he joined an expedition to the Rocky Mountains under General F. W. Lander, and exhibited his first views of western mountain scenery at the National Academy in 1860. Thereafter he enjoyed a wide reputation as a landscape painter, maintaining a studio on the Hudson River. This later was destroyed by fire. Bierstadt died in relative obscurity in New York City.

MULTNOMAH FALLS / 37
Signed lower right, A. Bierstadt. No date. Oil on canvas 44 x 30 inches.

MOUNTAIN MAN / 112
Signed lower left, A. Bierstadt. No date. Oil sketch on paper 13 x 9 inches.

SIERRA NEVADA MORNING / 194–5

Signed lower right, A. Bierstadt. No date. Oil on canvas 56 x 84 inches.

Blumenschein, Ernest L.

1874–1960 Born in Pittsburgh, Pennsylvania, Ernest Blumenschein studied music and art in New York and Paris. An assignment with McClure's *magazine sent him to New Mexico in 1897, and following another period of study abroad, he established a permanent studio in Taos, New Mexico. He was elected to the National Academy in 1927.*

MOON, MORNING STAR, EVENING STAR / 305

Signed lower left, E. L. B. No date. Oil on canvas 50 x 40 inches. Ex-collection: the artist.

ENCHANTED FOREST / 306

Signed lower right, E. L. B. No date. Oil on canvas 50 x 35 inches. Ex-collection: the artist.

Bodmer, Carl

1809–1893 Swiss draftsman and watercolorist Carl Bodmer accompanied Prince Maximilian of Wied Neuwied on a tour of the United States in 1832–4. Sketches produced during a trip up the Missouri River in 1833–4 supplemented the publication of Maximilian's journal (London, 1839–43) and are considered today to represent the finest pictorial documentary of the Missouri frontier extant. Bodmer lived most of his life in France, dividing his time between Paris and Barbizon.

VIEW ON THE MISSISSIPPI: TOWER ROCK / 78

Vig. IX of atlas accompanying the English edition of Prince Maximilian of Wied's *Travels in the Interior of North America*. By John Outhwaite after Carl Bodmer, published by Ackermann and Company, London, January 1, 1840. Colored engraving 7 x 10½ inches, plate size 12¾ x 14 inches, on trimmed stock 17 x 23½ inches.

BULL-BOATS / 81

Tab. 16 of atlas accompanying the English edition of Prince Maximilian of Wied's *Travels in the Interior of North America*. Published by Ackermann and Company, London, February 1, 1841. Colored engraving 9½ x 12⅝ inches, plate size 14 x 17 inches, on trimmed stock 17 x 23½ inches.

TRAVELERS MEETING WITH MINATAREE INDIANS / 82

Vig. XXVI of atlas accompanying the English edition of Prince Maximilian of Wied's *Travels in the Interior of North America*. By Alex Manceau after Carl Bodmer, published by Ackermann and Company, London, July 1, 1842. Colored engraving 7½ x 11 inches, plate size 11⅛ x 13½ inches, on trimmed stock 17 x 23½ inches.

ENCAMPMENT OF TRAVELERS ON THE MISSOURI / 82

Vig. XXIII of atlas accompanying the English edition of Prince Maximilian of Wied's *Travels in the Interior of North America*. By John Outhwaite after Carl Bodmer, published by Ackermann and Company, London, n.d. Colored engraving 7 x 10½ inches, plate size 10¾ x 14 inches, on trimmed stock 17 x 23½ inches.

THE CITADEL ROCK ON THE UPPER MISSOURI / 84

Vig. XVIII of atlas accompanying the English edition of Prince Maximilian of Wied's *Travels in the Interior of North America*. By Charles Vogel after Carl Bodmer, published by Ackermann and Company, London, January 1, 1839. Colored engraving 7 x 10⅜ inches, plate size 9¼ x 12½ inches, on trimmed stock 17 x 23½ inches.

CHASING OFF GRIZZLIES / 88

Tab. 36 of atlas accompanying the English edition of Prince Maximilian of Wied's *Travels in the Interior of North America*. By Lucas Webber after Carl Bodmer, published by Ackermann and Company, London, December 1, 1842. Colored engraving 12 x 17½ inches, plate size 15½ x 21¼ inches, on trimmed stock 17 x 23½ inches.

BEAVER HUT ON THE MISSOURI / 98

Vig. XVII of atlas accompanying the English edition of Prince Maximilian of Wied's *Travels in the Interior of North America*. Published by Ackermann and Company, London, December 1, 1839. Colored engraving 7 x 10¼ inches, plate size 10 x 13½ inches, on trimmed stock 17 x 23½ inches.

Borein, Edward

1873–1945 Western genre painter and etcher Edward Borein established his first studio in Oakland, California, about 1902, where he produced many scenes of western and cowboy life, for which he is best known today. He taught for a period of time in the 1920's at the Santa Barbara School of Arts in Santa Barbara, California, where he maintained a second studio until his death.

THE STAGECOACH / 162

Signed lower left, Edward Borein, and dated 1915. Oil on canvas 24 x 28 inches.

TRAIL DRIVER *or* ROPE MAN / 291

Signed lower right, on plate, Edward Borein. Signed by artist's hand, in pencil, below plate, Edward Borein. Etching 5 x 7 inches. Ex-collection: Philip G. Cole, Tarrytown, New York.

Cary, William de la Montagne

1840–1922 Born in Tappan, New York, William Cary made his first trip up the Missouri River in 1860, and a second in 1874 to accompany the return voyage of the Northern Boundary Survey team. He produced many pictures illustrative of his Western travels, and his work was regularly featured in Eastern periodicals throughout the 1860's and 70's. He maintained a studio in New York City until shortly before his death, which occurred in Brookline, Massachusetts.

MISSOURI ROUSTABOUT AT THE TILLER
OF A MACINAC [Mackinaw] BOAT / 73

Titled or inscribed in pencil at bottom in artist's hand. Unsigned, dated 1874. Pencil sketch on paper 14 x 9 inches. Ex-collection: Clinton M. Cary, New York, New York.

JIM BUTER, MOUNTAIN MAN... / 80

Titled in pencil beneath subject, in artist's hand. Unsigned. No date. Pencil sketch on paper 9 x 15 inches. Ex-collection: Clinton M. Cary, New York, New York.

NORTHERN BOUNDARY SURVEY
UNDER MAJOR TWINING / 86

As inscribed on reverse in artist's hand. Unsigned, dated 1874. Oil sketch on paper 11 x 15 inches. Ex-collection: Clinton M. Cary, New York, New York.

DECK HOUSE ON THE FONTANELLE / 87

As inscribed in pencil in artist's hand. Unsigned. No date. Pencil and wash sketch on paper 13 x 10 inches. Ex-collection: Clinton M. Cary, New York, New York.

Catesby, Mark

1679–1749 English naturalist, author, and artist Mark Catesby made two visits to America between 1712 and 1725, during which time he traveled extensively in the southern Atlantic colonies. His <u>Natural History of Carolina, Florida, and the Bahama Islands</u>, published in two volumes (London, 1731–43), featured 220 hand-colored plates of American flora and fauna. A posthumous volume entitled <u>Hortus Brittano-Americanus</u> also contained a number of his etchings of American trees and shrubs. He died in London.

THE GREAT HOG FISH / 26
Plate 135 of Catesby's *A Natural History of Carolina, Florida, and the Bahama Islands*, Volume II. Hand-colored line engraving 10¼ x 13¾ inches, on untrimmed stock 14 x 20 inches.

THE PARROT OF CAROLINA / 29
Plate 11 of Catesby's *A Natural History of Carolina, Florida, and the Bahama Islands*, Volume I. Hand-colored line engraving 10¼ x 13½ inches, on untrimmed stock 14 x 20 inches.

Catlin, George

1796–1872 Born in Wilkes-Barre, Pennsylvania, George Catlin early abandoned his studies at law to devote himself to art, securing a reputation as historiographer of western Indian life following nearly eight years spent in the trans-Mississippi wilderness. In 1840 he went to Europe, where he exhibited and lectured for another eight years, and also published several volumes of his observations among the western tribes. He made at least one trip to South America before his death in Jersey City, New Jersey. His Last Rambles Among the Indians of the Rocky Mountains and the Andes *appeared in 1868.*

UNTITLED SKETCH / 50
From the artist's field sketchbook, ca. 1832–6. Pen and ink on paper, 6½ x 6⅜ inches, page size 9 x 7 inches. Ex-collection: Sir Thomas Phillipps, London.

BUFFALO HUNT UNDER WHITE WOLF SKINS / 52
Signed lower right, Geo Catlin. No date. Watercolor on paper 8 x 10 inches, mounted in an album of fifty original watercolors inscribed and dated in the artist's hand on the first page, "George Catlin, London, 1849." Commentary by Catlin inscribed throughout album opposite each watercolor illustration. Cardboard cover. Ex-collection: Sir Thomas Phillipps, London.

SKETCHBOOK PAGES / 54
From the artist's field sketchbook, ca. 1832–6. Page size 9 x 7 inches. Ex-collection: Sir Thomas Phillipps, London.

DANCES OF THE NORTH AMERICAN INDIANS / 57
Unsigned. No date. Pen and ink sketch from the artist's field sketchbook. Ex-collection: Sir Thomas Phillipps, London.

MUCK-A-TAH-MISH-A-KAH-KAIK, SAC CHIEF, THE BLACK HAWK / 59
Signed lower right on mounting beneath portrait, Geo Catlin. No date. Watercolor on paper, trimmed and mounted on Bristol board, 5¾ x 4¾ inches. Ex-collection: Sir Thomas Phillipps, London.

WAH-RO-NEE-SAH, OTO CHIEF, THE SURROUNDER / 59
Signed lower right on mounting beneath portrait, Geo Catlin. No date. Watercolor on paper, trimmed and mounted on Bristol board, 5¾ x 5¼ inches. Ex-collection: Sir Thomas Phillipps, London.

SHA-KO-KA, MANDAN GIRL / 59
Signed lower right on mounting beneath portrait, Geo Catlin, and dated 1832. Watercolor on paper, trimmed and mounted on Bristol board, 5¾ x 5¼ inches. Ex-collection: Sir Thomas Phillipps, London.

SIOUX BEAR DANCE / 60
Signed as part of decoration on Indian tipi in middle background, "G. Catlin, 1847." Oil on canvas 25 x 32 inches.

CROW WARRIOR ON HORSEBACK / 61
Unsigned. No date. Pen and ink sketch from the artist's field sketchbook. Ex-collection: Sir Thomas Phillipps, London.

PIGEON'S EGG HEAD (ASSINIBOINE CHIEF) GOING TO AND RETURNING FROM WASHINGTON / 61
From the artist's *North American Indian Portfolio* (London: Day and Haghe; 1844). Colored lithograph 17½ x 13 inches, on trimmed stock 23 x 16¾ inches.

CATCHING WILD HORSES / 62
Unsigned. No date. Oil on canvas 12 x 16 inches. Ex-collection: Sir Thomas Phillipps, London.

WIGWAMS OF THE CROW TRIBE / 63
Unsigned. No date. A detail of pen and ink and wash sketch from the artist's field sketchbook. Ex-collection: Sir Thomas Phillipps, London.

INDIAN TROOP / 64
Signed lower center, "G. Catlin, London, 1844." Watercolor on paper 12 x 15½ inches. Ex-collection: Sir Thomas Phillipps, London.

PA-TOH-PEE-KIGI, BLACKFOOT / 69
Unsigned. No date. Pen and ink sketch from the artist's field sketchbook. Ex-collection: Sir Thomas Phillipps, London.

VIEW OF THE GRAND DETOUR / 74
Unsigned. No date. Pen and ink sketch from the artist's field sketchbook. Ex-collection: Sir Thomas Phillipps, London.

SKETCHES / 76
From the artist's field sketchbook. Page size 9 x 7 inches. Ex-collection: Sir Thomas Phillipps, London.

ORNAMENTED BUFFALO ROBE / 170
Untitled watercolor sketch from the artist's field sketchbook. Page size 9 x 7 inches. Ex-collection: Sir Thomas Phillipps, London.

BUFFALO HUNT ON SNOWSHOES / 176
Unsigned. No date. Oil on canvas 25 x 32 inches. Ex-collection: Sir Thomas Phillipps, London.

GRIZZLIES KILLING A WHITE BUFFALO / 187
Unsigned. No date. Oil on canvas 11 x 14 inches. Ex-collection: Sir Thomas Phillipps, London.

U.S. DRAGOONS MEETING COMANCHES AND BUFFALO / 215
Unsigned. No date. Oil on canvas 11 x 14 inches. Ex-collection: Sir Thomas Phillipps, London.

WIN-PAN-TO-MEE, THE WHITE WEASEL / 262
Signed lower right "G. C." and dated 1836. Watercolor on paper, trimmed and mounted on Bristol board, 5¾ x 5 inches. Ex-collection: Sir Thomas Phillipps, London.

NOTCH-EE-NIN-GA, SON OF WHITE CLOUD / 262
Signed lower right, Geo. Catlin, and dated 1836. Watercolor on paper, trimmed and mounted on Bristol board, 9½ x 8 inches. Ex-collection: Sir Thomas Phillipps, London.

DETAILS IN PEN AND INK / 300
From the artist's field sketchbook. Ex-collection: Sir Thomas Phillipps, London.

Church, Frederic Edwin

1826–1900 Born in Hartford, Connecticut, Frederic Church studied painting under Thomas Cole and first exhibited at the National Academy in 1845. He was elected to the Academy four years later. In the 1850's he traveled extensively in South America, the West Indies, Europe, and the Near East, but is best known today for his American landscapes. His last twenty years were spent in enforced idleness as a result of rheumatism.

NIAGARA FALLS / 38

Signed lower left, F. E. Church. No date. Oil on canvas 36 x 39 inches.

Colyer, Vincent

1825–1888 Crayon portraitist and watercolorist Vincent Colyer was born in Bloomingdale, New York, and elected to the National Academy of Design in 1849. During the Civil War he served as a medical corpsman and afterward devoted several years to work of this kind among the western Indian tribes. Having settled near Darien, Connecticut, in 1866, he later returned there to develop many paintings from sketches obtained during his western travels.

FORT GIBSON, INDIAN TERRY., IN 1868 / 216

As inscribed, and signed lower right, V. Colyer. Watercolor on paper 5 x 10¼ inches.

Cross, Henry H.

1837–1918 Born in upstate New York, Henry H. Cross displayed a talent for drawing at an early age and in 1853 was sent to France to study under Rosa Bonheur. In 1860 he settled in Chicago and in 1862 visited southwestern Minnesota during the Sioux uprising in that vicinity. Afterward he traveled with P. T. Barnum's circus as a wagon and sign painter, and later visited the Far West to study Indian and animal life. He spent much time on commissions in the decade preceding his death, producing many Indian portraits, for which he is best known.

KICKING BEAR / 223

Inscribed upper left corner, "Kicking Bear, Sioux, one of the most prominent leaders in the Ghost Dance War – H. H. Cross." No date. Oil on canvas 30 x 25 inches. Ex-collection: Thomas B. Walker, Minneapolis, Minnesota.

RED TOMAHAWK / 218

Signed lower right, H. H. Cross, and dated 1880. Oil on canvas 30 x 25 inches. Ex-collection: Thomas B. Walker, Minneapolis, Minnesota.

WILD BILL HICKOK / 254

Inscribed upper left corner, "James B. Hickok. 'Wild Bill.' From life by H. H. Cross, 1874." Oil on canvas 30 x 25 inches. Ex-collection: Thomas B. Walker, Minneapolis, Minnesota.

Crumbo, Woodrow

1912– Creek-Pottawatomie Indian painter, dancer, and musician born near Lexington, Oklahoma, Woodrow Crumbo studied art at Wichita University and the University of Oklahoma at Norman, and in 1943 became art director of Bacone College near Muskogee, Oklahoma. From 1945 to 1948 he worked as artist-in-residence at the Thomas Gilcrease Institute in Tulsa, receiving widespread recognition for his work. He now lives in Colorado and exhibits widely in the Southwest.

ANIMAL DANCE / 58

Signed lower right, Crumbo. No date. Tempera painting on paper 25½ x 44 inches. Ex-collection: the artist.

SINGERS FOR THE DANCE / 293

Signed lower right, Crumbo. No date. Oil on canvas 30½ x 35 inches. Ex-collection: the artist.

DeBry, Theodore

1528–1598 Flemish goldsmith and engraver Theodore DeBry was born at Liège and established a printing firm in Frankfurt, where he published the first views of America based on the drawings of Jacques Le Moyne du Morgues and John White. He was introduced to White's sketches of the natives of Virginia by English historian Richard Hakluyt, who encouraged him to reproduce them for wider distribution. White's illustrations appeared in engraved form in 1590, followed a year later by a volume of Le Moyne's Florida French colony drawings. Other publications followed in a series produced by his son and son-in-law, Matthew Meriani, under various titles. Little else is known of DeBry's life.

EQUESTRIS ORDINIS...IN VIRGINIA / 18

Unsigned. No date. Line engraving attributed to Theodore DeBry, plate size 5½ x 7 inches on untrimmed stock 13 x 9 inches.

OPPIDUM SECOTA / 21

Unsigned. No date. After John White, ca. 1590. Line engraving 12 x 9 inches on trimmed stock 13 x 9-1/16 inches. Included in dealer's volume of DeBry plates produced between 1590–1602. Ex-collection: William L. Clements, Bay City, Michigan.

Eakins, Thomas

1844–1916 Portrait and genre painter Thomas Eakins studied at the Philadelphia Academy of Art and the École des Beaux Arts in Paris, becoming an instructor at the Philadelphia Academy in 1876. Considered to have been one of America's foremost realists, Eakins resigned his teaching position at the academy about 1886 to devote himself exclusively to painting. He is represented by many excellent portraits and studies of everyday American life.

FRANK HAMILTON CUSHING / 297

Signed lower middle of extreme left of picture, Eakins. No date. Oil on canvas 90 x 60 inches.

Ehret, George Dennis or *Dionysius*

1710–1770 German-born botanical illustrator George Dennis Ehret worked in London for a number of years, during which time he assisted British naturalist Mark Catesby in the preparation of his Natural History of Carolina, Florida, and the Bahama Islands *(London, 1731–43). He is represented by a folio of watercolors in the Gilcrease library in Tulsa, Oklahoma.*

MAGNOLIA ALTISSIMA / 30

Signed lower right, G. D. Ehret. No date. Watercolor studies on vellum 20½ x 14 inches. Enclosed in a dealer's folder, stamped and dated 1743. Folder size 22 x 15 inches. Ex-collection: Moncure Biddle, London.

Farny, Henry F.

1847–1916 Born at Ribeauville, Alsace, Henry F. Farny settled in Cincinnati, Ohio, in 1859, establishing himself as a book illustrator and painter. A frequent contributor to Harper's Weekly *and* Century *magazine, he made numerous western trips between 1880 and 1900 in search of material. His present reputation as an artist rests largely upon pictures produced during this period. He died in Cincinnati.*

BREAKING A PONY, *or* FORDING A STREAM / 67
Signed lower right, H. F. Farny, and dated 1905. Oil on canvas 21 x 32 inches.

THE SORCERER / 68
Signed lower right, H. F. Farny, and dated 1903. Oil on canvas 22 x 40 inches.

Frenzeny, Paul (see Tavernier, Jules)

Gaul, William Gilbert

1855–1919 Born in Jersey City, New Jersey, Gilbert Gaul studied at the National Academy of Design and the Art Students League in New York City, traveling westward in the 1880's to make a study of western military activity. He illustrated numerous magazine articles on this and related subjects, exhibiting his paintings in the eastern United States and at the Paris Exposition of 1889, where he won a gold medal. He died in New York City.

ISSUING GOVERNMENT BEEF / 300
Signed lower right, Gilbert Gaul. No date. Oil on canvas 30 x 42 inches.

Granville, Charles Bécard de

1675–1703 French-Canadian cartographer employed by the French government to make topographical maps of New France, Charles de Granville may have produced a pictorial record of the flora and fauna of that region in an album preserved in the library of the Thomas Gilcrease Institute in Tulsa, Oklahoma. Several maps in this volume indicate that the artist traveled widely. The sketchbook itself, tentatively dated around the year 1701, was published by the Baron Marc de Villiers under the title Codex Canadiensis *(Paris, 1930). De Villiers credited the work to de Granville.*

/ 22 Page from album of 180 pen and ink drawings attributed to Charles de Granville, ca. 1701. This volume contains two double-page maps and seventy-nine leaves of illustrations, page size approximately 14 x 9½ inches. Published by Baron Marc de Villiers under the title *Codex Canadiensis* (Paris, 1930).

DRAWINGS / 24
From album of drawings attributed to Charles de Granville, ca. 1701. Page size 14 x 9½ inches.

/ 27 Page from an album of drawings attributed to Charles de Granville, ca. 1701.

/ 28 Page from album of drawings attributed to Charles de Granville, ca. 1701.

DRAWINGS OF AMERICAN WILD FOWL / 43
Unsigned. No date. Page from album of drawings attributed to Charles de Granville, ca. 1701.

/ 44 Drawings and commentary by Charles de Granville.

CAPITAINE DE LA NATION ILLINOIS / 48
Unsigned. No date. From album of drawings attributed to Charles de Granville, ca. 1701. Page size 14 x 9½ inches.

/ 97 Page from album of pen and ink sketches attributed to Charles de Granville, ca. 1701. Page size 14 x 9½ inches.

GRAND BOEUF DU NOUVEAU D ANEMAR
EN AMERIQUE / 266
Unsigned. No date. Page from album of pen and ink drawings attributed to Charles de Granville, ca. 1701. Page size 14 x 9½ inches.

Hays, William Jacob

1830–1875 Born in New York City, where he spent most of his life, William Hays owes his reputation as an animal painter and western artist to material gathered during a trip up the Missouri River in 1860. He later exhibited his canvases of western game animals in New York City and London, and some were reproduced in lithographic form. Many remain abroad in private collections.

HERD ON THE MOVE / 169
Unsigned. No date. Oil on canvas 36 x 72 inches.

Jackson, William Henry

1843–1942 Born at Keesville, New York, William H. Jackson is best known today for his photographs of the American West. Accompanying a wagon train across the continent in 1866, he was later employed as a photographer with the Hayden survey of the Yellowstone, and subsequently made many photographic reports of western scenery and geological formations. He produced some paintings descriptive of his western experience, most of which are in private hands.

CALIFORNIA CROSSING / 142
Signed extreme lower left, W. H. Jackson, and dated 1867. Oil on canvas 22 x 34 inches.

James, William R. "Will"

1892–1942 Born in Montana, author-illustrator Will James spent his early years as a ranch hand and rodeo performer, and first began contributing articles on these subjects to Scribner's Monthly *and* The Saturday Evening Post *in the early 1920's. Some of these later were republished in book form. His first fictionalized story,* Smoky the Cowhorse, *published in 1926, was illustrated throughout with his drawings. About 1928, James retired to a cattle ranch in Montana, where he continued to paint and write until his death.*

PACK MULE / 129
Signed lower left, "Will James—27." Pencil on paper 18 x 14 inches.

Kurz, Rudolph Friedrich

1818–1871 Born in Berne, Switzerland, Friedrich Kurz received his early art training in Paris. Between 1847–52 he visited America, spending most of this time on the Missouri frontier between St. Louis and Fort Union. He produced many sketches at this time, few of which remain in this country. He died in Berne, where he returned following his American adventures.

CREE CHIEF LE TOUT PIQUE AND FUR COMPANY
AGENTS AT FORT UNION / 90
Unsigned. Inscribed upper right, "Cree Chief Le Tout Pique 19.10.52." Ink and wash drawing on paper 14 x 20 inches.

INTERIOR VIEW OF FORT UNION / 92
Unsigned. Inscribed upper right, "Fort Union 4.2.52." Pen and ink on paper 13 x 16 inches.

Lackey, Vinson

1889–1959 Born in Paris, Texas, designer-draftsman Vinson Lackey graduated from the University of Oklahoma, and for twenty years was head of the layout inspection department of Douglas Aircraft in Tulsa, Oklahoma. During the 1940's he worked on commission for the late Tulsa oilman and collector Thomas Gilcrease on a series of architectural reconstructions on canvas of more than one hundred of Oklahoma's pre-statehood governmental institutions. These are now in the Gilcrease collection in Tulsa.

FORT GIBSON / 217
Signed lower right, Vinson Lackey. No date. Oil on canvasboard 9 x 12 inches.

F. Lehnert

No biographical information available.

ARRIEROS / 135
Signed lower left, F. Lehnert. Colored lithograph published by Julio Michaud y Tomás, Mexico, ca. 1840. Plate size 11½ x 16 inches.

HACENDADO Y SU MAYORDOMO / 268
Signed lower left, F. Lehnert. Colored lithograph published by Julio Michaud y Tomás, Mexico, ca. 1840. Plate size 12¼ x 16¼ inches.

Leigh, William Robinson

1866–1955 Born in Berkeley County, West Virginia, W. R. Leigh studied art in Baltimore and at the Royal Academy in Munich before seeking employment as an illustrator in New York City in the early 1900's. He made the first of many trips into the West in 1906 in search of material for his pictures, returning annually thereafter for a number of years to paint and sketch. He accompanied Carl Akeley to East Africa in 1926 to gather material for the backgrounds of the African habitat groups later installed in the Museum of Natural History in New York City. A prolific writer as well as painter, Leigh maintained a studio in New York, the contents of which were transferred to the Thomas Gilcrease Institute in Tulsa, Oklahoma, following his death.

UNTITLED STUDY OF A HORSE / 160
Signed lower right, W. R. Leigh. No date. Oil on canvasboard 13 x 17 inches. Ex-collection: the artist.

UNTITLED STUDY OF A BUFFALO / 180
Unsigned. No date. Pencil sketch on paper 14 x 20 inches. Ex-collection: the artist.

UNTITLED STUDY / 181
Signed lower left, W. R. Leigh. No date. Oil on canvasboard 13 x 17 inches. Ex-collection: the artist.

A CLOSE CALL / 184
Signed lower right, W. R. Leigh, and dated "N.Y. 1914." Oil on canvas 40 x 60 inches.

UNTITLED STUDY OF A GRIZZLY BEAR / 184
Signed lower left, W. R. Leigh. Inscribed in pencil on back, "Bronx Zoo, 1912." Oil on canvasboard 13 x 17 inches. Ex-collection: the artist.

UNTITLED STUDY OF A PRONGHORN / 189
Signed lower right, W. R. Leigh. No date. Oil on canvasboard 17 x 13 inches. Ex-collection: the artist.

UNTITLED STUDIES OF A GREY WOLF / 189
Unsigned. No date. Pencil and pen and ink sketches on paper 14 x 17 inches. Ex-collection: the artist.

UNTITLED FIGURE STUDY / 212
Unsigned. No date. Pencil on paper 18½ x 24 inches. Ex-collection: the artist.

UNTITLED STUDIES OF FIGURES / 226
Unsigned. No date. Pencil on paper 18½ x 24 inches. Ex-collection: the artist.

BUFFALO BULL / 271
Signed W. R. Leigh. No date. Bronze casting 15 inches high, base length 21 inches. Ex-collection: the artist.

UNTITLED SKETCH OF A COWBOY / 286
Unsigned. No date. Pencil on paper, a detail 15 inches high on page 18½ x 24 inches. Ex-collection: the artist.

WALPI, FIRST MESA / 294
Signed lower right on plate, W. R. Leigh. No date. Etching 16 x 19 inches. Ex-collection: the artist.

UNTITLED STUDY OF INDIAN SHELTER / 307
Signed lower right, W. R. Leigh. No date. Oil on canvasboard 13 x 17 inches. Ex-collection: the artist.

UNTITLED HEAD OF A BURRO / 308
Signed lower right, W. R. Leigh. No date. Pen and ink on paper 9 x 7 inches. Ex-collection: the artist.

UNTITLED BURRO STUDY, UNFINISHED / 308
Signed lower right, W. R. Leigh. No date. Pencil and oil on canvasboard 13 x 17 inches. Ex-collection: the artist.

UNTITLED STUDY / 309
Signed lower right, W. R. Leigh. Dated in pencil on back, "Polocca, Ariz., 1929." Oil on canvasboard 13 x 17 inches. Ex-collection: the artist.

UP WHERE THE BIG WINDS BLOW / 310
Signed lower right, W. R. Leigh, and dated "N.Y. 1918." Oil on canvas 50 x 38 inches.

BRONC RIDER / 310
Signed lower right, W. R. Leigh, and dated 1945. Pen and ink on paper 22 x 15 inches. Ex-collection: the artist.

GARDEN OF THE GODS / 311
Signed lower right, W. R. Leigh, and dated 1913. Oil on canvasboard 13 x 17 inches. Ex-collection: the artist.

ANATOMICAL HORSE STUDIES / 312
Signed lower right, W. R. Leigh. No date. Oil on canvasboard 13 x 17 inches. Ex-collection: the artist.

WESTERN PONIES / 313
Signed lower right, W. R. Leigh. Offset reproduction of pen and ink drawing on tan card stock 4 x 6½ inches. Ex-collection: the artist.

NAVAJO BURRO / 313
Signed lower left, W. R. Leigh, and dated 1937. Pen and ink on paper 14 x 18 inches. Ex-collection: the artist.

CANYON OF THE YELLOWSTONE / 314
Unsigned. No date. Preliminary charcoal sketch on sized canvas 49½ x 37 inches. Ex-collection: the artist.

Leutze, Emanuel

1816–1868 Born at Emigen, Germany, Emanuel Leutze grew up in Philadelphia and in 1841 returned to Europe to study art. Gaining a reputation as a painter of historical scenes and subjects, he again visited the United States in 1851, where he remained to complete a mural in the House of Representatives in Washington, D.C. He died in Washington.

WESTWARD THE COURSE OF EMPIRE / 242–3
Signed bottom left center, E. Leutze. No date. Oil on canvas 30 x 40 inches.

Lewis, James Otto

1799–1858 Engraver and portraitist James Otto Lewis traveled in 1819 with Governor Cass of Michigan to the Great Lakes region, where he was employed by the government to paint Indian portraits. He attended numerous Indian councils in Wisconsin and Indiana during the 1820's, and published his Aboriginal Portfolio in ten separate parts in Philadelphia in 1835–6. Other Indian portraits of his, copied by Washington painter Charles Bird King, appeared in Thomas McKenney and James Hall's History of the Indian Tribes of North America (Philadelphia, 1837). He is believed to have settled in Detroit, where he did some engraving.

VIEW OF THE GREAT TREATY HELD AT PRAIRIE
DU CHIEN, SEPTEMBER 1825 / 40
Printed at bottom, center, "painted on the spot by J. O. Lewis." Illustration featured in Part 3 of the artist's *Aboriginal Portfolio* (Philadelphia: Lehman and Duval; 1835). Colored lithograph 7⅛ x 11⅞ inches, on trimmed stock 11 x 19 inches.

Lindneux, Robert

1871–1970 Born in New York City and educated by private tutors, Robert Lindneux studied art at the Düsseldorf Academy and the École des Beaux Arts in Paris, returning to the United States in 1893 and settling in Colorado, where he became interested in western history. A friend of C. M. Russell and "Buffalo Bill" Cody, Lindneux exhibited widely in the United States and in Europe, and his works are widely scattered today.

A HOLD UP / 198
Signed lower left, "Robert Lindneux, Copyright 1943." Oil on canvas 32 x 38 inches. Ex-collection: the artist.

Lion, Henry

1900–? California sculptor-painter Henry Lion was born in Fresno and studied at the Otis Art Institute and with S. McDonald Wright. After becoming acquainted with C. M. Russell, Lion sculpted a figure of the elder artist, and later modeled a group sculpture of Captains Lewis and Clark with Sacajawea after a sketch by Russell. At least two bronze castings of this piece were made by the Roman Bronze Works, New York City. Lion also did the bronze doors for the Los Angeles City Hall, and is represented by a number of statues in that city. He died in Los Angeles sometime between 1962 and 1967.

LEWIS, CLARK, AND SACAJAWEA / 17
Unsigned. No date. Bronze casting by Roman Bronze Works, New York. Height 35 inches. Ex-collection: Charles S. Jones, Flintridge, Los Angeles County, California.

McAfee, Ila Mae *(Turner)*

1900– Born in Gunnison, Colorado, Ila Mae McAfee studied art at the Colorado State Normal School and specialized in mural painting in Chicago under James E. McBurney. In 1926 she married Elmer Turner and settled in Taos, New Mexico, where she has remained, painting landscapes, wild animals, and livestock, particularly horses, for which she is most noted. She is represented by murals in Colorado, Texas, and Oklahoma, and in a great many museum and private collections throughout the Southwest.

LONGHORNS WATERING ON A CATTLE DRIVE / 276
Signed lower right, Ila McAfee. No date. Egg tempera on masonite panel 21½ x 37¾ inches. Ex-collection: the artist.

MacMonnies, Frederick

1863–? Born in Brooklyn, Frederick MacMonnies studied sculpture under Augustus Saint-Gaudens and later at the Art Students League in New York City. He continued his education in art in Munich and at the École des Beaux Arts in Paris. He established a studio in Paris in the 1880's, where he produced a number of works based on classical and American subjects.

BUFFALO BILL AND HIS DOG / 240
Signed F. MacMonnies. No date. Bronze casting 12 inches high, base length 17 inches.

MacNeil, Herman Atkins

1866–? Born in Chelsea, Massachusetts, sculptor Herman MacNeil was an instructor at the Art Institute of Chicago for many years, and executed murals in Chicago, Buffalo, and Paris. He produced many works of sculpture based on American Indian subjects.

THE RETURNING OF THE SNAKES:
MOQUI PRAYER FOR RAIN / 314
Signed H. A. MacNeil. No date. Bronze casting 21 inches high, base length 16 inches.

Miller, Alfred Jacob

1810–1874 Born in Baltimore, Maryland, A. J. Miller studied painting under Thomas Sully and later attended the École des Beaux Arts in Paris. In 1837 he accompanied a hunting excursion into the West under the leadership of Captain William Drummond Stewart, producing a great many studies of western mountain scenery and Indian and fur trapper life. He traveled to Scotland in 1840 to visit Stewart, and about 1859 compiled a manuscript entitled "Rough Draughts to Notes on Indian Sketches" now in the library of the Gilcrease Institute in Tulsa, Oklahoma. This work may have been intended for publication. He died in Baltimore, receiving scant recognition for his work during his lifetime.

LOST TRAPPER / 105
Unsigned. No date. Watercolor on paper 9½ x 8 inches. Ex-collection: L. Vernon Miller, Baltimore.

TRAPPERS ON THE BIG SANDY / 106
Unsigned. No date. Watercolor on paper 9 x 12½ inches. Ex-collection: L. Vernon Miller, Baltimore.

FORT WILLIAM ON THE LARAMIE / 116
Unsigned. No date. Oil on canvas 18 x 27 inches. Ex-collection: L. Vernon Miller, Baltimore.

INTERIOR VIEW OF FORT WILLIAM / *118*
> Unsigned. No date. Watercolor on paper 10¼ x 14 inches. Ex-collection: L. Vernon Miller, Baltimore.

TRAPPERS' RENDEZVOUS / *120*
> Unsigned. No date. Watercolor on paper 9¾ x 15¼ inches. Ex-collection: L. Vernon Miller, Baltimore.

PIERRE, ROCKY MOUNTAIN TRAPPER / *120*
> Unsigned. No date. Sepia wash drawing on paper 6¾ x 9¼ inches. Ex-collection: L. Vernon Miller, Baltimore.

SNAKE AND SIOUX INDIANS ON THE WARPATH / *122*
> Unsigned. No date. Watercolor on paper 14 x 20¼ inches. Ex-collection: L. Vernon Miller, Baltimore.

WILLIAM DRUMMOND STEWART AND
ANTOINE CLEMENT / *122*
> Unsigned. No date. Inscribed in artist's hand, lower right, "Sir W. D. S. & Antoine." Watercolor on paper 7¼ x 9¾ inches. Ex-collection: L. Vernon Miller, Baltimore.

INDIAN ENCAMPMENT / *124*
> Signed extreme lower right, A. J. Miller. Dated 1850. Oil on canvas on board 30 x 24½ inches.

MIRAGE ON THE PRAIRIE, or TRADERS' CARAVAN / *130*
> Unsigned. No date. Watercolor on paper 7 x 13½ inches. Ex-collection: L. Vernon Miller, Baltimore.

BUFFALO HUNT / *175*
> Signed extreme lower right, A. Miller, and dated 1840. Oil on canvas 30 x 40 inches.

Moran, Thomas

1837–1926 British-American engraver and landscape painter Thomas Moran was born in Bolton, Lancashire, and studied art in France and Germany. In 1871 he made his first trip into the American West under the auspices of the Northern Pacific Railroad with a government-sponsored geological expedition to the Yellowstone led by Dr. F. V. Hayden. Afterward he visited Yosemite and in 1873 accompanied Major John Wesley Powell into southern Utah and Arizona. He produced many views of the American West, traveling widely all over the United States and Europe. He was elected a member of the National Academy in 1884. His brother, two of his nephews, and his wife Mary Nimmo Moran were accomplished artists in their own right. Many of Moran's favorite sketching sites in the American West have since become National Parks.

PICTURED ROCKS OF LAKE SUPERIOR / *191*
> Titled in pencil, lower left margin. Signed lower right within the plate itself with the distinctive "M" of Moran. Wood engraving 9⅛ x 8⅞ inches. Ex-collection: the artist.

IOWA GULCH, COLORADO / *192*
> As titled upper left in artist's hand. Unsigned. Dated 1879. Pencil and wash sketch 11½ x 18 inches. Ex-collection: the artist.

GLORY OF THE CANYON / *200*
> Signed lower right, Moran, and dated 1875. Artist's thumb print visible, lower left. Oil on canvas 52 x 40 inches.

LOWER FALLS OF THE YELLOWSTONE / *200*
> Signed lower right, Moran, and dated 1893. Oil on canvas 40 x 60 inches.

UNTITLED STUDY / *201*
> Unsigned. No date. Pencil on paper 12 x 8¼ inches. Ex-collection: the artist.

LOWER FALLS OF ADAM CREEK / *203*
> Titled at bottom in artist's hand. Unsigned. Dated 1865. Pencil sketch on paper 9¼ x 6 inches. Ex-collection: the artist.

UPPER FALLS OF THE YELLOWSTONE / *204*
> Signed lower left with the distinctive "M" of Moran, and dated 1874. Watercolor on paper 10½ x 8½ inches.

UNTITLED STUDY OF TREES / *206*
> Scratched in artist's hand on stone, lower left, printed reverse lower right of print, "Moran 1869." Lithograph 20½ x 16 inches. Ex-collection: the artist.

BLUE SPRING, LOWER GEYSER BASIN, YELLOWSTONE / *208*
> Signed lower left, Moran, and dated 1873. Watercolor on paper 10 x 14 inches.

Palmer, Frances Flora

1812–1876 A lithographer for many years with Currier and Ives publishing company in New York City, Frances Bond married Edward Seymor Palmer, also a lithographer with Currier and Ives. The husband and wife team specialized in railroad and riverboat scenes until Mr. Palmer's death in 1859.

ACROSS THE CONTINENT: WESTWARD THE COURSE OF EMPIRE TAKES ITS WAY / *196*
> Signed lower right (or printed lower right), "Drawn by F. F. Palmer." Colored lithograph published by Currier and Ives, 1868. Plate size 17½ x 27 inches.

"LIGHTNING EXPRESS" TRAINS LEAVING
THE JUNCTION / *197*
> Printed lower left, "Del by F. F. Palmer." Colored lithograph published by Currier and Ives, and dated "New York, 1863." Plate size 17½ x 27½ inches.

AMERICAN RAILROAD SCENE: SNOW BOUND / *203*
> Unsigned. Colored lithograph published by Currier and Ives, dated "New York, 1871." Plate size 8½ x 12½ inches.

Popple, Henry

n.d. Eighteenth-century British cartographer-draftsman, for whom no biographical information is available.

LOUISIANA / *34*
> Included in a bound volume of maps attributed to Henry Popple entitled *Maps of the British Empire in America* (London, 1773). Center-fold page 27½ x 20 inches. Hand-colored line engraving.

Pyle, Howard

1853–1911 Book illustrator Howard Pyle worked as an artist for <u>Harper's Weekly</u> in the 1870's and 80's, and later maintained a studio at Chadds Ford, Pennsylvania, where he taught such notables as N. C. Wyeth. He is remembered chiefly for his illustrations of children's histories and literary classics.

GEORGE ROGERS CLARK ON HIS WAY TO KASKASKIA / *34*
> Signed lower left, Pyle. No date. Oil on canvas 35 x 24 inches.

Ranney, William Tylee

1813–1857 Born in Middletown, Connecticut, William Ranney studied painting in Brooklyn and maintained a studio in New York City during the 1840's. Following service in the Southwest during the Mexican War, he settled in West Hoboken, New Jersey, devoting the latter years of his life to the depiction of American historical and frontier scenes.

PENNSYLVANIA TEAMSTER / 129
Signed lower right, Ranney, and dated 1846. Oil on canvas 29½ x 40 inches.

Ray, J. J.

n.d. *No biographical information available.*

PROSPECTOR'S DEPARTURE / 244
Signed lower right, "J. J. Ray, California." No date. Oil on canvas 16 x 12 inches.

Reaugh, Frank

1860–1945 Born in Morgan County, Illinois, Frank Reaugh studied art at St. Louis and the Julian Academy in Paris before moving to Texas, where he became known for his rural landscapes and paintings of cattle and other livestock. He exhibited widely in the United States and also is represented by pictures in Belgium and Holland.

THE HERD / 278
Signed lower right, F. Reaugh, and dated 1899. Pastel on board 15 x 36 inches.

Remington, Frederic

1861–1909 Born in Canton, New York, Frederic Remington studied at the Yale Art School and the Art Students League in New York City before traveling westward for his health in 1880. Soon he began producing western sketches for Harper's Weekly and Outing magazine, establishing his reputation as a reporter of U.S. military and Indian life in the west. He served as a war correspondent during the Spanish-American War, and his illustrations appeared in numerous books and periodicals, several of which he authored. During the last twenty years of his life he produced more than 2,700 paintings and drawings and twenty-four bronze sculptures.

HORSE THIEF / 53
Signed Frederic Remington and copyrighted Frederic Remington 1907. Bronze casting by Roman Bronze Works, New York, 25¾ inches in height. Ex-collection: Dr. Philip G. Cole, Tarrytown, New York.

INDIAN WARFARE / 70
Signed lower right, Frederic Remington, and dated 1908. Oil on canvas 29½ x 50 inches. Ex-collection: Dr. Philip G. Cole, Tarrytown, New York.

THE MOUNTAIN MAN / 103
Signed Frederic Remington, copyrighted 1903. Bronze casting #24 by Roman Bronze Works, New York, 28½ inches high. Ex-collection: Dr. Philip G. Cole, Tarrytown, New York.

COMING AND GOING OF THE PONY EXPRESS / 154
Signed lower right, Frederic Remington. Below signature, "Century, copyright 1900." Oil on canvas 26 x 39 inches. Ex-collection: Dr. Philip G. Cole, Tarrytown, New York.

EPISODE OF A BUFFALO HUNT / 173
Signed lower right, Frederic Remington, and dated 1908. Oil on canvas 28½ x 26½ inches. Ex-collection: Dr. Philip G. Cole, Tarrytown, New York.

HUNGRY MOON / 174
Signed Frederic Remington and dated 1900. Oil on canvas 19½ x 25½ inches. Ex-collection: Dr. Philip G. Cole, Tarrytown, New York.

THE SERGEANT / 211
Signed Frederic Remington and copyrighted Frederic Remington 1904. Bronze casting #49 by Roman Bronze Works, New York. Height 10¼ inches. Ex-collection: Dr. Philip G. Cole, Tarrytown, New York.

THE SCALP, *or* TRIUMPH / 215
Signed Frederic Remington and copyrighted Frederic Remington 1898. Bronze casting #7 by Roman Bronze Works, New York. Height 25¼ inches. Ex-collection: Dr. Philip G. Cole, Tarrytown, New York.

WOUNDED BUNKIE / 220
Signed Frederic Remington and copyrighted 1898. Bronze casting by Henry-Bonnard Foundry, New York. Height 20¼ inches. Ex-collection: Dr. Philip G: Cole, Tarrytown, New York.

TROOPER OF THE PLAINS / 224
Signed Frederic Remington and copyrighted Frederic Remington 1909. Bronze casting #9 by Roman Bronze Works, New York. Height 26½ inches. Ex-collection: Dr. Philip G. Cole, Tarrytown, New York.

BATTLE OF WAR BONNET CREEK / 224
Signed lower right, Frederic Remington. No date. Oil on canvas 26½ x 39 inches. Ex-collection: Dr. Philip G. Cole, Tarrytown, New York.

THE ESCORT / 228
Signed lower right, Frederic Remington. No date. A black-and-white oil on canvas 39 x 26 inches.

MISSING / 232
Signed lower right, Frederic Remington, and dated 1899. Oil on canvas 29½ x 50 inches. Ex-collection: Dr. Philip G. Cole, Tarrytown, New York.

THE MESSENGER / 233
Signed lower right, Frederic Remington. No date. Black-and-white oil on canvas 39 x 26 inches.

ARREST OF THE SCOUT / 234
Signed lower right, Frederic Remington. No date. Black-and-white oil on canvas 20¼ x 29½ inches.

THE OUTLAW / 255
Signed Frederic Remington and copyrighted Frederic Remington 1906. Bronze casting #31 by Roman Bronze Works, New York. Height 23½ inches. Ex-collection: Dr. Philip G. Cole, Tarrytown, New York.

BRONCO BUSTER / 265
Signed Frederic Remington and copyrighted Frederic Remington 1901. Bronze casting #67 by Roman Bronze Works, New York. Height 22¼ inches. Ex-collection: Dr. Philip G. Cole, Tarrytown, New York.

THE STAMPEDE / 277
Signed Frederic Remington and copyrighted 1910. Bronze casting #2 by Roman Bronze Works, New York. Height 21¼ inches. Ex-collection: Dr. Philip G. Cole, Tarrytown, New York.

COMIN' THROUGH THE RYE, *or* OFF THE RANGE / 282
Signed Frederic Remington and copyrighted Frederic Remington 1902. Bronze casting #1 by Roman Bronze Works, New York. Height 27¼ inches. Ex-collection: Dr. Philip G. Cole, Tarrytown, New York.

STAMPEDED BY LIGHTNING / 288
Signed lower right, Frederic Remington, and dated 1908. Oil on canvas 27 x 40 inches. Ex-collection: Mr. Hobart O. Schofield, Santa Barbara, California; Dr. Philip G. Cole, Tarrytown, New York.

THE NORTHER / 288
Signed Frederic Remington and copyrighted Frederic Remington, 1900. Bronze casting by Roman Bronze Works, New York. Height 22 inches. Ex-collection: Dr. Philip G. Cole, Tarrytown, New York.

COMANCHE SCOUT / 298
Signed lower right, "Frederic Remington, copyright 1890." Pen and ink drawing on paper 28½ x 17 inches.

Rindisbacher, Peter

1806–1834 Swiss-born genre and animal painter Peter Rindisbacher came to America in 1821 to settle near the present Winnipeg, Manitoba. With his family he later moved to Wisconsin Territory and finally St. Louis, where he established a studio and began contributing sporting scenes to the American Turf Register. His present importance rests on pictures of Indian and frontier life produced during his earlier travels in the wilderness. He died in St. Louis.

WAR DANCE OF THE SAUK AND FOX / 41
Frontispiece, Volume One, of Thomas L. McKenney and James Hall's *History of the Indian Tribes of North America*, 3 vols. (Philadelphia: E. C. Biddle; 1837). Printed lower right of illustration "painted from life by P. Rindisbacher." Colored lithograph 6½ x 13½ inches on trimmed stock 14 x 20 inches. Printed inscription at bottom beneath title credits the lithography to Lehman and Duval. Copyrighted or registered by E. C. Biddle, Philadelphia, 1834.

CONFERENCE / 44
Unsigned. No date. Watercolor on paper 8 x 11 inches.

UNTITLED SCENE ALONG THE UPPER MISSISSIPPI / 46
Unsigned. No date. Pen and ink sketch on paper 8 x 14½ inches.

VIEW OF FORT SNELLING / 46
Unsigned. No date. Pen and ink sketch on paper 8 x 14½ inches.

UNTITLED SKETCH OF A PACK HORSE / 146
Signed at bottom in ink, "Peter Rindisbacher, St. Louis, Missouri." No date. Pencil sketch on paper 8 x 7 inches.

Russell, Charles Marion

1864–1926 Western painter-sculptor C. M. Russell was born in St. Louis and spent his youth as an itinerant ranch hand in Montana, where he began to sketch scenes of cowboy and Indian life. Largely through the efforts of his wife, he eventually achieved recognition for his work, of which he produced an enormous volume. Totally preoccupied with latter-day Western themes, he maintained a studio briefly in Pasadena, California, in the 1920's, before returning to Great Falls, Montana, where he died. His works are widely scattered in a number of private collections.

SECRETS OF THE NIGHT / 49
Signed C. M. Russell and copyrighted 1926. Bronze casting by Roman Bronze Works, New York. Height 13¼ inches. Ex-collection: Dr. Philip G. Cole, Tarrytown, New York.

MEDICINE MAN / 66
Signed C. M. Russell and copyrighted 1920. Bronze casting by Roman Bronze Works, New York. Height 7 inches. Ex-collection: Dr. Philip G. Cole, Tarrytown, New York.

BUFFALO COAT / 69
Signed lower left, C. M. Russell, and dated 1908. Oil on canvas 21¼ x 15¼ inches. Ex-collection: Dr. Philip G. Cole, Tarrytown, New York.

RUNNING BUFFALO, *or* THE BUFFALO RUNNER / 71
Signed C. M. Russell and copyrighted by Russell as *Buffalo Hunt* in 1905. Bronze casting by Roman Bronze Works, New York. Height 10½ inches. Ex-collection: Dr. Philip G. Cole, Tarrytown, New York.

HER HEART IS ON THE GROUND / 71
Signed lower left, C. M. Russell, and dated 1917. Oil on canvas 23 x 35 inches. Ex-collection: Dr. Philip G. Cole, Tarrytown, New York.

SALUTE TO THE ROBE TRADE / 110
Signed C. M. Russell and dated 1920. Oil on canvas 29 x 47 inches. Ex-collection: Dr. Philip G. Cole, Tarrytown, New York.

JIM BRIDGER / 110
Signed C. M. Russell and copyrighted 1925. Title misspelled on piece itself as "Jim Bridges." Bronze casting by Roman Bronze Works, New York. Height 14¼ inches. Ex-collection: Dr. Philip G. Cole, Tarrytown, New York.

ON THE FLATHEAD / 113
Signed lower left, C. M. Russell, and dated 1904. Word "copyrighted" appears in artist's hand to right of signature and date. Watercolor on paper, mounted, 11 x 16 inches. Ex-collection: Dr. Philip G. Cole, Tarrytown, New York.

THE ROBE TRADERS / 114–15
Signed C. M. Russell and dated 1901. Oil on canvas 20 x 30 inches. Ex-collection: Dr. Philip G. Cole, Tarrytown, New York.

CARSON'S MEN / 130
Signed lower left, C. M. Russell, and dated 1913. Oil on canvas 24 x 35 inches. Ex-collection: Dr. Philip G. Cole, Tarrytown, New York.

WHERE MULES WORE DIAMONDS, *or* BELL MARE / 134
Signed lower right, C. M. Russell, and dated 1910. Oil on canvas 29 x 19 inches. Ex-collection: Dr. Philip G. Cole, Tarrytown, New York.

ATTACK ON THE WAGON TRAIN / 136
Signed lower left, C. M. Russell, and dated 1904. Oil on canvas 23 x 35 inches. Ex-collection: Dr. Philip G. Cole, Tarrytown, New York.

A DOUBTFUL VISITOR / 140
Signed lower left, C. M. Russell, and dated 1898. Oil on canvas 29 x 35 inches. Ex-collection: Dr. Philip G. Cole, Tarrytown, New York.

WAGON BOSS / 148
Signed lower left, C. M. Russell, and dated 1909. Oil on canvas 23 x 36 inches. Ex-collection: Dr. Philip G. Cole, Tarrytown, New York.

THE BUFFALO HUNT / 172
Signed lower left, C. M. Russell, and dated 1900. Oil on canvas 47 x 70 inches. Ex-collection: Dr. Philip G. Cole, Tarrytown, New York.

WHERE TRACKS SPELL MEAT / 178
Signed lower left, C. M. Russell, and dated 1916. Oil on canvas 29½ x 48 inches. Ex-collection: Dr. Philip G. Cole, Tarrytown, New York.

MEAT'S NOT MEAT TILL IT'S IN THE PAN / 182
Signed lower right, C. M. Russell, and dated 1915. Oil on canvas 23 x 35 inches. Ex-collection: Dr. Philip G. Cole, Tarrytown, New York.

BETTER THAN BACON / *183*
Signed lower left, C. M. Russell, and dated 1905. Watercolor on paper 12 x 14 inches. Ex-collection: Dr. Philip G. Cole, Tarrytown, New York.

RUNNING BUFFALO / *263*
Signed lower left, C. M. Russell, and dated 1918. Oil on canvas 29 x 47 inches. Ex-collection: Dr. Philip G. Cole, Tarrytown, New York.

ILLUSTRATED ENVELOPE / *264*
Signed at left below buffalo skull drawing, C. M. Russell. Watercolor and ink on paper 3½ x 6 inches. Letter postmarked "Great Falls, Montana, 3 P.M., March 1, 1902." Letter addressed to "Young Boy, Cree Indian, Havre, Mont."

WHEN GUNS SPEAK, DEATH SETTLES DISPUTES / *280–1*
Signed lower left, C. M. Russell. No date. Oil on canvas 24 x 36 inches. Ex-collection: Dr. Philip G. Cole, Tarrytown, New York.

CAMP COOK'S TROUBLES / *284*
Signed lower left, C. M. Russell, and dated 1912. Oil on canvas 30 x 44 inches. Ex-collection: Dr. Philip G. Cole, Tarrytown, New York.

JERKED DOWN / *286*
Signed lower left, C. M. Russell, and dated 1907. Oil on canvas 22½ x 36 inches. Ex-collection: Dr. Philip G. Cole, Tarrytown, New York.

Sanchez y Tapia, Lino

n.d. Military draftsman for the Mexican government, Lino Sanchez y Tapia may have accompanied the Texas boundary survey of 1827–8 under Jean Louis Berlandier. He reproduced in watercolor many of Berlandier's botanical sketches and the studies of Texas inhabitants made by José Maria Sanchez y Tapia. Many of these were included with survey records entrusted to José Maria following Berlandier's death. A folio of thirty-eight watercolors by Lino Sanchez y Tapia is preserved in the library of the Gilcrease Institute.

RANCHERO DE 'N' LEON Y TAMAULIPAS / *275*
Signed lower right, Lino Sanches y Tapia. No date. Watercolor on paper 12½ x 8½ inches. Plate XXXV of album of thirty-eight watercolors. Ex-collection: Sir Leicester Harmsworth, London; Sir Thomas Phillipps, London.

Schreyvogel, Charles

1861–1912 Born in New York City, Charles Schreyvogel studied art in Munich and traveled west for his health in 1893, where he acquainted himself with western military life. His first western canvas, My Bunkie, won an award when exhibited at the National Academy in 1900, and he afterward enjoyed a brief decade of acclaim before his death as a result of accidental blood poisoning. He produced large pictures, though limited in number.

THE FIGHT FOR WATER / *221*
Signed lower right, "Chas Schreyvogel A.N.A." Dated and copyrighted 1909 beneath signature. Oil on canvas 53 x 40 inches. Ex-collection: Dr. Philip G. Cole, Tarrytown, New York.

BREAKING THROUGH THE LINES / *222*
Signed lower left, Chas Schreyvogel A.N.A. No date. Oil on canvas 39 x 52 inches. Ex-collection: Dr. Philip G. Cole, Tarrytown, New York.

THE LAST DROP / *230*
Signed Chas Schreyvogel, and copyrighted 1903. Bronze casting 12 inches in height.

CUSTER'S DEMAND / *236*
Signed lower right, Chas Schreyvogel, A.N.A. Inscribed lower left, "Copyright 1903 by Chas Schreyvogel." Oil on canvas 54 x 78 inches.

Seltzer, Olaf Carl

1877–1957 Born in Copenhagen, Denmark, O. C. Seltzer traveled to Great Falls, Montana, in 1892, and found work as an apprentice machinist with the Great Northern Railroad. He became friends with C. M. Russell, and following Russell's death traveled to New York City to fulfill some of Russell's last commissions. During the 1930's he produced a series of pictorial documentaries on Montana history for collector Philip G. Cole of Tarrytown, New York. This material is now owned by the Thomas Gilcrease Institute in Tulsa, Oklahoma. Seltzer died in Great Falls.

LEWIS AND CLARK AT BLACK EAGLE FALLS / *35*
Signed lower middle, O. C. Seltzer. No date. Oil on illustration board 4½ x 6 inches. Ex-collection: Dr. Philip G. Cole, Tarrytown, New York.

LEWIS AND CLARK AT THE GREAT FALLS
OF THE MISSOURI / *39*
Signed lower left, O. C. Seltzer. No date. Oil on illustration board 4½ x 6 inches. Ex-collection: Dr. Philip G. Cole, Tarrytown, New York.

L'VOYAGEUR / *100*
Signed lower right, O. C. Seltzer. No date. Watercolor on paper 12 x 7 inches. Ex-collection: Dr. Philip G. Cole, Tarrytown, New York.

HALF BREED / *100*
Signed lower right, O. C. Seltzer. No date. Watercolor on paper 12 x 7 inches. Ex-collection: Dr. Philip G. Cole, Tarrytown, New York.

HUDSON'S BAY TRAPPER / *101*
Signed lower right, O. C. Seltzer. No date. Watercolor on paper 12 x 7 inches. Ex-collection: Dr. Philip G. Cole, Tarrytown, New York.

MANUEL LISA WATCHING THE CONSTRUCTION
OF FORT LISA / *108*
Signed lower left, O. C. Seltzer. No date. Oil on illustration board 4½ x 6 inches. Ex-collection: Dr. Philip G. Cole, Tarrytown, New York.

THOMAS FITZPATRICK / *108*
Signed lower left, O. C. Seltzer. No date. Oil on illustration board 4½ x 6 inches. Ex-collection: Dr. Philip G. Cole, Tarrytown, New York.

FRONTIER TRADER / *109*
Signed lower right, O. C. Seltzer. No date. Watercolor on paper 12 x 7 inches. Ex-collection: Dr. Philip G. Cole, Tarrytown, New York.

IMMIGRANT / *133*
Signed lower right, O. C. Seltzer. No date. Watercolor on paper 12 x 7 inches. Ex-collection: Dr. Philip G. Cole, Tarrytown, New York.

STAGE DRIVER / *145*
Signed lower right, O. C. Seltzer. No date. Watercolor on paper 12 x 7 inches. Ex-collection: Dr. Philip G. Cole, Tarrytown, New York.

COW SKULL AND MEADOWLARK / 292
Signed lower right, O. C. S. No date. Watercolor on paper 8½ x 7 inches. Ex-collection: Dr. Philip G. Cole, Tarrytown, New York.

BEAD WORKER / 298
Signed lower right, O. C. Seltzer. No date. Watercolor on paper 12 x 7 inches. Ex-collection: Dr. Philip G. Cole, Tarrytown, New York.

GOVERNMENT SCOUT / 299
Signed lower right, O. C. Seltzer. No date. Watercolor on paper 12 x 7 inches. Ex-collection: Dr. Philip G. Cole, Tarrytown, New York.

PRAIRIE WOLF AND COW'S SKULL / 316
Signed O. C. S. No date. Watercolor on paper 9½ x 7 inches. Ex-collection: Dr. Philip G. Cole, Tarrytown, New York.

Sharp, Joseph Henry

1859–1953 Born in Bridgeport, Ohio, J. H. Sharp studied abroad and in 1883 made the first of many trips into the West to study Indian life. Paintings exhibited at the Paris Exposition of 1900 resulted in his receiving a commission from the government to produce a series of Indian studies for its permanent collection at the Smithsonian. Sharp's first studio was on the site of the Custer battlefield in Montana. In 1909 he settled in Taos, New Mexico, making frequent trips throughout the West as well as to Hawaii and the Orient in later years. He died in Pasadena, California.

SPOTTED ELK / 302
Signed lower left, J. H. Sharp, and dated 1909. Oil on canvas 18 x 12 inches. Ex-collection: Dr. Philip G. Cole, Tarrytown, New York.

STORY OF THE WAR ROBE / 303
Signed lower right, J. H. Sharp. No date. Oil on canvas 30 x 36 inches. Ex-collection: the artist.

Shrady, H. H.

1871–1922 American sculptor, for whom no biographical information is available.

MOOSE / 206
Signed H. H. Shrady. No date. Bronze casting 20 inches high.

Simon, John

See Verelst, Johannes

Stanley, John Mix

1814–1872 Portraitist and landscape draftsman John Mix Stanley began his career as an itinerant artist in the 1830's, traveling between Detroit and Chicago. In 1842 he visited the Cherokee capital at Tahlequah, in Indian Territory, and in 1845 joined a wagon train for Santa Fe. From Santa Fe he went to San Diego, California, as an artist on the staff of Colonel Stephen Kearny, and saw military action. He later visited Hawaii, returning to the United States in 1849 to exhibit his collection of paintings in Washington, D.C. While in Washington he was commissioned to accompany Issac Steven's Pacific railroad survey in 1853–4. Nearly all of his Western paintings were lost in a fire at the Smithsonian Institution in 1865.

GAME OF CHANCE / 65
Unsigned. No date. Oil on canvas 27 x 38 inches.

Tavernier, Jules

1844–1889 Illustrator with Harper's Weekly, Jules Tavernier traveled from France to the United States in 1871, and in 1873 accompanied Paul Frenzeny on a sketching tour across the American continent. Remaining in California for a period of time, he later traveled to Honolulu, Hawaii, where he died of acute alcoholism. Many of his pictures were published in Harper's between 1873 and 1876, but only a few of his paintings have survived to the present time.

INDIAN CAMP AT DAWN / 57
Signed lower right, Jules Tavernier. No date. Oil on canvas 24 x 34 inches.

SLAUGHTERED FOR THE HIDE / 165
Signed lower right within margin of picture, Frenzeny and Tavernier. Wood engraving on newsprint, published by Harper and Brothers, New York, 1874.

Verelst, Johannes

1648–1719 Little is known of the life of Dutch painter Johannes Verelst. Establishing himself in London in 1691 as a painter of flowers, birds, and portraits, he served as court painter in the latter half of Queen Anne's reign, during which time he produced numerous portraits, many of which were reproduced in engraved form. He died in London.

ETOW OH KOAM, KING OF THE RIVER NATION / 42
Printed lower left of picture, "J. Verelst Pinxt." Printed lower right, "J. Simon fecit." Mezzotint engraving 13½ x 10⅛ inches on trimmed stock 14 x 10¼ inches. Numeral 2 appears in extreme lower right corner of margin. The picture represents one of four Mohawk chieftains from America who visited Queen Anne in 1710. Inscription beneath title of print reads "printed for John Bowles and Son, at the Black Horse in Cornhill, London." No date of publication given.

Walker, James

1819–1889 British-American painter James Walker grew up in New York City and served as an interpreter with the U.S. army in Mexico City during the Mexican War. He established a studio in New York in 1848, traveling to Washington and San Francisco on commissions. He is noted particularly for his large battle scenes and depictions of the Spanish-American vaquero.

ROPING A WILD GRIZZLY / 186
Signed lower right, James Walker, and dated 1877. Oil on canvas 29 x 50 inches.

ROPING WILD HORSES / 273
Signed lower right, Jas. Walker, and dated 1877. Oil on canvas 14 x 24½ inches.

VAQUEROS ROPING HORSES IN A CORRAL / 274
Signed lower right, James Walker, and dated 1877. Oil on canvas 24 x 40 inches.

Ward, E. C.

n.d. No biographical information available.

ENTER THE LAW / 250
Signed lower left, E. C. Ward, over a line, underneath which appears the number 24 (1924?). Oil on canvas 21 x 28 inches.

Wilson, Charles Banks

1918– Born in Miami, Oklahoma, on August 6, 1918, Charles Banks Wilson studied at the Art Institute of Chicago and later specialized in painting Oklahoma Indians of the present day. Known nationally as an author, historian, and educator, he has illustrated some twenty-eight books on various subjects, chiefly history, and his life-size portraits of Sequoyah, Jim Thorpe, Will Rogers, and Robert S. Kerr are presently displayed in the rotunda of the capitol in Oklahoma City. Widely represented by his lithographs, Wilson also produced ninety watercolor illustrations, which were featured in Ford Times, and he served for fifteen years as head of the art department at Northeastern Oklahoma A & M College in Miami. He is currently involved in a project commissioned by the state legislature to produce a series of mural paintings for the capitol building illustrative of the development of Oklahoma from its Indian Territory days to statehood.

WILLIAM THOMAS GILCREASE

Signed lower left, Charles Banks Wilson. Egg tempera painting on wooden panel 38 x 32½ inches.

Wyeth, Newell Convers

1882–1945 Born in Needham, Massachusetts, N. C. Wyeth studied art under Howard Pyle and is best known today for his many illustrations for children's classics and books of this kind. He also produced a number of murals in the 1930's, and was elected to the National Academy. His son Andrew Wyeth and other members of his family are well-known artists. N. C. Wyeth died at his home in Chadds Ford.

THE JAMES GANG / 258

Signed lower left, N. C. Wyeth. Inscribed above the signature in artist's hand, "To Bert Stimson from N. C. W." No date. Oil on canvas 25 x 42 inches.

Yves

n.d. No biographical information available.

CHASSE AUX BISONS / 270

Signed lower left, in plate, Yves. No date. Colored lithograph 18 x 24¾ inches. Printed in lower left margin, "Paris, rue de la Banque 15 pres la Bourse." Printed lower center, "Imp Lemercler, Paris," with the title following. Printed lower right margin, "Yves Lith."

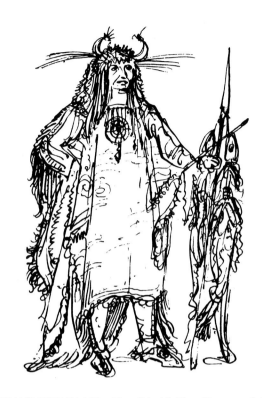

Bibliography

The Wilderness

ARTHUR, STANLEY CLISBY / *Audubon: An Intimate Life of the American Woodsman*. New Orleans: Harmanson and Company; 1937.

AUDUBON, JOHN WOODHOUSE / *Western Journal*. 2 vols. Cleveland: Arthur Clark and Company; 1906.

BARCK, OSCAR, JR. / *Colonial America*. New York: The Macmillan Company; 1958.

BARTRAM, WILLIAM / *Travels through North and South Carolina, Georgia, and West Florida*. Dublin: by subscription; 1793.

BURROUGHS, JOHN / *John James Audubon*. Ed. by M. A. deWolf Howe. Boston: Small, Maynard and Company; 1902.

CATESBY, MARK / *A Natural History of Carolina, Florida, and the Bahama Islands*. 2 vols. London: by the author; 1731–43.

CUMING, F. / *Sketches of a Tour to the Western Country*. Pittsburgh: Cramer, Spear and Eichbaum; 1810.

DE LAC, PERRIN / *Travels Through the Two Louisianas*. Trans. by R. Phillips. Snow Hill, Vt.: J. G. Barnard; 1807.

GABRIEL, RALPH HENRY / *Pageant of America*. Vol. I: *Lure of the Frontier*. New Haven: Yale University Press; 1929.

HAWKESWORTH, JOHN / *An Account of the Voyages for Making Discoveries in the Southern Hemisphere*. 3 vols. London: by the author; 1773.

HAYES, CARLTON J. H. / *Problems in American Civilization: The Turner Thesis*. Ed. with introduction by George Rogers Taylor. Boston: D. C. Heath and Company; 1949.

JAMES, EDWIN / *An Account of an Expedition from Pittsburgh to the Rocky Mountains*. 2 vols. Philadelphia: Carey and Lea; 1823.

LEWIS, JAMES OTTO / *Aboriginal Portfolio*. 10 parts. Philadelphia: Lehman and Duval, Lithographers-Publishers; 1835–36.

LEWIS, MERIWETHER, and CLARK, WILLIAM / *Travels to the Source of the Missouri River and Across the American Continent to the Pacific Ocean*. London: Longman, Hurst, Rees, Orme, and Brown; 1817.

LORANT, STEFAN / *The New World, First Pictures of America*. New York: Duell, Sloan and Pearce; 1946.

MATHER, FRANK J. / *The American Spirit in Art*. New Haven: Yale University Press; 1927.

McKENNEY, THOMAS L., and HALL, JAMES / *History of the Indian Tribes of North America*. 3 vols. Philadelphia: Edward C. Biddle; 1837–44.

NUTTALL, THOMAS / *Travels in Arkansa Territory*. Philadelphia: Thomas Palmer, printer-publisher; 1821.

Original Journals of the Lewis and Clark Expedition. 8 vols. Ed. by Reuben G. Thwaites. New York, 1904–5.

PIKE, ZEBULON / *An Account of Expeditions to the Sources of the Mississippi and through the Western Parts of Louisiana*. Philadelphia: C. and A. Conrad and Company; 1810.

Indians of the Plains

BERTHRON, DONALD J. / *The Southern Cheyennes*. Norman, Oklahoma: University of Oklahoma Press; 1963.

CATLIN, GEORGE / *Letters and Notes on the Manners, Customs and Condition of the North American Indian*. 2 vols. London, 1841. *North American Indian Portfolio of Hunting Scenes and Amusements*. London: by the author; 1844.

EWERS, JOHN C. / *The Blackfeet*. Norman, Oklahoma: University of Oklahoma Press; 1958.

GRINNELL, GEORGE BIRD / *The Cheyenne Indians: Their History and Ways of Life*. 2 vols. New Haven, 1923.

HODGE, FREDERICK W. / *Handbook of American Indians North of Mexico*. Washington, D.C.: Bureau of American Ethnology; Bulletin 30, 1910.

IRVING, WASHINGTON / *Tour on the Prairies*. London: John Murray; 1835.

LATROBE, CHARLES JOSEPH / *The Rambler in North America*. New York; Harper and Brothers; 1835.

MOONEY, JAMES / *The Ghost Dance Religion.* Washington, D.C.: Bureau of American Ethnology; Annual Report, Vol. XIV, No. 2, 1896.

MURRAY, JOHN / *Travels in North America.* 2 vols. London: Richard and Sam Bentley; 1839.

ROE, FRANK G. / *The Indian and the Horse.* Norman, Oklahoma: University of Oklahoma Press; 1955.

WEDEL, WALDO R. / *Prehistoric Man on the Great Plains.* Norman, Oklahoma: University of Oklahoma Press; 1961.

WISSLER, CLARK / *Indians of the United States: Four Centuries of Their History and Culture.* New York, 1940.

WORMINGTON, MARIE H. / *Ancient Man in North America.* Denver, Colorado: Denver Museum of Natural History; 1957.

The Missouri River, Waterway West

CATLIN, GEORGE / *Letters and Notes on the Manners, Customs and Condition of the North American Indian.* 2 vols. London: by the author; 1841.

DEVOTO, BERNARD / *Across the Wide Missouri.* Boston: Houghton, Mifflin Company; 1947.

DUNBAR, SEYMOUR / *A History of Travel in America.* 4 vols. Indianapolis: Bobbs-Merrill Company; 1915.

HABERLY, LOYD / *Pursuit of the Horizon.* New York: The Macmillan Company; 1948.

MAXIMILIAN, PRINCE OF WIED / *Travels in the Interior of North America.* Trans. by H. Evans Lloyd. London: Ackermann and Company; 1843.

TABEAU / *Tabeau's Narrative of Coisel's Expedition to the Upper Missouri.* Ed. by Annie Heloise Abel. Trans. from French by Rose Able Wright. Norman, Oklahoma: University of Oklahoma Press; 1939.

Trappers & Traders

CHITTENDEN, HIRAM MARTIN / *History of the American Fur Trade of the Far West.* 2 vols. Stanford, California: Academic Reprints; 1954.

GALBRAITH, JOHN S. / *The Hudson Bay Company as an Imperial Factor.* Los Angeles: Berkeley Press; 1957.

MILLER, ALFRED JACOB / "Rough Draughts for Notes to Indian Sketches." Unpublished manuscript of 228 pages in the library of the Thomas Gilcrease Institute, Tulsa, Oklahoma. ca. 1860.

Mountain Men and the Fur Trade of the Far West. 5 vols. Ed. by LeRoy R. Hafen. Glendale, California: Arthur H. Clark Co.; 1965.

NEWHOUSE, SEWELL / *The Trapper's Guide.* New York: Mason, Baker & Pratt; 1874.

PHILLIPS, PAUL CHRISLER / *The Fur Trade.* 2 vols. Norman, Oklahoma: University of Oklahoma Press; 1961.

ROSS, ALEXANDER / *The Fur Hunters of the West.* Ed. by Kenneth A. Spaulding. Norman, Oklahoma: University of Oklahoma Press; 1956.

RUSSELL, CARL P. / *Firearms, Traps and Tools of the Mountain Men.* New York: Alfred A. Knopf; 1967.

RUXTON, GEORGE FREDERICK / *Ruxton of the Rockies.* Ed. by LeRoy R. Hafen. Norman, Oklahoma: University of Oklahoma Press; 1950.

TOWNSEND, JOHN K. / *Narrative of a Journey Across the Rocky Mountains to the Columbia River.* Philadelphia: Henry Perkins; 1839.

WILLSON, BECKLES / *The Great Company.* New York: Dodd, Mead and Company; 1900.

Overland Trails to Oregon & California

CARROLL, H. B. and HAGGARD, J. VILLASANA / *Three New Mexico Chronicles.* Quivera Society, Volume XI. Albuquerque: University of New Mexico Press; 1942.

DRIGGS, HOWARD R. / *Westward America.* New York: Somerset Books, Inc.; 1942.

DUNBAR, SEYMOUR / *A History of Travel in America.* 4 vols. Indianapolis: Bobbs-Merrill Company; 1915.

GREGG, JOSIAH / *Commerce of the Prairies.* 2 vols. New York: H. G. Langley; 1844.

JACKSON, CLARENCE S. / *William H. Jackson, Picture-Maker of the Old West.* New York: Charles Scribner's Sons; 1947.

MARCY, RANDOLPH B. / *The Prairie Traveler, A Hand-Book for Overland Expeditions.* Ed. by Richard F. Burton. London: Truber and Company; 1863.

STORRS, AUGUSTUS / *Upon the Origin, Present State and Future Prospects of Trade between Missouri and the Internal Province of Mexico.* A Congressional Report. Washington, D.C.: Government Printing Office; 1825.

THOMAS, ALFRED BARNABY / *The Plains Indians and New Mexico, 1751–1758.* Ed. by George P. Hammond. Coronada Cuarto Centennial, Volume VI. Albuquerque: University of New Mexico Press; 1940.

Freighting & Western Commerce

American Cyclopedia. New York: D. Appleton and Company; 1866.

American Heritage Pictorial Atlas of United States History. New York: American Heritage Publishing Company; 1966.

BEBEE, LUCIUS, and CLEGG, CHARLES / *U.S. West, the Saga of Wells Fargo.* New York: E. P. Dutton and Company; 1949.

CONKLING, ROSCOE E. and MARGARET B. / *The Butterfield Overland Mail, 1857–1869.* 2 vols. and atlas. Glendale, California, Arthur H. Clark Company; 1947.

EGGENHOFER, NICK / *Wagons, Mules, and Men.* New York: Hastings House Publishers; 1961.

FREDERICK, J. V. / *Ben Holladay, the Stagecoach King.* Glendale, California: Arthur H. Clark Company; 1940.

HOOKER, WILLIAM FRANCIS / *The Bullwhacker.* New York: World Book Company; 1924.

ROOT, FRANK A., and CONNELLEY, WILLIAM E. / *The Overland Stage to California.* Topeka, Kansas, 1901.

STRAHORN, CARRIE A. / *Fifteen Thousand Miles by Stage.* New York, 1911.

WALKER, HENRY PICKERING / *The Wagon Masters.* Norman, Oklahoma: University of Oklahoma Press; 1966.

WINTHER, OSCAR O. / *Express and Stagecoach Days in California.* Stanford, California: Stanford University Press; 1936.

Hunting Scenes & Sporting Amusements

BRANCH, DOUGLAS E. / *The Hunting of the Buffalo.* New York, 1929.

CAHALANE, VICTOR H. / *Mammals of North America.* New York: The Macmillan Company; 1961.

The Extermination of the American Bison. "With a Sketch of its Discovery and Life History." Washington, D.C.: U.S. Natural History Report, Part II; 1887.

HORNADAY, WILLIAM T. / *The American Natural History.* 4 vols. New York: Charles Scribner's Sons; 1914.

MAYER, FRANK H. and ROTH, CHARLES B. / *The Buffalo Harvest.* Denver, Colorado: Sage Books, Allan Swallow; 1958.

SETON, ERNEST THOMPSON. / *Lives of Game Animals*. 4 vols. New York: Doubleday, Doran and Company, Inc.; 1929.

Wild Animals of North America. Washington, D.C.: National Geographic Society; 1960.

WRIGHT, WILLIAM / *The Grizzly Bear*. New York: Charles Scribner's Sons; 1909.

YOUNG, STANLEY P., and GOLDMAN, EDWARD A. / *The Wolves of North America*. Washington, D.C.: American Wildlife Institute; 1944.

From the Hudson to the High Sierras

DRIGGS, HOWARD R. / *Westward America*. New York: Somerset Books, Inc.; 1942.

DODGE, GRENVILLE M. / *How We Built the Union Pacific Railway*. Council Bluffs: Monarch Printing Company; n.d.

HAYDEN, F. V. / *Survey of Yellowstone Park*. Boston: L. Prang and Company, Lithographer-Publishers; 1876.

JACKSON, CLARENCE S. / *William H. Jackson*. New York: Charles Scribner's Sons; 1947.

RAE, W. F. / *Westward By Rail, the New Route to the East*. New York: Appleton and Company; 1871.

VINTON, STALLO / *John Colter, Discoverer of Yellowstone Park*. New York: Edward Eberstadt; 1926.

WILKINS, THURMAN / *Thomas Moran, Artist of the Mountains*. Norman, Oklahoma: University of Oklahoma Press; 1966.

Troopers West

ARMES, GENERAL GEORGE A. / *Ups and Downs of an Army Officer*. Washington, D.C.: by the author; 1900.

BOURKE, JOHN C. / *On the Border with Crook*. New York: Charles Scribner's Sons; 1891.

CARRINGTON, FRANCIS C. / *Ab-sa-ra-ka, Land of Massacre*. Philadelphia: J. B. Lippincott Company; 1879.

CARTER, CAPTAIN ROBERT C. / *The Old Sergeant's Story*. New York: Frederick H. Hitchcock; 1926.

CARTER, GENERAL WILLIAM C. / *Horses, Saddles, and Bridles*. Baltimore: The Lord Baltimore Press; 1918.

CUSTER, ELIZABETH B. / *Following the Guidon*. New York: Harper and Brothers; 1890.

DOWNEY, FAIRFAX / *Indian Fighting Army*. New York: Charles Scribner's Sons; 1941.

Forts and Forays. Ed. by Clinton E. Brooks and Frank D. Reeves. Albuquerque: University of New Mexico Press; 1948.

FOUGERA, KATHERINE GIBSON / *With Custer's Cavalry*. Caldwell, Idaho: Claxton Printers, Ltd.; 1940.

FOWLER, WILLIAM W. / *Women on the American Frontier*. Hartford, Connecticut: S.S. Scranton and Company; 1883.

HERR, JOHN K. and WALLACE, EDWARD S. / *The Story of the U.S. Cavalry*. Boston: Little, Brown and Company; 1953.

LECKIE, WILLIAM H. / *The Buffalo Soldiers*. Norman, Oklahoma: University of Oklahoma Press; 1967.

LOWE, PERCIVAL G. / *Five Years a Dragoon*. Kansas City, Missouri: The Franklin Hudson Publishing Company; 1906.

PELTZER, LOUIS / *Marches of the Dragoons in the Mississippi Valley*. Iowa City, Iowa: State Historical Society of Iowa; 1917.

RICKEY, DON, JR. / *Forty Miles a Day on Beans and Hay*. Norman, Oklahoma: University of Oklahoma Press; 1963.

ROE, FRANCES M. A. / *Army Letters from an Officer's Wife*. New York: D. Appleton Company; 1909.

SPRING, AGNES WRIGHT / *Casper Collins*. New York: Columbia University Press; 1927.

WORMSER, RICHARD / *The Yellowlegs*. Garden City, New York: Doubleday and Company, Inc.; 1966.

ZOGBAUM, RUFUS F. / *Horse, Foot and Dragoons*. New York: Harper Brothers; 1888.

Western Characters

BORLAND, HAL / *High, Wide and Lonesome*. Philadelphia, New York: J. B. Lippincott Company; 1956.

BROWN, DEE / *The Gentle Tamers: Women in the Old Wild West*. New York: G. P. Putnam's Sons; 1958.

CONNELLEY, WILLIAM E. / *Wild Bill and His Era*. New York: The Press of the Pioneers; 1933.

COOLIDGE, DANE / *Fighting Men of the West*. New York: E. P. Dutton and Company; 1932.

CUNNINGHAM, EUGENE / *Triggernometry*. Caldwell, Idaho; Reprinted, Claxton Printer; 1934.

DICK, EVERETT / *The Sod House Frontier*. New York: D. Appleton, Century Company; 1937.

DYKSTRA, ROBERT R. / *The Cattle Towns*. New York: Alfred A. Knopf; 1968.

EBBOT, PERCY G. / *Emigrant Life in Kansas*. London: Swan, Sonnenschein and Company; 1886.

GARD, WAYNE / *Frontier Justice*. Norman, Oklahoma: University of Oklahoma Press; 1949.

HENDRICKS, GEORGE / *The Bad Men of the West*. San Antonio: The Naylor Company; 1941.

Letters from Buffalo Bill. Ed. by Stella A. Foote. Billings, Montana: Stella A. Foote; 1954.

LYMAN, GEORGE T. / *The Saga of the Comstock Lode*. New York: Charles Scribner's Sons; 1934.

MERCER, A. S. / *The Banditti of the Plains*. Norman, Oklahoma: reprinted by the University of Oklahoma Press; 1954.

PARKHILL, FORBES / *The Wildest of the West*. Denver, Colorado: Sage Books; 1951.

RUXTON, GEORGE FREDERICK / *Life in the Far West*. Ed. by LeRoy R. Hafen. Norman, Oklahoma: University of Oklahoma Press; 1950.

SELL, HENRY B., and WETBRIGHT, VICTOR / *Buffalo Bill and the Wild West*. New York: Oxford University Press; 1955.

SPRAGUE, MARSHALL / *A Gallery of Dudes*. Boston: Little, Brown and Company; 1966.

The Cowboy

ABBOTT, E. C. (TEDDY BLUE), and SMITH, HELENA HUNTINGTON / *We Pointed them North*. New York: Farrar and Rinehart, Inc.; 1939.

ADAMS, ANDY / *The Log of a Cowboy: A Narrative of the Old Trail Days*. Boston: Houghton Mifflin Company; 1903.

BRISBIN, GENERAL JAMES S. / *The Beef Bonanza or How to Get Rich on the Plains*. Philadelphia; J. B. Lippincott and Company; 1881.

DALE, EDWARD EVERETT / *The Range Cattle Industry*. Norman, Oklahoma: University of Oklahoma Press; 1930.

DENHARDT, ROBERT M. / *The Horse of the Americas*. Norman, Oklahoma: University of Oklahoma Press; 1947.

DOBIE, J. FRANK / *The Longhorns*. Boston: Little, Brown and Company; 1941.

The Mustangs. Boston: Little, Brown and Company; 1952.

The Voice of the Coyote. Boston: Little, Brown and Company; 1949.

LATHAM, DR. HIRAM / *Trans-Missouri Stock Raising*. Introduction by Jeff L. Dykes. Denver, Colorado: The Old West Publishing Company; 1962.

LOMAX, JOHN A., and ALLEN / *Cowboy Songs*. New York: The Macmillan Company; 1938.

McCOY, JOSEPH G. / *Historic Sketches of the Cattle Trade.* Washington, D.C.: reprinted by The Rare Book Shop; 1932.

OSGOOD, ERNEST STAPLES / *The Day of the Cattlemen.* Minneapolis, Minnesota: University of Minnesota Press; 1929.

PEAKE, ORA BROOKS / *The Colorado Range Cattle Industry.* Glendale, California: Arthur H. Clark Company; 1937.

RICHTHOFEN, BARON VON WALTER / *Cattle Raising on the Plains of North America.* New York: D. Appleton and Company; 1885.

STUART, GRANVILLE / *Forty Years on the Frontier.* Cleveland, Ohio: Arthur H. Clark Company; 1925.

TOWNE, CHARLES WAYLAND, and WENTWORTH, EDWARD NORRIS / *Shepherd's Empire.* Norman, Oklahoma: University of Oklahoma Press; 1945.

WEBB, WALTER PRESCOTT / *The Great Plains.* Ginn and Company; 1921.

Romance & Realism

ADAMS, RAMON F., and BRITZMAN, HOMER E. / *Charles M. Russell, the Cowboy Artist.* Pasadena, California: Trails End Publishing Company, Inc.; 1948.

BOREIN, EDWARD / *Borein's West.* Ed. by Edward S. Spaulding. Santa Barbara, California: Press of the Schauer Printing Studio, Inc.; 1952.

DODGE, THEODORE A. / *Riders of Many Lands.* London: Osgood, McIlvaine and Company; 1894.

LUHAN, MABEL DODGE / *Taos and Its Artists.* New York: Duell, Sloan and Pearce; 1947.

PINCKNEY, PAULINE A. / *Painting in Texas in the Nineteenth Century.* Austin: University of Texas Press; 1967.

TAFT, ROBERT / *Artists and Illustrators of the Old West, 1850–1900.* New York: Charles Scribner's Sons; 1953.

Paul A. Rossi, director of the Thomas Gilcrease Institute since 1964, was born in Denver, Colorado, in 1929. Before attending Denver University (1947–51), he spent two years as a cowboy and harvest worker. He came to the Institute in 1961 as curator and deputy director; prior to that time he worked for the Colorado State Historical Society, ran a commercial art studio, and did industrial design and illustration. Mr. Rossi has illustrated many works and has written magazine articles on western and aviation subjects. He is co-author of *Western History Through the Eyes of Artists Who Painted the West*. His paintings and sculpture have been shown in Colorado, Wyoming, New Mexico, and Oklahoma.

David C. Hunt, curator of art for the Thomas Gilcrease Institute, was born in Labette County, Kansas, in 1935. He was graduated from Tulsa University in 1958 and took an M.A. in art history from the same university ten years later. Mr. Hunt did industrial illustration and design until 1965, when he joined the Gilcrease Institute as production manager of museum publications. He became curator of the art collection in 1967 He has been associate editor of the museum's quarterly, *American Scene,* for which he has written many articles. He is married to the former Carol Beth Keene.

DESIGN & PRODUCTION NOTES

This book was photo-composed in film by Westcott and Thomson, Philadelphia, Pa. and York Graphic Services, York, Pa.

The text type is Elegante, the film counterpart of Palatino, which was originally created by Herman Zapf.

Calligraphy used for display and headings was created by Gun Larson especially for this edition.

Paintings & other works of art from the Gilcrease Institute were photographed by Oliver Willcox.

Design & graphics were directed by R. D. Scudellari.